SO-AIP-900

This Business of Glass

Loretta Radeschi

AMERICAN CRAFT
INFORMATION CENTER

JUN 2 7 1997

HD
9623
.R23
1994

The information contained in this book is intended to supplement other informational sources and the reader's own business acumen and common sense. This is not a comprehensive resource and the publisher does not accept responsibility for the results of any business decision made by an individual or corporate business owner.

All rights reserved. No part of this publication may be reproduced or transmitted in any form or by any means, electronic or mechanical, including but not limited to photocopying, recording, and or any other information storage and retrieval system, without written permission of the publisher.

Copyright © 1994 by The Glass Press, Inc.

Printed in the United States of America

Design and Typesetting by Dark Horse Press
Cover design by Joe Porcelli
Cover Layout by Enterprise Graphics, Philadelphia, PA
Photo of author by Steven Barth
Cover and Profile Photos by Meade Breese, Doug Benedict,
Michael D'Orio, and Alan Kravitz

First American Edition
ISBN #: 0-962-9053-3-X

Published by:
The Glass Press
PO Box 678
Richboro, PA 18954
(215) 579-2720

10 9 8 7 6 5 4 3 2 1

For George and David

Contents

INTRODUCTION

This Business Of Glass is both long overdue and timed perfectly. Long overdue because no single source of business information has ever been available for glass people. Until now, we gleaned our glass business savvy and professionalism from either non-glass sources or learned the hard way, by trial and error; making the same mistakes twice, some three times.

This Business Of Glass is timed perfectly because the glass industry today, more than ever before, offers great opportunities for the creative artist and entrepreneur. Opportunities abound for those with the spirit and the willingness to devote the same smarts and energies that go into creating a beautiful work in glass into setting up and running a successful glass business. The public is ready for glass. The tools and materials are there, the talent is there, and now with this book, so are the means for putting all the pieces together.

Businesses of any nature share certain characteristics and are subject to many of the same economic forces. The glass business, however, is different because it creates such fine lines of distinction between art, craft, design, home improvement, commerce and service. In addition, passion for the material (glass) drives many of its practitioners rather than money lust. This subtle, but important dynamic of personality has always been the glass industry's perpetuating force and, at the same time, its greatest handicap.

The cliche reads, "Art (or craft) and business don't mix." It's not true. Talk to those who have made a successful career for themselves in glass, or in any other art and craft for that matter, and you'll find they have also made a successful

career of managing their businesses. In fact, many claim that improving their business skills and earning power actually enhanced their artistic and creative abilities. Art and business do mix, but you need to study, improve and perfect your business skills in the same way you study, improve and perfect you glass working skills.

This Business Of Glass is a "how-to" of a special kind. It takes over where books on technique stop. Once you've learned how to create and express yourself in the medium of glass, This Business Of Glass takes you to the next plateau ... building a career around your skills.

The need for a qualified reference work on the business of being a glass professional is something I have felt for a long time. You probably have to, or you wouldn't be reading this. To have a writer of Loretta Radeschi's professionalism and background tackle the project is a real plus for us. This is no "skim the surface, pie-in-the-sky" quick reference. Loretta's done a fine job of making *This Business Of Glass* a comprehensive, nuts and bolts, pull up your bootstraps, information-packed book that can get you off and running. If you're already in business, *This Business Of Glass* will get you running at a better pace.

Read, digest and enjoy this book. Keep it handy. Most of the information it contains you'll be able to put to use immediately. Some you'll find useful further on in your career. But rest assured, it's all here when you need it. *This Business Of Glass* is a reliable tool you can turn to again and again as you build and improve your glass business skills.

When you tap into the new surge of optimism and energy shared by more and more glass people today, you can't help feeling the excitement they feel about what they do, especially if they're successful at it. Talk to someone who has just purchased a work in glass for their home or office and you

can't help being reminded of the magic and awe-inspiring power of the material itself. It's that same magic and power that you and I felt when we first discovered glass.

Good glass working skills and good business skills are a perfect match. They support and nurture each other. Don't let anyone tell you otherwise.

You've taken the first step in putting your glass career on the right track; you've picked up this book. Keep up the good work, and read on.

Joe Porcelli

1

A Short History of Glass

"Glass is inherently beautiful. The process is seductive;
the finished results even more alluring."
—*Douglas Heller*, Heller Gallery

Hot or cold, glass' beauty, transparency, and strength come alive in the hands of master craftsmen. For thousands of years, artists/craftsmen have manipulated glass through the use of colors, shapes, and designs. Born of fire over 40 million years ago, glass remains a challenge.

"As a professional artist/craftsperson I know that struggling with the material and its limitations has always been a major part of my career or any other person's career," says glass artist, Paul Stankard. In working with stained glass, artists start with the chaos of ordinary light which, by its essence, cannot be projected straight except through a laser. Working with that chaos, they carefully plan glass' ethereal and practical uses.

Glass making is one of the world's oldest crafts; its appeal has been universal for thousands of years. Glass beads and amulets dating to 2500 BC were first discovered in Mesopotamia. Egyptian royalty treasured glass vessels made, as early as 1350 BC, by wrapping hot glass around a clay core.

Glassblowing is believed to have begun around 500 BC

1

in Syria and Palestine; it then spread throughout the Roman Empire. Glassblowers created drinking cups, bowls, and pitchers, and glassblowing became the standard way of shaping glass vessels until the 19th century. Bowls and bottles, richly embellished with glass, were used by the Muslims and treasured by Islamic princes during the Middle Ages.

Beginning in the 10th century, the center of decorative glass in Europe was Venice, also a center of trade and art during the late Gothic and early Renaissance periods. The Venetian glass guild was formed in the early 1200s and glass makers were highly regarded.

"A great deal of support for the arts came out of religion which was tied to magic," says Doug Heller of Heller Gallery in New York. The magic, according to Heller, wasn't hocus-pocus, but was essentially tied to man trying to understand the universe and himself, coming into touch and contact and being at ease with things that are obviously more powerful and vibrant than he.

Imbued with this fervor, craftsmen created elaborate stained glass windows during the Gothic period. From the mosaic-like pieces of glass used in northern European architecture to the highly decorative stained glass Rose windows that blossomed throughout France in Chartres, Notre Dame and other churches in the 12th and 13th centuries windows cast an ethereal light into the Christian architecture.

Venetian glass makers emigrated to Germany and England in the 1500s. At the same time, glass cutting was introduced in England by German and Bohemian craftsmen who applied a geometric pattern of facets to lead glass enabling it to sparkle. This led to the creation of "crystal."

Glassblowers were among the settlers in Jamestown in 1607 and while glass making was America's first industry, the craft didn't thrive until 1739 when Caspar Wistar estab-

lished the first glass factory in New Jersey.

Molded blown glass speeded production in the early 1800s. In 1820 a mechanical pressing machine made possible mass production of tableware. It was a major turning point in the history of glass making.

By 1880 Corning Glass was producing light bulbs for Thomas Edison. In 1903 Michael Owens invented an automatic bottle blowing machine.

Eugene Rousseau and Emile Galle were among the first artists to work with glass in France. Galle is considered a master of the Art Nouveau style in glass. An avid gardener, he used many natural themes. Impressed with Galle's work at the 1889 World Exhibition in Paris, Louis Comfort Tiffany blew glass forms of sensual flowers on attenuated stems. He called his glass "Favrile," an old English word meaning "made by hand." Rene Lalique, a Frenchman who first became famous as a designer of Art Nouveau jewelry, created a style of vases, bowls, and jars decorated with a high frosted relief sometimes accentuated by red or black enamel.

In contrast to the highly decorative Art Nouveau style, the strong lean lines and functional aesthetics of the Swedish Modern style emerged from Orrefors Glassworks. Two forms of cased glass, called *Graal* and *Ariel,* were developed by artists Simon Gate and Edvard Hale in Sweden. They produced colored relief decorations covered with clear, smooth crystal. Boda and Kosta factories later produced this style.

After World War II, efforts to rebuild devastated European cities, especially in Germany, generated an unprecedented demand for stained glass installations. The results heralded the modern movement of the medium. During the 1950s and 60s, this highly influential period inspired stained glass artists in all parts of the world.

A new era of glass making began in the 1960s with the studio glass movement led by Americans Harvey Littleton and Dominick Labino. Littleton, a professor of ceramics whose father was the director of research of Corning Glass Works, believed blown glass could transcend its identity as an industrialized craft and approach fine art and that it could be worked in a small studio. Labino, a friend of Littleton and a glass scientist, developed a formula for a glass that would melt at a relatively low temperature. Littleton's and Labino's ideas led to the introduction of the small studio kiln, a seminal development in blown and fused glass; the contemporary glass movement was born.

The late 1960s also saw a growing interest in stained glass as a hobby. By the mid 1970s retailing stained glass supplies grew into a sizable business. Schools were teaching it; studio artists were working with it. From serendipitous sun catchers to lamps and window panels, stained glass was evolving into a major decorative element and hobby. A retail trade evolved around the increasing demand.

Large-scale stained glass has emerged in architectural designs. It is seen in public and private institutions including universities, hospitals, and airports throughout the world and continues to reinforce its presence in the international architectural community.

Cast glass as an architectural and sculptural element in the United States appeared in the late 1970s through the efforts of Paul Marioni and Howard Ben Tre.

The changes in glass, both hot and cold, over the last 20 years have been astounding, according to Doug Heller. "If one were to have dropped in at five-year intervals to see the changes in the field, one would be stunned at the progression," says Heller. "The ideas are more complex; the techniques more sophisticated and complicated; the work is more mature."

4

The entrepreneurial spirit flourished as more and more glass artists began marketing glass from their own studios. The number of large major studios, once the signature of the art glass industry, especially stained glass, has diminished since the 1970s. The art glass industry reflects the trend of other businesses in the United States toward specialization. The glass industry's remarkable growth is due to individuals choosing to own their own businesses, to educate the public about glass, and to market their own work. As a result, the public's interest in glass, and crafts in general, has enjoyed a resurgence over the last two decades equal to and surpassing the phenomenal activities of the late nineteenth and early twentieth centuries.

In an era of high technology, where machines, robots, and computer chips create and operate many of the products we use, a hand-crafted piece of glass humanizes the environment. It enables a person to touch the creative energy of the artist in the contours, colors, and textures of the glass. It enables the artists to share a part of him, or herself, through the glass. The public's acceptance and desire for handmade glass has helped to place examples in museums, galleries, important private collections and at the finest craft and art shows here and abroad.

Succeeding in business as a glass professional, whether an artist, craftsperson, or retailer, is within reach and more feasible than ever before. Many, as you will read in the following chapters, have done it.❖

2

Having What It Takes

"Success is the result of the reality of the excellence of your work."
—Paul Stankard

As a glass artist/craftsperson you're presented with challenges not encountered in other professions. Glass attracts a certain type of personality, one that likes challenge and responds to situations that call for spontaneity and change. In a world where you see an erosion of classic values, glass is one material that calls for dedication, application, commitment, and integrity in order to succeed with it. If you work with glass professionally, you have a career, and like any other career, the more seriously you approach it the more likely you'll succeed.

Whether you work in a studio creating hot glass or cutting cold glass, whether you have a glass business you want to expand or a hobby that you want to turn into a business, one of the first steps to take is to question yourself, your goals, and the reasons for getting into or staying in the business of glass.

Questioning whether you have the personal and business traits necessary to succeed can be a powerful tool in helping you reach your potential. It might not always be easy. The questions could make you feel uncomfortable or provoke the

6

unexpected. But the answers play an important part in your success as a glass artist.

PERSONAL TRAITS

Glass artists who have successfully pursued a livelihood through their artwork share several qualities. To determine whether you have the personal qualities frequently found among successful artists/craftspeople begin by asking yourself if you are:

- Comfortable with risks?
- An original thinker?
- Self confident, but have self doubts from time to time?
- A good organizer?
- Healthy?
- Flexible?
- Quick to recognize and seize opportunities?
- Energetic?
- Understand or use new technology?
- Willing to do whatever it takes to get the job done, whatever the job?
- Willing to work long hours, seven days a week if necessary.

You can't reach the upper echelon of the contemporary glass world or any other category of glass without contributing, mastering your craft, understanding what excellence is, building on a tradition, and bringing originality to your work of art. According to Paul Stankard, "There is a glass ceiling over people who are not original and who do not work well. If you want to grow, you have to identify areas to improve on. You have to master your craft and deal with all sorts of limitations set by the material."

Scott Haebich

Scott Haebich, owner of The Stained Glass Place in Grand Rapids, Michigan, understands the power of printed material in operating a successful retail business. "You can't run a successful business without it," he says succinctly. With a degree in business communications and experience working as a graphic designer and commercial artist in a print shop, Scott puts the power of print to work in his store.

With direct mail fliers and in-store handouts, Scott has seen his retail business grow steadily since he took over ownership in 1984. The success, he says, is in direct relation to the amount of promotional material he distributes. "The more we use promotional material, especially direct mail pieces, the more our business has grown." He sends direct mail fliers to existing customers on a regular basis. The fliers highlight new products, list classes, and free seminars and promote major store events like the Stained Glass Festival that has kicked off the fall season with several seminars on one day, and the Spring Art Fair that has given customers a chance to display their work in the store with the opportunity to win an award. Scott's promo pieces have filled classes, sold products, encouraged new business, and increased the interest of current customers.

The Stained Glass Place is not a studio. Scott's store sells products and gives classes. It does not design and market finished pieces. Before he owned The Stained Glass Place, he managed it under another name.

Scott became interested in stained glass as a hobbyist while working as a commercial artist. He took a class at a retail store, enjoyed it and when the opportunity came to manage a stained glass store in 1982 he took advantage of it.

Three years later he bought the store, later changed its name, increased its customer base and turned it into a profitable operation with several full- and part-time employees.

Scott aims his marketing strategy at two markets—persons who have not been in the store and his regular customers. It includes "great" customer service to both groups. He offers several types of workshops to introduce people to stained glass and numerous classes and seminars to those who have worked with glass. Service, he says, goes beyond being friendly; it's making sure you learn what every customer needs, listening and finding an answer to every question that's asked. Listening has led Scott to realize there's a need among hobbyists for practical information.

To fill that need, in 1988 Scott began publishing *Stained Glass News*, a newspaper for hobbyists that's distributed free through retailers in the US, Canada, and overseas. "I'd watch my customers leaf through a hobbyist magazine and put it down just because of its price." says Scott. "I thought it would be really nice to have a publication that would address their specific needs, and I only hoped other suppliers felt the same way I did."

They have, and Stained Glass News has continued to grow. The four-color publication encourages reader participation through a question and answer section, a Readers' Gallery featuring color photos of their work, and readers' suggestions on working with stained glass. *Stained Glass News* also includes new product information and highlights safety, hot glass, and basic glassworking information provided in columns written by industry professionals known for their expertise.

"The reason for the store's and the newspaper's success is that I have a dedicated group of co-workers who help me continue to build on what we've done well over the years, while constantly adding new, exciting aspects to each business."

"Working as a glass artist requires a great deal of belief in yourself and what you want to do," says Vincent Olmsted, studio artist and former technical advisor at the Creative Glass Center in Millville, New Jersey. "You have to ride with the ups and downs of the market and with the attitudes you feel about yourself. You're not always going to have a good day," he says. "but if you can maintain belief in yourself and keep going, not blindly but with a plan, you're going to be successful."

Vincent admits it's not always easy to keep on going. "If you sell your work, you have to be the marketer, the ad agency, and the rep. The earnings in the beginning are not always enough for you to hire a person to do your marketing. To promote yourself effectively, you have to be very organized," he says.

If you're interested in supporting yourself and perhaps a family as a professional craftsperson in glass. Paul Stankard suggests you begin by learning as much as you can about glass through magazines, workshops, schools, and museums; acquire a bibliography of suppliers and manufacturers, expose yourself to Excellence, visit and view the collections of the Corning Glass Museum in Corning, New York and the Museum of American Glass in Millville, New Jersey. The Corning Library can provide you with a bibliography of museums nationwide that have major glass collections.

Schools, such as Pilchuck, Penland, and Haystack are important glass centers, but what's most important is to have historical familiarity with glass. Study the glass from the past. It gives you a reference point. Museum collections have preserved excellence in glass. "If a glass artist familiarizes himself with excellence from the works of art in glass, he will heighten his own expectations," says Stankard. Learn your technique from the masters, take their knowledge and apply

it to yourself and your ongoing growth as an artist.

When Doug Heller of Heller Gallery looks at a piece of glass art, he looks for originality, creativity, and technical achievements as well as those elements that are difficult to define but are known when seen—an emotional quality that a good work has that goes beyond just the technical precision, that has the ability to generate a visceral response in the viewer, that gives you a terrible craving. "It can be something that can range from sadness to elation, but something that really moves you. You recognize those qualities when you're in contact with them," says Doug.

Good work is a power or eloquence that transcends time, culture, and many, many different things that normally limit and define us.

More important to an artist than projecting a sense of commercial success is that he exude a sense of confidence about what he's doing, according to Heller. "For many, the money by itself is not the goal. If you look at most successful people, they work for the pleasure and challenge of growth and achievement. They constantly challenge themselves and what they can do next," he says.

Hortense Green of the American Craft Council echoes that observation. "The challenge facing a glass artist depends upon what he expects from what he does," she says. "Most people of real talent are going to work at their craft whether they sell or not." If you can combine your love of working with glass, whether as a studio artist or a retailer with earning a living, you've achieved what many people dream of—doing what they love.

Today there are plenty of galleries or art stores where you'll find no works of art or creativity but plenty of product. The down side to this great support of the arts is that mundane and mediocre work is supported, which Heller regrets.

"It's laudable for everyone to be as creative as they can, but I don't think everyone should strive to be a professional artist. Some people should just 'sing in the shower'."

BUSINESS TRAITS

A great deal of satisfaction can be gained from doing something meaningful and being fairly rewarded or compensated for it. And what a glass artist does is meaningful. "He creates cultural property," says Larry Kolybaba of Baye Glass Studio in Delta, British Columbia. "He's creating people's emotions and feelings that will be around for a long time."

If you are going to do artwork and are serious about it, you have to create the business structure that will allow you to do the artwork. If you can't run a business, you won't be able to have the luxury of creating art: you need to have money. "I can't imagine somebody making art without recognizing business is important. You've got to make money. You need it to live. If you have an alternate source of income that's fine. But business is not incidental to art," says Kolybaba.

"You have to be practical, organized, decisive, diplomatic, even-tempered, positive, honest, intelligent, and energetic. "Lots of times I'm a cheerleader for my staff. I ask questions and listen. You have to be good at solving problems, at being a mediator," says Peggy Karr, owner of Peggy Karr Glass.

"You have to learn the vocabulary," says Diane Essinger of the Michigan Glass Guild. Know the meaning of the words used in glassworking as well as the related trades. If you create architectural panels, understand the building trades terminology that relates to installations. If you make lamps, know the names of each lamp part. Be able to present proposals to clients in a professional manner.

Operating A Business Takes, Among Other Things:

Drive, which encompasses responsibility, initiative, and persistence. Responsibility looks different through the eyes of the self-employed than it does through an employee. You have the responsibility to find the jobs that will support you. There is no cushion from responsibility when you work for yourself. Do you have the initiative to find the work and the persistence to keep looking?

Thinking ability, including original, creative thinking (which as a glass artist you already possess), along with critical and analytical thinking. Can you break down the meaning of financial statements to understand how they relate to what you've done in the previous months? Can you understand your business—its major trouble points, the underlying problems? Can you determine what's really important, what needs to be done to improve your business and to wonder what questions you haven't asked? Do you have a clear set of goals and a plan to achieve them?

Ability to relate to others, with sociability, consideration, cheerfulness, tact, persuasiveness, counseling, advice, and the ability to sell your ideas. Can you accept the blame when things don't go right and congratulate others when things go well? Success has 1,000 fathers; failure is an orphan. Do you magnify your ability and minimize your shortcomings? Are you a leader or a follower?

Communication skills—verbal and written. Can you converse and write in a clear, concise and considerate manner to employees, suppliers, and customers? Can you take criticism and jealousy from those who might say, "Get a real job"?

Technical knowledge. Is your work an example of excellence?

"You have to put the customer first if you sell supplies," says one New York retailer. "If you're not serious about your customers, you create ill will not only for your operation but for the industry as a whole," he says.

Vincent Olmsted learned some of his business skills watching the Nightly Business Report and other programs about management and profiles about different companies on the Public Broadcasting System. "I look at other people who I think are successful and read lots of books written by business people about becoming successful, both in business

and within yourself. You have to deal with your own personal aspects before you can successfully deal with people," he says.

If you've worked with glass for a number of years, or have worked at other businesses in your lifetime, you bring to this venture a number of advantages. By starting a business when you're older, you'll likely have confidence in your own judgment. You know how and where to get help and how and when to delegate responsibility. You bring a mother lode of common sense to your business.

Owning and operating your own business gives you the opportunity to visualize and make things happen. To many entrepreneurs, it's not the potential money that they can earn that's exciting, but rather being the motivator. It's doing what you enjoy. As Peggy Karr says, "It's a real thrill to get an idea and work it out."

Successful businesses have become that way, more often than not, because they stand for something. While customer satisfaction, a good product, having a market to sell, knowledgeable and talented staff, and cost control are all important elements to success, the critical factor is to consider what is truly important to you. What are the vital, critical factors of your business? Each business despite its similarities to others is unique. Use your particular strengths to survive and prosper.

Part 2

HAVING WHAT IT TAKES/PUBLIC'S PERCEPTION

*"The more the art community educates the public, the more
sophisticated they'll become. A sophisticated consumer won't ask
where you get your ideas."*
—Hortense Green, American Craft Council

Ask about the public's perception about any aspect of glass art—decorative, architectural, or sculptural—and the answer will revolve around their need to be better informed.

Glass is as ubiquitous in the modern world as it is beautiful. We can't go anywhere without seeing it, without using it. From the most modern office building to fiber optics, glass is everywhere. It can be hard edged, cutting, and threatening, or soft, flowing, and graceful. Glass has a unique ability to transform light. In creative hands, the possibilities are endless.

"When a person looks at glass there is an inherent fascination because of the light, surface, and an intrigue with technology and science that comes through to people, but I don't think there's a broad-based understanding of glass in the fine arts," says Daniel Stetson, executive director of Laguna Gloria Art Museum in Austin, Texas.

No one has grown up in an environment where they haven't seen something precious made of glass. Yet, there's been a dearth of promotion and information about glass as a decorative element or as a fine art. Only occasionally do we see it in mainstream decorating magazines.

Public relations and promotion have a great deal to do

15

with how people view anything and art glass suffers from the lack of both. Most of the information about art glass in architecture, sculpture, and decorative objects appears in specialized glass and art magazines, away from consumers and the mass market.

Many people aren't aware of the creative work being done with glass. The need to educate the public is evident when you see a person tap a piece of glass art with his fingernails to prove to himself the object is glass and not plastic.

Understanding the public's perception and educating them to become astute, sophisticated buyers can only help glass artists in whatever area of glass they work. To that end, galleries such as The Heller Gallery in New York and Mindscape Gallery in Evanston, Illinois, conduct seminars for the public. Sometimes the talks are directed to current shows; other times they concern topics the galleries think are appropriate to explore, including discussions among artists about their art and making a living as an artist.

"The lectures galvanize people," says Doug Heller. "It brings them in. It helps them recognize the aspects and awards of owning glass beyond those of just several impulsive acquisitions. The primary reward of owning glass is the intellectual and emotional stimulation that one gets," says Doug. "The purchaser is allowed to share some of the process that began with the creative process of the artists."

In addition to the programs provided by galleries, another way to educate the public is through museum and state council exhibitions. They give a grounding, a credibility to crafts, according to Hortense Green.

"A wide range of work is primarily decorative and that's perfectly legitimate," says Doug Heller. For the most part, glass remains in many people's eyes as a classic aspect of the

decorative arts.

Glass straddles between being perceived as a craft and viewed as an art form. When glass is exhibited in an art gallery it is viewed as art. However, when glass is installed in a building, as a window, or on display on a coffee table as opposed to a pedestal, is it not also art? "Leaded glass/flat glasswork is really an architectural art," says David Crane of Plumstead Studios in Plumstead, Pennsylvania. "It's a hand made architectural sculpture as opposed to a Renaissance easel painting. What makes a painting art and architectural glass not art? What makes one vase a work of art and another just a container? Often it's the utilitarian nature of the work, although utilitarian objects somehow become art when they're obsolete."

When people think of stained glass, the first thing that comes to mind is church windows. But that's changing, as people see more glass in galleries, craft shows, in homes, and in architectural applications.

"Much of the public thinks glass is beautiful, but they don't understand quality in stained glass. What they like frequently has nothing to do with craftsmanship, but rather reflects their personal taste," according to Vicki Payne, of the Stained Glass With Vicki Payne television series.

Certain media become trendy because they're fun to work with. Decorative glass appears at times to be trendy, partly because of the availability of colored sheets of glass, and the ability of glass manufacturers to respond to popular demand. The variety of colored glass makes it enjoyable to work with and more adaptable in decorating themes that follow trends.

"The general public wants more handcrafted American-made products," says Peggy Karr. From her experience, selling to wholesalers through craft shows, Peggy has ob-

served that people have a growing understanding of stained glass and are starting to learn about fused glass. She informs her customers about glass in general and her work in particular. With each plate she sells, Peggy attaches a care guide and story about how the plate is made.

Glass is one of the oldest materials we have. Ancient cultures had a philosophy of blending the arts, including glass, into the world in which they lived. It was a natural thing to do. When glass, whether as a fine or a decorative art, is more integrated into our lives, our lives become richer.❖

3

Building Your Business On Your Talents

"If you can follow your bliss, you can slowly edit through all the distraction and do what feels right for you."
—Paul Stankard

Glass offers exciting possibilities. It can be blown, fired, bent, embossed, fused, cut, painted, etched, crushed, and sandblasted. Whether you work in a one-person studio, or in collaboration with other artists; whether you retail, restore, or repair glass; whether you sell designs, lecture or make videos, the opportunities are limitless for creative and financial satisfaction. From jewelry and decorative objects for the home to massive architectural panels and sculptural designs, the applications for glass are endless.

When deciding what area of glass you want to focus on, take advantage of the information available at schools, from artists, in museums, on videos of craftspeople at work, and in magazine articles devoted to the art. Review historical and contemporary glass, slowly editing what you see until you find an area in glass that pleases you. Once you've identified an area, learn more about facilities that would support that kind of work. In addition to schools like Pilchuck, Penland,

and Haystack, colleges and universities throughout the country offer glass programs. From anywhere in the United States, a person is probably no more than 100 miles from a glass program. The Corning Museum of Glass library has a listing of schools that offer glass courses.

The basis for your decision regarding the area of glass you want to focus on should be determined by what you really want to do, not upon limitations of space and economics, according to Paul Stankard. "You have to take a leap of faith.," says Stankard.

He believes that if you're going to work with glass, you have to do it well. If you spend six months to two years researching an area of glass, you'll be able to put it all together and make it work.

Do what feels right for you. Since childhood, Stankard always loved flowers. "From the time I was twenty to thirty-two years of age, I was trying to be something other than I was.," says Stankard. "Slowly, when I discovered glass and focused my energies on making glass flowers, things started to take on added meanings. I started to feel a sense of pride. I felt that I was accomplishing something and it felt good."

Once you decide how you want to work with the glass, whether you want to fuse, sandblast, etch, blow, or cut it; whether you'd like to work in a studio or as a retailer or alone or in collaboration with other artists, consider the marketing options. Does commission work interest you? What about restoration, or teaching, or designing? In the following section look at some of the more common options available to glass artists.

DECORATIVE OBJECTS

The decorative glass object has been the starting point for many successful artists. Decorative objects can be functional

as well as beautiful. Their usefulness can make them easier to sell than more abstract, artistic, sculptural glass art.

You can design and fabricate sun catchers, boxes, picture frames, ornaments, planters, game boards, clocks, windows, platters, paperweights, miniature furniture, lamps, and bowls from stained glass, just to name a few items. You can make them in a home workshop and sell them through craft fairs, stores, and glass boutiques.

"Whatever you make, develop your own style and stand out from other glass artists," urges Vicki Payne. "Specialize in something. If you design boxes, make something unique in the boxes. Maybe the uniqueness of what you do is to incorporate precious stones, agates, or costume jewelry in the boxes." One good way to test their marketability is to make a small number of these items, display them in the best light possible and see the public's reaction. If they don't move after a few shows, that's not what people are looking for. Develop something else.

Glass objects made for the home can be more marketable if they follow decorating trends. To learn what the upcoming colors are, keep up with the major decorating magazines and publications or consider joining trade associations in the furnishing and decorating industries, such as the Color Association of the U.S.

ARCHITECTURAL PANELS

Architectural stained glass works are being seen more and more in public buildings, airports and institutions. Once relegated to churches, stained glass panels are being used to humanize all forms of architecture. Architectural panels may be large in scope and size, but the applications of fine craftsmanship and individual design are no different than those applied to any fine stained glass object.

Paul Stankard

In 1972 with a wife and four children to support, Paul Stankard left his job as a scientific glass blower for a pharmaceutical company, along with a steady salary and began his artistic career making paperweights "Upon seeing antique French paperweights, I saw more beauty and presence in them than in anything else I ever made in glass." says Paul. "It was an untrained response to beauty, but it was very real to me." After rediscovering the process through trial and error because there were no books available about it, Paul focused all his energies on making paperweights. His gross income the first year after left the pharmaceutical company plunged 40 percent.

Since then, his paperweights and botanical sculptures have joined the permanent collections of major museums throughout the world, are highly sought after by collectors and have propelled Paul into becoming one of glass art's most prominent figures. He was a founding member of the Creative Glass Center in Millville, NJ and has taught at Pilchuck, Penland, and Haystack schools. He lectures extensively, has received several awards, been featured on television, has an instructional video and his words and works have appeared in numerous publications.

Through a meticulous, methodical, and delicate procedure, one of which steps is flameworking, Paul makes miniature glass wildflowers, appearing to be suspended in glass. The roots are tiny figures which seem to nurture the plant. Every part of each flower is authentic with the leaf, petal, pistil and stamen clearly visible. "Paul's *naturalism* has set new standards in the paperweight world," wrote Doug Heller in *Paul J. Stankard: Poetry In Glass.*

As a person, Paul is an extrovert. He enjoys conversations and is involved in several art and civic organizations. As an artist, he compares himself to the quiet solitude of a monk. His work is contemplative, based on a reverence towards nature. His whole focus is paying homage to flowers, a love he's had since childhood. Since 1988 he's been paying homage to flowers with words as well as glass. He writes a poem to accompany each botanical. "I love the idea of the words and the glass coming together for me," says Paul.

"Glass is an interesting medium. It's satisfying for me because I can see the result of my labor within two days. Oftentimes when I'm working on the hot glass I'm emotionally involved and am on a creative high. When I put it in the oven to anneal, I'm excited, it feels good. Three hours later when I take it out of the oven, I immediately see what's weak about it. Very seldom do I look at what's good about things because I instinctively always analyze what's weak, what's bad.

"When I first became a studio artist, 95 percent of my energy was focused on mastering my craft. Over a four- to five-year period I became skillful and was able to spend more time becoming creative with the material. Now I go into the studio and because I have a repertoire of skills that I can pull together. But for years it was a constant struggle." His success is the result of his work. "As long as it is the best I can do, everything else is secondary to the reality of excellence."

"To do images about nature in glass would be my best dream. Ultimately, my work would compete in the history of objects of glass. And long after I'm gone my work would be shown in the context of a person's response to nature, and the material would take on secondary importance."

Many artists who create architectural panels have made small objects at some time in their careers, many continue to do both. Artist Peter McGrain's first small decorative panels sold in gift shops. Today his work beautifies an airport terminal, a zoo, and university buildings. Val Sigstedt from Point Pleasant, Pennsylvania, first studied ecclesiastical art, and created hanging ornaments in glass. In 1990 he created a series of stained glass panels for Graduate Hospital in Philadelphia. The art work was installed to help soothe patient anxiety in the hospital's hi-tech testing facilities. Since then, he has been commissioned by other hospitals.

Commissions for government projects come through the states' Percent for Art programs. The projects are announced, specifications are given and artists are invited to submit slides for jurying. To build his reputation as an architectural artist and get his work seen by the public, Peter McGrain bid and executed his commissions at a rate much lower than that of his competition. A project that he would charge $75,000 to do today, he accomplished for much less a few years ago. His strategy worked. He quickly became recognized as a creative artist capable of tackling large-scale commissions.

The site specific nature of architectural panels dictates the artist recognize his responsibility to project the overall essence of harmony between the work and its environment. "It is essential to control the powerful nature of glass to provide the desired balance," says Larry Kolybaba of Baye Studios in Delta, British Columbia.

Artists who are commissioned for architectural works, whether public or privately supported, are chosen on the basis of their reputation and their ability to create glass works that enhance the architectural environment.

RESTORATIONS

Restoring stained glass windows requires more than simply being a good craftsperson. Because many of the stained glass windows in the United States were installed 100 or more years ago, a restorer needs to understand the meaning of preservation. "There's a great deal of integrity to maintain," says Julie Sloane, president of McKernan Satterlee Associates, Inc. in Brewster, New York. The consultancy firm specializes in stained glass conservation and restoration. "You have to know the history of the period, art history, and the iconography of the church."

David Crane of Plumstead Studios, in Plumstead, Pennsylvania, compares restoration work to that of being a physician. "No two jobs are exactly the same, just as there are no two people the same. Windows, like patients, may tend to have related problems, but depending on the life they've led and where they've lived it, they'll be in various states of disrepair. That's one of the beauties of doing restoration. Sometimes you'll be pleasantly surprised and sometimes you get disappointed, just like with people," says Crane.

An important element to remember with restoration is that when you're done, the client shouldn't be able to tell the window was ever in need of repair.

To learn the basics of repairing windows, Crane suggests you work on junk windows found at flea markets. Because restoration of stained glass windows could involve rebuilding wooden frames, a restorer should have a knowledge of woodworking. Churches, educational institutions, and government buildings comprise a majority of restoration work.

Promoting himself with a well designed promotional package to potential clients, as well as architects, has worked well for David. "Surprisingly, while I've received limited work from architects, I find that some institutions hire me

based on an architect having received my direct mail." Trade publications like *Faith* and *Form* list job opportunities.

LAMP REPAIR

Repairing stained glass lamps requires as much knowledge and diligence as restoring windows. To repair the lamp to its original look it's important to understand how the lamp was constructed, the designer's artistic perception, and the materials used. Knowing how to adapt present day materials to replicate the look of the original lamp is vital. Like a well restored window, a repaired lamp should not look like it's been repaired or restored. Lamp repair doesn't usually require heavy equipment or a large investment in tools and materials. It's a natural adjunct to lampmaking, especially if you make Tiffany reproductions. According to Joe Porcelli, of the Porcelli Studio in Newtown, Pennsylvania, antique dealers constantly have pieces in need of repair.

A good reputation, based on performance and integrity, precedes a successful venture in restoring and repairing windows and lamps.

INSTRUCTION

The popularity of working with glass opens up the opportunity of your teaching the craft. This can be done through your own studio, in adult education or community school programs, through workshops at trade shows, or through books and videos. The number of instructional books and videos on the market and the large number of attendees at workshops attest to the popularity and profitability of teaching glassworking.

The most inexpensive way of promoting your teaching skills is through adult education programs at your local high school. The school lists the program in its schedule sent to all

26

Submitting To Magazines

If you're interested in submitting your designs, send the magazine a self-addressed stamped envelope and request a copy of their submission guidelines. These will tell you what the magazine wants in terms of photos, transparencies, slides, and drawings; how soon you can expect a response and how much they'll pay you for your design.

Maureen James, editor of *Glass Patterns Quarterly*, a magazine that features design patterns from glass artists recommends that you:

Submit only original designs for publication.

Send only your best designs. The characteristics of a good design, according to Maureen, are a line drawing, which can stand on its own, minimal solder lines and the subject as the main focal point.

Have your work, both the design and the finished work, professionally photographed to present your design capabilities in their best light. Publishers usually place the most visually appealing materials on the top of the stack.

Send black and white line drawings of the design and a resumé or brief description, no longer than one page in length, of your creative history.

Follow up your submission at an appropriate time. If you call, make sure that the contact person is available to talk. If not, make an appointment to call back at a more convenient time. Know what results you want from the conversation. List the information that you need to know before you pick up the phone. Be brief. While your designs should stand on their own merit, it's also important to present yourself in a professional manner.

residents in the surrounding area.

Three to six months before the session begins, send the program director an outline of what you'd like to teach, how many nights would be required, and whether there would be a charge for materials. According to your agreement with the school or institution, you may share a percentage of the profits or be paid on a hourly basis. This is especially helpful to get yourself known as a glass artist.

If you'd like to teach hot glass at a college, crafts center,

or glass school, submit a resumé to the director of the glass program at the institution. The programs are usually planned at least a year in advance. Teaching at a respected center or school can greatly increase your credibility and reputation as a fine glass artist.

Teaching a class in hot or cold glass in your own studio entails the cost of advertising the program in local newspapers or magazines. Your income from teaching in your own studio would probably be more than you would get if you were to teach in an adult education program, but your organizational responsibilities are increased. Before you offer classes in your own studio, be sure your insurance protects you from liability if someone were to get injured. More of this in the chapter on insurance later in the book.

Many of the lecturers at trade and glass shows are invited to speak. If you have a technique or special knowledge to share with other glass artists, write to the show organizers describing the kind of workshop you'd like to present. Workshops and seminars, like programs at schools, are usually planned at least a year in advance.

The popularity of instructional videos and books about glassmaking proves the public's and artists' interests in learning new applications for tools, techniques, and material. Books continue to be popular instructional tools and when combined with a video are even more marketable. Videos and books are marketed through book publishers, cable television, and glass wholesalers and retailers. Vicki Payne's Cutters Video Productions, for instance, is a major producer of stained glass related instructional videos.

DESIGNING

Not every person who works with glass is comfortable drawing their own patterns. If you're adept at designing objects

for fabrication in glass, you may want to submit the designs to glass pattern, craft and do-it-yourself magazines, or publish your own instructional booklets and sell them through stained glass retailers. There are numerous magazines that publish design patterns and instructions on a regular basis. Browse newsstands and check with your local stained glass retailer to find the magazines that would be appropriate for your designs. Publications interested in stained glass designs are listed in the back of this book. Always address your submissions to the appropriate editor. The names are listed on the masthead, or credits page, usually found in the front of the magazine.

Glass Patterns Quarterly addresses those who have been working with glass for a long time as well as new artists and hobbyists. If your designs are intended for the beginner, nurture him. Tell him what he needs to know to get started. Submit precise, step by step instructions with each design, whether for the beginner or the experienced craftsperson.

"We need pattern books of all kinds," says Editor, Maureen James. "The more types of techniques and patterns magazines can offers the public, the more creative and interested people will become." Since 1988 when Maureen encouraged editors of craft magazines to include stained glass patterns in their publications, readers have reported that such patterns have become some of their favorite features.

"The more involved you become in creating designs, the more you become an artist," says Diane Essigner of the Michigan Glass Guild. "As an artist, I can design and make something original, I don't have to make someone else's patterns."

ONE-OF-A-KIND NON-COMMISSIONED WORK

The essence of many one-of-a-kind works is that they fre-

quently fulfill an inner desire and not a commercial calling. Often artists tell me that they make something simply because they want to. They're often surprised by the public's and art field's enthusiasm for the work and even more so for any commercial success that the work generates. But the concept of the "starving artist" is not a badge of honor. Fair wages and working conditions will result in increased opportunity and challenge focused on the artists' responsibilities, not on basic survival, according to Larry Kolybaba of Baye Studios in Delta, British Columbia.

The time is right for those increased opportunities. Never have there been more marketing outlets for one-of-a-kind work than there are now. People cherish handcrafted work. They attend exhibitions, visit galleries, shop at fine craft shows, read art magazines, and hire consultants to assist them in their choices.

COMMISSIONS

The process of commissioned art has remained the same for centuries. It is commissioned by someone of someone for someone for some reason. It can be a complex process requiring the full development of many meaningful interrelationships. It is not the result of a spontaneous subconscious expression of a free-spirited individual, but rather a meeting of many minds. Input is collated by the artist, or team of artists, recognized as being able to accept responsibility for an artwork born of a shared vision. "The artist," says Larry Kolybaba, "has been deemed to be able to clearly see and grasp hold of the whole vision and has likely demonstrated through past performance a certain ability to bring the vision to physical reality."

Creating a commissioned work of art is a demanding exercise and when successful, the sum total of all the energy

expended should produce a valuable cultural property of lasting significance, historically and artistically, according to Larry. It can be an exciting game to play with exciting rewards.

"You may not completely agree with your client but listen carefully," suggests Val Sigstedt, a stained glass artist from Point Pleasant, PA. Val has created stained glass panels to relax patients and humanize the architecture in Graduate Hospital's (Philadelphia, PA) testing facilities. "Sooner or later the person will tell you (even if he doesn't know he's telling you) what he wants. It's necessary that everyone involved clearly understands the intent of the commission and to offer in a positive way whatever they can to make the commission all that it can be."

Time schedules and a client's desire to change an aspect of the work come into play with commissioned art. "Find a way to control the process," suggests Kim Wickham of Wick-amore Glass in Margaretville, New York. Her work includes residential panels, church windows, and a window adorning the main entrance to Children's Hospital in Denver. The panel honors Kim's grandfather, Robert Fisher, a pediatrician associated with the hospital.

"If you can't visit the site where the commissioned piece will be installed, have the client send you a videotape (if possible). This will give you a sense of the interior and exterior space and the surrounding area." Kim takes measurements of the space and presents the client with a drawing. Some clients want a perfectly scaled drawing; others are satisfied with a thumbnail sketch to begin with.

You have a responsibility to be true to yourself and to your client. A person has come to you for finalization of his idea because of your value. Your job as a commissioned artist is to take a client's message and translate it into a tangible

form. This can be much more difficult than acting independently. But it can be more challenging; it helps you grow; it makes you stretch yourself as far as you can. It can take you out of your comfort zone.

ONE-PERSON STUDIO OR COLLABORATIVE WORK

Working for oneself has a magical sound to it. You're your own boss. You set your own hours and the manner in which you work. Your energies can be self-focused; your work is self-directed, your creativity unbounded. If your work is contemplative or unique, working in a one-person studio could be what's best for you. Working by yourself can also be lonely. Because you work alone, there is no other artist with whom to share opinions, knowledge, concerns, or answer questions on a day to day basis. Studio artists often have a sheltered, restrictive view of what's going on outside the studio.

An alternative to working alone, without hiring employees, is collaboration. Collaborating on a project with one or more other artists extends your reach. It gives you more tools to work with and an audience you might not reach by yourself. Because glass is labor intensive, collaborating enables you to create a large portfolio of work faster than if you worked alone.

If you have a common definition with the artists on how a finished piece should look and if there are certain parts you enjoy doing more than others, collaboration could give you the best of both worlds. You become much better at the specialty you enjoy most while creating a large portfolio.

Collaboration requires guidelines. Baye Studios uses the rules outlined in Robert Fulghrum's book *Everything I Need to Know I Learned in Kindergarten*. The book includes simple lessons of sharing and fair play.

STUDIO AND STORE

Operating a studio and a store can also be the best of both worlds. You create the work that brings you personal satisfaction while augmenting your income by operating a retail outlet for other artists or hobbyists. It can also be the worst of both worlds. Being a store owner is different from being an artist. "Running a retail business is not a hobby or an outlet for your creative talents," says Scott Haebich of The Stained Glass Place in Grand Rapids, Michigan. "You're expected to help others who know nothing about stained glass and keep them interested." Unless you're prepared to operate the store as a professional, providing full service to customers, you'll likely turn people off not only to your store, but to the industry. "Don't let the ego of being an artist get in the way of selling supplies," says one successful retailer.

"There is no built-in need or want for your product. This is not a business to get into if you want to get rich quick," says Haebich. "It takes time to build your market."

The vast majority of retailers are craftspeople who frequently approach it from a craftspersons's point of view, not from the business aspect, according to a New York retailer. "They want to make windows, lamps, etc. but find it's difficult to make a living, so they sell supplies, which is good, but they don't give supplies their due. They maintain part-time hours and look at the customer as a necessary nuisance. If you operate a store, you must take an interest in the retail customer because he provides you with your daily cash flow. If someone operates a store on a part-time basis and looks at the customer in a negative way, that person can harm the entire industry. Not only does he turn the customer off from shopping at his store, but he could discourage him from participating in glass altogether."

If you operate a retail store, you should know how to

33

work with the glass, be available to answer questions, and to teach from time to time. You have to have the craft experience behind you. If you don't, you can't get excited about the product.

Many artists successfully combine studio work with a retail store. If you don't want to deal with customers in a store, define that you'll work in the studio and hire someone else to run the store.

"Many people come in here, think it's great, it's creative, it's fun," says another successful retailer. "The fact is that it's a job. What they say is true, but you have to approach owning and operating a store as a house payment, car payment, your kids' education. It takes a lot of time and hard work. Don't come in and think you'll have a picnic. You have to put in serious time and money and there's no stopping. People depend upon you to be here. You can't be closed. You're committed for the time you have the store going. It's not the same as working out of your house or doing a show. You have this location, you sell supplies, people expect you to be here. The hours are long—60 a week is not unusual."❖

4

Retail, Wholesale, or Both

"The artist who believes business 'just happens ' is just as blind as the business person who believe art 'just happens.'"
—*Larry Kolybaba*

Selling your products makes your business "happen." With the uniqueness and versatility of glass art, you can sell wholesale, retail, or both in a variety of places through a number of venues. You have the option of working at a volume level where you are most comfortable and which will provide you with the income and lifestyle you want. The growing interest in handcrafted items has created a surge in the number of wholesale and retail outlets available to glass artists. A major retail marketing outlet for decorative glass objects is retail craft shows, of which there are hundreds throughout the country. Public art programs are venues for selling commissioned work, especially architectural panels and large-scale works in glass.

The wholesale market offers numerous outlets. If you create one-of-a-kind work, you can wholesale your art to galleries, antique dealers, glass boutiques, gift shops, and interior decorators; through art agents, art consultants, gal-

lery, museum, and corporate exhibitions and merchandise marts. If you make a production line of glass items, you can market your work to gift shops, glass boutiques, department stores, and corporations as gifts for their customers and vendors. Artists who specialize in entranceways and panels have enjoyed commercial success through membership in home builders associations.

The opportunities are many.

CRAFT SHOWS

Craft shows are a major marketing outlet for many glass artists. Retail shows cater to the individual consumer while wholesale shows are directed to buyers from galleries, gift shops, glass boutiques, department stores, and catalogs. Retail and wholesale shows have much in common. Both types of shows require a booth, support materials, and a professional personal attitude. In each show, the organizer rents you space from which you sell your products.

Whether you are interested in just resale or only wholesale craft shows, I recommend you read the information about both. Much of the information is appropriate for either kind of show.

RETAIL SHOWS

Thousands of retail craft shows are held throughout the year all around the country. They are held outdoors and indoors and attract a variety of buyers. People enjoy buying handcrafted items, whether it's for their home or for resale in their own shops.

Craft shows can range from those held in fire houses and church halls with items selling for a few dollars apiece to very competitive, high-end juried shows where perhaps five percent of the applicants are accepted and where glass pieces

can sell for several thousand dollars. Retail shows can be profitable; their popularity attests to it. Show organizers invite exhibitors, select them based on viewing the work from slides, or simply accept those whose checks arrive before the deadline. Choosing an appropriate retail show requires planning, investigation, and questioning.

Before participating in a retail craft show, visit it if you can. You'll see whether the types of buyers represent the market you want to reach and whether other crafts, including those in media other than glass, are similar in price and quality to your work. At high-end craft shows, where the prices of handmade items can be in the thousands of dollars, you'll also find some crafts selling for less than $50. If your work sells for several hundred or thousands of dollars, don't disregard the show simply because of the lower priced items. Organizers plan a show to appeal to a wide range of buyers. Consider the overall atmosphere of the show, the audience it attracts, and the location. A show in an upscale suburb is likely to draw a different type of buyer than a show in a rural community. Know your target audience.

On the afternoon of the last day of the show, the buying frenzy usually has passed. This would be a good time to visit the show again and talk with the exhibitors. Ask them how satisfied they were with the turnout and sales. Ask them how many times they've participated in the show, how easy it is to set up and break down the booth, how well the show organizer promotes the show and works with exhibitors. Does the organizer help exhibitors load and unload? Does he provide "booth sitters" so you can take coffee and meal breaks? Most states require vendors to display their sales license. Do the organizers provide exhibitors with instructions for obtaining a license?

A good promoter will stagger the set-up times to allow

Baye Glass Studios

Baye Studios is a successful collaborative glass art studio located in Delta, British Columbia.

"As a commission studio, it is our challenge and responsibility to express our client's message as clearly as possible," says Larry Kolybaba, founder and spokesman.

"We take our active role in this process very seriously. To create a meaningful piece requires acute listening skills as well as translation abilities. Communication with our clients and within the studio are key factors. " Through dedication and experience, Baye Studios has matured in awareness to recognize its responsibility as a collaborator in the creation of cultural property. The application of this awareness permeates through each of Baye Studios commissions. "To do otherwise would not only be inaccurate, it would be dishonest and meaningless," says Larry. As a result of their collaborative effort, the artists at Baye Studios are able to provide a tangible expression of thought, feeling and emotion which evolves from the input of their clients.

"Creating art is important work" states Art Director Bruce Taiji. "One need only go to a museum anywhere in the world to recognize the importance of art to humankind. It is virtually the only thing that has been regarded so highly that it has been maintained, revered, and passed on lovingly. But in our rapidly changing modern world, this legacy is fading. We are squandering our inheritance and jeopardizing the ability of future generations to benefit from the enrichment of their past."

Our culture will certainly pass on realm of data and technology, but we must also pass on a perspective and human identity of our culture to give it all meaning. Art has and will continue to fulfill this need.

"Our mission at Baye Studios is to create awareness of the value of art as cultural property through the powerful medium of glass," summarizes Larry.

craftspeople with longer set-ups, or those who are in the back of the exhibition area to arrive earlier than those who can set up quickly or who are at the front of the show site. This is especially important if hundreds of craftspeople will be exhibiting.

Well planned shows provide participants with travel directions, lodging accommodations, restaurant listings, and order forms for additional services such as electricity and chairs. They advertise the show well and distribute directories of the show to attendees identifying the name and location of each exhibitor.

Well known shows like the Philadelphia Craft Show sponsored by the Philadelphia Museum of Art and the Washington, DC. Craft Show sponsored by the Smithsonian Institution accept about five percent of their respective applicants. Because your work wasn't selected at one craft show doesn't mean it won't be accepted the following year or at other shows where there are different jurors. If you're not accepted, don't ask the organizers why. You put them in an awkward position of having to explain their standards or jurying procedure, neither of which may have anything directly to do with the quality of your particular works.

Do the best work you can and present it in its best light with the highest photographic quality. Be persistent and don't get discouraged. Jurors look at thousands of slides over a period of one or two days. Your slides will appear on a screen for only a few seconds.

Booth Fees

You rent space, usually an eight by ten or ten by ten foot area, from the organizer. Booth fees vary tremendously from a few dollars to several hundred dollars, depending upon the location and reputation of the show. However, a high booth

fee doesn't necessarily mean only high priced items will be shown or that the show is appropriate for your work. The geographic location (shows in metropolitan areas are usually more costly than those in less populated areas) along with the organizer's cost, including rental of the show site and union costs, advertising, and promotion of the show drive up the booth fee. Knowing who your target market is and whether the show attracts those buyers is a much more important determining factor in participating in a show than the booth fee.

Booth Styles

Craft show organizers rent you space. According to each promoter's offering, you may have to provide the booth or table, lights, carpet, counters, shelves and everything else you need to create a selling environment.

Your booth is your retail outlet; it's an extension of yourself. It says a great deal about yourself and your products and how you feel about your customers. At craft shows you're competing not only with other glass artists, but with every other craftsperson present. To stand out from the competition, make your booth as enticing and exciting as possible without having it compete with your product.

Set a tone based on the type of products you're selling. If you sell stained glass picture frames, set them on shelves or on a table by a comfortable chair where your customers can relax. If you're marketing glass jewelry, wear it as well as show it on velvet behind glass cases. The velvet adds a touch of elegance and enhances the jewelry's perceived value. If you make glass boxes, show some closed and have others opened with necklaces draped over the side. Use a mirrored backdrop to show the design on the sides and backs of boxes. Show the customer how the product can be used. Encourage

customers to touch the piece. Glass not only appeals to the eye, but to the sense of touch. It looks beautiful and has a sensual feel. Help the customers understand glass. Explain the process. People who visit craft shows want to know how you make the finished product.

The booth itself should be eight feet tall, as easy as possible to break down and set up and well lighted. If the booth is less than eight feet tall, the booth of the craftsperson next to you will likely be seen over the top along the sides and the back, making the appearance in your booth a little less attractive.

Booth styles can range from simple rods and curtains to be used as a backdrop and supplied by some show organizers or exhibition sites, to handmade booths built by craftspeople, to professionally designed and built display units costing thousands of dollars. Rods and curtains provide a basic, non-descript backdrop that can be enhanced with shelving, pedestals, and counters. While professionally designed booths can be expensive, they're easy to transport and are designed to be set up with a minimum of effort and tools. For outdoor shows, tent-style booths with the top and four sides made of nylon or canvas are popular. The top offers protection from the sun and rain. In considering outdoor shows, remember that summer thunderstorms are usually accompanied by high winds. Can your booth and products withstand the elements? Outdoor shows are rarely as secure as those held indoors. For that reason, consider how easily you can pack and unpack your work each evening and morning.

It's not unusual for craftspersons to use two or three different booths before finding one that fits their needs. Seeing the different styles of booths at craft fairs (especially before you participate) can help you find a style that's ap-

propriate for your work.

When planning your booth, allow space for product storage as well as bags, wrapping material, and paperwork out of public view. This can be behind a small counter, hidden in a pedestal or kept behind the display. Some craftspeople will section off a portion of the back of the booth for storage, allowing a narrow walk-through area. Others reduce the exhibition space by moving their booth forward and using the space behind the booth for storage. Keeping your booth as free of clutter as possible enhances the appearance of your art.

The brighter a booth, the more inviting it is, and nothing shows the beauty of glass more than a flood of light. To cast your work in the best possible light, consider track, clip-on, articulating and spot lights. Track, clip-on, and articulating lights usually use 60 watt maximum bulbs. Plan to use several, keeping in mind the electrical usage limitations set by the show organizer. Some shows restrict the amount of wattage each exhibitor is allowed. This is especially important if you plan to display a number of stained glass lamps. Your work is on display, not your light fixtures. Having the fixtures the same color as the backdrop helps them to blend into the background.

Craft show sites usually have an unsightly floor. Complement your booth with a floor covering. It delineates your booth from the aisle and helps you create a special area. Floor tiles or a low-pile commercial carpet, taped down with double sided tape works well. Create a floor design that complements the style of your product.

Display an appealing amount of merchandise without making the booth appear cluttered or disorganized. Have enough merchandise on hand to replace items that sell. Plan to take twice as much inventory as you hope to sell. This will

give the customer a choice and enable you to keep your booth well stocked.

What you place in the booth along with merchandise can be as important as the booth design and your products in helping to sell your work. If you've won awards or been in exhibitions, have posters made of the winning piece. If you've been written up in newspapers or magazines, display the article. Place a listing of exhibitions, media coverage, awards, and collections where passers-by can easily read them. Craft buyers love to know how glass is made. Display a description of the process for people to read. Include a description with each piece you sell.

Retail shows can be very profitable. The number of shows around the country and the number of buyers who attend indicate there's a market for handcrafted work. Retail shows can also be time-consuming, frustrating, tiring, and expensive. Maintaining an upbeat attitude throughout a long and tiresome day is imperative. It can also be difficult, especially if your work isn't selling. There's a tendency when there's a lull in customer activity for craftspersons to read a newspaper or a book. Don't. Instead, appear alert and upbeat. Sketch new designs during the quiet times if you feel you must do something, but put your sketchbook down when customers come in. Glass artists often stand away from the booth to enable the consumer to view the work without feeling uncomfortable by having the artist sitting or standing within a foot or two. Remember, your selling space is small. Standing away from your booth, but with your eyes always alert for the customer who shows interest, doesn't guarantee you'll make more sales, but it will create a more comfortable environment for many customers.

A typical retail show runs for two or three days. If it's a profitable show, the time is well spent. Otherwise, it could

be frustrating. "Craft shows are a burn out," says Vincent Olmsted. "You're away from your studio. You're taking your energy away from your work." You have to be at the show (the artist and not his rep is expected to be at a retail show.) You have to promote yourself. You have to be a salesperson. and if it's not a good show, it can be very frustrating.

If you sell your work through galleries and participate in a craft show that's in the same city as a gallery that represents you, buyers who would likely purchase your work from the gallery would probably go to the craft show with the expectation of buying work from you at a lower price than what your work sells for in the gallery. This can create ill will between you and the gallery. Some galleries cite in their contract that the artist will give them a percentage of their sales from a local craft show, in lieu of the gallery losing a potential sale. Be aware of this possibility.

ART CONSULTANTS

Art consultants are conduits between artists and corporations. They are paid by companies to find and acquire art. Art consultants may be in-house or independent. In addition to purchasing art, consultants can provide a range of services to their clients such as lighting design, installation, access to appraisers or conservators and educating the employees about the art and the artists through the company newsletter or seminars.

Art consultants work with artists on a retail level, purchasing the work from artists at the retail price. An artist's relationship with art consultants is different from that of a gallery. A gallery works in a geographic area as your agent. A consultant works for his business client. Consultants don't have exclusionary contracts. You can work with as many consultants in one geographic area as you wish.

Provide art consultants with the same information you send to galleries and museums: slides, artistic statement, exhibition, awards list, and resume. The pieces represented in the slides do not have to be available for sale, but they should define the style of your work.

"Once we receive slides and information from an artist, it's not a matter of promoting the artist's work; it's finding a situation where the work will be appropriate," says Richard Cooper, an art consultant with Artlook, in St. Paul, Minnesota. "We try to define our client's goals." Because of that focus, artists should not expect a consultant to sell a given number of his works every so many months. Sometimes it will be months or a few years before a consultant's client has a situation that is appropriate for your work.

It's important to keep consultants up to date with current slides and information about where you've placed your work, exhibitions, etc. If they don't know about your current work, they can't discuss it with their clients.

In addition to receiving slides directly from artists, art consultants visit and work with galleries around the country and around the world. When an art consultant purchases a piece of art from a gallery, you would receive the wholesale price you established with the gallery. You should expect to receive payment within 30 days of the sale. If you're shipping the piece, the consultant or his or her client should pay the freight charges. Art consultants are not art agents. Art consultants represent their client; art agents represent the artist.

ANTIQUE DEALERS

If you design and build Tiffany reproduction lamps, your biggest marketing outlet will be antique dealers. Your relationship with them will be one of outright purchase. They will buy the lamps from you and sell them at whatever price

they see fit. There are no industry standards that set prices on Tiffany reproduction lamps. What a dealer in New York is willing to pay for a lamp can differ from what a dealer a few miles away in a suburban community will pay. The prices can vary greatly throughout the country. They depend upon craftsmanship, quality of materials, and how well the work represents the original. Know your product. Be able to describe its fine points. Stress the excellence of your work. Understand the dealer's market. Know your competition. It is a highly competitive and specialized field.

PUBLIC ART

Art in public places is also known as the Percent for Art program. Nearly every state, as well as numerous cities and counties, the federal government, and universities allocate a percentage of a project's total cost for the purchase of art. The projects are announced publicly. To learn about the projects, ask the cities', states', and counties' art councils you're interested in to put your name on their mailing lists. *Art Calendar* magazine lists Percent for Art programs. Specifications for each project are sent to those who request them. Artists submit slides along with an application and any other supporting material requested. Jurors review the slides, discuss the artist's background and ability and award the commission. Awards are sometimes limited to residents within a geographic region.

Some agencies, such as the states of Minnesota and Washington, have slide banks. When a job comes up, the client agency looks through the slide bank and selects the artists they want to do the job. Excellent quality slides (or photos) are imperative. It can be difficult for an artist to get his first public commission, according to glass artist Paul Marioni. To increase their chances some artists make mock-

up models with cut out photographs of people and cars to make it look like they've actually done the work. "I'm not against someone doing that," says Paul. "If you're creative and ambitious enough to go for it, you're probably able to do the job." Paul served on juries that have selected work for public projects.

Professionalism and presentation are important when applying for public art programs. You're not only selling your design talents, but your ability to work with architects, designers. and other professionals on the project. Your submission materials should reflect that professionalism.

Many public art projects involve the placement of art in a new building. You must know how to read blueprints and discuss structural requirements, lighting, design, and technical details as a professional. You must be flexible; your first design might not be your final design.

WHOLESALING

Wholesaling can offer business stability for glass artists who make production pieces. You will know how many pieces need to be made, will have agreed upon the total amount of money you'll be paid, and receive a deposit before you begin. It's also an excellent vehicle for artists who prefer to work in the studio rather than in a selling environment. You will be selling multiples of the same item as opposed to one of a kind.

Wholesale Craft Shows

Wholesale craft and gift shows present a powerful outlet for marketing your work to retailers. They give you ready access to buyers for department stores, gift and specialty shops, interior design companies, shops, galleries, gift catalogue companies, museum shops, and corporate gift firms. Several thousand people visit these shows.

Wholesale shows are held around the country throughout the year. They are sponsored by numerous marketing and craft organizations. American Craft Enterprises and The Rosen Group sponsor major wholesale craft shows in a number of cities. The shows are restricted to handcrafted items. Many glass artists participate in these shows. Noel and Janene Hilliard of Lamps By Hilliard have exhibited at A.C.E. shows for several years. The Rosen Group's Buyers Market was the first show Peggy Karr, of Peggy Karr Glass, participated in.

A.C.E. shows are directed towards both wholesale and retail markets. Two or three wholesale-only days precede the retail shows. Wholesale shows are intended for those outlets to whom you would sell in quantity and who will retail your work to the public. Retail shows are open to the general buying public who may wish to buy one or two items. Rosen's Buyers Markets are wholesale only. Both shows are held in convention-like centers that can hold several hundred booths.

GIFT TRADE SHOWS

Gift trade shows that feature mass-produced gift ware, jewelry, housewares, as well as handcrafted items are held in cities across the country. You compete with imported, mass produced products from throughout the world and are marketing to a clientele that may not be knowledgeable about glass. Despite those obstacles, gift trade shows have been viable outlets for some glass artists. You can build a cache for yourself, according to Brian Maytum of Maytum Glass Studios in Boulder, Colorado. "You get access to stores that wouldn't think of going to craft shows, such as upscale jewelry stores or stores that have a bridal department." Brian markets his glassware and perfume bottles to such stores

through the gift trade shows. "There's a real interest in buying American-made products and there aren't that many people who are showing good glass at these shows." Some of the gift trade shows have a special section for handcrafted items. The major gift shows are listed in the back of this book. Entrepreneur magazine lists trade shows in each of its issues.

Learn as much as possible about the show before you decide to participate. Many successful glass artists spent a year studying wholesale shows before they participated. They visited the shows, spoke with exhibitors about the show's sponsor, and learned which buyers attend the show.

Booth fees for wholesale craft shows are several hundred dollars. For trade shows the fees can be $1,000 or more, depending upon the amount of space you rent. Add your travel and lodging expenses, plus the cost of shipping your products, and the price of your display and a wholesale show, can be expensive. It's important that you understand your market, research a show and determine if your products are appropriate for the wholesale buyers.

If possible, visit the show twice—on opening day and on the last day --before you participate. Many wholesale buyers attend shows on opening day. Visit it on the first day to see the traffic. Notice the number of exhibitors and number of buyers, and the style and quality of products being sold. Visit again on the last day to talk with the craftspeople. Learn what people are selling. If you're not in direct competition with them, most craftspeople are willing to share their knowledge and experiences with you. You can learn about booths, suppliers, workshops, shippers, techniques, materials, promotion, other shows, and outlets.

If you can't visit the show, at least speak with several artists who have participated and whose quality and price of work is similar to yours. They do not have to work with glass,

but their product should attract the same type of consumer as yours. Directories of exhibitors are printed by the show organizers; ask for a copy.

Major wholesale show organizers provide a packet of information that takes you through every step of the show from arrival times, accommodations, setting up, breaking down, fire, safety and parking ordinances, union laws, renting furniture, etc. Many also offer suggestions for shipping your work and some may provide names of persons who specialize in shipping craft work.

DYNAMICS

The basic goals of wholesale and retail shows are similar. They provide you an outlet to sell your products. But the thrust of a wholesale or gift show varies from retail shows. Shoppers at retail shows are impulsive buyers. An item catches their eye; they like it; they buy it. Buyers at wholesale shows represent stores or other retail outlets. They're at the show to find products they believe they can sell to their customers. They're careful shoppers because they're making a major financial and marketing commitment.

Wholesale shows provide you with a broader variety of prospects than retail shows. The shows can generate a greater number of leads. They enable you to introduce a new product or technique to a larger market.

The atmosphere is more business-like than at a retail show. You need to convey your message in a shorter period of time than at retail shows. There are more booths. You have to quickly engage, communicate, and close a sale.

Booth Display

At wholesale shows where upwards of 1,000 exhibitors are trying to catch the buyer's eye, your booth has to be a

show-stopper. The suggestions for creating an attractive booth for a retail show also apply to a wholesale show: use plenty of lighting, an attractive floor covering, shelves, and a small counter space for taking orders. Store extra order forms, price lists, and brochures in the back of the counter. You won't be selling the items on display, so you need not bring bags or wrapping material for customers. Display a variety of products, every type you offer if possible. You won't have to bring as much inventory to a wholesale show as you would to a retail show because the items shown are for display only, not for sale.

SUPPORT MATERIALS

Brochures

A brochure listing your terms including delivery, billing, and shipping and a brief bio about yourself or description of your company is vital when marketing at wholesale shows. The brochure need not be in color or expensively produced, but its appearance should reflect your business attitude. The brochure should be neat and professional looking with the information clearly written and easy to understand.

Price Lists

Prices change from time to time. Yours will hopefully increase because of the demand for your products and an increase in your costs. Your prices may also vary depending upon the number of items ordered. Print a price list separate from your brochure, but include all your terms and visual samples of your products. A separate price list keeps your printing costs down. Also, not every potential buyer will want or need a brochure; some may be satisfied with only a price list.

Develop your credit, minimum orders, and shipping

policies. Determine whether you expect to be paid COD, within 10 days or 30 days, whether you'll charge a small percentage (usually 1.5%) on invoices more than 30 days late. Print up credit policies on all order and invoice forms. "When I first participated in a wholesale show, all I really knew was that the price I charged the retailer would be doubled when the store sold the item to the public. Everything else I learned as I went along," says Peggy Karr. "When someone asked me about terms, my first response was 'We have nice terms,' then I ran behind the booth and asked someone what 'terms' meant."

Your support material should contain enough information about your company and your products for the buyer to make a informed decision and be comfortable buying from you. Thousands of buyers attend wholesale shows. It's likely not all of them will be interested in your products, but many might. Bring more brochures and price lists than you think you'll need.

MERCHANDISE MARTS

Merchandise marts have been a successful wholesaling outlet for several artists. Preston Studios in Florida first showed their nature panels in the Atlanta Mart. Noel and Janene Hilliard of Lamps by Hilliard generate a major portion of their sales through the marts. A merchandise mart is a large exhibition space housing samples of decorative handmade and mass-produced items from several wholesalers. They rent space on a permanent or temporary basis and many have interior designer open houses and gift shows during the year. The artist must be a wholesaler. You hire a rep to sell your work at the mart. Merchandise marts can provide you with names of reps. The marts advertise in decorative accessory magazines and are listed under Trade Show News in *Entrepreneur* magazine.

GALLERIES

A gallery is another wholesale outlet. You consign or sell your work to them at a wholesale price and they retail it for you. Before you contact a gallery, learn what kind of gallery it is.

Galleries can serve walk-in customers who purchase on the spot, clients with specific decorating needs, and collectors seeking one-of-a-kind works of art. The term gallery can be applied to glass boutiques that sell production or limited edition work to craft stores that sell primarily production pieces in various media in a wide range of prices, to galleries whose clients collect one of a kind pieces that cost thousands of dollars.

Some galleries market only the work of local or regional artists. Some are co-ops owned and managed by a group of artists. Others are independently owned and carry work from artists throughout the world.

The primary difference between a glass boutique and a gallery is that the boutique owner buys/sells and tries to analyze and satisfy his market posture. A gallery is much more involved in exhibitions, education, and developing ongoing relationships with artists whose works are evolving. The gallery owner is not so much trying to analyze the market into a marketing niche or trying to satisfy an existing taste, but trying to find work they perceive as having true merit and originality and bringing it to the public with the hope that the work finds an audience.

A gallery that specializes in contemporary glass is substantially the same as a fine art gallery, according to Doug Heller. "There is no substantial difference between contemporary glass and fine art," he says. "What you're trying to do in all cases is attract an audience and create a desire that's so compelling that people feel they need to have what you're offering."

Before you contact any gallery visit it, if you can, as an observer. Notice the style of work the gallery sells. Is it traditional, contemporary, eclectic, abstract? Are the prices and styles complementary to yours? Does the gallery sell production pieces? Do they sell only one-of-a-kind work? Can the space accommodate your work? Ask how long the gallery has been in business. Longevity and reputation say a great deal about the viability of the gallery and the business acumen of the gallery owner and manager.

If you can't personally visit galleries that could be appropriate for your work, you can learn about them through Glass and American Craft magazines and The Crafts Report. The booklet, Shopping for Crafts in the USA, published by American Craft Enterprises, lists craft galleries throughout the country. The guide lists the media the galleries carry, whether they operate seasonally or year round, if regular exhibitions are held, and what percentage of their merchandise is handmade. The gallery guide from the New York, Experimental Glass Workshop in Brooklyn, New York lists glass galleries and museums around the country.

Look at the ads in *Glass* and *American Craft* magazines. Do you see the names of glass artists whose work you admire being promoted by galleries? If the artists are well known, it's likely the gallery is reputable. Are those galleries in geographic areas you'd like to be represented? Is the work aesthetically similar to yours? If your art is traditional, it could be inappropriate in a gallery that markets only avant-garde art.

Let your friends know you're looking for an appropriate gallery to represent you. Ask them to keep that in mind when they visit galleries in various cities. Ask them to pick up any information about galleries that they visit. Many galleries have printed promotional material about themselves that

they're happy to give to the public.

If you're interested in a local gallery, follow its ads and exhibitions listed in the newspaper for several months. If there's a local art magazine or newspaper, subscribe to it to learn what local galleries exhibit. Notice how much press coverage the gallery receives. Attend openings to see how the artists are presented and the quality of work that's shown.

PRESENTING YOURSELF AND YOUR WORK TO A GALLERY

Once you've selected the galleries you think are appropriate for your work, call to ask them what their viewing policy is. Some galleries want to see slides; others prefer photographs, and some may want to see the work in person. Contact them before you approach them. "Often I get a phone call from an artist who says he's in town and wants to drop by and show me slides of his work," says Andrea Cooper of Snyderman Gallery in Philadelphia, Pennsylvania. "It's a very egotistical approach and very irritating. Gallery staff have much to do every day. They don't sit around waiting for artists to come by."

Presentation is critical; put together a package that will make you visible, that generates interest in your work, and opens a door to a gallery that might otherwise not notice your work. You have to have a very slick presentation for galleries to even consider you, according to Vincent Olmsted.

Send six to eight slides or photos of professional quality. They should show your work alone against a neutral background. "When we see slides taken in someone's backyard, we automatically assume the work is as amateurish as the presentation," says Andrea Cooper. Slides should be of 35mm with a cardboard frame and in a slide sheet. Photos should also be numbered and in a photo sheet. Include an

accompanying sheet identifying each slide or photo. The information should be typed or very neatly hand printed and include the dimensions (height x width x diameter), materials, year the piece was completed, and the wholesale price. Send a resumé, a one-page cover letter, and a self-addressed stamped envelope for the return of your slides or photos. Galleries receive hundreds of slides from scores of artists each week. If you don't send an SASE, don't expect your slides to be returned.

Include on your resumé: exhibitions, scholarships, fellowships or grants, commissions, awards, public and private collections (with the collectors' permission), education relevant to your art and the names of newspapers, magazines, or television and radio talk programs that featured you or your work.

Also include a self-addressed, stamped postcard with a pre-written message stating, "We've received your slides and will be contacting you shortly." All the gallery has to do is sign it and drop it in the mail. In your cover letter, ask the gallery to return the postcard. Three weeks after you receive the postcard, follow up your letter with a telephone call to the gallery.

If the gallery requests to see your work, bring it in person or ship, if necessary, works from five years ago, some from two or three years ago and your latest work. This shows the gallery how your style has developed and how your work has improved. If you've just begun creating glass art, don't apologize. Send your best work.

Converse intelligently about your work. Leave your emotions home. Be prepared to deal with negative reactions. Be confident about your work, but not smug. Be objective, not emotional.

If the gallery rejects your work, ask why. The gallery

might represent several other artists whose works are similar in style to yours or fall into the same category. It might be that while your work is good, it's too high priced for the gallery or wouldn't appeal to the gallery's clientele. If you're rejected for those reasons, ask the gallery to suggest other galleries where your work might be appropriate. Ask the gallery director if you could use his name as a reference when contacting other galleries. A good way to get your cover letter read or your slides seen is to open a letter with the phrase, "John Jones from ABC Gallery suggested I contact you."

WHAT SHOULD YOU EXPECT FROM A GALLERY?

Before leaving your work with the gallery, ask what their insurance policy covers. Is your work protected by them against theft and damage? Will you be reimbursed for the full value of your work if it's stolen or damaged, or will you be liable for the deductible amount of the gallery's insurance? Who pays for shipping? Usually the artist pays for shipping to the gallery. The gallery pays to ship the piece back to the artist, if necessary. If you're leaving your work on consignment, ask how soon after a sale is made can you expect payment. Thirty days is a reasonable amount of time. You may not be notified that your work has been sold until you receive a check. While galleries like to think they'll be able to sell your work, sometimes pieces can sit unsold for several months. Ask how frequently they'd like you to change the work. Some galleries like to have new work every few months; others prefer that a piece remain at least six months.

Selling art is a very delicate procedure. "While art pretty much sells itself, we help the collector and artist come together. It can take several months to develop a dialog with the client," says Kristen Peterson of Snyderman Gallery.

Because your work will likely be taken on consignment

rather than purchased by the gallery, know the laws in your state about property rights of consigned work. Until recently, Pennsylvania law considered all the consigned contents in a gallery the gallery's property if the gallery went bankrupt. It meant that the artist had no legal claim to his property in that eventuality. The value of the artwork became an asset for the gallery in settling creditors' claims. Contact the Volunteer Lawyers for the Arts in your state for information about consignment laws.

Have a written contract with the gallery. It could simply be a letter answering your questions about consignment, insurance, shipping, exclusivity, and exhibitions.

WHAT GALLERIES EXPECT FROM THE ARTIST

Galleries expect some degree of exclusivity, whether it's regional or national. This means only the gallery can sell your work within a geographic area. If it wants the exclusive right to market your work, ask the gallery how they will promote your work and when you could expect an exhibition. If you're a new artist, the gallery will likely want to wait until your work is selling well before arranging for an exhibition.

There's nothing wrong with exclusivity contracts. Good galleries work to build an audience for the artists they represent. Many have clients throughout the country and even the world. If you show your work through several galleries in your region or even along the East or West Coast, the galleries' interest in promoting your work may not be as strong as if they were the sole representative. The uniqueness of your work could be diminished by it being seen in more than one gallery in a city. There's nothing wrong with exclusivity contracts. Understand what they mean to you and how they can impact your life and your ability to market your work.

Galleries expect a commitment from the artists to be

professional and businesslike. In addition to doing the best work you can, galleries expect you to deliver work on time. A multi-media gallery in suburban Philadelphia relates the story of a customer who ordered glasses as a wedding gift. The artist promised they'd be delivered in three weeks. They never arrived; the artist never called to explain why he couldn't keep his promise. The gallery no longer does business with him.

Keep the gallery updated with slides of new work, and information about the development of your art, your recognition in the art community, awards you've received, and anything else that adds to your credibility as an artist. At the minimum send an update of slides once a year. It can be difficult for the gallery staff to talk intelligently to potential clients about your work if the slides are several years old and if the gallery hasn't been kept up to date on advancements in your career. Keeping a gallery current increases your chances for your work to be talked about, shown, and sold.

Many glass artists, especially those represented by several galleries, consider keeping the galleries up on what they're doing, a part-time job.

Galleries expect you to do the best work you can, to work toward the mutual goal of building an audience.

"You have to start with a basis of mutual respect. If either side doesn't feel the other side is worthy of the effort, you go nowhere. If an artist doesn't have some respect for our business judgment and aesthetics, we don't have a firm basis to sell," says Doug Heller. "I have to have faith that these are truly creative people with high standards." Doug will frequently sit down and ask an artist in the very beginning what it is he, or she, hopes to accomplish, what he, or she is really interested in doing with the work; whether they are highly productive and want to maintain a high profile or are more

interested in making a limited amount of pieces. "Both attitudes are good, but different. Each calls for a different strategy. Some people don't care to be famous. Some can't deal with high visibility. Others say they want to be the best known person in the field. We can approach things differently," says Doug.

Integrity and commitment are the key words for any successful relationship. The Heller Gallery, like most reputable galleries, wants an artist who has goals, has a desire to achieve and is committed to the traditional ethics of integrity, professionalism, and pride in what he does. "I like to work with people who are pleased with themselves," says Doug. He looks for a talent, an individual who has enough confidence in himself to take criticism and the kind of feedback that's necessary. "It's very difficult to walk on eggshells with people who are emotionally unstable," says Doug.

The Heller Gallery once postponed a show for an artist who was in a transitional phase. Postponing the show was not an easy or pleasant thing to do. The response of the artist was that the gallery wasn't supporting him emotionally.

"Neither the artist nor the gallery would benefit by having a mutual admiration society that permits me to tell you just what you want to hear," says Doug. "Building a career is always a fragile situation. You're only as good as your last success. If you go in and I know your work is in a period when in a year it would be stronger and better, and I permit you to go out and make a fool of yourself and show your weakness, it's like allowing someone to go on stage who's not fully rehearsed. Part of my job is to say hold it, wait a minute, you're not ready."

Heller believes his job is to help orchestrate and support what will bring out the artist's best to the public. "This isn't meant to say that I want in any way to change what the artist

does, but we want to see if we can interface most comfortably. The artist in the studio has a very sheltered, restrictive view of what's going on out here. Friends tell you what they think you want to hear and that's a very dangerous situation. Encouragement is important. Everyone needs moral and emotional support, but sometime we need to hear the truth. If your gallery or dealer can't provide that, it's an incomplete relationship."

Mindscape Gallery in Evanston, Illinois, carries only professional artists' work. It looks for design integrity, a signature, a basic imagery, or statement among the artist's work that is unique in glass, according to owner Ron Isaacson. From the artist they expect a strong degree of professionalism and loyalty. It's important that the artist provide as much information as possible about his work to help galleries introduce and educate the public to it. The gallery is the marketing end of what the artist is trying to do. About 3500 feet of Mindscape's 11,000 square foot gallery is devoted to exhibiting and selling glass.

EXHIBITIONS

Museum, corporate, and gallery exhibitions are wonderful sources of opportunities for sales. Exhibitions help you get discovered and add credibility to your prominence as an artist. The exhibition catalog and critics' reviews document the validity of your work. The reviews, remarks, and criticisms further define your work and its place in history. Exhibitions show your work to people who might not know it or be able to see it elsewhere. Audiences at exhibitions, especially those at museum exhibitions, are visually sensitive individuals. Exhibitions give you a chance to show your best pieces, the ones that can help establish your reputation. Exhibitions are a chance to stretch your mind, your techni-

que, your abilities.

Many museums discover artists for exhibitions through their visits to galleries. "We couldn't do shows without the help of galleries," says Daniel Stetson, executive director of Laguna Gloria Museum in Austin, Texas. "We expose, out of the commercial context, the artists the galleries represent." That exposure ultimately adds to the value of the artist's work.

In addition to inviting artists to participate, exhibition sponsors also select artists from slides submitted through applications. The exhibitions are announced in publications such as American Craft and The Crafts Report as well as through state art and craft organizations. Exhibitions usually have no, or a nominal, application fee. Participants are also chosen through slide files at state councils or art and craft organizations. Johnson & Johnson, for example, chooses artists from the slide files of New Jersey Designer Craftsmen in New Brunswick, New Jersey, for exhibits at their corporate headquarters.

Daniel Stetson suggests artists send museums slides, resumés, artists' statements, and invitations to upcoming exhibitions and shows. "It's important the artist supply museums with material," says Daniel. "While we can only do a limited number of exhibitions each year, if we have files about artists we try to work them into themes." Museum exhibitions include a variety of themes, such as history, landscape, poetry of life and death, vessels, paintings, subject, and abstraction, in which glass can fit. Yet Daniel says he's received very little material from glass artists. "If I haven't seen your work, it doesn't exist for me."

Glass artists, he says, will sometimes self-limit and only look to glass related institutions. Glass has a role not only in museums of glass but also in museums that feature decora-

tive, historical, ethnographic, craft related and multimedia themes. "Art museums are concerned with how glass is used, not the media itself," says Daniel.

Know the style and focus of the museum you're contacting. Museums might focus on local or regional art, American art, historical perspectives, or the full gamut of media. Deal with them professionally and politely. And remember, says Daniel, that most museums are understaffed and their employees are overworked and underpaid. They try to do the best they can.

When you're chosen to participate in an exhibition, you're asked to have the work at the location by a certain date. The exhibitor installs, promotes, and insures the work while it's there. It's shipped back to you at the close of the exhibition. Programs are usually printed and many times the artist's hometown, if not his complete address, is listed.

Enter into as many exhibitions as you can. If you don't get accepted one year, try again. Jurors change. At the very least, different jurors and critics will see your work. If you're submitting applications for exhibitions all over the country and aren't getting accepted, Daniel suggests you evaluate what you're doing and how it can be improved.

Marketing art is a business. Galleries sell it, critics write about it, and museums have the role of arbiters of taste, albeit flawed sometimes. Everyone in that circle of activity is working toward understanding, making, promoting, and marketing art.

Develop and market your own work in a way that guarantees it good, long-term strengths.❖

5

Pricing

"The goal of the price should be to maximize profits, not sales."

O f all the decisions you have to make as a glass artist, the most difficult or frustrating can be determining how to price your work. The best price for a product is not necessarily the price that will sell the most units, nor is it always the price that will bring in the greatest number of sales dollars. The best price is one that will maximize your profits.

The best selling price should be cost- and market-oriented. It should be high enough to cover your costs and make a profit. It should also be low enough to attract customers and build sales volume.

The consumer's perceived value of your work is a key determinant in setting prices. Your work will sell if the consumer thinks the piece is worth the price.

Arriving at the appropriate price for your work can be relatively simple once you consider all of the direct and indirect costs involved in making each piece of glass or in the day to day operation of your store. No matter what role you assume in the art glass business, your prices should reflect a reasonable profit or you won't be able to stay in business (unless the business is supported by some other means).

When determining the best selling price for your work, it's important to consider three elements: direct costs, indirect costs, and profit.

DIRECT COSTS

Direct costs are easy to understand. They are the cost of the material and the direct labor (yours as well as any employees') required to make the product. Direct costs are those costs directly related to the design, fabrication, and the selling of a piece of glass, or management of a studio or retail store. For studio artists, direct costs could include the purchase of pattern books, art materials, glass, came, solder, paints, finishes, polishes, and any other material you use to make the glass piece as well as packaging, shipping, handling, and storage costs for your work.

You can arrive at the direct cost in two ways: One is to determine the amount of each product you use in producing each piece of art glass. An easier way would be to record how many pieces of one product of glass art, (e.g., plates, lamps, picture frames, boxes, sculpture, vases) are made in a specific period of time, in a month, for instance. Add the total amount of material you use plus the total labor costs. Let's say that you make a hundred plates a month, and your total direct costs are $600. Divide this $600 by 100 and you arrive at a cost of $6 per plate. This will be your starting point for pricing your work. This gives you the direct cost amount per piece. Even if your work load is heavier during certain times of the year and you would be selling more pieces at those times, remember that your costs will also be increased. Therefore the direct cost per piece figured on a monthly basis would be the same regardless of your workload.

Labor costs include not only salaries but also Social Security taxes, workers compensation, unemployment in-

65

Heller Gallery

From a tiny space on Madison Avenue in 1973 to over 4,000 square feet of exhibition space in New York's SoHo district, Heller Gallery has gone from being a glass boutique to one of the world's leading glass galleries, representing artists from throughout the world.

"With the glass boutique, I was in a buy-and-sell frame of mind, trying to analyze and satisfy the market," says Doug Heller.

Operating a gallery, he and his brother, Michael, are much more involved in exhibitions, education, and developing ongoing relationships with artists whose works are continuously evolving. "We're not trying to satisfy an existing taste or find a market niche but rather bring work that we perceive as having true merit and originality to the public's attention," says Doug.

Most of the glass the gallery sells is purchased by people who have been involved with glass for years and who have built significant collections. Much of what Heller Gallery represents goes beyond the simple business approach. The gallery is a resource for magazines and books, a conduit between collectors and artists, and a source of education for the public.

Every January during their Glass America exhibition Heller offers a Sunday seminar free to the public. The seminar is held outside the gallery, away from the selling space. The presentations are either about the ongoing exhibition or of topics related to a specific area of art glass. The payback has been a constantly good response from the public. While the motivation was to present something special and not to increase sales, the seminars have turned out to be a good business incentive.

Typically, the gallery runs two or three exhibitions simultaneously in different rooms of their Soho location. There might be one artist with a concentrated collection in one room, the second room would have another solo exhibition, and the third area would show an overview of the works of several gallery artists.

Rather than a job, operating a gallery and being a part of the glass community has turned into a career that's constantly evolving and providing fresh ideas for the Hellers. "It remains challenging and there aren't that many fields that can offer that kind of potential," says Doug.

"We deal with interesting and creative artists who are dedicated and talented individuals. Some approach genius. It's a rare opportunity to work with people like that."

"On the other hand, we work with extremely intelligent and dymanic collectors who have often been enormously successful in their own fields. We stand at this crossroads of wealth and cultures, being the link between the two."

No less exciting is to be serving as a catalyst for artists. "People come in and tell us that what we've done has been worthwhile, or that by coming here they feel better, and get inspired to do something creative themselves. This kind of feedback makes us proud and is an ongoing delight. It's an unusual kind of job."

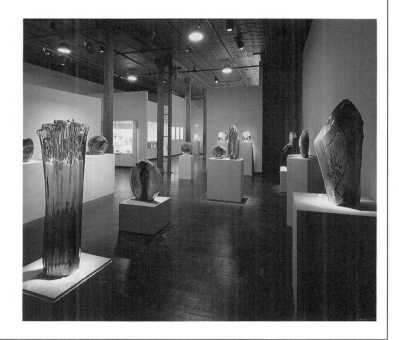

surance, and fringe benefits such as insurance, retirement and health benefits. Thirty percent is a common benefit percentage, according to the Small Business Administration. Adding that percentage to an employee's hourly wage is an easy way to arrive at the total labor cost.

INDIRECT COSTS

Indirect costs are all costs other than direct material and direct labor. They can include clerical, accounting, payroll, legal, and janitorial (refuse) services as well as insurance, taxes, equipment, depreciation of equipment, building and tool repairs, rent, subscriptions to professional magazines, membership fees, advertising, office and cleaning supplies, utilities, loans, interest, and transportation. The outlay for some of these expenses will vary throughout the year. For example, membership fees and subscription costs are usually paid only once a year. Equipment repairs may be needed at any time. Advertising could be higher during certain seasons and your need for office supplies could vary throughout the year. Because you will incur the cost of some of these items at different months throughout the year, determine what your total costs for the year will be (allowing moneys for repairs and other unplanned expenditures), and divide the amount by 12 to arrive at your monthly costs. If your annual total of indirect costs amount to $7200; divided by twelve, your monthly indirect costs would be $600. Divide the $600 by the number of pieces (100 plates you make in a month). The $6 indirect costs per plate ($600-100 = $6) added to the $6 direct costs brings the total cost per plate to $12.

When developing overhead costs, don't depend on the previous year's costs. Revise the charges to reflect current costs including inflation and higher benefit costs. Project the costs for a six month period, including increased salaries as

well as any other projected costs.

In addition to the above costs, total all your monthly living expenses to determine what amount of profit you need to make to maintain your standard of living. These expenses include utilities, food, mortgage or rent, real estate taxes, savings, auto, life, house and health insurance, estimated federal, state, local income tax, loan or credit card payments, and disposable income. Prorate the total of these expenses into the profit. If you need $3,000 a month to meet all your personal living expenses, determine how much profit you have to generate to earn that much money and cover all production, overhead and labor costs. ($3000 divided by 100 pieces = $30 plus $12 costs = $42 selling price).

As a general rule, material and labor shouldn't exceed 50 percent of your selling price. Stationery stores have a variety of small business record forms to help you keep listings of your expenses. A number of computer software programs designed for small businesses are also available. Also, if your studio is production oriented, the expense of having your accountant provide quarterly reports that show an accurate financial picture of your income and outgo could be money well spent.

Time Studies

Time studies of how long it takes to do a procedure are important, especially as you begin your career in glass art. You can fool yourself into thinking one process takes only an hour when it's taken all morning. You run out of paper towels and take time to get them. You discover you need a specific polish or paint or cutter for the job and spend a few minutes ordering it or traveling to your local supplier to get it.

"I used to hate doing time studies, but have found they're important in determining an appropriate price for your

time," says glass artist, David Crane. By keeping time studies, you get an idea of how long each process takes. A simple notebook is all you need to do time studies. Keep a log of everything you do relating to each glass project each day, noting how much time was spent on everything you did to produce your piece of glass art. To price a commission, keep a record of each procedure you've executed for that job by the date, time, and client. Eventually, determining the time you need to allot for consultation, designing, cutting, painting, annealing, packaging, etc. will become second nature. The lack of knowing how much time, money, and materials you spend on each project can lead to lower profits, inconsistent pricing, scheduling problems, and a customer's perceiving you as a unprofessional. Consumers feel uncomfortable when prices for similar products over a period of only a few months vary for no tangible reason. Business has been lost because a customer wasn't able to rely on the stability of an artist's price.

It's easy to keep time records. If you make it part of your way of doing business, it will become second nature.

COMMISSIONED WORK

It's important to reiterate the labor intensive, hand produced effort that goes into making a commissioned piece, whether it's a panel, lamp, glass object, or sculpture.

Estimating your price by the square foot (to cover all your costs and to make a profit) is one method of pricing commissioned flat glass work. Some artists use $100 as a ballpark figure and adapt it slightly lower or much higher depending upon the complexity of the work and the costs involved. Other artists estimate the cost by the number of pieces of glass they use. David Crane has learned that it's easier to reduce his price than to increase it. However, reducing your

original estimate downward can jeopardize your creditability unless you have practical reasoning behind it. "Sometimes people know what they want but aren't ready to commit to a price," says David. "If I've quoted them a price of $2,000 and they want to spend $800, I tell them I can make the window with fewer pieces of glass. People understand that."

As a collaborative studio, Baye Studios has found that establishing a budget prior to conceptual work allows the client and the studio to focus attention on the objective. The budget, says Larry Kolybaba, becomes a vital component of the development blueprint. They price their work based on the following allocation of expenses:

- 25% Labor
- 20% Materials & Subcontract
- 15% Administration and Overhead
- 10% Liaison, or sales costs to generate the commission
- 30% Profit

With many studios, payment is usually made in installments; the number of which will vary from one studio to the next. Terms may be as simple as one half down when a contract is signed and the balance paid upon delivery or completion, or having the client make three payments: one third upon signing the contract, another halfway through the project, or after final changes are agreed to, and the final third upon completion.

DESIGN FEES

Astute business people require a fee before they begin a design for a project. Clients tend to take you more seriously if you charge a design fee. It also compensates you for your time if the project fails to materialize. The customer should

expect to pay for any preliminary work. It represents your expenditure of creativity, energy, and time, all of which carry value. Designs can be thumbnail sketches, drawn to scale or full size depending upon the project, your style of work, and the client's wishes. The fee depends upon the size of the project and the amount of time you estimate it will take you to understand what the customer wants, and to finally draw the design. Some people visualize in their minds what they want, but can't articulate it. Many glass artists suggest you take notes and make preliminary drawings of what the client likes as he or she looks through the portfolio of work you have done.

Many studios charge a flat rate for design work, a sum of money that can later be applied to the final price and re-couped by the client as part of the actual commission fee. For a lamp or panel, for instance, a flat design fee of $100 can be charged against the commission, paid outright if the project is not commissioned, or incorporated into the entire budget if approved.

ONE-OF-A-KIND

"It's tough to price one-of-a-kind work," says Vince Olmsted. One-of-a-kind work has an emotional element built in that's not found in production work. It's hard to put a price on emotion. "I combine my experience, ability, and the way I feel about the work, but also what the market will bear."

If you're beginning your career, consider pricing your work relative to your competition, keeping in mind their reputation and experience. If a renowned glass artist is sell-ing his work for $5,000 and your work is in the same genre but you have little experience or credibility in the field, it would be unrealistic for you to expect collectors to pay $5,000 for your work. Price your work lower, being careful not to

under price it, and increase your prices gradually as you build your reputation in the art glass field. Consider your costs in pricing your work, but in the beginning of your career, expect your profit margin to be less than those of experienced glass artists. You'll spend much time experimenting with techniques and materials.

Some gallery dealers can offer valuable help and insight into pricing works, especially to young artists. They are involved with the three sides of the pricing question, the artist's, the gallery's, and the client's. Reputable dealers understand the long range benefits of proper pricing of new works, and are sensitive to the importance of a good working relationship among all parties. Don't be afraid to ask for their help.

RESTORATION

Restoration is labor-intensive in ways other kinds of art glass are not. As a restorer, you remove, transport, and disassemble the old window and then restore, rebuild, and reinstall it. Pricing restoration work can be difficult in the beginning of your career, according to David Crane. "Besides determining how long it will take to do each procedure, the restorer has to add in a factor for the unknown mystery of the piece he's working with and the logistic problems that come with handling stained glass windows."

You might uncover numerous cracks, extra layers, or deteriorating paint that you didn't expect, or problems you could not predict. Include a provision in your contract that ensures you'll receive additional moneys to cover the costs of addressing these problems, should they occur. When determining your fee, consider if the window has to be removed, or if it can be repaired in place. Determine what exactly has to be done to the window. How much reglazing

and joining is required? Will support bars have to be restored or added? How much reframing and reinforcing will have to be done? What will replacement glass cost?

If the window has to be removed, how many persons will be needed to remove it? What kind of equipment will be needed? What are the costs to bring the equipment to the site? Does the job require special equipment, such as scaffolding or a sandblaster, which you might not have? If you rent the equipment, those charges must be reflected in your price. If you buy it, include a portion of its cost to your overall fee. Amortize the balance over one, or several years, depending upon the life expectancy of the equipment and its monetary worth. Your accountant can help you to determine how much of the equipment's value to amortize each month and how to amortize it. Amortization can more accurately reflect the value of your equipment as an asset than if you wrote off its entire cost at one time. You can also amortize the cost of leasing equipment.

If you remove the window to your studio and it remains there a month or longer once the work has been completed, storing the window in your studio costs you money. The window is taking up space and risks being damaged. If the window is especially valuable, get a rider on your insurance policy to protect you against damage or theft of the window while it is in your possession. Include the cost of the rider in your fee if it is purchased specifically for the project.

In addition to the window-related expenses, consider your cost of travel to the site, along with lodging and meals, as well as the value of your time in meetings with the client. Some institutional restoration and repair decisions are reached by a committee. Anticipate extra time to meet with these groups and determine whether you'll charge for your time. Some artists write off time spent in meetings and other

non-studio related work as part of their operating expenses and do not charge the customer or clients for them. Others include a portion of the costs in the amount they charge to the customer. Some artists believe that their reputations warrant being paid for all of the time spent on a project and charge the client for travel costs as well as time spent on meetings related to the commission. Such charges must be explained up front, before they are incurred.

In deciding whether or not to charge your client for such time, consider how important it is for you to secure the commission or job, and how your career or business might be enhanced by such. By all means, consider your client's reaction to being charged for your time. In some situations, billing for such expenses is expected, in some, it is not.

If the window, or set of windows, is to be repaired in place, how much time will you be allotted on the premises? Will the time spans be limited because you're allowed to work only certain hours, or in the case of religious institutions, when services aren't taking place?

Consider how difficult it could be and how much time you'll expend to find a certain piece of glass or period materials. David Crane works on an hourly rate based on one-half or full day blocks. This method allows him time to gather materials, travel to and from the site, and handle unanticipated problems.

Lamp Repairs

The price of lamp repairs depends on the nature of the repair, the quality of the materials that have to be replaced or repaired, your time and any necessary peripheral repairs, for example, replicating the look of age and time in a patina. You can not overcharge someone for a repair based simply on your reputation as a fine craftsman or capable restorer, ac-

cording to Joe Porcelli. "A lot of collectors have friends who have had lamps repaired by others. They know a fair price. Your price has to be competitive with others of comparable ability in the field. If the customer is satisfied with the price and the job, he or she, will come back."

"Antique dealers constantly receive lamps that need repair," says Joe. "They want to be comfortable with an honest price and a good job. Reputable antique dealers need reliable sources for repair and restoration. If they know that you can provide quality repairs, deliver your work in a reasonable amount of time and at an honest price, they will employ your services whenever needed."

Know your product and service, your materials, and your techniques. Antique dealers and collectors are usually well versed in restoration and repair, especially in their areas of specialization. In other words, they may know your job as well as you do. The most knowledgeable collectors and reputable antique dealers have done much of the same research that you might have done to fine tune your expertise. What they are seeking is the skill and the professionalism to perform the needed services dependably and at a fair price. If they can depend on you, or your studio, for the quality of work they require, they will call on you again, and again.

PRICING YOUR WORK FOR WHOLESALE AND RETAIL

Glass artists can sell their work wholesale and retail. Either can include doing commissioned work. The costs for wholesaling and retailing are different. Consider each in relation to the profit you want to make.

Selling Wholesale

By wholesaling you sell or consign your work to a retailer who sells it to a consumer. The retailer's markup is usually

100 percent of the wholesale price, but it can vary. Antique dealers, gift shops, and galleries are retailers.

The advantage of dealing with antique dealers and gift shops is that in many cases they will buy your glass art outright. You don't have to wait until they sell your work before you get paid. Because they own the product, they set the retail price. Antique dealers generally deal in one-of-a-kind or limited editions. Antique dealers are negotiators. They negotiate prices from buyers and to sellers. There are no industry standards that say an antique dealer has to mark up anything they sell 100%. The nature of most antique businesses is based on ownership of the inventory. As a result, dealers in small communities could charge a different price for a similar style lamp or other product than dealers in major cities. The same pricing strategy holds true for gift shops. A store in a rural Midwest community will probably price your glass art differently than a glass boutique in Chicago. You determine the wholesale price you want from the retailer, regardless of the selling price he charges the consumer.

In addition to selling your work outright to a wholesaler, another way of selling wholesale is through consignment. Some retailers, especially galleries, will expect you to put your work on consignment. This means you don't get any money from the retailer until the work is sold. When you place your work on consignment, you state the amount of money you expect from the sale. This becomes in essence, your wholesale price. The retailer's markup is usually 100 percent over that.

Many craft artists say they can't afford to sell wholesale; that they need the entire retail price to meet their expenses and make a profit. What they fail to realize is that their costs are less, under certain circumstances, when they sell wholesale.

Suppose you operate a one-person studio and sell your work at craft fairs. In addition to the expenses related to making your products, include the booth fee (which can cost several hundred dollars at the better known shows), the traveling costs (gas, tolls, meals, lodging) to and from the show, the costs while at the shows, which could include meals, lodging and auto costs to and from the motel if the show runs for two or three days, the cost of making or buying a booth (which can run to a sizable amount for a professionally designed and fabricated booth), and the lights, carpet, chairs, tables, and other sundries necessary to display your work in the best possible way. Most important, consider the work time that's lost by your being away from your studio.

Let's say you sell picture frames at $50 each. Just to cover the cost of the show, which can reasonably total $1,000 for well-known shows in a metropolitan area, you would have to sell 20 frames (20 frames at $50 each). To make the same amount of money as you would make if a retailer sold your work, $1000, you would have to sell 40 frames (40 frames at 50% of $50, or $25 each). Then calculate how many more frames you would have to sell to pay for your time away from the studio and for the cost of the booth, packaging, and promotional materials. You might have to sell 50 or 60 frames to make the same amount of money as having a gallery sell only 40 frames.

Wholesaling your work to galleries and gift shops can cost less than retailing them yourself. To arrive at a wholesale price, include the cost of all of the following:

- cost of raw materials
- shipping costs—packaging, shipping, handling, storage
- any labor you hire to make the piece
- all of your indirect costs.

Whether you work alone or operate a production studio, the quantity of product you can manufacture in a given time is limited. Sometimes your production is limited by labor, sometimes by equipment. Consider how quickly you or your employees design a fused or slumped glass plate. How many plates can be annealed in your kiln at one time? How long does each annealing take? Sometimes your production is limited by the availability of glass and other raw materials. Whether you ship directly to customers or manufacture for inventory affects your production and financial operations. Recognize all of these factors in order to maximize your profits. Key your pricing formula to the particular resource, whether it's labor, equipment, or material, which is in the shortest supply.

Retailing

The first question frequently asked of glass artists at craft fairs is, "How much does it cost?" quickly followed by "How long did it take?" Too often, buyers at craft shows initially determine the value of a handcrafted item based on the length of time it takes to make it. You can almost see the consumer dividing the price by the number of hours.

If you sell a one-of-a-kind sculpture for $3,000 and because of your experience working with glass, you planned, designed, and fabricated it in 20 hours, some people may be taken aback that you're asking $150 an hour for your work. Those people are the uninformed and usually the uninterested. Their experience as craft buyers is minimal. That $150 an hour, of course, has to cover all your direct and indirect costs and allow for a reasonable profit. It also reflects your experience and reputation in your field. One twenty year veteran of glass work, known for his outstanding skill and artistry, when asked by the curious how long it took him to execute a particular piece, would respond, "Twenty years…!"

If you sell your work through craft fairs, consider the additional expense of entry and booth fees, commissions (some shows take a percentage of your gross sales), travel and lodging expenses, the cost of your booth and your time for being at the show, and fees charged by credit card companies to you for accepting their charge cards.

If you sell your work from your own studio, consider advertising costs, packaging, the cost of designing and maintaining the display area, the cost of the inventory that's sitting on shelves, and the labor hours needed to keep the studio open to the public.

PRICING AND YOUR IMAGE

The price of what you sell should be consistent with the image you want to project of your studio or company. The image of your business is crucial to obtaining and keeping your clientele. If you want to project an image of a studio that makes commissioned, one-of-a-kind panels, the price of the panel should reflect the uniqueness of your work.

Pricing glass art goes beyond the traditional pricing system of most consumer products, whereby a product is marked at a few cents off a round figure, for example $5.98, $19.95, $7,799. This type of pricing, known as "odd pricing," is generally associated with mass produced products. Fine, handcrafted, glass art requires a price look different from that found on assembly line products. Whole dollar pricing is appropriate for glass art.

Displaying the Price

How you or another retailer displays the price can have an impact on sales. If you're selling your work in a gallery, prices will be listed on a card next to the piece of glass art. In an exhibition prices will be in a catalog. At a retail store or

craft fair, note the price in a place easy for the purchaser to see, but not in such a way that it draws more attention than the piece itself. A small round sticker placed in a corner or on the bottom of a decorative object would be appropriate. If you reduce the price on a particular item while it's on display, replace the sticker with a new one rather than crossing out the price and replacing it with a lower one. Seeing a price crossed out and replaced with a lower price devalues the work of a handcrafted item in the eyes of the consumers.

Evaluating Your Price

Suppose one of your products doesn't sell at the established price. If the public won't buy your product at a price that will cover your costs and return a reasonable profit, you can do five things:

- discontinue the product
- accept a lower profit margin
- explore methods to reduce costs
- price below the competition
- differentiate your product from your competition's in the minds of the buyers.

Consider the first three options based on your profit requirements and whether or not you can reduce costs enough to allow selling at a price the market will accept. Pricing similar work below the competition's reduces the profit margin on each piece of art glass sold. To compensate for this loss, increase your sales and reduce costs by:

- locating your business in an inexpensive location or facility
- closely controlling inventory
- limiting production to your most profitable products

- designing ads and promotional materials that separate you from your competition
- seek out ways to reduce your materials cost, for instance, volume purchases, different sources, etc.

Before you price your work below that of your competition, don't assume your competition has better judgment when it comes to pricing. His costs are more than likely different than yours. If your product is similar to other glass artists and you think your pricing decision could be limited by what customers have been accustomed to paying, you may be able to overcome that problem by using the fifth option differentiating your product from your competitor's.

Compare both products objectively and look for dissimilarities that would make it reasonable for you to charge a higher price. Is your use of colors more artistic? Is the soldering neater? Is the sculpture better balanced? Do you offer more services ? Emphasize quality, service, delivery time, or anything else that sets your work above that of your competition. Remember, you're in business to make a profit. The differences could mean money!

We'd like to think that people buy glass art because they like it, regardless of the price. However, price may make a difference to certain buyers. This is more likely to occur among the casual buyers of less expensive decorative objects than among collectors of more serious works.

If you can show your customer that you provide an advantage in product quality, or the services you offer, you'll find that price is not as important as it would be if you didn't emphasize these advantages.

Discounting

If you sell your work yourself and also consign it through a

Markup

Your initial markup must be large enough to cover anticipated expenses and reductions and still produce a satisfactory profit:

1. Have you estimated sales, operating expenses, and reductions for the next selling season?

2. Have you established a profit objective for the next selling season? Once you have calculated your initial markup based on direct, indirect costs, and profit, you can then set prices on your merchandise. Initial markup is an important decision and should be carefully considered. Before you price the products consider any additional factors that may suggest or affect what the best price should be.

3. Is your tentative price compatible with established store policies? Policies are written guidelines indicating appropriate action in different situations. They can save you time in decision making and provide for consistent treatment of shoppers. Specific policy areas that you should consider are:

- Would periodic special sales, combining reduced prices and heavier advertising, be consistent with the store image you're seeking?
- Do certain items have greater appeal than others when they are part of a special sale?
- Have you considered the impact of various sales items on your profit?

Also look to your competition when making decisions regarding pricing. Ask yourself the following questions:

4. Do you know what your direct competitors are doing price-wise?

5. Do you regularly review competitors' ads to obtain information on their prices?

6. Do you employ a person who can comparison shop?

gallery, it's important that the selling price of similar works be the same. Having the same price maintains the integrity of the value of your art. Some consumers tend to think if they buy a piece of glass art directly from the artist, they should pay less than if they bought it through a gallery. At first

glance, that might make sense. After all, by purchasing directly from the artist the customer is not paying the retailer's or gallery's expenses and profits. If you choose to sell your work through a gallery or other retailer, it's probably because you see it as a good way of marketing your work. The dollar value of your work should not be lowered because you sell it yourself. This practice could jeopardize your artist/gallery relationship. A gallery owner could easily see such discounted sales as undermining his own potential for selling your work. At the very worst, you may be sacrificing his, or her, representing your work at all.

"People don't go into Bloomingdales and ask for a discount, but they perceive the artist as willing to give a discount and are prepared not to pay the retail price," says Vince Olmsted. "Everybody wants the 15 percent discount. People expect it. Galleries give it," he says. Retailers do what they can to sell a product. If a gallery is willing to take 15 percent less than the stated price in order to make a sale, that's the gallery's business, especially if you receive the wholesale price you stipulated. Such discounts should not affect your wholesale price.

Discounting the price of your work can adversely affect your relationship with a gallery. You become a competitor against the gallery that represents you.

"Once you start discounting, you're deceiving yourself," says Kay Bain Weiner, glass artist, designer, author, and instructor, "You ruin the business for everyone. It becomes a price war."

RETAIL STORE PRICING

As the owner of a retail glass art and supply store, you will sell a variety of tools, equipment, and materials in addition to your own and perhaps others' glass art. Before you set

prices, you must understand your costs, the market, and your competition. If you operate a small store, compare your prices to that of other small suppliers. Do not compare your prices to those of large suppliers or retailers of similar items. Because they buy in volume and their cost per unit will be less, large suppliers and retailers can offer items at lower prices. Highlight the factors and services you offer that a larger supplier or retailer cannot.

Pricing your products higher than those of your competition with a similar size operation can work under certain circumstances. Sometimes a consumer does not consider price the determining factor for shopping in a certain store. You might be able to justify the higher prices if you offer more services, are in a more convenient location and/or carry hard-to-find merchandise.

Your pricing strategy, whatever the glass product, involves numerous factors, such as markup, competition, customer feedback, and store policy.

CUSTOMER FEEDBACK

As a retailer, you'll be selling to a variety of people with a variety of needs. Many of your customers will be glass hobbyists or artists, but their needs will differ. Some will be very price conscious. Others will want convenience and knowledgeable sales personnel. Because of these variations, learn about your customers' desires in relation to different products. Getting feedback from customers is a good starting point. It will help you answer the following questions:

- Will odd-ending prices such as $2.98 and $9.95 be more appealing to your customer than even-ending prices?
- Will consumers buy more if multiple pricing, such as 2 for $8.50 is used?

- Should any leader offerings (selected prices with quite low, less profitable prices) be used? Leader offerings are generally those products used by most people, bought frequently, at a very familiar regular price and not a large expenditure for consumers. Sales of leader offerings can get customers into the store.

CHANGING PRICES

Once you have determined that your costs are increasing enough to warrant a price increase, before doing so, ask yourself:

- Whether your customers will remain loyal to you after a price increase; if not, why not? If needed, develop a strategy that will keep your customers coming back: better service, better quality, or more convenience in shopping.
- Whether your customers are aware of your competitor's prices? If they aren't, the price changes would not likely affect the number of units you sell.
- What affect the price change would have on the consumer's perception of value of the product.

Whether you sell wholesale or retail, are a one-person studio or a production studio, whether you sell from your studio or operate a retail store, when determining an appropriate price, ask yourself the following questions:

- Do I price all items at a level which provides an adequate profit margin?
- Do I monitor costs and make price changes to provide for continued profitability?
- Do my prices cover variable costs and fixed costs, profit, and subsequent price reductions?
- To maintain a higher price than the competition, do

I offer extra services?
- Do I realize that idle facilities and space have certain fixed costs whether I use them or not?
- In establishing a price strategy, do I consider channels of distribution, competition, annual volume, opportunities for special market promotion?
- Is my price consistent with the product image?
- Do I want my company to be a price leader?
- Do I determine and update material costs frequently?
- Do I set my prices realistically?
- Have I estimated sales, operating expenses, and reductions for the next selling season?
- Have I established a profit objective for the next selling season?
- Do I know what my competition is doing price-wise? Do I visit galleries and craft shows where their work is exhibited? Do I review their ads?
- Have I marked the calendar for a periodic review of my pricing decisions?

The key to ensuring a profit is to have a well planned strategy and established prices and to monitor prices and operating costs at regular intervals.❖

6

Setting Up Your Studio/Store

"The idea for a business can begin anywhere. The business itself must take place in a specific location - not in a corner of a family room or on the dining room table. It must be a separate entity."
—Joe Porcelli

Many studio glass artists work in a room or the basement of their house, in the garage or a separate building on their property. Some of the finest cold glass artists began as hobbyists creating decorative pieces on the kitchen table. If you're a professional, it's important that the studio space be separate from your family living space and family traffic. Discussing a commission with a potential client over the kitchen table is not professional. Pushing aside schoolbooks and clothing, or sharing your work space with yesterday's laundry is not professional.

A distinct, separate work space not only says you take your work seriously but leads to creativity, productivity, and satisfaction. It permits you to work whatever hours you choose in an atmosphere that you choose and can control.

LOCATION

"The more educated the community, the better off the artist is because the community will understand where you're coming from," says Vince Olmsted.

Many successful glass artists work where they live, but in separate areas. Others choose to have studio space far removed from their homes. Where you choose to locate your studio depends upon the type of glass art you create, the method in which you will market your work, your economic situation, your personal preference and the zoning designation in the particular area. Hot glass requires a studio separate from your home. Cold glass allows more flexibility regarding location. The size of the work you do determines the amount of space you need. Large, architectural panels require a larger working area than decorative boxes. Production work sold to hundreds of outlets requires a larger space than that of one-of-a-kind pieces sold through a few galleries. Working out of a studio in a rural area imposes fewer restrictions than locating in an urban building.

Many municipalities have zoning laws that designate the use of properties within the community. Those uses are generally designated as residential, commercial, and industrial. In many residential zones studios are allowed, if they're secondary to the main use of the property, that is residential, and if they are non-commercial; they don't encourage traffic and consumers to come to the studio on a regular basis. Commercial zones are more flexible; they might allow both residential and commercial uses. In addition to industrial/manufacturing type businesses, industrial zones might also permit commercial uses. The zoning designations and regulations vary among communities. If you have any doubts whether your studio conforms to the designations of a particular zoned area, contact the local zoning department

or municipal administration authority.

If you're looking at space in a developed area where other people work or live, consider their needs and attitudes. As an artist, you're not confined to a 9 to 5 work schedule. Look for an area that is compatible with your work style. How will your neighbors react to the hours you might choose to work, the noise, or dust level created by your work? Are you flexible enough to accommodate your working style for a neighbor? Talk to residents and artists about the neighborhood.

Inspect the site carefully with the local building inspector, especially if the building is old or has been uninhabited for a number of years. Be sure its electrical and ventilation systems are adequate for your work and the amount of natural light conducive to your glass art. The local historic society or housing development agency might be able to identify areas appropriate for your studio.

Over the years, artists have been some of the country's best developers. They've gone into low-rent urban areas, taken warehouses and vacant industrial space, refurbished them and, through their pioneering efforts, brought neighborhoods back to life.

Wherever you choose to set up your studio, make it as pleasant, safe, and convenient as possible. These qualities lead to creativity, productivity, and satisfaction.

STUDIO SPACE

Surround yourself with what you love. Make the studio the most comfortable it can be. You're a creative person and working in an environment that makes you feel good not only unleashes your creativity but makes you feel competent.

An efficient floor plan includes separate areas for different processes. This helps prevent contamination (impor-

tant, especially if you're working with hot glass) and disorganization. It also enables you to perform various aspects of glass art without having the work interfere with what's being done elsewhere in the studio. Have separate work areas for designing, cutting, fabricating, and finishing. Your area for grinding, where a great deal of glass dust is generated, should be separate from where you lay out your work. Allow for plenty of storage.

The layout of the floor plan depends upon whether you're working with hot or cold glass. Hot glass requires a minimum space of about 2,000 square feet. This allows you room for a hot area in which to produce your objects and another area for the annealing ovens. The cold area would allow for a table on which to design your work, and an area for finishing, grinding, and polishing.

Vinyl, wood, or ceramic flooring is appropriate. Wood is the most comfortable, according to some artists, but it wears unevenly. Ceramic sweeps and mops up easily, but glass will likely break if it's dropped on a ceramic or stone floor. If you have a ceramic floor place a rubber mat by your work bench, it will make standing for long periods more comfortable. A vinyl floor can have more cushioning than wood or ceramic; it cleans up easily. Never work over a rug or carpet.

If you're a cold glass or stained glass artist, plan to have several work tables. This enables you not only to keep non-working areas clean, but allows you to work on several projects at one time. Your work tables must be as large as the largest piece you intend to make. If you design and fabricate entranceways, allow yourself a worktable the entire size of the glassed area. This allows you room to work freely and see the entire piece as a whole. Be sure the tables are strong enough to support the weight of the pieces you make. Mark Beard of Scintilla Architectural Stained Glass in Doylestown,

Val Sigstedt

Val Sigstedt of Point Pleasant, Pennsylvania, is the consummate artist. He grew up under the tutelage of his father, a master wood sculptor from whom he learned to carve ecclesiastical furniture and illustrative panels. He apprenticed in stained glass as a church art studio mechanic, then worked as glazier, beveler, mirror maker, and installer. He set up and managed the stained glass department of the Santa Fe Studios of Church Art, Inc., in New Mexico, where he made and installed ecclesiastical stained glass in a 400 mile radius around Santa Fe. While serving in the U.S. Army in Europe in 1954 he studied European stained glass, especially the art of Chartres Cathedral in France.

In the late 1950s Val studied art at the Tyler School of Fine Arts in Elkins Park, Pennsylvania. In 1960 he established his stained glass studio in Point Pleasant in an old schoolhouse building overlooking the Delaware River.

He originated the hanging ornament industry in 1961 with a cus-

tomer list which included George Jensen, B. Altman's, The Brooklyn Museum Shop, and Serpendipity Three in New York City. In 1961 the studio was making ornaments, doing restorations, and designing custom stained glass. By 1966 Val was designing and making original lamp shades. His stained glass and jeweled lamps adorn major restaurants throughout the country. His customer list included the Tavern on the Green restaurant in New York City.

He was the first stained glass teacher in the Bucks County, Pennsylvania region, having started the stained glass department at Bucks County Community College in 1972.

One of the most dramatic uses of his stained glass panels is in the high tech medical imaging facilities of Graduate Hospital in Philadelphia. In five murals totalling over 500 square feet, Val created a series of distinctive and masterful designs on the ceiling and the walls.

Made of two by two foot stained glass panels set in the suspended ceiling grid, they reach about 18 feet across the ceiling and six to eight feet down the walls. The scenes gives the illusion of looking into a lily pond, sitting under a growing tree, viewing Planet Earth from a distance and looking at the inner world of a human body. Ethereal in nature, the panels are filled with details and surprises to help distract and relax the patients who come to the facilities regularly.

Val's panels were the first of their kind to be used by a hospital for therapy. To the uninitiated the success of stained glass in relieving patient anxiety had been surprising. To those who understand stained glass as an art form, it comes as no surprise. Hospitals around the country have been commissioning Val to design panels for their facilities.

"Stained glass is a rarefied art form, yet it has weight requiring mechanical solutions," says Val. "Consider the chaos of ordinary light. It dazzles and reflects going straight only when it moves through a laser. You have to understand what you want it to do inside a building and know how to achieve those results.

"Stained glass is a craft that is aesthetic and practical. How that craft becomes art is mysterious. Art lurks in the depths between your mind and the physical world. Then all of a sudden it just pops out."

Pennsylvania, maker of faceted glass panels, says a one inch thick panel of dalle de verre glass measuring 16 square feet can weigh 175 pounds. The kind of glass art you do will determine how you set up your studio or workplace.

Mark places homeosote as a surface over his plywood work tables. Homeosote is a compressed paper product used in building insulation; it can be found in most lumber yards. Mark has found it also works well as a surface for hammering horse shoe nails, or stops, around a design to keep the glass in place. Homeosote maintains a smooth work surface and doesn't split or splinter as wood does when nails are hammered into it.

When determining the height of your work tables, consider what you will be doing at each table. You might enjoy cutting glass sitting down and soldering standing up. Plan the tables for a height most comfortable for you, keeping in mind the height of the stools and chairs you'll be using. The most common height for worktables is 36" from floor to surface.

Allow enough space in your studio layout for flexibility. You may have to enlarge or adapt the area as your interests grow. Many well-known stained glass artists who create large panels or lamps began their careers by making small decorative pieces. If you're building a studio, consider forecasting your needs and the growth of your business a few years down the road. Consider whether to build a larger studio than you presently need, or design it in such a way that it can easily be enlarged.

If your office with a computer and files is part of your studio, physically separate the office area from your studio work space. Put the office on a separate floor of your studio, if possible, or enclose the office space with sound proof partitions. Computers and business equipment are delicate

machines and expensive to repair. They function best in a cool, dust-free environment. Furthermore, an active or noisy work area is not conducive to performing administrative responsibilities.

LIGHTING

Plan for lots of light. Natural, fluorescent, and incandescent lighting is extremely important for a glass artist. Holding the glass you choose for a project up to the light enables you to see whether its qualities are those you want to project in your finished piece. Light projects a feeling of well being. Fluorescent lights can be run in series along the ceiling. Incandescent and fluorescent lights can be placed on your work tables, shelves and throughout the studio. If you're building your studio, plan to include windows on the east and west sides to get the most benefit of natural lighting all day. If your studio space is in your home, place it in an area that gets the most light all day, or consider adding windows. If you can't increase the window space in your studio, consider planning your work schedule when the natural light is at its maximum in the area.

STORAGE

Glassworkers are notorious packrats. Set up your studio with a great deal of storage space. Keep glass in a safe, retrievable place. Separate glass by colors and place large sheets of glass on edge on open shelves, racks, or in bins against the wall. Fasten the racks to the wall for additional strength and place the racks low to the floor for ease in removing the glass. Never place glass racks higher than you can reach.

Use wire rack shelves for smaller pieces of glass. Keep tools in boxes or on magnetic boards. Put small items in containers that hang from wall brackets. The brackets and

containers are available at hardware supply or home im-provement stores. If your tools are in boxes, label and arrange the boxes in alphabetical order for easy retrieval and storage. Place patterns and tracing paper in drawers where they can remain flat, unwrinkled, and ready to use.

Keep magazines in bins specifically designed for mag-azines. These are available at office supply stores. Label the bins and place them on shelves with other reference ma - terials.

SUPPLIES

Stained glass requires only a small investment in equipment and tools to begin. A set of good, medium-priced tools will cost about $100. This includes solder, glass cutter, soldering iron with rheostat, running and breaking pliers, flux, copper foil or lead, patterns, patinas, and polish. If you've been working with stained glass, you probably already have most of the supplies you need to become a professional, especially if you plan to market and sell the types of items you have been making all along. As your interest and business in stained glass increases, studio, retail, wholesale suppliers, hobby shops, hardware stores, mail order companies, and local glaziers carry many of the additional glass supplies that you will need.

Your basic supplies are: sheets of stained glass, glass cutters and pliers, cutter lubricant, copper foil or lead came, soldering iron and rest, cellulose sponge, solder, flux brush, wire, hammer, glazing nails, scissors, steel ruler, work gloves, work aprons, first aid kit, safety goggles, gloves and aprons, table brush for cleaning work surface, glass cleaner, clean rags, abrasive stone, graphite glass pencils, lead vise, patina solutions, light box, putty or glazing compound, whit-ing powder, graph paper, tracing and carbon paper for trac-

ing templates, a glass grinder, and grinding wheels.

Better equipment, more available materials and technology enable you to be more creative with alternative glass techniques such as fusing or combining flame working with fusing. You can establish a studio in which you combine these techniques with cold glass for about $1,000.

If you're fusing glass, you'll need a kiln. You can't fire, slump, or fuse glass without a kiln. A kiln is an oven made out of a special type of durable brick, heated by electric heating elements set into the brick. Kilns come in various sizes for different needs. The size of the heat chamber determines the price of the kiln. The most practical kilns for glass are electric. They are preferred over gas because the impurities in natural gas can discolor glass surfaces. Kilns can be loaded in the front or from the top. Front loading kilns have elements on three sides, leaving a cold area where no element exists. Heating is uneven. If you do not need even heat, a hybrid ceramic kiln can work well for your glass. Top loading kilns are more compact than front loaders and the heating elements surround the chamber. A programmable controller to regulate the heat in the kiln is highly recommended. It frees you from having to remember to turn off the kiln. Several controllers are on the market.

Operating a hot glass studio can be a very costly investment, about $25,000 to start, not including the building or workspace. You'll need a gas-fired or electric furnace for melting the glass, a glory hole, or furnace for re-heating and re-shaping glass, at least one annealing oven to cool the glass, a computer to control the oven temperature, work benches, blow pipes, cullets, frits, pontils, powder, diamond grinding wheels, cutters, jacks, shears, hand held torches for spot heating, and sundry other items to assist you in the creation of your glass work. The variety of hand tools depends upon

the type of glass art you will be producing.

You can purchase almost any kind of oven, kiln, or furnace. However, continuing a trend that began in the 1960s, many hot glass artists choose to build their own. The Glass Art Society has been a resource of information for hot glass artists, including names of artists who build furnaces. "There is a lot of sharing of information among hot glass artists," says Steve Lundberg of Lundberg Studios in Davenport, CA. The basic process of working with hot glass has changed little over the centuries. In many instances, the equipment and tools used to create the variety of finished artwork, in addition to the furnaces, have been designed and built by the artists themselves. "You have an idea and design a machine to bring the idea to fruition. The hot glass artist becomes an electrician, a welder and a technician," says Steve.

In its September/October issue, *Glass Art* magazine publishes a directory of hot and cold glass industry suppliers. There is an alphabetical listing of companies and a second listing of products and services. This is an excellent source for hot glass artists, according to Steve. The December issue of *Professional Stained Glass* magazine features a buying guide for artists who work with stained glass. Throughout the year, numerous suppliers advertise in both magazines.

In addition to the trade magazines, you can find suppliers listed in the *Thomas Register*, a voluminous series of books available in the reference section of libraries that list manufacturers in every field. This book is especially helpful if you're looking for an industrial tool, machine, or supply not normally used by glass artists or sold by glass industry suppliers.

Business-to-business telephone directories provide another source of suppliers. Call your local Bell operator to request a directory. Many metropolitan areas also have in-

dustrial guides. Contact your local chamber of commerce for information about acquiring these guides.

SETTING UP A STORE

"Operating a store doesn't require a real cutting-edge knowledge of business, but lots of sincerity to help people enjoy stained glass."

Glass is fun. It's creative and relaxing. Stained glass can be inexpensive and appealing to any age group. Customers span generations. Rainbow Stained Glass in Andalusia, Pennsylvania, has one customer who is 85; another was 73 years old when he began working with stained glass. Eight years later, he was still working with the craft.

Many artists have combined their love of creating art glass with the practicality of supplying other glass artists and hobbyists. They use their store as a source of regular and daily income while doing commissioned work in their studio. Others have chosen to operate a store as their primary career. Owning a retail store requires, among other things, careful planning in selecting the best location, designing the layout, displaying merchandise, and choosing inventory.

LOCATION

Your store's location is dependent upon your customer base. When choosing a location, use the services of the Bureau of Census Data. They can provide population breakdown for communities by age, sex, race, educational level, income, occupation, home ownership percentage, the value of the homes owned, the average age and quality of the homes, and the degree of auto ownership. In addition, the bureau can tell you the total purchasing power within a trading area, the

general appearance of the area, particular zoning regula-
tions, the quality and number of competing stores, the quali-
ty of the access routes to the area, and the customer appeal
of a particular shopping district. Generally, local libraries
have this information. If your library does not, you can
request it directly through the Census Bureau, US. Depart-
ment Of Commerce, Washington, DC., 20233. Telephone:
301-763-4100.

Also, consider the general appearance of the area, the
business climate, the possibility of expansion, the tax burden,
as well as the impact of the area's schools, cultural, and
community atmosphere on your business.

If you live or have lived in the area in which you plan to
open a store, you probably already know much about the
demographics as well as the number and quality of estab-
lishments that will be your competition. This knowledge will
guide you in selecting the best location for your business.
Real estate agents who specialize in the sale and rental of
commercial properties can help you find an appropriate
location.

If your goal is to attract walk-in customers, a storefront
with large window space on a main street in a downtown
area or in a strip mall could be appropriate. If your targeted
audience is in a wide geographic area and will be driving to
your store, consider locating the store at a site near major
thoroughfares. If you'll be giving classes at night, be sure the
area is well lit and in a low-crime area. You do not have to
be on a high-rent street, but consider how far away from
major roads and shopping areas you can locate your store
and still be convenient to your customers. Will you have to
give lengthy directions to the store?

One major retailer moved her store from a busy thor-
oughfare to a larger, less expensive location. While her reg-

ular customers continued to shop, the number of new customers declined. When she relocated to the main street, her new business increased. It seemed people would drive along the highway, see the store, and tell their friends who work with glass about it. Stained glass is an esoteric product and in this case, it needed constant exposure.

Many communities and shopping centers have restrictions on signage regarding the size, lettering, height, and style of store signs. Does your proposed location allow for a sign that can be easily seen from the road? Does your sign clearly identify your store as a stained glass outlet or will people think you sell auto glass?

Ample parking is important. If you are locating in a center with other shops or businesses, be sure the lease specifies a number of parking spaces that can accommodate the maximum number of cars you expect at any one time. Frequently, the size of the store determines the number of allotted parking spaces. This is especially true if the store is in a shopping center with only a few other shops. If your store is in the center of town, is there curbside or lot parking? Are parking lots conveniently located to your store? Who owns and operates the lots? Do the merchants pay for their upkeep? How is the amount paid by each merchant determined?

Once you've located a site you think is appropriate for your market, or decide you want to operate the store out of your studio or home, learn whether the proposed business conforms to local zoning ordinances. In many parts of the country, municipalities have zoning laws that specify areas as business, commercial, office, industrial, farming, or residential zones. The zoning ordinances specify what is allowed or disallowed in a particular zone. Your local or county zoning board can tell you in which zones your type of store

or business can be located. Store owners usually are required to meet local safety and health codes, such codes may require the installation of a sprinkler system. If you are renting space, ask the town's building or fire official to inspect the premises. If the store's owner is in violation of a safety code, for instance if sprinklers aren't installed, your business is at risk and your insurance costs could be higher, even though you don't own the building.

Once you have established that you can operate a stained glass supply store in the area you've chosen, talk to a number of other retailers in the immediate area and throughout the community. It can help you get a feel for the business climate.

The Store

The size of the store should be determined in proportion to your inventory. A large store with a moderate amount of inventory can appear to be poorly stocked. A small store overflowing with inventory in boxes on the floor can create a safety hazard, as well as appearing disorganized. Art glass stores are most commonly between 1,000 and 3,000 sq. ft. in size, according to the Art Glass Suppliers Association. A well-stocked store requires about 1200 square feet of space. This allows for an area in which to display the supplies, a section for finished products, a work space or classroom area, and storage.

Successful retailers recommend you find a store with large windows, easy delivery, and no steps. The importance of large windows is vital in operating a successful stained glass store. With kits and finished products in the window, they provide free advertising.

Windows and stained glass can be solar conductors. They can generate a great deal of heat in your store. Be sure the store has good climate control.

Store Layout

The way you lay out your store depends in large part to the building's configuration. But whatever its shape, include the following:

Place finished products in windows, on shelves, tables and if possible in room settings.

Display new products and promotional material in an accessible place near the entranceway.

Make the entranceway appealing with new products displayed in an attractive way.

Have plenty of natural and fluorescent lighting.

Place glass in the front of the store. Staple items in the back.

Put products where people can touch them.

Keep classroom areas separate but visible from the retail area.

Stock several pattern and instruction books.

Have demonstration and work tables in a convenient yet unobtrusive area.

Be sure you have enough storage area on the main floor to accommodate glass. Glass is heavy, you do not want people to trip when carrying it. Double doors in the front and in the back of the store are convenient for removing large commissioned work or delivering large cases of glass. Avoid a vinyl or carpeted floor where glass will be delivered. They show wear and can damage from having a 500 lb. case of glass rolled across them. A hardwood or concrete floor wears better and is better suited to this kind of environment.

DISPLAYING THE MERCHANDISE

The arrangement of supplies and working areas inside the store is as important as large windows, double doors and an appropriate location. Separate your retail, or glass supply area, from the finished products. This can be done with different flooring, the placement of counter space, shelving, pegboards, display racks, or doorway openings. Avoid straight aisles. Make a walk through your store an interesting

experience of discovery. Include areas for retail sales, demonstrations, classrooms, promotional displays, new products, staple items, storage, and office space.

Have glass and finished products occupy a prominent space in the front of your store. Display glass in low racks for easy retrieval and storage. Glass can break. Salvage your investment by selling small pieces of scrap glass by the pound. Keep small sized, empty boxes available for people to leave or pick up smaller pieces of glass.

Stock staples such as solder, copper foil, and lead in the back of your store so customers will have to walk by other items to find these staples. Display new products in the front of the store. Whatever is put inside a counter does not sell well, according to one retailer who has been selling supplies since 1975. Place the supplies and products on shelves, peg-boards or on the wall so people can touch them.

Place books and small supplies on free standing swivel display racks. The swivel racks give you flexibility to rearrange the store from time to time for added interest. Often, people won't notice something that's been in the store for a while until after it's been moved to another location. Scott Haebich of The Stained Glass Place, keeps magazines and books very visible. "Once you've taught someone to do something in glass and they buy tools," says Scott, "books and patterns should catch their eye for projects they want to make."

Make your entranceway attractive with finished and new products, promotional displays and brochures that answer general and technical questions about stained glass. Dale Bauers of Rainbow Stained Glass in Andalusia, Pennsylvania, shows finished work made exactly as suggested in the books and magazines he sells. It helps to sell the products. All of the finished work he displays are intended to sell other products; not to be bought themselves.

On your retail counter, by the cash register, place free handouts, such as Stained Glass News, available through Scott Haebich's Stained Glass Place, and copies of your upcoming classes and special events and sales. Allow room on the counter for working, to show how a tool works or operates, and to cut glass. Use the interior of the counter for packaging materials.

If your store is large enough, placing the finished products in a setting with appropriately styled furniture can add to the allure of stained glass. Antique furniture works nicely. Include tables that support lamps, jewelry boxes, and picture frames. If you're selling to hobbyists, show a finished piece made from a pattern. If you do not have the space for room settings, individual tables displaying finished products work well. Move them around to change the look of the store, especially with each new season. Always make your store an interesting place to see something new and to shop.

Hobbyists tend to be traditionally oriented and like the traditional look of stained glass. However, others might like a contemporary look or the style of a particular artist, such as Frank Lloyd Wright. Know what your customers like and make the store reflect their tastes. Also, display a few finished pieces in various styles or influences to show the range of stained glass art. If customers feel comfortable in your store, they'll want to be there and purchase or create something that creates that feeling in their own home.

Lighting is the essence of stained glass. It is the magic and allure of the craft. It makes it sell. Capture the ambiance of stained glass with natural light from large windows or provide a light table on which your customers can place sheets of glass. Use incandescent lights in room settings. Brighten your supply area with fluorescent lights. People like to see what they're buying.

Set up tables where customers can try, and you can demonstrate, new products.

INVENTORY

The abundance of available glass art supplies enables the retailer to focus on the specific needs of his customers. You can't carry everything, retailers say, so determine what your customers want. Stock products that you have been satisfied with and your customers have expressed an interest in. Include as many different kinds of products as you can, even if you carry only a limited number of each. This will help you learn what products appeal to your customers. Carry all the components necessary to complete a project. For instance, if you sell patterns for making table lamps, have available everything a customer needs to make a complete lamp. This would include: lamp bases, harps, sockets, switches, loops, nipples, crossbars, spiders, cords, plugs, couplings, neck spacers, shade raisers, washers, nuts, bushings, and caps. The convenience of being able to shop for these sundry, non-glass supplies in one place will keep your customers coming back.

Demonstrate the products you sell. Show sample grinders that can be worked by customers. Demonstrate the uses and advantages of new tools being introduced to the market. Offer the products your customers see advertised in stained glass magazines. Use safety equipment while working. You will always attract customers by demonstrating supplies.

In stocking your store, begin with the necessities: the solder, copper foil, soldering irons, glass cutters, glass pliers, grinders, patinas, fluxes, lead came, safety glasses, respirators, a line of bevels and, of course, a good selection of glass. Carry a variety of colors and textures in machine rolled and art glass. If your customers are primarily hobbyists, it is

important that the glass they encounter as beginners is consistent in color mix and texture and easy to cut.

In determining your inventory budget, the Art Glass Suppliers Association (AGSA) recommends you spend 33 to 50 percent of your inventory dollars on glass. Books, patterns, and glass should dominate the inventory to help sell other items.

If your customers are primarily hobbyists, carry as many pattern and instruction books as you can afford to buy and display. Give your customers as wide a variety as possible. The more variations you can show your customers, the more enthusiastic they'll likely become about working with glass. Carry a selection of instructional videos and full size patterns. If your customers are new to stained glass, consider carrying white metal lamp bases which are less expensive than brass or bronze. Stock as many tools or devices that make working with glass easy for the beginner.

If you are a supplier to other artists, carry a good selection of art glass. Ask them what products they want; they'll likely specify the brand names of the glass and products they prefer.

Stock what you know, but keep an open mind to tools and products you haven't used. When you have a store, you will more than likely have people coming in who have been taught by others. Learn from your customers' techniques or use of a tool, retailers say. Realize there are different ways to do things. Visit other retailers or attend trade shows to learn what's on the market and whether it is suitable for your customers.

CLASSROOM AREA

You have a vested interest in how students learn. If you operate a retail store, plan to conduct classes in a variety of techniques, such as fusing, etching, and decorative soldering in addition to basic and advanced stained glass. Offer classes in special projects such as lampmaking, light boxes, hanging

panels, and seasonal decorations to keep customers interested and working. Show your customers all the ways they can decorate with stained glass. If you are not familiar with a technique, hire someone who is. Supplement live instruction with videos. Some retailers have viewing areas where instructional video tapes can be viewed by shoppers. Others let video programs run during busy shopping hours to spur the interest of non-glass customers.

Retailers who run classes recommend you work with a maximum of eight students. This enables you to give each participant individual attention while allowing an exchange of ideas and support among students. Offer each student a discount on glass and supplies while he, or she, is enrolled in a class. You may want to extend discount privileges for a limited time after their initial class to keep students coming back to you for their supplies. The AGSA suggests you have intermediate and beginning students in the same class. This can stimulate the beginners as well as filling space during the slower months. If you do mix the two groups, be sure the projects are advanced enough to keep the more experienced students interested and not too challenging for the beginners.

Separate the classroom area from the retail area, but keep it within sight of your retail area. Seeing workshops in session can encourage customers to participate in future classes and get the casual observer interested in stained glass.

SAFETY

Lead fumes, silica dust, and toxic vapors are the most common hazards of working with glass. Whether you operate a one-person studio, conduct classes in a retail store, or manage at least one employee, you and others can be at risk. If you are an employer or give lessons, you are legally required to comply with state or federal OSHA (Occupational Safety

and Health Administration) rules and regulations. Contact your state, department of labor to learn whether your state or the federal OSHA regulations apply to you. Studio artists who work alone and who have no employees are not bound by OSHA regulations. For these craftspeople and artists, safety should be a personal concern.

Federal and state OSHAs have a vast number of rules regarding lead exposure, equipment, workspace, and numerous other potential hazards that could affect the health and safety of employees. The federal OSHA rules and standards are in the Code of Federal Regulations 29 CFR 1900-1910. The book is not easy to read; however, if you are an employer, and are regulated by federal OSHA, the book details the rules that could apply to your particular operation. The book can be purchased through your local OSHA office.

If your business is regulated by a state OSHA, contact them for a listing of their regulations. If, as an employer you do not take the precautions detailed by OSHA, the agency, citing any violations, could force you to do so through fines or legal action.

EXPOSURE STANDARDS

Lead is one toxic material whose damage has been well documented. Exposure to lead has been linked to blood poisoning. Lead is also known to cause lead colic, a serious illness with flu-like symptoms, brought about when large amounts are ingested or inhaled at one time. Chronic exposure to even small amounts of lead can accumulate in the system over time. Such exposure can result in serious problems. Lead exposure has been linked to certain psychological disturbances, learning problems, anemia, nervous system, and kidney damage. It is also known that lead harms a fetus and can affect the reproductive abilities of both men and women.

OSHA requires that all employees exposed to the hazards of lead be tested for lead in the blood on a regular basis, and be provided with showers and changing rooms to avoid their carrying any lead particles from the workplace to their homes. To monitor your exposure from lead and other airborne chemicals, federal and state OSHAs have set exposure limits standards. The limits, however, do not guarantee protection, nor are they meant to apply to children and high risk-individuals. As medical tests become more sophisticated and studies reveal in more detail, the hazards and effects of long-term exposure, the limit standards are revised. OSHA can provide you with current exposure limit standards.

One of the ways to reduce the hazards of lead toxicity is to use lead-free solders. They are currently being manufactured for use with stained glass. Ask your distributor for the names of manufacturers, or look for ads from manufacturers in glass magazines.

The disposal of scrap lead and lead-bearing products is, in itself, an environmental issue that should be of great concern to the stained glass industry. To help keep lead out of landfills, the Michigan Glass Guild, as an example, has organized a lead recycling program in which they take lead scraps to a lead recycler. The moneys generated from selling the scraps are put back into the guild's treasury. Check with your local environmental agencies about ways to recycle and dispose of lead properly. Lead and lead-bearing products are highly recyclable. In more and more communities, it's not only the responsible thing to do, it's the law.

RIGHT TO KNOW

Part of the OSHA regulations is the employee's Right To Know program. Ask your state department of labor if your

business comes under the state or federal Right To Know program. Ask the appropriate agency for a copy of the law and guidelines for instituting the program. Basically, the program requires that you:

- identify all chemicals and other hazardous materials
- assemble Material Safety Data Sheets (MSDS) on all hazardous materials. MSDSs are health and safety information sheets available from the product's manufacturer
- apply proper labels to all containers into which chemicals have been transferred
- check that product labels comply with the law's labeling requirements
- make all lists of hazardous materials and MSDSs available to your employees
- implement a training program for employees who are potentially exposed to toxic chemicals; one that explains toxicology, risk, and exposure standards.

PUTTING SAFETY IN THE STUDIO

Education, intelligence, and implementation make a studio safe. Whether you operate a one-person studio or your business comes under the rules of OSHA, the dangers from toxic materials in the studio are real. They can be minimized. Here are basic safety guidelines to consider when creating glass art that can help make your studio or classroom environmentally friendly and safe:

- Separate the work area from your living environment. Never do stained glass in the kitchen, bedroom, or any other area subject to family traffic.
- Keep things in order. Cleanliness not only prevents accidents but breeds productivity.

111

- Adequate ventilation is very important. Use fans, exhaust systems, and the proper types of respirator masks in conjunction with open doors and windows to help remove polluted air, dust, and lead fumes from your environment, as well as let fresh air in. Capture dust or vapors with a properly installed exhaust hood directed to the area in which you are working. Any such apparatus should be connected to a ventilation system that ducts through a wall to the outside. Filtration systems are advertised in glass publications and The Crafts Report. Be sure the system you use can capture small particles of abrasive dust and lead fumes. Filters rated by the National Institutes of Occupational Safety and Health (NIOSH) as high efficiency particulate air (HEPA) filters are the only filters acceptable for stained glass work, according to Monona Rossol in her books: The Safety Training Manual and The Artist's Complete Health And Safety Guide. Monona is an industrial hygienist and leading authority on health and safety.
- The Safety Training Manual is an easy to read book with information about air contaminants, MSDSs, lead, exposure standards, fluxes, solders, patinas, metals, solvents, plastics, and studio safety. It is available from Professional Stained Glass magazine.
- Smooth, non-absorbing work tables and floor surfaces enable you to wet-wipe or mop particles, debris, and spills. Never vacuum or sweep. Small particles pass through the vacuum and are returned to the studio. Sweeping raises dust.
- Wear protective clothing in the studio and leave it

in the studio. This could reduce the likelihood of your carrying lead particles into your home. Wash your work clothing separately from other laundry.

- Keep a first-aid kit and topical disinfectant nearby in case of cuts and minor injuries.
- Wash you hands thoroughly after working with lead or solder.
- Use protective eye wear, such as goggles, when grinding to prevent glass particles and dust from getting into your eyes.
- Do not eat or drink in the studio or classroom.
- Install an ABC fire extinguisher near the areas most likely to create fire damage. An ABC extinguisher is designed for fires generated by common combustibles such as paper and wood, by chemicals and toxic solutions like solvents, patina and finishes, and by petroleum products like gasoline and kerosene.
- Separate the wet and dry working areas to prevent water splashing on electrical equipment. Install ground fault interrupters on all electrical outlets. The interrupters cut off current immediately when they get wet.
- Electrical equipment should be certified as safe by Underwriter's Laboratory (UL) or other recognized testing laboratory.
- All grinders should have face guards. Stationary grinders should also have a built-in exhaust ventilation system. Wet grinders that use tap water are less likely to cause respiratory infections than grinders with reservoirs that retain stagnant water.
- Electric kilns should be ventilated. Larger kilns should be equipped with their own ventilating sys-

tem. Placing smaller kilns near a window exhaust fan might be sufficient for adequate ventilation.

- Fluxes contain a mixture of chemicals. Use them exactly as the manufacturer indicates. Ventilate the area well when working with fluxes.
- Solvents, such as turpentine, lacquer thinner, kerosene, and acetone can cause respiratory distress, eye damage (if splashed into the eye), and skin irritation. Avoid breathing solvents, wear goggles and use gloves or barrier creams when handling solvents. Place solvent-soaked rags in self-closing waste cans. Follow local, state, and federal codes for storing, handling, and disposing of solvents. Use the least toxic solvents.

For more detailed information about the use of toxic materials in the studio, read The Safety Manual or contact The Center for Safety in the Arts, or Arts, Crafts, and Theater Safety (A.C.T.S.); Both groups promote awareness of health and safety hazards related to glass art. Their addresses are listed in the back of the book.

COMPUTERS
Selecting A Business Computer System

While the creative forces that drive the artistic nature of glass art can be said to be the antithesis of technology, the practical application of that creative energy has flourished as a result of technology. Nowhere is the balance between creativity and technology better seen than in the use of computers. Through word processing, database and design programs, computers enable artists to project an image of a professional, modern-day businessperson, and in some cases improve their artwork as well.

114

Whether you're a studio artist or a retailer, you share the same fundamental business needs of any other business: accounting, bookkeeping, record keeping, marketing, and customer service. Computer programs designed for those areas can save hours and days of labor. In addition, design and drawing programs enable you to plot original designs quickly and accurately. Today, computers are easy to use and offer a wide range of software for almost every need. They have become a basic business tool.

A computer system's hardware includes the computer, keyboard, screen and additional tools such as a mouse, modem, and printer. Computers come with a number of "slots" into which you can plug modems, network, or memory cards that increase the computer's capacity and capabilities, if the need arises. These additional tools can be purchased at a later time. A computer contains a hard disk on which it can permanently store a huge amount of information from various software programs.

The information from software programs come on disks which are inserted into the computer. You can store information from these "floppy disks" onto the hard disk if you choose. Such "saved" information becomes a permanent resident of your computer system. You no longer have to insert a floppy disk to get to it. The most basic software programs are used for word processing, database organization, accounting, and design.

The kind of printer you select to output your information is determined by your needs and the software program you choose. Some programs require laser printers or plotters for design work. If you plan to use the computer to print invoices, mailing labels, or information for in-house use only, a simple dot matrix printer could be suitable. For business correspondence, a letter-quality impact printer could be

used; these look like typewriters without a keyboard.

Some printers have a choice of print quality, ranging from dot matrix to letter quality. All levels of quality are determined by the resolution, or readability, of the printed characters.

Maintenance contracts are available for computers and printers. In addition to covering the cost of repairs, the contracts can provide for periodic checkups and in some cases, loaner equipment, should your system fail.

Determining Your Needs

Before selecting a computer system, determine what you want to do with it. Do you want to draw your designs, list your inventory, maintain financial and customer records, publish newsletters, prepare and layout advertising, or write proposals? Your use will determine how powerful a computer, and software programs you'll need.

As a retailer, Scott Haebich of The Stained Glass Place, uses a computer to track his store's inventory on a database. The database contains the name of major suppliers, the wholesale/retail prices of items they sell, Scott's profit margin on each item, the store's actual inventory at any one time, and its purchases. "The computer can tell us how much we've sold in a given year," says Scott. With a listing of 400 colors of glass, the database helps Scott determine the latest color trends.

A word processing system that is as artistic in its element as you are in glass can be an important marketing tool. It can create a first class artistic presentation, putting you and your work in a higher profile than your competition. John Emery, of Preston Studios, uses his computer to write and design newsletters he sends to clients and potential clients.

Studio artist Merridy Pohlman designs original panels on

a Computer Aided Design & Drafting (CADD) program. CADDs draw designs on the computer screen based on their full size. This is an advantage over a conventional computer drawing program in which you are drawing a picture on a prescribed size of paper, instead of designing the artwork according to specific measurements. CADD designs can be scaled down for presentation to the client or printed in full size on special printers called plotters. If you decide to use a CADD program, you don't necessarily have to purchase a plotter. Plotters can be very expensive. Computer information service companies and local printers who produce blueprints can print the design from the information on your disk.

Vicki Payne uses a Fast Pak mail system database program for mailing lists. The system can sort names and addresses by zip code and provide memo lines for information about clients, such as when you last spoke with them, what they ordered, when they ordered it, etc. The program can keep records on 25,000 customers, but it can be just as helpful if you have only 100 clients.

Up to date and accurate records are a must for any successful business. There are accounting systems as simple as checkbook writing programs to sophisticated systems that retrieve financial, inventory, and vendor information.

Once you've determined the ways you intend to use the computer, choose the software you plan to use. Computer consultants recommend you choose your software before you choose your computer. The software will dictate the type of computer system that would be best for you and how much money you should expect to spend. Computer hardware and software can be as simple or as sophisticated as you demand. When selecting your software packages, keep an eye to the future and buy a package that can grow with your company. Software programs come with step by step instruc-

Computer Considerations

Consider the following when purchasing a computer system:

1. What do I want to do?
2. How can a computer help me and my business?
3. Which specific software programs will enable me to do it?
4. How much money can I expect to spend?
5. Where would be the best place to buy the computer?
6. What kind of advice or help do I need?
7. What kind of system should I buy?
8. How can the system be expanded for growth?

tions; many with on-screen tutorials. The prices for software purchased from a reputable mail-order software company will likely be less than if you purchase software at a computer store. On the other hand, a local computer vendor can provide instruction, guidance, and consultation that mail order vendors cannot. This kind of help is very important to new computer users.

Basic accounting, database, and word processing programs are suitable business programs for glass artists and retailers. In these basic program groups, the choices are many.

Learn as much as you can from other glass artists, computer magazines, software, and hardware manufacturers, and user groups to help you determine the best type of computer and software for your specific needs. Local computer stores can help you locate a user group. User groups are informal "clublike" organizations of computer users sharing certain computer oriented interests, such as a type of software program or particular area of concern, like desktop publishing. Trade shows and wholesale craft shows have had computer demonstrations and workshops. Glass magazines carry ads for software programs. As more and more glass businesses and artists turn to computer use, the quality

and quantity of glass related software will increase.

Computers are no longer an option to many businesses; they have become a necessary tool. Computers help businesses stay competitive. At their best, they give small businesses the power and capabilities of much larger operations.

Where To Buy a Computer

The availability of computers is so widespread that they can be purchased through a variety of sources including independent dealers, chain stores, warehouse outlets, and mail order. Almost every community now has access to a computer retailer.

Know what you want before you enter a computer store. Salespeople in independent and chain store computer shops are likely to be more familiar with the products they sell than with understanding your specific needs. The products they sell might be higher in price than those purchased at a warehouse outlet or through the mail, but the dealers often provide more personalized attention.

Warehouse shopping has become more and more popular in recent years. Once relegated to selling tires, food, and pet food, warehouse outlets are now selling many different products, including computers and software. If ever there was a no-frills shopping experience, warehouse shopping is it. You can probably get a computer at a warehouse for less than through other sources, but here, more than any where else, you must know exactly what you want. If you've ever shopped at a warehouse, you know that the help is more likely to be hired to stock shelves than to be computer literate.

Purchasing a computer and software through a mail order catalog is another option. While some mail order companies offer technical support, repairs, and a 30-day refund policy, be aware of possible scams in which the company

accepts orders, demands a deposit, takes your credit card number and closes up shop. If you purchase a computer through the mail, look for a reputable company that has been around for a while. Many computer magazines rate mail order companies every year, based on customer satisfaction, delivery of goods, price, and service.

Choose one that bills you after your merchandise is shipped, or better yet accepts C.O.D. payments.

To help keep the purchase price down, you can consider buying a used computer. However, used computers are not state of the art. They are likely on the secondary market because they are obsolete by current standards. Also, it can cost several hundred dollars to have a computer repaired. Unless a used computer comes with a good warranty, be cautious about buying one.

Care and Maintenance

Computers are delicate pieces of equipment and subject to damage. The high repair costs of computers make maintaining them and keeping them clean essential. Dust, cigarette smoke, and liquids can damage keyboards. Cover the unit when it's not in use and vacuum the keyboard occasionally. Special computer care kits are available through dealers. Avoid drinking any beverage near the computer.

Dramatic changes in electrical current, such when electricity is lost and then resumed during a storm, can damage components and erase information stored on a computer's hard disk. A surge protector, a device that looks like a multi-plug outlet, installed between your computer and your wall outlet, will reduce the power surge. However, surge protectors do not protect against direct lightning. It is more prudent to unplug your computer during electrical storms.

Static electricity, common in less humid environments,

especially during the winter, can also damage disks and sensitive components. Static mats and bars offer inexpensive protection.

Magnets can be deadly to computers. Telephones, and even some screwdrivers, have magnets that can cause damage. Avoid putting small magnets anywhere near your computer.

Computers function best in a cool environment. If the environment is not air conditioned, use a fan near the computer. Keep the area around the computer clear so the air can circulate.

Make back-up copies on floppy disks of the data stored in the computer. This will ensure that you have a copy of all your information if your computer is damaged and out of service, or if the information in the computer was lost as a result of a mechanical or electrical problem. ❖

7

The First Step: Putting Your Business On Paper

"Success is a journey; not a destination."
—*Gardiner G. Greene, author of* How To Start and
Manage Your Own Business.

O wning and managing a business can be one of the most exciting ventures in life. You're in the driver's seat. You determine where you want to go and the route you will take. It can be a thrilling and rewarding experience.

As you begin your business venture, professional advice will help you decide the type of business entity and the record keeping and accounting systems that are best suited for your particular needs. A certified public accountant and a tax attorney familiar with small business operations, as well as a counselor from the Small Business Administration, can be of tremendous help. Ask other craftspeople, artists, small businesses, or your local chamber of commerce to recommend an accountant and attorney knowledgeable about small businesses.

The SBA has advisory services, training, educational, and financial programs available for new businesses. Through

their Small Business Development Center, the SBA has established programs with colleges and universities throughout the country that provide counseling assistance to new business owners or persons considering opening a business. Check your telephone book for the SBA office nearest to you or contact them at 1-800-U-ASK-SBA in Washington, DC. Ask the SBA to send you their general information kit and information on counseling. Their information booklets are designed for new businesses and written in an easy-to-understand manner.

BUSINESS ENTITIES

One of the first decisions you will have to make when you decide to start your own business, whether you sell wholesale or retail, whether it's home-based, in a studio, or as a retail outlet, is the legal form your business will take. Will you choose a sole proprietorship, partnership, corporation, or S- corporation? Each has benefits as well as liabilities.

SOLE PROPRIETORSHIP

This is the simplest form of business organization. There is no separate legal or tax identity between you and the business. No separate tax returns are required. Taxes are computed on tax form Schedule C 1040. (See figure 1) and submitted as part of your individual tax return. All income from the business is taxed as personal income and reported on your personal income tax return. You can deduct the business' expenses but you are taxed on its profits. With a sole proprietorship, you own the business.

An advantage to being a sole proprietor is that you are taxed only once. As a corporation, the business would be taxed on its profits, and you would be taxed again on the moneys you take out of the business as income. You can

123

choose a sole proprietorship whether you operate the business under your own name or under an assumed or trade name.

Sole proprietorship as a business entity might sound simple, but it comes with a great deal of risk. Under a sole proprietorship, because you and the business have the same legal and tax identity, you are personally responsible for all the business' liabilities. If your business can not satisfy its debt obligations, the creditors can legally come after your personal assets. If a lawsuit has been won against your business, the value of your personal assets could be used to satisfy the financial award. The business' liabilities are your personal liabilities. Sole proprietorship puts your personal assets at risk for all liabilities incurred as a result of the business.

Because there is no legal separation between your business and yourself, your personal assets and liabilities could be considered if you apply for a business loan. The amount of the loan could not, under these circumstances, exceed your personal worth.

On the other hand, as a sole proprietor, you can operate the business any way you wish according to local, state, and federal regulations without answering to shareholders or partners.

PARTNERSHIP

A partnership is an association of two or more persons in the same business. Partners may be related by marriage or blood or unrelated. Each partner contributes money or skill, and each shares in the profits and losses of the business. Depending upon how the partnership agreement is written, each partner can bind the company contractually and make day to day decisions affecting the business. Each partner pays

taxes based on his share of the profit, or loss, of the business.

The greatest risk of partnerships is that each partner is liable not only for his decisions and percentage of the business, but also for losses and liabilities incurred by any of the other partners. Carefully consider your choice of a business partner. If your partner is chosen for reasons of friendship rather than business strengths, the venture could be rife with problems. Look for a partner whose strength offsets your weakness in a particular area. You might have great artistic skills; but lack marketing knowledge and salesmanship. One partner may have great communicative skills; the other, organizational talents, and so on. A business succeeds when each partners' strengths are complemented by the other. Personalities, egos, methods of doing business, and failure to acknowledge limitations can, and will, create problems. Look for a partner who shares your goals for the company. Clearly define each partner's responsibilities in running the business and his, or her, role in making decisions. After you have carefully thought out the terms of the partnership agreement, seek the advice of an attorney to ensure that the interests of each partner are addressed on paper.

The advantages of partnerships are economical and practical. With two or more people listed as partners, more capital is likely to be available. Credit could be easier to obtain and the operation of the business could be more efficient because of the greater pool of talent, labor, and resources. A partner also offers his, or her input, imagination, energy, and support for projects, ideas, and plans that keep the business vital.

LIMITED PARTNERSHIPS

A person who wants to invest in a company and share in its profits, but not be responsible or have control over its operation can become a limited partner. He, or she, would be taxed

Noel and Janene Hilliard:
Lamps by Hilliard

Sometimes the obvious is not easily recognized. Noel and Janene Hilliard always enjoyed making lamps but neither pursued the interest in college. Noel studied sculpture and painting; Janene majored in painting. While traveling around the country investigating graduate schools, they frequently found themselves at garage and estate sales looking for lamp bases for the shades they were making. "We loved making lamps so we gave up the idea of going to graduate school and decided to make lamps our art," says Noel.

"We had a simple existence in the beginning. We would find someone who wanted a lamp. We designed it, sold it, paid our bills, and repeated the process. It was a hands-to-mouth existence." That was in 1975. Four years later, Noel and Janene realized lampmaking was going to be their livelihood. From their studio in northern California, they began marketing their lamps on consignment through a San Francisco gallery. By the early 1980s they were showing lamps in interior design showrooms, first in San Francisco and then throughout the country, and at American Craft Enterprises (A.C.E.) shows.

The design showrooms were a major turning point for the Hilliards. "When a decorator placed an order for a sample lamp we had at the showroom, we received a 50 percent deposit," says Noel. "Earning a living from our art became much easier for us financially."

Their lamps sell best when people can see them in person. "The lamps have a life, a character. They create an ambiance that can be realized only in person," says Noel. The Hilliards' primary selling outlets are the design showrooms in major metropolitan areas.

Noel and Janene have distinctively different approaches to lamp-making and design. Janene is more artistic than Noel in her design. She'll create a lamp from an image in her mind without consideration of how difficult the lamp could be to pack and ship. Noel is more pragmatic and technical. He works from a drawing, and designs and builds jigs and equipment to facilitate the lamp's fabrication. He makes his own bases and manipulates the glass with hot glass techniques which puts his lamps in a special niche of craft. Janene's lamps are usually one-of-a-kind and sold through retail shows or galleries.

Noel's designs are marketed through the interior design show-rooms. Their styles can be more easily replicated than Janene's. As a result of Noel's and Janene's different approach to lampmaking, Lamps by Hilliard offers one-of-a-kind, commissioned and stylized series of lamps, though every time a series lamp is built it varies from all the others in the series.

Noel and Janene no longer make lamps on consignment. Today their lamps which sell for several thousand dollars are made on order. They have several full and part-time employees, including a manager who oversees the day to day management while Noel devotes more time to designing lamps. His and Janene's passion for lampmaking that began two decades ago continues.

"It's exciting for us to sell our lamps." says Noel. "In art school we were told to pursue our art for the love of it and not to expect to make a profit from it. We feel successful to be selling what we love."

on their share of the profits. Because of the person's limited control over the company, the law limits his, or her, liability to the amount of money invested. A limited partnership could be appropriate if credit is expensive or difficult to get. While a limited partner is entitled to receive a share of the profits, if the company does not show a profit, the limited partner receives nothing. A creditor, however, would still have to be paid. To form a limited partnership, you must file a limited partnership certificate with your appropriate state office.

CORPORATIONS

A corporation is a tax and legal entity separate from its owners (shareholders). It provides its shareholders with almost complete protection from personal liability; they can lose only their investment. Yet it allows them control over the operation of the corporation through voting privileges. The mechanisms under which a corporation functions vary significantly from a sole proprietorship or partnership. While a corporation protects an investor from personal liability and restricts his loss only to the amount of money he invested, a corporation may not be dissolved as easily as a partnership or sole proprietorship. Tax laws and allowable deductions are different for corporations. Shareholders also elect a board of directors and create rules stipulating how the board may operate. In a small corporation, the board of directors may likely be the major shareholders. The rules by which the board operates are known as articles of incorporation and must be filed with the state. A major disadvantage to incorporating is the double tax burden placed on shareholders. They are taxed twice on the corporation's profits—once when they are paid out as dividends, and once when paid out as the owners' income. Incorporating is not difficult,

but it does require the assistance of an attorney. There are formalities required by the state that must be adhered to and fees that must be paid to incorporate.

SUBCHAPTER S CORPORATION

This entity provides the same protection from liability offered by corporations while enabling the owners to avoid double taxation. Profits are taxed only once, as personal income of the shareholders. An S-corporation is limited to 35 people.

Before you choose a business entity, discuss your particular situation with your accountant and tax attorney. Once you have chosen the type of entity your business will be, your accountant will be able to set up an accounting system suited to your particular type of business.

CHOOSING A BUSINESS NAME

As a businessperson, you have the option of operating your business under your own name or a fictitious one. Operating a business under your own name is the easiest way to do business. No separate federal income tax returns are required. Items of income and expenses are reported on Schedule C of your 1040. Frequently, operating under your own name does not warrant any additional formalities. It is the simplest and most direct way to start out in business. If you choose to operate your business under a name other than your own, a fictitious name, you would be required to file a form of certificate with the state in which you are operating the business.

The legal and tax ramifications of using a fictitious or trade name for your business are the same as if you were to use your own name in operating your business. Unless the business is a separate legal or tax entity, a corporation, you

are responsible for its liabilities and taxes on income earned.

If you choose to use a fictitious or trade name, individual states require that you request the name through them to ensure that no other business in your venue is using that name. Ask your accountant or attorney to assist you with filing the name or contact your state's corporation bureau, commerce department, or labor and industry department to find out the appropriate agency for filing your request in your particular state.

Many states also require that you file a form of certificate disclosing the legal name of the owner of the business as well as the trade name.

Choosing whether to do business under one's own name or a fictitious one is a personal preference. You are the best person to decide whether it is beneficial to use a trade name or your own name for your business. As an artist, you might feel it is important to build your reputation, in which case using your own name might be preferable. Yet, if your business venture includes running a large operation, employing several employees, conducting classes and selling supplies, you might find that having a trade name makes your business appear more substantial and more easily identifiable to your customers. When deciding upon a name, consider whether the business name is directly related to the type of business it is. Does the name "Glass World" identify what you do or could it be construed as selling auto glass, plate glass, or window products? Compare the benefits with the restrictions of giving your business a name that identifies its location. Calling your company "Center Valley Stained Glass" tells the customer where it's located, but does it limit you to that geographic area? Will that name sound logical if you open another store in a different community? An exotic name might sound fascinating, but will the public identify it

with your work? Consider where you'd like your business to be in five years in terms of profit, growth, and locale. Choose a name that is applicable to your goals and one you can live with and your customer can remember for a long time.

SALES TAX CERTIFICATES

Whether you use your own name or a fictitious name to operate your business, if your state has a sales tax, you will be required to file for a sales tax license. This can be done through your state's department of revenue. Periodically throughout the year, you will be required to file a sales tax return to your state, whether you have collected any sales tax during that period or not. The state will send you forms on which to report your sales.

SALES TAX EXEMPTION CERTIFICATE

Be sure to apply to your state for a sales and use tax exemption certificate. This enables you to buy, tax-free, products that you use in making your art glass, such as glass, solder, copper foil, lead, and other products which become part of the finished objects that are sold and subject to a sales tax.

The products you use in making the finished piece can be bought by you tax free. The retailer who ultimately sells the finished piece, whether it is you, a gallery, gift store, or other business, would be responsible for collecting the required state sales tax from the buyer and then paying the tax to the state.

Give a photocopy of this certificate to any supplier with whom you do business, glass related or not. You won't be charged a sales tax. Many suppliers will request a copy of the certificate to validate to the state revenue department their reasons for not charging you sales tax. Until you become an established account, you may have to remind your supplier

131

of your tax exempt status every time you order a product that will be used in an object that will be sold. A tax exempt certificate is one of the requirements of opening an account with glass and tool suppliers and wholesalers, and applying for credit with them. You cannot do business with them without it.

EMPLOYER IDENTIFICATION NUMBER

As a businessperson, you are required to have an Employer Identification Number (EIN) which you can obtain from the IRS by completing Form SS-4. Use this number to identify your business account and related tax returns and documents. An EIN is required if you are a sole proprietor, partnership, corporation, or S-corporation, whether or not you have any employees. Use the EIN number on all Federal tax forms that require it, and refer to the number on all tax payments and tax-related correspondence and documents. You can get Form SS-4 from your local IRS office or by calling the IRS at 1-800-829-3676.❖

8

A Business Plan

"Unless you know how to get where you're going, you will
end up somewhere else."
—*U.S. Small Business Administration,* Focus on the Facts:
Planning ... The Most Important Ingredient.

As the owner of a new or growing business, you determine the objectives and purposes of that business. Most successful firms are driven by a clear sense of mission and purpose, according to Thomas J. Peters and Robert H. Waterman, Jr. in their best selling book In Search of Excellence. Think of the major companies of the world. Most of them likely focus on a few products, a clearly defined target audience and a well identified mission.

Is the dominating purpose of your company to sell your art, repair and make lamps, restore windows, or to be a retailer to glass artists and hobbyists? As an artist you are in competition with not only other glass artists, but craftspeople and artists in every media. If you install windows, you are competing for moneys the homeowner might spend on home improvements, such as a remodeled kitchen or deck. As a supplier, you are competing with hobby shops not only in your geographic area, but thanks to faxes, 800 numbers, and catalogs, with every hobby supplier throughout the world.

133

If you choose to be an artist and a supplier, you have two distinct markets.

Planning the path your business will follow enables you to determine your future.

BUSINESS PLAN

A business plan is one of the most basic, yet important, elements in business whether you plan to work as an individual or have several employees, whether you work alone in a studio, or manage a multi-faceted operation. It is a blueprint for the building of your business. It allows you to structure the complexities of the business world with a clear sense of purpose. If you plan to seek financing, lenders will want to see your business plan.

A business plan is a written document that defines the goals of your business and outlines methods to achieve those goals. It answers the questions of who, what, where, when, how, and why. It describes what a business does, how it will be done, who has to do it, where it will be done, why it's being done, and when it has to be completed. It is the management and financial blueprint for your business.

Your business plan should address sales volume, profit, and inventory. It should include information about the kind of glass products you produce, their market, start-up costs, equipment costs, working capital, your experience, the financial estimate of your resources, cash flow projection for at least three years, and your collateral to back the enterprise.

If yours is a new business, talk to other artists or retailers who have been in business. They will give you information and insights about potential markets, expenses and break-even points that lenders and financial institutions will consider in determining whether to lend you money or not. You have to establish all your expenses as best you can. You have

to establish a basis for profit. An accurate business plan can make or break your loan application. The figures you use on your business plan must reflect actual sales and expenses. If yours is a new business, the information will be based on your tax returns. Define your goal. Study the market. Rewrite your plan and redefine your goals until they're reasonable.

BUSINESS PLAN CHECKLIST

Include the following elements into your business plan.

Overview

The overview should concisely describe the key elements of your business plan.

Summary

If you are seeking financing, the summary should convince the investor or lender that the plan is worthwhile. Briefly cover the following in the summary:

- Name, location, and legal structure (e.g. sole proprietorship) of your business.
- What type of business am I in? The statement is not as silly as it may sound, especially if you're an artist who runs a retail outlet, sells your work through crafts shows and galleries, exhibits in museum and corporate exhibitions, and gives seminars. The better you can accurately describe your business, the easier it will be for potential investors, banks, or otherwise, to evaluate your proposals.
- Its products, markets, and competition. Does your business satisfy an existing need? Can you develop a niche for your particular services or abilities?
- Background and expertise of the management. Why are you the best person to run the business?
- Amount and use of financial assistance required. Why do you want the money? Every business needs

Peter McGrain

Peter McGrain is proof positive that you can turn a hobby into a successful stained glass career. The one-time hobbyist is today a shining star the glass art movement.

Peter cut his first piece of stained glass in 1980 while employed as an engineer with the United States Forest Service in Colorado. To help pass the time in the winter when he wasn't working or skiing, Peter began making small panels that sold in local stores for about $20 each. After three years he was earning more money making commissioned panels for homes and restaurants than he was working for the Forest Service. During a subsequent visit to his hometown of Rochester, New York, Peter found studio space and decided to spend a few years doing production work before moving onto a community more attuned to glass. He's been in Rochester since 1984 and has become known for his experimental work.

"Ever since I started working with glass, the challenge has been to break traditional bounds while using established methods such as selective cutting, sandblasting, plating, and painting." His show work, he says, is chock full of experimental applications of these techniques.

His work has been published in *Glass Art*, *Professional Stained Glass*, *Stained Glass Quarterly*, and *American Craft* magazines. He's had panels exhibited at the Corning Museum of Glass and is sought out by other museums. Among his public commissions are stained glass panels

for Syracuse University, Seneca Park Zoo in Rochester, University of Wisconsin, NY State Forestry School, and the Rochester International Airport's main terminal building.

The strategy Peter used in the beginning of his career to break into the realm of architectural work was to essentially "give away" a few large installations for specially selected, highly-visible public settings. One project, for which he would now charge $75,000 was accomplished a few years back with a very limited budget of $3,000. This approach enabled him to quickly become recognized as a creative artist capable of tackling the large-scale commissions.

He's learned everything he knows about glass from observation and trial and error. Peter admits that he is a sponge. "Nothing is original, everything I do comes from someplace else." One of those places is nature. With a degree in forestry and an interest in the environment, Peter puts a great deal of naturalism into his work, be it in the characteristics of specific trees for a landscape panel, or in the flow and progression of a non-representational composition. "I studied environmental design and engineering and have experience in drafting, layout, and technical drawing, all of which comes in handy when I work with architects. I understand physics and blueprints.

"Many people started the way I did, with no idea about the art market. Unfortunately, many people have been pushing inferior work on an uneducated public, though it seems to be changing now," he says. Peter sees a responsibility of the glass artist to educate architects and the buying public. He resents the secretive attitude sometimes found among glass artists regarding method and technique. He enjoys teaching at workshops, seminars, and lectures where he can connect with people who started as hobbyists. "I like sharing my approach with others because I think it'll improve the overall quality of the glasswork that out's there." He believes that stained glass belongs in the realm of fine art.

The competition is tough, says Peter. for the commercial glass market. He attributes his success to good design coupled with fine craftsmanship. "The design is critical to good work," he says, "but it's only as good as the craftsmanship."

money, but lending institutions need to know your specific needs for the financial support you're seeking. Pinpoint and describe how and where you will use the money.

- Business goals. What the business plans to achieve over a set period of time.

Sales and Marketing

- Who is my market?
- Where is it?
- Is it a growth or static market?
- Is my product or service needed?
- Why will consumers buy from me?
- What does my product or service do for my customer?
- What doesn't it do that it might do later?
- What is unique about my product or service?
- What percentage of the market will I shoot for in the first year, second, and third years? These answers will come from researching information from trade associations, gallery owners, show organizers, other artists, and retailers. The information must be based on fact to be viable.
- What is my marketing strategy; my pricing policy?
- How will you get the product to the customer? As an artist, will you work through galleries, architects, designers, craft shows, art agents or will you sell directly from your studio or a combination of markets? As a retailer, how will you promote and advertise your product?
- What sales volumes do I expect to reach in the first year, second year, and third year, in units and in dollars?
- Who are your competitors? Determine the strengths

and weaknesses of your competition. Learn why they're doing well or poorly.

- Do they give excellent service?
- Do they make a quality product?
- Do they have a good marketing strategy?
- Are they aware of the latest trends? You can get information about your competition from news-papers (if they are frequently in the news via press releases), trade magazines (if their work featured), from their customers (if they are retailers, ask their customers what they like about doing business with that store or individual), at exhibitions (ask the cura-tor what he liked about the artist's work to have chosen him), at craft shows (listen for customer comments, look at the artist's portfolio, his listings of exhibitions, awards, etc.).
- What are my advantages over the competition? Are my products better made and/or more attractively priced? Can I provide better service?

Production

- What equipment is needed to make my product, or provide my service?
- How much will it cost to buy or lease equipment and where will I get it?
- What materials will I need, where will I get them, and how much will they cost?
- Will I need to hire staff? If you need to hire em-ployees to make your product or provide your ser-vice, list the skills needed, the number of persons you will require, their salaries and availability (part time, full time, occasionally). List your time as well in computing production costs.

- How much space will I need? If you are working in hot glass, consider 2,000 sq. ft. as the minimum space in which to work. You will need an area for the furnace, as well as space for finishing. If you're working alone in cold glass, you can begin in a small space and increase it as your business expands.
- Where will I have to locate the business? As a retailer, Rainbow Stained Glass, of Andalusia, PA, functions in a crowded 800 sq. ft. storefront on a main thoroughfare a half-mile from Interstate 95. Warner-Crivillaro, a wholesaler/retailer in Bethlehem, PA, has a two-story building with several thousand square feet in an undeveloped area a few miles from major roads and near a regional airport.

Include space for parking facilities, as well as storage space for raw materials, and for finished products. Keep in mind how the cost of renting or owning that space will affect your profit.

- Are there any local ordinances I must comply with?
- List overhead costs of items such as tools, supplies, utilities, payroll taxes, holidays, and vacations, employee benefits, shipping, and advertising.

Financial Management

This is the most critical part of your business plan. A rational, reasonable, well thought out financial schedule will guide your company's growth. List your accountant's, lawyer's, and banker's name and address.

Incorporate in your business plan start-up capital (money you will need to open the door), and working capital (money you will need to finance the operation until it shows a profit).

Start-Up Capital includes moneys you will have spent for

attorney fees, whether for consultation or to incorporate, and for your accountant to set up your books. Start-up money is what you use to purchase inventory, including tools, to buy or lease machines, to advertise, to buy office supplies, to pay a month's rent in advance if you are leasing property, to install telephone lines, to open a checking account, to buy insurance coverage.

According to several studio owners and retailers, starting up or expanding your business will likely cost you more than you anticipate. Allow yourself at least 25 percent more money than you budgeted for start-up costs.

Working Capital is money you will need to pay for all your business expenditures including: suppliers, creditors, utilities, rent, salaries, and taxes and still maintain a bank balance. It is the day-to-day, week-to-week, and month-to-month money that supports the running of your business.

FINANCIAL STATEMENTS

Once you've decided how much money you need to start up or expand your operation, and how that amount compares with the projected profit, you will be able to determine the viability of your plan. It's not unusual for glass related businesses, or any business, to operate at a loss for up to three years. Any longer than that could cause a severe hardship and could raise questions by the IRS whether you are a viable business or just a hobbyist.

If you're a retailer, it is unsound business practice to plan to stay in business longer than a year without making a profit. Your plan must be geared to turning a profit as soon as possible. Plan to have enough cash to carry your business until you turn a profit or draw a salary.

If you need to borrow money, the lender will expect you to show how the borrowed money will be spent, as well as

your business' ability to generate enough money for you to repay the loan. To determine if your plan is feasible, complete a projected statement of sales and expenses for one year.

Cash flow

Expectations of future sales might sound hopeful, but expectations won't pay the bills; cash must flow into your business at certain times and with a regularity to meet expenses. If you make plates and project that 50 plates MUST be sold each month to a specific market, the question is whether that many CAN be sold. Can that market absorb 50 plates? Why would the retailer purchase from you? What is your competition? If your work is commissioned, how will you provide for a cash flow between commissions? Will the proceeds from the commission pay for all your expenses between assignments? If you plan to sell window panels to the home building market, are enough homes being built in the price range suitable to support the inclusion of your work?

Investigate the market carefully and hire an accountant to work out financial projections. Money spent for professional help is money well spent.

A cash flow forecast will help you determine whether your projected sales and expense figures are realistic.

If you are expanding your operation, the bank will want to see a balance sheet. The balance sheet shows the financial condition of your business as of a certain date. It shows what the business has (assets) and what it owes (liabilities) at a glance.

The Working Business Plan

After you have developed your business plan, but before you spend much money opening your business, consider doing what several glass artists do; they test market their products

142

on a small scale to see if they will sell.

Peggy Karr did that when she attended her first wholesale show. She showed a number of retailers samples of fused plates she made before she invested money in space, inventory, and employees. Peggy accepted orders only for the number of plates she knew she could make without hiring someone to help her. With low overhead, Peggy built her business by putting the profits of the first few years back into the business.

Preston Studios in Florida tested the interior design market by displaying their nature panels at the Atlanta Merchandise Mart. Only after the panels were in demand, did Jerry Preston and John Emery produce more for other markets. Within four years they were creating panels for Florida's major developers.

Take a few samples of your work to retail stores in the demographic market areas you want to reach. Ask the store owners or managers if they will accept your work on consignment. This gives you a retail outlet from which to test the market viability of your product without spending much money on start-up costs.

Maintain a record of all the expenses you incur in test-marketing your products. As a legitimate part of your start-up (or expansion) costs, they are tax deductible.

Test-marketing, also known as a working business plan, is an effective strategy to get financing. You have essentially put to practice what you wanted your business to do. You have shown the lender that your business can do what you say it can.

FINDING HELP

Your local chamber of commerce can help you draw up a business plan. Also, contact local colleges and business

schools for help. Don't overlook the Small Business Administration (SBA) and SCORE (Service Corps of Retired Executives).

The SBA is funded by the federal government; it provides free start-up kits and counseling for new and existing small businesses. Located in major cities, the SBA sponsors workshops and seminars. For the SBA office nearest you, look in the telephone book under US. Government Offices, Small Business Administration, or call the SBA at 1-800-UASKSBA

SCORE is an organization of volunteer business executives associated with the SBA who can walk you through local requirements, help you write a business plan, and give advice at various stages in your business' development. Their consulting services are free.❖

9

Financing Your Business /Buying A Business

"The most important measure of the firm's value is its earning power. The true earning power of the enterprise, in your eyes, is the profit it can generate under your ownership—not the profit under ideal conditions, because you'll seldom experience ideal conditions."
—*Albert Lowry*, How To Become Financially Successful by Owning Your Own Business.

Because the earning power of an operating business is measurable, many successful stained glass retailers have chosen to buy an existing stained glass supply store rather than starting from scratch. Scott Haebich, owner of The Stained Glass Place in Grand Rapids, Michigan, encourages anyone who is serious about getting into the business to work in a store first. "You learn the day-to-day operation. You see the cash flow, the financial records; you know the customer base," says Scott. Tony Glander, owner of Glass Fantasies in Gaithersburg, Maryland, worked as an employee for three years in the store he eventually bought. He echoes Scott's observations. "You see the marketing strategies. You learn what works and what doesn't, and how your business strategies might apply," says Tony.

Ask the right questions, seek the right answers, and buying a business rather than starting from scratch could be the right choice. There are advantages to buying a business:

- The cost of buying an existing business might be less than starting one from scratch.
- You bypass start up problems.
- You save time buying equipment and finding suppliers.
- You purchase an existing customer base.
- Guesswork is minimized regarding location, advertising, space, and price.
- The owner can give you information about the community, competition, and seasonal fluctuations.
- You get a list of suppliers and service people.
- You may have access to trained employees.

If you are considering buying an existing stained glass retail store, begin by looking at the business' lease. Some leases might not be transferable to a new owner. Others might allow a transfer but at a cost to you, the new owner. Find out how long the lease is in effect, its terms for renewal, the lessor's and lessee's responsibility for the upkeep of the interior and exterior of the building, and how happy the seller has been with the lease and the property owner or manager. Review the lease point by point with the seller and with your attorney.

Once you have determined the property can be leased by you, review all other contract documents especially: insurance coverage, accounts receivable, employment contracts, and existing loans to determine if they are transferable to the buyer. These should be reviewed before signing a purchase contract. Once you have studied them and are satisfied with their provisions, learn as much as you can about the company.

146

What Should You Look for in an Existing Business?

Begin by noting the reputation of the business. This can be more important than the length of time the business has been in operation. Satisfied customers make a business successful. Was the reputation built on the type of service and managerial methods you will be implementing? If the business you are purchasing did commissioned work as well as operate as a retail store, will your artistic style and technique be on the same level as that of the previous owner? What percentage of the business' profit was generated from commission work? Consider what effect your attitudes and methods will have upon the customer base and the store's or studio's reputation. If your business style varies greatly from the style that has made the store successful, consider whether you can work within that style, and how you will make changes without alienating the satisfied customers.

Consider the store's location; is it appropriate and convenient for the customers you want to attract? Is it located in an area that has had an economic decline or a growth? What are the business and population trends? List everything that's good and bad about the location, using your own knowledge about the trading area, information from business organizations such as the chamber of commerce, local and county governments and statistics from the Census Bureau.

Ask the employees whether they will be staying or leaving with the changing of ownership. Learn as much as you can about their abilities and their role in the business. Use their knowledge of the business to help you determine the value of the business and your chances for success.

What questions should you ask the seller?

Ask him why he's selling? There are as many reasons for selling as there are sellers. A for-sale sign does not mean the

Paul Marioni

Passion drives Paul Marioni. You see it in his surrealistic, figurative art. You know it from his ability to work in many different glass techniques— cast, blown, stained, fused, sandblasted, in the size of his work—large and small pieces and in their placement—public and private sites, architectural, and residential commissions.

With an insatiable desire to learn, strong curiosity and personal drive, the philosophy and English literature graduate and former blue collar worker began his artistic career in the late 1960s. "My two brothers were artists and I saw they were the only people in society who were tolerated for their eccentricity," says Paul.

While working at filmmaking at the Art Institute in San Francisco, Paul met Judy Raphael who introduced him to glassmaking. In 1971, he had his first show at a time when galleries weren't showing glass. There was no market for glass, except in church windows. "One of my brothers got me an appointment with the director of John Bowles Gallery in San Francisco, who agreed to exhibit my work. Whether it was out of friendship for my brother or because he liked my work, I'll never know," says Paul. The show got great reviews. Critics played it up tremendously because it was different from anything they had ever seen. Galleries throughout the country began showing Paul's work. The American Craft Museum exhibited his pieces. Art collectors and public agencies wanted to own his work.

Paul uses various techniques, many of which he developed. He uses them only as a tool to achieve his vision. "A technique can become a nuisance. People come to identify an artist's work through a specific

technique. My reputation got based on my use of techniques when that wasn't what my work was about," says Paul. People say his work is eclectic, but he says it's regularly figurative and surrealistic. "About three to five percent of my work is strong political statements, but I find that those pieces burn a lasting image into the minds of many people who see all my work in that vein."

Today, although galleries show his work, Paul derives most of his income through private and public commissions. "I like public work. I like the idea that the art is owned by the public. I like to put art into a place where people don't expect to see art, like a police station, hospital, or elementary school," says Paul.

He collaborates with his wife Ann Troutner on many of the commissions. "When Ann and I approach a commission, it's always for the users of the building. If it's a grade school, we make something the kids will love."

Paul enjoys doing architecturals-cale work, most of which is cast glass. It enables him to see a big idea become reality.

Paul pioneered architectural cast glass the same time glass artist Howard Ben Tre did around 1978. "Howard and I were friends. Though we didn't work together, we shared a lot of our frustrations and developments. The Swedish and Czech influences had not yet arrived and so we had no basis from which to work."

Only a handful of people do large-scale cast glass but to a large percentage of glass afficianadoes, cast glass is as popular as, if not more popular than, blown glass, according to Paul.

Paul's marketing strategy is the same as it was when he began his career. From his studio in Seattle, he travels around the country, showing his slides to museum curators, architects, gallery directors, and fellow artists. "In the 1970s there were no glass magazines in which to show your work, as there are now, but personally showing my slides continues to work for me," says Paul. Self-taught Paul Marioni recommends students of glass take drawing as a foundation, And painting, sculpture. photography, dance, and everything else. "After all", says Paul "art is about the human spirit."

business is failing. As you study the financial records, you will learn how viable the business is and whether the asking price is a fair one.

Ask to see the store's mailing list to determine its customer base. Ask whether the mailing list and customer base remains with the business after the sale. If the seller is moving his business to another location, he may want to take his list of customers with him. You can include in the contract a Covenant Not To Compete clause in which the seller agrees not to operate a competing retail outlet within a designated geographic area for a specific number of years after the sale.

If the owner does studio commissioned work as part of the retail operation, ask whether unfinished commissioned work and the list of commission clients stays with the business or leaves with the seller. This decision may be left up to the customer. "Whatever is decided, put it in the contract," urges Tony Glander.

If the seller plans to continue working from his or her studio, the Covenant Not To Compete clause can specify that they can continue doing commissioned work, but cannot sell retail from their studio.

How do you determine if the asking price is a fair price?

The most important tangible data about a business are its financial records. A business' four main sources of financial data are: the financial statements, income tax returns, internal records, and external sources. Tony Glander, owner of Glass Fantasies in Gaithersburg, Maryland, recommends you carefully study the information before deciding to purchase a business.

Financial statements include a balance sheet and profit and loss (income) statement. Review financial statements

and income tax returns for at least the last five years. Have a CPA audit the statements.

A balance sheet lists a business' assets and liabilities showing the financial position of a company at a given time. It does not show how the business arrived at that financial position or where it's going. Use the balance sheet as a starting point to begin your financial review of the business and to generate questions about its assets and liabilities.

Assets include cash and marketable securities, accounts, receivable, inventory, property, equipment and furnishings, depreciable and intangible assets, prepaid and deferred items, accounts and notes (loans) receivable. Always include some allowance for bad debts.

Cash is the sum of the existing petty cash account and the amount in the business checking account. Securities should be stated in their market, not their purchase, value. Consider the value of the inventory as the lower of its cost or replacement value. Property, equipment, and furnishings could be difficult to value directly and their current market value may not accurately reflect their worth to the buyer. Value them on their income-producing capacity. For instance, special lighting used to enhance a finished stained glass object can add to the value of the business. It could have a positive impact on generating income.

Depreciation is an allowance made for income tax purpose and usually does not reflect the true aging process undergone by the asset.

Depreciation rates for furniture and equipment is 50 percent once they have been put in use, and perhaps zero percent after 10 years. However, if you were to sell them after 10 years, they might be worth 10 or 15 percent of the original price. Deduct the cost of replacing worn-out furniture and equipment from the asking price.

Find out the age and working state of the equipment; ask the machine's manufacturer whether it can be repaired or is obsolete and how much time can you expect to lose if it needs service. Determine whether you really need the equipment that's being sold. One seller had a blueprint machine which he used for printing specs and plans. It was convenient, but for the number of times he used the machine, it cost him more just to own and maintain the machine than to pay a printer to run off the plans.

Ask the owner to provide evidence of ownership. It's important to establish that the seller has clear title to all fixed assets such as land, buildings, equipment, furniture, automobiles, trucks, and vehicles connected to the business. Hire a title company or search the company's records in the county courthouse yourself for mechanics and tax liens, unpaid assessments, and remaining mortgages. Ask the seller to give you receipts for equipment and ownership titles of auto and trucks if evidence of title is lacking elsewhere.

The amount recorded for intangible assets such as goodwill, patents, and trademarks is very small. Check with local business people, local bankers, and the current employees to help you determine that the business does indeed have a store of goodwill behind it. This reflects back to the business' reputation.

Other assets included in the purchase of a business are prepaid or deferred items that will be valuable to the business in the future. For example: prepaid taxes, fuel bills, insurance, janitorial services, maintenance contracts on equipment, and advertising expenses. Examine each item to determine if you can make full use of the prepaid item. If, for example, the prepaid advertising shows a picture of the present owner, its value would have to be prorated.

Notes receivable are another asset; in a small business,

Contract Contents

Briefly, the sales or purchase contract should include the following:

- Date and parties to the contract.
- Full description and address of the location.
- Purchase price and a full accounting of what is being purchased.
- Terms of payment, including down payment and any amount amortized over a period of years, including its interest rate.
- The method of determining what adjustments to the final purchase price are to be made at the time of takeover. This is important because changes arise from the fact that in an ongoing business assets and liabilities can change from day to day. For example, the amount of inventory can increase or decrease.
- Whether the buyer is prepared to assume any liabilities, such as mortgages or leases.
- The seller should make expressed warranties on certain items, such as good and unencumbered title to all assets specified in the sale, financial statements, unspecified liability, contingent lawsuits, and the accuracy of all statements and material supplied to the buyer.
- The buyer's rights must be protected during the period between the signing and actual takeover. This is important since a fire or other major change could ruin the buyer financially.
- The seller assumes all risks of a loss through fire, theft, vandalism, etc. during the interim period. If the loss is sufficient to close down the business for a specified event, the buyer has the right to negate the contract.
- The seller must operate the business in the best interests of the buyer, maintaining accurate records and giving the buyer full access to the business premises and financial records during this time.
- Specify the time, date, and place of closing.
- Indemnify the buyer as a result of the seller's breach of warranty or contractual obligations. A portion of the purchase price could be put in escrow to protect the buyer against the possibility of a breach.
- Agreement must be signed and dated by both parties.

notes receivable should be negligible or non-existent. If they do exist, it could mean that the client has defaulted on a payment and signed a note. This is a bad sign. The longer a receivable remains unpaid, the less likely it will be paid. Place a small percentage on the value of notes that need to be collected.

Check the income stated with the totals for each month as recorded in the company's books. Seasonal peaks should be noted. Look carefully at the business' cash flow.

Liabilities are accounts payable, notes payable, taxes payable, mortgagees, or long-term notes. Accounts payable indicates how much money is owed by the business. Check invoices against signed shipping receipts to verify that the supplies have been received but not yet paid for.

If the current owner is far behind in payments to his suppliers, the suppliers might have applied a mechanics lien on the assets of the business. Be sure this is settled before you sign the contract. Notes payable are similar to accounts payable. Be sure all accounts and notes payable are settled before you sign the contract.

Long-term liability are mortgages or long-term loans. Review documentation that states the terms and conditions of any long-term liability. As the new owner, these liabilities will become yours.

Hidden liabilities are those that exist but are not documented on the balance sheet, such as inventory that's been ordered but not delivered and booked for paying.

An important class of hidden liability could be faulty merchandise that has been sold to customers and which will be returned. There could be potential legal problems and costs arising from the faulty completion of a past contract. The business' insurance coverage may not be sufficient to cover past claims against it. Discuss this in detail with your

154

insurance agent and attorney. A glass business may have some potential liability resulting from the faulty fabrication or installation of panels.

In addition to information on the balance sheet about assets and liabilities, look at the business' internal and external data to help you determine the company's viability. Internal data are purchase receipts, sales records, cash budgets, and cost control sheets. External data are information from suppliers, bankers, public tax records and credit rating report. Ask a banker to obtain a credit rating report on the prospective business for you.

At whatever time during a year a business is purchased, there will be an amount of accrued tax liability to federal, state, county, city, or other local authority. Evaluate every tax thoroughly, especially FICA and sales taxes to establish the responsibility for payment and to ensure that there are no unpaid tax liabilities current on which interest penalties must be paid.

What should be included in the sales contract?

A noncompetition clause is extremely important to put in the sales contract. This states that the seller agrees not to open a similar business within a specified geographic area and/or within a specific time period. If the seller does commissioned work from his, or her studio, the contract should stipulate that he, or she, won't be selling supplies from their studio.

If you purchase stock in the company rather than assets, you automatically assume past liability because of the legal continuity of the business. You can include a clause in the contract that indemnifies the buyer against contingent liabilities. Also, you can request that a portion of the purchase price be held in escrow against the possible contingent liabilities.

Include clauses to protect yourself against undisclosed liens, against the seller competing against you locally, or any changes that take place in the business between the time of the first agreement and the closing of the deal.

Another major element of the contract is your willingness to assume any business liabilities; study each liability carefully before agreeing to assume responsibility for it.

START-UP COSTS

"Start with a zero balance," says Tony Glander of Glass Fantasies. Work with your accountant to determine how much money you can allocate to purchase inventory and make changes in the store. If you intend to announce the new ownership or increase commission work, plan for advertising expenses.

As a new business you will be required to get an occupancy permit from the local municipality, a business license and resale tax number from the state, and an Employer Identification Number from the IRS. All of these incur a cost.

Allocate moneys for store and studio insurance to be paid to a private carrier for worker's compensation and withholding taxes to be paid to the state and federal governments.

Discuss the business with your accountant and attorney to determine whether you will be operating as a sole proprietorship, corporation, or partnership.

Keep start-up costs down by purchasing, or leasing, equipment from discount stores, through classified ads or from stores going out of business. Consider leasing equipment rather than purchasing it. Leasing may provide certain tax advantages.

Use the knowledge and expertise from the chamber of commerce, the SBA, your accountant, and attorney, the business departments at colleges, non-competing stained glass

retailers, the Art Glass Suppliers Association, and other glass-related organizations to help you assess the intricacies of the business.

FINANCING YOUR BUSINESS

"Money is the lifeblood of business."

A business needs money. Without it, the business ceases to exist. Running out of money is the most typical problem for new businesses. Often it's because the business is undercapitalized, has higher than planned costs, is a one-client operation, has bad debts, slow payers, uncontrolled rising costs, or is poorly managed. Your business needs money to survive.

Financing begins with your business plan. Once you have defined your goals, outlined methods to achieve those goals, and carefully projected your sales, profit, and expenses, you should have a fairly good idea of how much money you need. Once you've determined how much you need, spend time figuring out where you will get it, how you'll repay it, and how much you can afford to pay for it.

There are two kinds of money available to you for your business—yours and someone else's.

Your own money can include cash on hand and liquid assets such as marketable securities as well as money you can borrow against your good name or equity, such as mortgages, lines of credit, credit cards, and insurance policies.

Friends, relatives, banks, suppliers, and government-backed loan programs are sources for borrowed money. Other sources of someone else's money are fellowships and awards given to artists by foundations, councils, schools, and other art-related organizations. This type of money is not, as a rule, available for retail or supply businesses.

The Four Cs

When you ask people to invest their money into your business, be prepared to make a strong argument for your case. Along with presenting your business plan, substantiate your capital, capacity, collateral, and character. Investors expect it.

Capital is the amount of cash you have to invest in the business. It might come from your savings, silent investors, monetary gifts from relatives, equity loans, or any other source of money.

Capacity is your ability to repay. If you are expanding your existing business, show lenders a balance sheet and profit and loss statement for the past three years. One of those statements should be as recent as six months. If you are beginning a business, present a projected P&L and cash flow statement. Include on the forms an allocation for the interest of the proposed loan.

Collateral is a secondary form of repayment. This can include real estate, cash, fixed assets, equipment, inventory, and receivables as well as the cash surrender value of life insurance policies, the fair market value of marketable securities, and assigned savings accounts. Banks consider lending against a percentage of the value of your collateral. If you do not have enough collateral to guarantee repayment, you can ask a friend or relative to co-sign the loan. Co-signing, in effect, makes them liable for repaying the debt if you default.

Character is who you are. Detail the capabilities and background of the business owner, or owners, with a written resumé including their education, managerial ability, and business background. Do a credit check of yourself and business partners before applying for a loan. This enables you to eliminate any false information on your credit report and explain any discrepancies to the lender. Bankers also consider an applicant's appearance, preparedness, and professionalism. Do not overlook them.

INVESTING IN YOURSELF/YOUR MONEY

A successful business needs more than good intentions and hard work to survive. It needs an owner whose belief in the company is so strong that he, or she, is willing to invest their own money in it. When you ask others to invest in your business, it's important to show them that you are investing your own money in the venture as well. Use as much of your

own money as you can afford. Leave some capital aside for expansion of the business for unexpected expenditures. Invest in your own company, and you'll have an easier time convincing others to do the same; you will also save equity capital costs and have fewer people looking over your shoulders.

Home mortgage and equity loan rates have generally been lower than commercial or personal loan rates. Consider refinancing your home or borrowing on its equity if it is a feasible option. Remember, though, the risks involved if the business fails. If your tax situation makes it attractive, consider liquidating your investments.

OTHER PEOPLE'S MONEY

A business uses four types of money. When deciding to borrow money, consider what you will specifically use the money for. Your purpose in borrowing determines the type of money available.

Short-Term Credit or Loans. These are for periods of less than a year. Lenders provide this type of money to carry you in your purchases of inventory for special reasons, such as buying inventory for the next selling season. Such loans are self liquidating because they generate sales dollars. Another source of short-term credit loan is a line of credit. This provides you with money without your having to apply for a loan.

Long-Term Credit or Loans. These are for more than a year and are used for expansion or modernization of your business. A mortgage or promissory note with terms are examples of long-term loans.

Equity Funds. This type of money is never repaid. You get it by relinquishing a part of your profits to an investor. You sell an interest in your business.

Trade Credit. This is money you owe to those suppliers who allow you to maintain an open account; it is not borrowed in the sense that money is provided by a bank in the form of a loan. Trade credit enables you to have more control over your cash flow throughout the month. Suppliers provide you with materials when you need them; you then pay the suppliers on a regular basis. This is different from ordering supplies and paying the total within 30 days. The terms in a trade credit arrangement are negotiated between you and the supplier. The trade credit could be similar to a revolving charge account. Check with your suppliers about the availability and terms of such accounts.

Good business sense dictates that money borrowed for a temporary purpose be used to produce profits and be repaid out of those profits. Equity funds, on the other hand, are those which remain in the business and increase the net worth of the owner.

COMMERCIAL SOURCES

Banks are the traditional funding sources. Borrowing money from a bank for a new business is difficult at best, and as an artist, your chances are even less. Banks do not like to take risks on new businesses, as a rule. One banker likened a request for money for a new business to an 18 year-old asking for a car loan. He has no collateral or track record for being a good credit risk. The money is loaned on the collateral of a co-signer, usually his parents. To a banker, a new business has no collateral or a track record of being successful. Therefore the more financial solvency you can show, either with marketable securities, or money from relatives, friends or investors, the greater the likelihood a bank would lend you the money. Although some may, banks are not likely to consider the equity on your home as collateral for your loan.

They want assets that can be easily liquidated if necessary to repay the loan. If you're seeking financing to expand your business and have a record of success and profit, your chances of securing a loan from a bank are better than if you were a new business.

Know the kind of bank you are applying to. Begin with the bank where you already have accounts—checking, savings, mortgage, or car loan; look for one that has a record of lending money to small businesses. Every time you submit a loan application and the bank runs a credit check, an inquiry from the bank will appear on your credit report. A lender might interpret numerous inquiries on your credit report as your having been turned down for a loan by several banks. If possible, identify yourself as something other than an artist when asking a bank for a loan. One lamp designer, who uses metal for the stands, says he calls himself an industrial designer; a wholesaler says she identifies herself as an artist to clients and as a manufacturer to bankers.

If you go to a bank for a loan, the better prepared you are, the more you understand the kind of information the bank wants, and the more time you allow yourself to get a loan, the greater your chances (assuming you have substantial financial backing or your business can show growth and a profit) of getting a loan.

SMALL BUSINESS ADMINISTRATION

The SBA is an independent federal agency that provides prospective, new, and established persons in small businesses with financial assistance. They offer guarantees on loans made by private lenders. Three SBA specialized financing programs helpful to glass artists and business are: Small Loan Guarantees to help businesses needing capital of $50,000 or less, Seasonal Line of Credit Guarantees for firms

facing seasonal business increases and SBA 504 program, which helps business owners get long-term loans to buy real estate, to build, expand, or renovate facilities, or to buy machinery and equipment. For the office nearest you, consult the listing "US. Government" in your telephone book or call 1-800-UASKSBA.

The following guidelines for new and established businesses were prepared by the SBA. The same information would be necessary if you were applying to any other funding source. All of the following information should be in your business plan.

New Business

- Prepare a written business plan and loan proposal.
- Prepare an estimate of how much CASH you have available to invest in the business and how much you need to borrow. As a general guideline, the SBA recommends you plan on a maximum ratio of 2:1 of borrowed funds to your investment funds i.e. you may be able to borrow $2 for every $1 you invest in order to start a new business.
- Prepare a current financial statement (balance sheet) listing all personal assets and liabilities of the owners, or each partner. or each stockholder owning 20% or more of the corporate stock or ownership in the business.
- Prepare a detailed projection of business earnings for the first year the business will operate and/or until your business reaches a projected break-even point.
- List collateral to be offered as security for the loan, indicating your estimate of the present market value of each with a listing of any liens against each item.

Itemize by category: real estate, machinery and equipment, furniture and fixtures, and/or inventory. (Banks aren't likely to consider these assets as collateral for new businesses. They want liquid assets).

- Review the information with SBA/SCORE.
- Take this material to your banker. Ask for a direct bank loan and, if declined, ask the bank to make the loan under SBA's Loan Guaranty Program.

Existing Businesses

- Prepare a current, written, loan proposal including a balance sheet, listing all business assets, and all liabilities.
- Prepare a business profit and loss statement for the previous three years and for the current year, no older than 90 days. Also, present the last three years' copies of your business' Federal Income Tax Returns.
- Prepare a current financial statement of the owner, or each partner, or each stockholder owning 20 percent or more of the corporate stock of ownership in the business.
- List all of the collateral to be offered as security for the loan, with your estimate of the present market value of each item and a listing of liens against each item. Itemize by category: real estate, machinery and equipment, furniture and fixtures, and/or inventory.
- State the total amount of the loan requested and explain by listing the exact purpose for which the money will be used by category and dollar amount.
- After you have met with an SBA/SCORE counselor,

take all of the above material to your banker. Ask for a direct bank loan and, if declined, ask the bank to make the loan under SBA Guaranty Loan Program.

FAMILY AND FRIENDS

Family and friends can be more difficult to approach for money than commercial sources, but if you can convince them to invest in your business, you can probably convince anybody you'll succeed. Borrowing money from family or friends presents a different situation than borrowing money from a commercial source. You will likely see or speak with your family and friends frequently. They might have a tendency to meddle in the business, to give you unsolicited advice, to constantly question your business procedures. You are using their money; they have a vested interest in you and your enterprise. With most other lenders, your only communication would likely be a monthly check. If you plan to borrow money from family or friends, approach it from a business standpoint. Do not make the mistake of treating such a transaction casually. Prepare a written loan form with a repayment schedule. Define how much involvement in the company their investment entitles them to. Approach the entire loan procedure as you would if you were working with a formal lending institution.

A benefit to borrowing from family or friends is that the financial rewards go to those you care about. People enjoy success and take pleasure in helping others succeed. Your family or friends who have a vested interest can be your most loyal supporters.

SUPPLIERS

Getting your suppliers to give you additional time to pay your bills is like getting an interest-free loan. As a new and

growing business, you will be needing an increasing amount of their products. After you have been in business a while and have established good credit with your suppliers, they might be more likely to give you a longer time to pay your bills. It is worth trying to establish such an account in the beginning of your career. The worst they can say is no.

VENTURE CAPITALISTS

Venture capitalist supply start-up capital by lending companies money or buying the company's stock. Unlike banks whose focus is low-risk, and want the loans they give to be secured with collateral, venture capitalists are interested in the cash flow and profits the business will generate. For their unsecured investment, venture capitalists usually want a high rate of return, as much as 50 percent interest in a business and some control over the company. They will take risks and help finance a new venture where conventional banks and lending institutions will not.

In their book Guerrilla Financing Bruce Blechman and Jay Conrad Levinson describe professional/traditional venture capitalists as firms funded by insurance companies, pension funds, major corporations, foundation, and even the government, such as SBA's Small Business Investment Companies (SBICs) and Minority Enterprise Small Business Investment Companies (MESBICs). They invest other people's money.

Nontraditional venture or adventure capitalists are people who put their own money into a business opportunity. They frequently invest in local start-up companies. Their investment requirements tend to be much less stringent than traditional venture capital firms. Because they are in your community, they're easy to contact. In addition to your relatives and friends, adventure capitalists can be persons you

already know on a business or professional level, such as doctors, lawyers, accountants, consultants, your suppliers, customers, employees, and noncompeting similar companies. You can locate adventure capitalists through investment bankers and financial planners. Also, talk up your plans with friends and associates.

The SBA's Financial Management FM5 A Venture Capital Primer for Small Business provides additional information about venture capital. It is one of several publications available from the SBA, P.O. Box 15434, Fort Worth, TX 76119.

OTHER NONTRADITIONAL FINANCING

Equipment Financing

Leasing equipment rather than purchasing it is another way to have more working capital. It is an opportunity for a small business to enjoy some of the benefits of a larger one. Borrowing money on new or used equipment you may have intended to own enables you to use the equipment and write off the leasing payments as a business expense, rather than to list the moneys you owe on the equipment as a liability. It is the use of the equipment your business needs, not the ownership. Most equipment suppliers, especially computer equipment sources, offer business leasing programs through affiliated leasing agents or firms. Leasing programs can be set up with schedules that range from one to five years, with interest and principal payments built in. Almost all have buy-out programs that allow you to buy the equipment for a nominal fee at the end of the lease. You also have the opportunity to upgrade your equipment, and turn over your lease, during or at the end of the term. Many businesses rely upon leasing programs to obtain equipment that they would otherwise have to wait for. The tax advantages to leasing, as

mentioned above, makes such programs attractive. Deposits, security payments, terms, interest rates, and buy-out options vary with every lease. Check each program carefully before signing, and be sure you understand all of the terms. Always consult your accountant when making any long-term financial agreements, including leasing.

Leasing agents and firms are like banks in that some are more willing than others to approve leasing programs to new, start-up businesses. Some only approve leases for businesses in existence for a certain period of time. Check with your equipment supplier and explain your situation to them; many work with more than one leasing agent.

Receivables Financing

Receivables financing means getting paid from someone other than your customer as soon as you ship your order or invoice the customer. You sell your accounts receivable, at a discount, to another party or factor who ultimately receives payment from your customer for the amount of the invoice. You get paid now, they get paid later. Selling your accounts receivables can put money in your pocket more quickly than if you waited for your customers to pay you. It frees you of collection expenses for delinquent customers. This could be a viable option if you have a high profit margin and customers who take a long time to pay. If your margin of profit is low, factoring could be too costly. According to Blechman and Levinson in *Guerrilla Financing*, factoring is a common form of financing even among very substantial and financially sound businesses.

For a glass business, receivables financing would be something to consider if yours is a wholesaling business that supplies quantities of goods to distributors or retailers. It is a way to realize payment for your goods immediately, but at

a price. Again, consult your accountant about the feasibility of receivables financing.

Real Estate Financing

Purchase business property rather than rent the space, recommend Blechman and Levinson. By owning the building you get tax deductions, the property appreciates in value and the loan payments can be amortized over 25 or 30 years. Your monthly mortgage payments could be about the same, or even lower than, the monthly rent on the premises. If you require only a small space as you begin your career in glass, consider buying an office or industrial condominium. The concept is the same as residential condos. You own part of a building. Financing an office or industrial condo can be more difficult than buying an entire building. Lenders are leery about owning a part of a building if they have to foreclose. To reduce their risk, they want about a 35 percent down payment. However, the SBAs 504 program guarantees a bank loan up to 90 percent of the value of the property. This means you only have to come up with 10 percent.

Government Financing

In addition to the widely known federally run SBA, federal, state, and local governments offer a variety of assistance programs for businesses, large and small. Dealing with government agencies can be unwieldy at best, frustrating at least. Numerous agencies have different kinds of funding programs for new businesses. Begin by contacting the chamber of commerce for the names of public and quasi-public agencies in your area that help businesses. Look in the telephone book under your city's, county's, and state's listing for agencies that have the words industrial or economic development in their names. Ask your state representative for

a listing of state programs and agencies.

The book, *Guerrilla Financing*, details these alternatives to traditional financing. It's an easy-to-read book filled with extensive information about financing your business. I recommend it.

NATIONAL ENDOWMENTS FOR THE ARTS, STATE ART COUNCILS, PRIVATE FOUNDATIONS

In some ways glass artists have an advantage over other types of businesses. Resources unique to the arts exist that provide financial support to artists.

Among the most common of the resources are Fellowships, which are sums of moneys given to artists to cover living and working expenses for a specified period of time. Fellowships are available from the National Endowment for the Arts, state councils on the arts, and private foundations. Conditions of the fellowships and their amounts vary from one organization to another. The NEA offers a variety of programs. Three of the most common for glass artists are:

Visual Arts Fellowships, which provide money to individual artists. Glass artists would enter in the "Crafts" category. The grants are available to practicing professional artists, not hobbyists or students pursuing graduate or undergraduate degrees. Along with the application form, an applicant would submit slides, and a list identifying the slides. Supplemental information can include a brief statement about the work submitted, video tapes, and books about the artist's work. According to the NEA, the review panel considers the quality of the applicant's work based on submitted slides, the record of his, or her, professional activity and achievement, and evidence that the applicant's work reflects continued serious and exceptional aesthetic investigation. Fellowships have been awarded annually for

$5000 and $20,000. Competition is intense. About five per-
cent of the applicants receive fellowships.

International Exchange Fellowships are for work and study
in Japan and Mexico. Artists apply to each program separate-
ly. A knowledge of the language is not required. Artists are
selected based on the excellence of their work, the appro-
priateness of the applicant's reason to go to the foreign
country, the extent to which working in a foreign country is
consistent with the applicant's artistic vision, and the ap-
plicant's intended use of the knowledge and experience
gained from his, or her, residency.

Five, six-month fellowships are awarded each year. The
fellowships are not project based. Artists are not required to
work on a specific project. The fellowship program is in-
tended to provide creative development opportunities for
US artists with limited exposure to other cultures. Priority is
usually given to qualified applicants who have spent less
than three months working professionally abroad.

Design Arts Program, which, through grants, supports a
variety of projects in architecture and interior design. The
program supports work that will advance the design arts and
benefit the public on a local, state, or national level. For the
individual artist, it supports projects that advance design prac-
tice, research, theory, and communication. The NEA encour-
ages artists to propose projects that address major societal
concerns that the design arts can affect. Panelists consider the
quality of the project, its potential to advance the design field,
the national, regional, or local significance of the project. the
applicant's ability to carry out the project, the presentation and
quality of written and visual materials and the applicant's
ability to describe the project and procedure with clarity. Pro-
ject grants for individuals have ranged from $5000 to $15,000
and are generally awarded for a period up to 24 months.

Application forms are available from the NEA at 1100 Pennsylvania Ave., NW, Washington, DC 20506 (202) 682-5400. The applications come in booklet form with easy to follow instructions.

Most states have an arts council or commission responsible for funding artistic activities. Fellowships from state councils are generally given only to residents of that state. For the address and phone number of the arts council in your state, call your library or state representative, or write to (state) Council on the Arts, in your state capital for information.

The Creative Glass Center in Millville, NJ offers twelve fellowships a year, each for three months. The center looks for artists who have basic hot glass skills. Preference is given to those with several years experience out of the educational setting. Artists are given free housing, a monthly stipend, 24 hour access to the glass factory at Wheaton Village and all of the glass they can use. Selected artists are notified within a few weeks after the August and December deadlines. The application includes 10 slides, two reference letters, a current resumé and a brief statement of intent. Contact the Creative Glass Center at Wheaton Village, Glasstown Road, Millville, NJ 08332 (609) 825-6800 for an application. There is no application fee.

A source for private funding is the book *Foundation Grants to Individuals*, published by The Foundation Center, 79 Fifth Ave. New York, NY. 10003 (800) 424-9836. This book lists more than 2,000 foundations that give money for scholarships, student loans, fellowships, residencies, travel internships, and arts and cultural projects. Another helpful resource is The Foundation Directory, which lists more than 7,600 foundations.

The Foundation Center offers a wide range of publica-

tions and services regarding funding. A core collection of nine of their publications can be found in more than 90 libraries and non-profit agencies throughout the country. Their reference collections can be found at The Foundation Centers in New York, Washington, San Francisco, and Cleveland. For further information about their services and publications, call 1-800-424-9836.

AWARDS

Award money is another source of funding for artists, albeit, limited. Museum and university galleries, glass associations and groups, and sometimes corporations with art related programs periodically hold exhibitions in which monetary awards are given for works of art, including glass. Aside from the money you could get from an exhibition, a benefit is that the exhibition and award can add credibility to your work and enhance your career.

Corning Museum of Glass awards a $5000 Rakow Commission annually to glass artists who have established glass as their primary medium. Any artist currently working in glass is eligible. There is no formal deadline or application procedure. If you are interested, send slides, a resumé and any other relevant information to the Corning Museum Of Glass, One Museum Way, Corning, NY 14830-2253. A committee of museum staff members selects the artist who then has approximately 10 months to execute the commissioned piece. The artist is encouraged to travel to Corning for the unveiling of the new work and to give a short talk to the museum's glass seminar participants about his, or her, work and the commissioned piece. There is no formal deadline or application procedure. Contact the Museum for details.

American Craft magazine lists fellowships awards and grants opportunities.❖

10

Credit and Collections

"If sales are the lifeblood of your business,
credit could be its life support."
—*Albert Lowry, author of* How to Become
Financially Successful by Owning Your Own Business.

Businesses today function by getting and giving credit. When you buy supplies for your studio or store, the supplier sends you an invoice for the purchase and may allow you up to 30 days to pay the bill. If you wholesale your glass art, it is normal business practice to extend 30 days' credit before expecting payment. If you market your glass art through consignments, it's typical for the seller to take a month or longer to remit your money to you. In effect, you are extending credit to the dealer.

In today's competitive market, businesses realize that extending credit is necessary. Whether it's in the form of accepting credit cards for retail purchases, or extending credit terms to those businesses you supply with your glass works and products. Extending credit can also be costly, especially if payment is late or the customer defaults. Knowing how to minimize your risk can maximize your protection.

THE CREDIT CHECK

The credit check is the most basic form of determining the creditworthiness of a business customer. It can be as simple as asking the customer for the names and addresses of at least three businesses with whom he has accounts, and asking those businesses how reliable he is in meeting his obligations. However, that does not guarantee the customer pays all his bills on time. He could maintain a good credit standing with a few creditors whose names he always gives out as references, while failing to pay other creditors. If you check only the credit references the customer gives, you are getting only the credit information the customer wants you to have.

For a more thorough credit check, ask the customer for the amount and creditors of outstanding loans. You can also get this information from credit information sources such as Dun & Bradstreet, TRW, and Manufacturers Credit Co-operative. Fees may vary.

The MCC is a credit information exchange and collection service for the giftware, housewares, and tabletop industries. It publishes a monthly delinquent account report listing retail accounts who are paying slowly, in collection, have written NSF (Non-sufficient funds) checks, are in bankruptcy or are abusing vendors' terms of sales.

Also, ask the customer to send you a photo of the inside of his, or her, store. This can show you whether the store is well-stocked, and what kinds of products the store carries. A well-stocked store can be a sign of a successful one.

It is sound business practice to extend only a small amount of credit at first. As the customer proves his reliability by paying his bills in full when they come due, increase the amount if you feel it is in your best interest. Determine how important it is for your business' success to offer large amounts of credit. Treat each request from each

customer separately, carefully studying their creditworthiness and the impact of their purchases on your company's profit.

If a new customer wants to place an order but you haven't completed his credit check or for any other reason you do not wish to extend him credit, suggest a form of payment that will not put you in jeopardy. You can require that payment be made before you ship the item. If the customer sends you a check, delay shipping the item until his check clears, usually three to 10 days. If the check is drawn on a local bank, it should clear in three days, on an out-of-state bank, about 10 days. A third option is to ask the new customer to send you a money order or cashier's (bank) check for the required amount. Any of these procedures is common practice among suppliers with new customers.

Most of the businesses, galleries, and retailers you will deal with will most likely be honest, but a few may not be. Knowing their strategies can help protect you from losses.

The Rosen Group, organizer of the Buyers Market wholesale shows, urges you to be cautious of persons placing three or four small orders that are followed up with prompt payment. This is a common practice among fraudulent operators. The next step may be a request for 30 day terms. Too often the seller will not put a credit limit on these terms. Finally, the dishonest buyer places a huge order for which the artist may never get paid. Uncollected accounts receivable is a major problem for wholesalers, according to Peggy Karr. Unfortunately, sometimes the amount of money you have to spend on collection fees makes it uneconomical to pursue a claim.

Accounts receivable can be a business' single greatest asset. According to MCC it is frequently the least well-managed, as illustrated in the following example:

35 Ways To Detect Credit Fraud

1. A favorite technique of the fraudulent operator is the planned overbuy. Beware of medium to large unsolicited orders received immediately after trade shows. Set low limits on shipments without a thorough credit check.

2. Is the name of the business confusingly similar to another successful local or national business?

3. Is the name of the business prestigious-sounding, e.g., American, National or Universal?

4. Is the first order paid promptly with reorders in large amounts?

5. Are reorders sent more frequently than your usual 'turnover' experience?

6. Are reorders with a new account sent out before previous invoices are paid?

7. Is the order marked for "immediate" or "rush" delivery, especially from a customer who is not known to you? Is the buyer unusually demanding?

8. Is there a marked change in the buying pattern of an account? This may be an indication that "new management" is buying the business with an established credit record.

9. Does the merchandise ordered seem unrelated to the customer's line of business?

10. Is the account ordering merchandise which is interchangeable with several types of retail operations, maybe not his. or her own?

11. Is the order placed by an out-of-state company? Fraudulent buyers frequently avoid placing orders in their state of residence.

12. Is the signature on the purchase order a facsimile stamp? This tactic is used for processing a large number of purchase orders.

13. Are the orders placed by telephone rather than in writing so as not to reveal additional information about the customer, thus avoiding a paper trail?

14. Are you receiving an inordinate number of credit inquiries for an account with whom you have little credit history?

15. Is there information on the credit application which cannot be verified?

16. Does the address of the credit reference have a suite number? Is so, it may be an answering service or a residence.

17. Is the telephone reference an answering service? Does the reference answer the telephone using the digits of a telephone number and not the name of the business? When reaching suspicious telephone references ask, "Is this an answering service?"

18. Are the credit references local, i.e., in the same city or state as the account?

19. Are the companies provided as reference unfamiliar to you, or generally unknown in the industry?

20. Are the credit references not listed in the telephone directories or unknown to directory assistance operators? Rather than using the telephone number provided on the reference sheet, contact directory assistance for the number.

21. Do the telephone references provide an immediate good report? If the reference does not have to check his, or her, records before responding, it could be a "drop phone," or dummy reference phone.

22. On telephone credit inquiries ask, "Have you had many inquiries on this account?"

23. Do the references advise that your call will be returned later?

24. Is the customer's attitude overly friendly or demanding when the order is placed and when references are requested and checked? A credit criminal relies on a short time frame between order placement and shipment of merchandise and preys upon a hurried credit decision.

25. Are there inordinate complaints concerning returns, shipping, prices, shortages, quality, etc.? A fraudulent account will use these tactics to delay payment and to prolong his operation time.

26. Beware of the request to ship on a C.O.D. basis. The customer may stop payment, close the account, or issue a fraudulent certified check.

27. Is the customer reluctant to submit a financial statement? When submitted, is the financial statement unaudited?

28. Does the financial statement have an inflated or "intangible" net worth? Many companies extend credit to a new customer based on a percentage of his net worth.

29. Is the financial statement consistent with your knowledge of industry standards?

30. Is the business less than one year old? If the business is incorporated, you can check with the secretary of state's office in the state in which the corporation is registered.

31. Request a completed, signed credit application prior to the shipment of an order to a new account.

32. Is the account unknown to your sales representative in the territory? Ask your representative to visit the account and to inspect the premises. (If you don't have a representative in that area, ask a friend or relative who lives there to visit the store, if possible.)

33. Has the applicant's bank account been in existence for more than one year? What is the average daily balance? Have there been any NSF or dishonored checks presented?

34. Does the applicant have a borrowing relationship with the bank? A lending relationship implies a credit investigation by the bank and is usually a positive indication.

35. In the event the debtor's bank will not provide credit information, ask your bank to make the inquiry.

Consider the sum of many of these precautions; one or two may not necessarily signal a problem.

Reprinted with permission of the Manufacturers Credit Collective.

Lundberg Studios

In 1971 James Lundberg (shown in photo, right) founded what was to become a major glass art studio known throughout the world for its paperweights. Like many studios, Lundberg Studios began modestly. In the backyard of a small house with a garage full of grinding and polishing equipment, chemicals, and the washing machine in the basement, James, his brother Steve (shown in photo, left), Marc Cantor and David Salazar made steam bubbles and vases patterned after the Tiffany Studios' Art Nouveau Glass. They sold their work at street fairs.

In August 1973 Lundberg Studios moved to their present location, a former bakery in the California coastal town of Davenport, 45 miles from San Jose, California.

At the suggestion of Lawrence Selman, a leading authority on paperweights, the Lundbergs applied their decorating technique to the paperweight format. The work became more refined, the decorations more intricate and the ideas more creative.

By 1974 Lundberg Studios was producing the "California Style" paperweight, a hybrid of the Tiffany surface decorating techniques and the classic French Style lampwork weights. "By taking our surface methods and encasing the patterns in crystal glass, we were creating a new approach to paperweight decorating," says Steve. Soon the

designs became more intricate and multi-layered and eventually developed into a cross between fantasy and realism for which the studio is so well known.

The ideas continued to flourish. In the early 1980s, Steve and Daniel Salazar developed the "insert" method. They would premake various parts of a flower and insert those parts into the various layers of glass while in a molten state. This led to increased realism and a more three dimensional effect in both blown pieces and paperweights.

In the early 1980s computer controlled furnaces made it easier for the Lundbergs to develop new colors. No longer did they feel confined to the more widely used European colors. Jim was asked to develop a paperweight with the image of the world.

Using a complex powdered glass drawing and several layers of specially formulated glass, Jim created The "Worldweight" which has become one of the most popular paperweights ever made. It's won numerous prestigious awards. From the Oval Office of the White House to the homes of Jacques Cousteau and Ted Koppel, the "Worldweight" has come to symbolize hope in a problem-filled planet.

The 1990s brought experiments in nontraditional, sculptural weights. Combined with delicate sand carving, intricate beveling, and multi-layered designs, the paperweights and vases of Lundberg Studios established a prominent place in the paperweight world.

"We've always been successful because we enjoy our work. It hasn't always been monetarily rewarding, but we've created a lifestyle we enjoy. We've never dreaded going to work," says Steve.

Co-founder Jim Lundberg's life was tragically ended on February 28, 1992, when the bicycle he was riding was hit by a car.

"Jim and I always believed that glass has a life of its own and is a very magical substance. Only glass has the integrity to replicate nature so beautifully," says Steve.

The studio produces high end, one-of-a-kind art as well as gift glass. Their work is seen in museum catalogs and major stores throughout the country. The paperweights are included in major museum and private glass collections.

Assume your company has a pre-tax profit margin of ten percent. If you wrote off $5,000 in bad debts (bankruptcies, closed stores without a formal declaration, NSF checks, balances too small to pursue, etc.), you would have to generate $50,000 in new sales just to cover for this bad debt write-off to replace the lost net profit.

CREDIT TERMS

These are the conditions or time limits under which you agree to extend credit. Set realistic credit terms. Some businesses have net 10 day. Net 30 is standard, especially for craft artists selling work to wholesalers. Net 30 means the total amount of the bill is due within 30 days from the invoice date. It also means you will not likely get paid in less than 30 days. If getting paid sooner is important to you consider offering your customers a small percentage discount, say two or five percent, if they pay their bill within 10 days after the date of the invoice, commonly called "10 net 30." Whether your customer accepts your offer could depend upon the amount of the invoice and his cash flow situation. Print the terms and payment penalties (percentages added to outstanding balances) in large type in an obvious location on your invoice.

COLLECTING OVERDUE ACCOUNTS

If your customer's account balance is not paid in full within 30 days, you might be able to charge interest on the unpaid balance. Usury laws laws that require you to disclose certain information relevant to a sale in which interest is charged. The disclosures come on pre-printed forms. Ask your attorney or the Volunteer Lawyers for the Arts organization in your state for the forms.

Charging interest does not guarantee the customer will pay his bill. If the invoice is unpaid after 30 days, send a

second invoice noting the balance is past due. If the balance remains unpaid after 60 days, consider speaking with the customer about the situation. It is much more effective than sending dunning letters that might be thrown away without being read.

When speaking or corresponding with customers who owe you money, always maintain a professional and resourceful attitude. The following suggestions from The Rosen Group may help you collect outstanding balances.

Begin your collection efforts, whether by phone or in writing, by knowing the business background, type of operation, success factor, pattern, and trend of debtor payments and previous collection experience with the account.

Telephone Tips

1. Maximum effect is usually achieved in the first few seconds of the call. You will do better with three short calls than a single, lengthy conversation.

2. Unless you're sure of the level of authority of an assistant or secretary, do not disclose the purpose of the call. If your call poses an embarrassment, you will have added another hurdle.

3. Don't speak too rapidly. Use a clear voice tone and natural pacing.

4. Morning calls are usually more productive than those placed late in the day. Calls placed late in the day before a holiday or long weekend may produce a quick promise—but one likely to be as quickly forgotten.

5. If your contact is absent due to vacation or illness, ask for others who have authority to release your payment.

6. When debtors launch into a tirade, let them talk themselves out. It may be the first time anyone's listened. Only then, will they be inclined to listen to your message.

7. Silence can be a powerful weapon. State your case and then wait. Don't feel obliged to fill the void. Eventually the debtor will respond, sometimes blurting out cases or reasons you'd get no other way.

8. Control the conversation, but learn more through questioning and listening.

9. Debtors judge you by your voice. If it sounds less than totally businesslike, practice with a tape recorder to build tone and timbre, learn pacing.

Letters

1. Keep form letters fresh. Review, revise, and rewrite them at least once a year.

2. When customized letters are required, use the same outline of form letters but insert appropriate phrasings or paragraphs.

3. To forestall claims that an invoice was never received, attach a photo copy to your letter

4. Final demand letters signed by your attorney and on his letterhead will likely produce more results than the same letter signed by yourself.

5. Keep letters brief and to the point with two or three short paragraphs. To spotlight delinquency, place the amount and exact number of days overdue (as of the date of the letter), in full caps at the top center of the letter—before the salutation.

6. If you are unsure that the letters are reaching the proper party, send at least one by certified mail with a return receipt requested.

7. Take the form out of form letters by adding quick, brief, hand-written comments to catch the reader's eye.

8. Except on sizable runs of computer generated letters, all letters should be personally and obviously signed by hand.

9. Use letters to set up your subsequent calls, if necessary.

Payment Plans

- Payment promises forced on the debtor are usually worthless. If you sense the debtor is agreeing merely to end the conversation, retrace steps until you reach a realistic settlement.
- Always give the debtor the opportunity to say how much he can pay now. It may be more than you anticipate.
- If the debtor cannot make full, immediate payment and does not propose a first payment figure, start negotiating at 80% level.
- If you are selling a stock item and are unable to collect the full amount, ask the debtor to return the remaining goods, at his expense, and bill him for the portion used.

Excerpts taken from "Credit & Collection", CraftEd, with permission from The Rosen Group.

Along with the above, ask the customer why he hasn't paid you, not when he expects to. Asking why conveys your concern about his business. If he says he is unable to pay the full amount at one time, ask him how he plans to make payment. This reiterates your interest in his plight and suggests that you are confident he, or she, will pay their bill. If no payment plan is offered, suggest one. Once you and the customer accept the payment plan, re-state the details before ending the conversation. Follow up your conversation with a letter confirming the details of the plan. Keep such a letter brief and to the point.

If the customer refuses to pay the debt, you might have to resort to taking the customer to Small Claims Court, or hiring a collection agency to attempt to collect the moneys.

All of which will cost you money.

Your goal is to collect the money due you. If the customer has been reliable but is experiencing temporary financial difficulty, try to be as flexible as possible regarding payment. In that way, you will keep the customer's business when times are better and will have a reputation in the industry for being a reasonable, rational person with whom to do business. Being arrogant and demanding can adversely affect your reputation with members of your business community, glass related or otherwise.

OBTAINING MERCHANT CARD STATUS

The apparent ease by which consumers can acquire credit cards makes using them an attractive and viable purchasing method. Accepting credit card purchases is becoming more and more necessary if your primary outlets are retail craft shows; accepting credit cards can increase your gross sales. Credit cards may be less important if you wholesale or commission your work. If you operate a storefront studio, or shop, where the acceptance of credit cards is taken for granted by customers, your chances of getting a merchant card status from a bank are much easier than if your business is located in your home. Banks prefer storefronts to home-based businesses. In the bank's eyes, home businesses are not perceived as viable retail outlets. Obtaining merchant card status can be difficult, but it is not impossible.

Whether you operate a store or a studio from your home, before you approach a bank for merchant credit card status, have the following information available:

- Credit references from businesses and suppliers.
- Bank references from other banks.
- A resumé.
- Feasibility study showing how you expect sales to

increase by accepting credit cards.

- A copy of your fictitious name form filed with the state, if you use a fictitious name.
- Forms proving the legal structure of your business, especially if it is a partnership or corporation.
- Proof that your studio operates legally within the community regarding zoning ordinances and licenses.
- Income tax returns.
- Bookkeeping records of average annual sales.
- Copies of your business license and sales tax form.
- Brochures, catalogs, and other printed material that indicate that you are a viable business.

Banks generally prefer studio artists to be in existence for a year before they grant them merchant card status. However, by providing the bank with verification of the craft shows where you will be selling your work over the next six months or so, the exhibitions you'll be participating in, or the advertisements you'll be placing, you will help substantiate the fact that you are serious about your work and that you have a viable retail business.

Banks prefer to do business with clients with whom they have had a long-term relationship. Apply for merchant card status from the bank with whom you have your personal and business checking account and other services. If yours is a new business, the bank will ask for personal references. They want proven personal and business stability.

The issuing bank takes a percentage of the sales, usually between 3 and 8 percent. Some credit card programs issued through business organizations and groups, such as local chambers of commerce, or the American Craft Association, might charge less. It pays to shop around. A bank might also

charge a monthly fee and impose an additional fee in months where you report no credit card sales. If you participate in retail craft shows only occasionally, consider whether the benefit of accepting credit card purchases is worth their costs.

Credit cards have become an important part of every retail business. They make purchasing easy and convenient. They have proven over and over again that they increase sales. If you do any sort of mail order or catalog sales relating to your glass business, they are required as a matter of good business practice. But like any other business tool, credit cards must be integrated into your business structure in an intelligent way and used properly. Credit card fraud, over charged accounts, and customers' right to return goods, and reverse charges are just some of the serious problems small glass businesses need to be aware of when accepting credit charges. Consumer credit is a business resource that must be approached carefully. Know the cards you accept and understand how they can help and hinder your progress. ❖

11

Your Sources of Supply

"If you really believe in what you're doing, you better get as many resources as possible to get as far as you can."
—Larry Kolybaba

The art glass profession might be small when compared to other industries, but the resources available to artists and store owners are vast. This chapter will focus not only on the sources for basic supplies to stock your studio or store, but also on the broad range of information and services available from the government, business, education, art, and professional sectors as well as from other artists. You are not alone. There is an abundance of people that can help you in each phase of your business, throughout your career.

MANUFACTURERS, DISTRIBUTORS, AND WHOLESALERS

Your basic source of supplies needed to physically create your work or sell products through your store comes from manufacturers, distributors (also called wholesalers), and retailers. Each performs a different function in the operation of your business.

Manufacturers make the products you use. They advertise their products in glass publications such as: *Professional Stained Glass, Stained Glass Quarterly, Glass Art, Glass Patterns*

Quarterly and *Stained Glass News*. They are also listed in The Thomas Register, a voluminous book that lists manufacturers of all products. Manufacturers generally sell their products through distributors. Rarely do manufacturers sell directly to artists or retailers. However, they will provide you with information about their products along with the name of their distributors from whom to purchase their product.

Distributors, also called wholesalers, often carry the products of several manufacturers in the same field. For example, one distributor might represent a number of art glass and cathedral glass manufacturers, along with manufacturers of grinders, bevels, cutters, kilns, came, solder, lamp bases, clocks, chemicals, patterns, and any other product used in glass art. Some distributors work only with large studios, some with retailers and others sell to artists and retailers, regardless of the size of the operation.

Some wholesalers also operate as retailers. Their price structure for products vary with a lower price for a quantity purchase and a higher price for persons who are buying a small amount. Some wholesalers charge the same price regardless of the amount being purchased, a practice that is frowned upon and seriously problematic in this, as in any industry. Many wholesalers have mail-order catalogs available to anyone. Distributors who sell wholesale and retail undermine other retail-only businesses and unfairly compete with their customers.

Like manufacturers, distributors/wholesalers/retailers also advertise in trade publications and exhibit at trade shows.

Retailers sell directly to glass artists and hobbyists. Most have a storefront operation. They stock glass, supplies, books, and magazines. They display finished products as an incentive to purchase the products they sell and many offer

workshops and classes. Some retailers have a studio operation through which they do commissioned work or make products for sale through craft shows and their own shop. Retailers are usually the primary contact hobbyists have with the glass industry. They are most often the hobbyist's first contact with the world of glass. Many progressive retailers also supply other studio professionals in their area, keeping them as customers even though they have passed the hobbyist stage. Rather than viewing them as competition, they maintain a business relationship not unlike that of building contractors with lumber yards. Retailers are listed in the classified section of telephone directories under "Glass—Stained and Leaded."

Suppliers, whether manufacturers, distributors, wholesalers, or retailers can tell you about trends, new products, new techniques, and what is going on in the glass industry. Conscientious retailers always have their "ear to the ground," so to speak; cultivate a friendship with them. It costs nothing and can reap you tremendous amounts of information.

SELECTING A SUPPLIER

If you are new to glass art and are planning, or have a small studio, artists and distributors recommend that you look for a very good retail store where you can purchase glass locally. Often, you'll need only a small piece of glass and the cost of buying a large amount of glass from a wholesaler, usually in the form of a minimum purchase, could be extravagant. Retailers give you the option of purchasing small quantities of glass related materials; most distributors do not. Good retailers often buy from several distributors and therefore carry a wide variety of products; this is to the artist's benefit.

A good retailer has basic supplies, reasonable prices, a

Mindscape Gallery

Since opening its doors in 1973, Mindscape Gallery has paralleled the lines of influences and sophistication of the American Craft movement. In the early 70s, people worked with utilitarian elements and that's what the gallery showed. As the artists' work evolved and grew, so did the gallery. It outgrew its first location in Chicago after one and one-half years and its second location after three years. Today Mindscape has 11,000 square feet of gallery space in Evanston, Illinois, of which 3500 is devoted to glass. It is one of the largest glass galleries in the Midwest and carries a broad range of glass art from functional to major sculptural work.

"This allows us to work with artists as they're emerging and developing a signature of a particular style," says owner Ron Isaacson. "Our goal is not to sell $30 paperweights, but their presence in the gallery as well as that of perfume bottles and goblets enable us to introduce potential collectors to glass. A majority of the glass collectors we work with began their collections by purchasing those smaller objects. We've seen customers evolve into purchasers of pieces costing thousands of dollars."

Mindscape carries only the work of professional artists who make their total or the majority of their livelihood through the sale of their art. "We look for work that projects a basic imagery that defines their work. We want to make sure we're not seeing a happy accident, but rather work that is done with intent," says Ron. Work is selected by a jury review

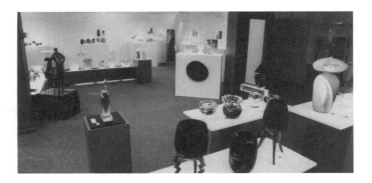

panel that meets several times a year and whose members travel around the country, attend glass conferences, and visit shows, galleries, and studios.

Education is an important component to the success of Mindscape. Its educational role extends to the artists and to the collectors. "Artists aren't taught business acumen in schools. We teach them how to survive," says Ron. Seminars are held regularly for collectors, and glass artists are invited to speak. Mindscape's artreach programs have brought artists and collectors together in the collectors' homes.

Isaacson and his business partner and wife, Deborah Farber Isaacson, began Mindscape as a storefront studio. They offered classes in a variety of media in the back of the studio and operated a small gallery in front. Ron is a sculptor, working in clay and metal, Deborah, a jeweler and fiber artist. They've understood the needs of artists.

Before long Mindscape was a success and the Isaacsons began earning their living from the gallery. "Because of that, we've had to make the gallery work. We have to be professional and respond quickly to the marketplace. We establish procedures and develop short- and long-term plans to meet the market needs or sidestep shortcomings in the economy. The gallery has shown a steady growth, even during the recession of the early 1990s. We're committed to being successful. There's no such thing as failure at Mindscape," says Ron.

The Issacson's influence in glass art extends beyond the gallery operation. They've been actively involved in dozens of national, regional, and local activities including serving on the advisory board of *The Crafts Report*, and *The Year of American Crafts* (1993). They've been selection or awards jurors for art or craft exhibitions and have served in an advisory capacity to various crafts organizations.

Jointly and individually Ron and Deborah have published numerous articles on crafts and craft marketing in the United States and England and conducted a variety of workshops on craft industry issues. In 1988 the Isaacsons established CRMS (Craft Retailers Marketing Council), a consulting firm that provides marketing and operations assistance to other retail organizations.

variety of glass, is helpful, and will place special orders to meet your specific needs. "It's important to have someone you can work with," says John Emery of Preston Studios. "Your needs and what the supplier does to meet those needs determine the best supplier."

Glass is the most important item you'll purchase. Because of the variety of textures and colors available, manufacturers number their individual glasses. A good supplier, says John, can equate colors with the numbers. This can be helpful when you have an idea of the color or texture of glass you want to use, but are not sure who manufactures it. If you order glass by phone, arrange to send the supplier a sample of the glass you want. Do not try to describe it.

You can't be a retailer without having a good wholesaler. Just as important as the artist/retailer relationship is the retailer/wholesaler relationship. As a retailer, you depend on getting supplies when you need them. You need a wholesaler you can depend upon. Be sure they can give you what you need. Know your suppliers' business personalities. Understand what they expect from you. Prices, service, and terms vary among suppliers. Develop a relationship with several suppliers. This will ensure that the products you'll need will always be available, if not from one supplier, then from another. Working with more than one supplier enables you to get the products your customers want when they want them. Some wholesalers are better suited to serve studio artists as accounts; other full line wholesalers target retailers as clients and some can supply both.

A great attitude, congeniality, and helpfulness are vital factors in choosing a supplier, according to several artists and retailers. Consider your specific needs when selecting a supplier. No matter how small your business, you should be important to your supplier.

Establishing an Account

To purchase from wholesale distributors, you will be required to prove that you are a legitimate business. You'll be asked to provide the name of the owner, submit a business card, a retail tax certificate, a copy of a Yellow Page ad and brief description of the kind of work you do. You will more than likely be asked to purchase a minimum dollar amount. To establish credit, you will be asked to supply the names and addresses of businesses with whom you have accounts. Although this sounds like a Catch-22, you can use your existing accounts with local merchants, such as printers, hardware stores and landlords as references.

Terms might be COD (cash on delivery), a credit card, or net 30. As in any business transaction, it is important to pay your bills on time, especially with your suppliers. If you don't, you will sacrifice your good credit standing and your suppliers will hesitate to extend any payment terms to you at all.

Networking

The success of your business depends in part upon the connections you make. Much of our knowledge comes through the experience of others, whether it's from reading articles, taking workshops, visiting trade shows, attending seminars, or simply speaking with others. How often have you solved a problem or found a source of supply by talking with other artists or retailers who shared their knowledge with you?

"Networking is the beginning of creativity," said Jim Schlitz of Schlitz Furnaces in Milwaukee, Wisconsin. Jim never minded sharing an idea or having someone use a technique he developed.

Your greatest resource for information on the business of

glass is other artists, retailers, and business people. You'll find that if you are not in direct competition, another artist or retailer will be more than happy to tell you the names of suppliers, shows, publications, antique dealers, galleries, exhibitions, etc., that have worked well for them. They will give you safety tips, marketing ideas, and practical information. Look at how many artists conduct workshops at trade shows, in schools, and in their studios. They are the artists and professionals who want to help. Most believe that their openness and ability to communicate are good for their business and the glass industry in general.

Networking through community and business organizations puts you in contact with potential customers. People like to buy from people they know. Networking provides opportunities to meet individuals in diverse occupations and with a variety of outside interests. It can open up a wide range of possible sales, as well as improve your image in the community.

Networking is usually associated with social or business events, but it can take place through membership in glass, art, and business organizations, through participation in workshops or any format in which two or more people communicate. Networking is being helpful to others and knowing how to ask for help in return.

Glass Associations

Art glass associations keep members up to date with information about trade shows, products, techniques, business opportunities, and strategies. The Art Glass Suppliers Association's (AGSA) members are manufacturers, wholesalers, importers, retailers, studio artists, consultant/designers/teachers and others involved in promoting art glass supplies. AGSA holds an annual trade show of industry

exhibitors, manufacturers' demonstrations, workshops on techniques and seminars about business management.

Glass Art Society (GAS) focuses primarily on hot glass. It holds an annual conference featuring technical workshops and artists' lectures and discussions. The G.A.S. Journal documents the information presented at the annual conference. It maintains a slide registry at the Corning Museum of Art, and publishes a newsletter twice a year. It holds exhibitions and offers insurance to members.

The Stained Glass Association of America promotes the development and advancement of the stained and decorative glass craft. It is operated exclusively for educational, scientific, professional, and cultural glass craft related purposes. Membership is open to full service studios, artists/designers/ craft supply manufacturers, distributors, and persons or organizations interested in the craft. It publishes a quarterly magazine Stained Glass, a newsletter, reference and technical manual, maintains an audio-visual library, conducts a juried competition, and provides information on latest developments by manufacturers, fabricators, designers, and marketers of stained glass. It offers an accreditation program for individuals who want to teach stained glass. It has a graphic design service and holds an annual conference.

The National Glass Association is a trade association for the flat glass industry, not to be confused with the decorative glass industry. Membership is open to manufacturers, fabricators, distributors, and retailers of annealed glass and windows, skylights, and related products such as greenhouses, sunrooms, patio and sliding glass doors, furniture and shower/tub enclosures. It holds an annual trade show and is active on the federal and state legislatures supporting glass and glass related issues.

Membership in local non-profit art glass associations like

the Art Glass Association of Southern California can be an excellent way to network with other glass artists on a local level. The Art Glass Association of Southern California provides workshops and seminars, has trips to studios, sponsors shows, works within the community to promote public awareness and understanding of glass art, and maintains an information center of products, events, and artisans related to art glass. Other groups are in the Atlanta Art Glass Guild and the Michigan Glass Guild.

Seek your associations' advice on business, health, and safety issues. They should be familiar with governmental rules and regulations, legislative proposals, safety equipment, and professionals in the health and safety fields.

TRADE SHOWS

Trade shows benefit everyone in the glass industry. In addition to the shows sponsored by AGSA, there is the Glass Craft Festival each fall in New Jersey. This four-day weekend program features stained glass workshops and seminars for hobbyists and professionals.

"Attending trade shows is a good way to meet suppliers and see what's out there," says one distributor who works only with studio artists, "It's an opportunity to learn a new technique, meet other artists, and learn more about the industry."

ART AND CRAFT RELATED ASSOCIATIONS

National and regional craft associations provide information about the craft market in general. The American Craft Council publishes American Craft magazine and maintains an information center which has a craft registry of approximately 2,000 craftspeople working in all media, 5,000 books, about 150 national and international publications, newsletters and

catalogs of national, regional, and local organizations, museums, galleries, and shops.

The American Craft Association, a division of the ACC, offers professional services to artists and retailers, including health, property, and casualty insurance plans, educational programs, and merchant card services with Visa and Master-card cards that waive the requirement of a retail location.

The Chicago Artists' Coalition conducts workshops on topics relevant to artists, offers health and studio insurance, maintains an active slide registry to promote artists' work to curators, collectors, and businesses, publishes a listing of exhibitions, has a job referral service, and publishes a monthly newspaper with information about local exhibition opportunities and national art issues. The newspaper is circulated throughout the country and is available to anyone.

The Craft Emergency Relief Fund (CERF) is a non- profit foundation which provides support to professional craftspeople suffering career threatening emergencies. CERF makes no-interest, no-specified pay-back date loans. Among their programs are a tool and equipment exchange which allows craftspeople to donate equipment to craftspeople whose tools and equipment are damaged or lost to disaster. Through their booth fee waiver program major craft fair producers provide free booth spaces to exhibitors who experienced disaster. CERF targets funds for craftspeople affected by serious illness or tragedies such as hurricanes and earthquakes.

Ontario Crafts Council is a multifaceted organization that publishes Ontario Craft, an educational magazine showcasing the works of Canada's foremost craftspeople; Craft-News a newspaper-style publication that brings its readers up to date on issues, opportunities and practical tips for working craftspersons, a variety of booklets designed to

assist the artist in the marketing of craft, a craft resource center, a network of more than 100 guilds, art councils, and educational institutions. The OCC provides awards, scholarships and exhibitions, a corporate gift program, and maintains a resource center.

The Society of Craft Designers advises craft designers in all aspects of promoting and marketing their designs to magazines and manufacturers. They hold an annual seminar and publish a bi-monthly newsletter.

Volunteer Lawyers for the Arts provides art law information at free or reduced fees. Although each of the Volunteer Lawyers for the Arts groups around the country are autonomous and each group might work on issues germane to the state they are in, they do share information with one another. "Organizations like ours that offer support for artists help to bring them to the business aspect. Once you move past survival, you become creative in your life in other ways. Artists all over the country have become interested in legislation. They are becoming proactive. They are much more able to focus on other issues," says Dorothy Manou, director of the Philadelphia VLA.

State Councils on the Arts

State Councils On the Arts were established to promote and develop the arts in their particular states. The councils are sources of funding. They list public Percent for Art projects, fellowship, and awards programs. They publish guides of local arts agencies, festivals, art centers, and museums. They develop art programs and stimulate greater public awareness of the arts. Contact your State representative for information.

State Guilds

State guilds differ from state councils. The guilds are com-

prised of craftspeople. The councils are part of the state government. Guilds are generally non-profit organizations. Each guild varies in its programs depending upon the needs of its members. Many, however, sponsor craft shows and publish a newsletter. Some have chapters throughout their states, conduct seminars and workshops, have craftsmen-in-residence programs, and offer insurance.

GLASS AND CRAFT MAGAZINES

American Craft magazine provides an in-depth view of contemporary craft with artists profiles, gallery exhibits, a national calendar of exhibitions, awards, workshops, book reviews, and information about new talent.

Glass magazine features articles about artists and reviews works, exhibitions, and books, and has a suppliers directory. Many important glass galleries advertise in the magazine. It is published by the New York Experimental Glass Workshop.

Glass Art magazine is about stained and decorative glass. It features information about artists, techniques, and materials. It reviews products and books. Suppliers advertise in the magazine. Its September/October issue features a directory to industry suppliers.

Professional Stained Glass magazine is for the artist and enthusiast who works with decorative glass. Its mission is to promote and encourage excellence in the glass arts. Professional Stained Glass picks up where the hobbyist magazines leave off. Written by industry professionals, it features articles about various uses of glass on an advanced and professional level, whether in lamps, architectural elements, panels, restoration, etc., throughout the world. It reviews products and lists shows, workshops, and seminars. Suppliers and manufacturers advertise in PSG.

Stained Glass is published by the Stained Glass Association of America. It contains many color illustrations and is circulated to architects, interior designers, craftspeople, artists, educators, and craft suppliers.

Stained Glass News is a full-color newspaper written for hobbyists and distributed free through retailers, who can use it to promote the products they sell to customers.

Glass Patterns Quarterly is a hobbyist publications using many patterns from a variety of sources, published every two months.

BUSINESS ORGANIZATIONS
Chambers of Commerce

The focus of chambers of commerce is to help businesses. Local chambers offer a range of free information and services to the artist and retailer, in addition to putting members in touch with other local businesses. Running a business is like scientific law, according to Brian Maytum of Maytum Glass Studios, Inc. in Boulder, Colorado.

"There are rules for running a business regardless of the business you're in. For example, cash flow and supply and demand affect everybody, just like the law of gravity," says Brian. "You need to find good business people to talk to." Because most chamber members are small business owners, the chambers' programs are geared to the needs of the entrepreneur and to their geographic area. Chambers hold seminars on those areas most important to its members, which might include managing, marketing, financing, and insurance. They hold business fairs to introduce members to each other and to the community. The various committees work on areas of interest to the members. Check with your local chamber of commerce for membership.

Home Builders Association

If the focus of your work is residential panels, doorways, and entranceways, membership in your local home builders association could be beneficial. Such an association has helped to put Preston Studios of Melbourne, Florida, in the forefront as a designer of residential installations.

Approach any such organization in a professional way. Understand construction terminology and building codes. Express your willingness to work as part of the home-building team and stress the custom look your work will provide for the custom-designed house. You may be able to establish your skills and your product by offering to make a panel for a model home. Keeping costs down in model homes is of utmost importance to builders. If you must, consider making the panel at little or no profit if that will bring your work to the attention of clients and other builders. Many HBAs have an annual "Parade of Homes" in which several new homes are completely decorated and awards are given for various aspects of the work. Winning an award can enhance your credibility and promote your business to this important group.

American Society of Interior Designers/ American Institute of Architects

Both these organizations have local chapters. Volunteer to speak to their members about your work. Show them how your area of expertise applies to their fields.

Business, trade, and art associations are people-to-people organizations. They are places were rapport is built, knowledge is shared, business contacts are generated, and relationships are forged. In a non-sales situation, people tend to be much more honest and open with one another. Active membership in an organization is a way of getting yourself into the market. "If what you're doing is viable, then anything

you do to become better known is good for your business," says Brian Maytum.

National, regional, and local associations can help you or waste your time. Consider your particular needs. Find out if an organization addresses those needs and determine if the benefit of joining an organization is worth the membership costs.

Schools

It is an exciting opportunity to work with a master crafts-man in your particular area of interest. Haystack Mountain School Of Crafts, Penland School of Crafts, Pilchuck Glass School, and The New York Experimental Glass Workshop offer a series of classes and programs during the year. In addition, local schools offer instruction on the adult educa-tion enrichment level. The Creative Glass Center in Millville, New Jersey, is a resource center for contemporary glass. It offers fellowship opportunities to artists, providing them with facilities in which to work, a stipend, and a place to live.

Colleges and Universities

The business and arts departments of local colleges and universities can be another valuable source of information. They often offer courses and programs that focus on the needs of new and existing businesses. Their faculty members are often experts in their particular field. According to glass artist Paul Stankard, there is probably a school or university with a glass program within 100 mile radius of everyone in this country.

Federal Government

The federal government provides a plethora of informa-tion. The Small Business Administration is specifically de-

signed to advise the entrepreneur. Just for the asking, you can receive free advice on preparing a business plan, securing a loan, insurance, budgeting, marketing, or just about any other facet of business. The advice comes either in person at a one on one meeting with an SBA representative or through the various booklets it publishes. In addition, the SBA's SCORE (Service Corps of Retired Executives) offers the expertise of thousands of older executive businesspersons. The SBA can assign a SCORE member to meet with you on a regular basis to review your business operation. It is a wonderful source of business advice that should not be overlooked. Contact your local SBA office for more information.

To ensure you're complying with OSHA (Occupational Safety And Health Administration) regulations, you can get a free evaluation of your studio or store from the Department of Health and Human Resources' National Institute of Occupational Safety and Health.

The Census Bureau maintains demographic profiles on the age, income, and educational levels of persons in geographic areas throughout the country. Census data can keep you in touch with potential customers. If the population of your market area has a high concentration of retired persons, you can plan your marketing strategy to appeal to those potential customers. The Data User's Service of the bureau can tell you how many art glass retailers or how many building contractors or architectural firms there are in a specific area. Every five years the bureau updates its facts on small businesses.

The Library of Congress' National Referral Center lists thousands of specialists on university staffs, in government, or working for non-profit organizations.

Your congressmen are also there to help you. Contact them with your questions and ask them to direct you to the

right source. You can also ask their help to get the information you need.

Museums

Museums are excellent resources. The Corning Museum of Glass has an extensive library about glass and a listing of schools throughout the country that offer courses in glass-working. Other museums, like the Metropolitan Museum Of Art in New York, and the Chrysler Museum at Norfolk, Virginia, have important collections of glass, supplemented by educational programs, slide libraries, publications, and curatorial staffs that can help your own educational efforts. Wheaton Village, in Millville, New Jersey, surrounds the Wheaton Museum of Glass, a repository of glass history and craft. Wheaton Village is also the site of the Creative Glass Center Of America (CGCA), a glass center committed to promoting contemporary glass and young glass artists.

The American Craft Museum in New York City occasionally mounts glass exhibits as a part of their commitment to excellence in craft and the decorative arts.

Libraries

The reference sections of local libraries contain directories and books listing thousands of organizations and businesses. The *Thomas Register* gives the names, addresses, and information about thousands of associations. If your work overlaps into another media, you can find the name of that media's association in the encyclopedia. If you are interested in learning more about the application of glass in architecture or interior design, associations in those areas are listed. The *Directory of Directories* is a reference book listing the names, addresses and descriptions of directories such as the *Directory of Corporate Art Collections* and *Directory of Craft Shops.*

204

The Telephone Directory

The telephone directory harbors a wealth of information. Look under the categories: Antique Dealers, Art, Museums, Schools, Glass-Stained and Leaded, Interior Designers, Decorators, Architectural Firms, Builders, etc. It's a good place to begin your mailing list or to learn about local organizations and businesses.

Local Bell telephone companies publish business-to-business telephone directories. These generally cover a greater geographic area than a consumer telephone directory. Companies are listed alphabetically and according to categories. The business-to-business directory can provide you with a greater list of local resources than the consumer directory. These are usually provided free to businesses. Ask your local Bell company for a copy.

AT&T publishes a toll-free 800 directory listing companies with 800 numbers alphabetically and according to categories throughout the country. These are also usually available at no charge.

Service Professionals

One of the least expensive and most valuable long-term assets of a growing business is the expertise of other people in their particular field. The best way they can help you is by your giving them as much information as possible about your business as you can. For instance, to ensure that you are meeting all local, state, and federal regulations when beginning your business, consult with a lawyer. Whatever the consultation fee, it is money well spent. With expert guidance, in this case legal guidance, you can avoid any regulatory confrontation that may, sometime in the future, jeopardize your business activities.

Work with an accountant to set up your books when you

start your business and to review your records periodically to identify how you can improve your profits. Accountants get an inside and in-depth look at the finances of many different kinds of businesses. One suggestion from an accountant about a better way to handle your finances could go a long way.

Protect your investment by meeting with insurance brokers familiar with your needs as a studio artist or retailer, or those recommended by other artists or retailers. Plan your promotion and marketing program with the advice of a publicist, ad agency, or graphic designer. Even a one-time, or periodic consultation with advertising or marketing professionals can reap long-term benefits for your business. Check the local economic climate and the financial soundness of your biggest customers through your bank. Banking personnel see businesses come and go. They may be able to give you insights into why certain businesses in your area prosper while others do not.

The benefit of working with professionals in any field far outweighs the expense. When beginning your business or at any time during your career, seek out the best possible sources of information. It is time and money well spent.❖

12

Marketing

*"Being a business person is as challenging as being an artist.
Marketing is the toughest challenge."*
—*Vincent Olmsted*

When you market your artwork or promote your store, you offer the buyer a product. Although your art may be very special to you and perhaps your services unique in the business world, they're just products. Like an automobile or any other commodity, your product has to be marketed. The better you are at marketing, the better the chances that your product will sell.

Marketing is knowing what people like and presenting what you offer in a way that makes them want to buy it. It is a positive projection of yourself and your business. It includes everything that identifies you to the public. It is your publicity and advertising, your customer service, and the image you project in everything you do. It is the key to a successful operation.

MARKETING TOOLS

Image

Marketing begins with an image of how you want the public to perceive you. Everything about your company contributes

to its image—your personal appearance and demeanor, your company's name, location, product, packaging, customer service, window display, logo, print advertising, and promotional material. An image is not a gimmick. It's an identity that defines you as an artist, a professional, and a businessperson. An image sets you apart from your competition. It cannot make a bad product better, but it does make a good product easier to sell.

Sculptural, hot glass artist Vince Olmsted believes an artist needs to provide an image that's professional and conveys to people that you believe in the kind of work you are doing, that your work has a relationship to the market you are selling to. "Everybody buys into something because they tie into it," he says.

The poverty-stricken, long-suffering artist might make an interesting character in a book, but not in a competitive, sophisticated world of art and fine crafts. Convey the impression that you believe in your work, that you are professional and serious about what you do, that you know the direction you want to go and you understand the market. Today's successful artists and craftspeople are intelligent, astute, goal-oriented individuals who understand the glass art community, the public's perception of glass and marketing.

What you say about yourself is important in developing a positive image. The glass art community is relatively small. Artists, gallery owners, craft show organizers, and antique dealers speak with their peers about the artists and craftspeople who work with glass. Someone once said, "If the British are a nation of shopkeepers, Americans are a nation of shop talkers." Be professional. Keep personal attitudes or emotions separate from business. Project a sense of success about your work without being dishonest.

Collectors like to see the progression of an artist's work.

They also want to know that an artist whose work they invest their money in is committed to his, or her, work. Galleries and dealers expect it.

Sometimes, you will likely feel frustrated, anxious, and unsure about whether choosing a profession as a glass artist, craftsperson, or a retailer is a good decision. This is normal. Every businessperson or entrepreneur feels that way one time or another. If you must share those feelings with someone, let it be a person outside of the glass community. Most people by their nature are not mean spirited, but neither are they discreet. To project a positive image of yourself to the glass art community, say only those things you wouldn't be embarrassed to have known throughout the glass community.

Once you've identified the image you want to convey, your marketing strategy has begun. The next step is to develop a marketing plan that defines where you want to go and how to get there.

Marketing Plan

Marketing effectively means planning carefully. Before you spend any money on advertising and publicity, you must identify your purpose, customers, products, services, and competition. You must position yourself in the marketplace. Include in your marketing plan your objectives, the amount of money you realistically want to earn, and strategies for a given period of time. These help you determine where you want to be in six months, or a year or two or three, and provide guidelines on how to reach your destination. A marketing plan helps you realize the goals you identified in your business plan.

A marketing plan can be as simple as a few paragraphs or lengthy and detailed depending upon your specific goals and your individual style as a business planner. When pre-

paring your marketing plan, consider the image you want to project, your sales goals, the audience you want to attract, the products and services you want to offer, and the competition you are facing. Marketing plans are not permanent. They're meant to be revised from time to time, depending on market conditions and changes in your products and services. Think of your plan as a guide.

Begin your marketing plan by assuming people know nothing about glass. Because there is a lack of information about the many uses of decorative glass, it is up to artists and retailers to inform the public about their studio, stores, and the many ways glass can beautify their homes.

STEPS TO DEVELOP A MARKET PLAN

Identify your sense of purpose. Write down your objectives as they relate to your customers, products, and services. Are you selling one-of-a-kind works, commissioned pieces, limited editions, and/or a product line? How will you sell them—through your studio, galleries, gift stores, museum shops, craft shows, antique dealers, interior decorators, architects, or public works?

Customers

Who are your actual and potential customers? This is also called market niche—the customers in a demographic area that you want to reach. Demographics are specific identifying elements of groups of individuals. Such categories as geographic area, income level, lifestyle, age, and education are all considered demographics. Are your potential customers glass art collectors? Are they homeowners with disposable income for remodeling or purchasing vacation homes? Do your customers live in rural areas and frequent local craft shows? Are they corporations, churches, or public

Kay Bain Weiner

The creativity that glass artists possess often extends beyond the craft. From the time she began working with stained glass as a hobby in the 1960s, Kay Bain Weiner has manifested her glass crafting skills into teaching stained glass to others through kits, demonstrations, videos, books, workshops, and casette tapes and to developing new products.

"I started teaching because I love to teach," says Kay. Her first stained glass students were participants in adult education programs at local schools in the 1960s. In 1970 Kay opened an art center in Cranford, New Jersey where she conducted classes. When owning the center didn't allow Kay time to be an artist, she sold the business to concentrate on designing decorative panels and objects.

She participated in national stained glass trade shows as a demonstrator for various supply manufacturers. She has, for instance, demonstrated solder products for Canfield Solder Co. since 1981. Together they produced a videotape showing the glass craftsperson how to use the solder efficiently and in making patterns of what is called decorative soldering.

Kay was asked by the editors of Chilton Book Company to write an instructional book for stained glass craftspeople. Her step-by-step instructions and explanation of materials and methods in the book *Stained Glass Magic* guide the beginning craftsperson through each process of making two- and three-dimensional decorative objects.

Today Kay is a coordinator of the National Annual Glass Graft Festival, teaches workshops and lectures throughout the country. She recently developed a color agent for use on the metal elements of stained glass products. She's marketing it through the Eastman Company, her own firm. As Kay has clearly demonstrated, the opportunities for glass artists do not end with a finished piece of glass art.

agencies? The study of demographics can give you insights and help you answer these questions.

Identifying your customers in a market niche and understanding whether their motives for buying your glass art is decorative, artistic, or utilitarian helps you plan your publicity and advertising. You can then promote your product or service in media seen or read by those potential customers. Contemporary glass artist Paul Stankard has seen people work very hard with strategies to promote their work through press releases, expensive photography, and all sorts of serious efforts that oftentimes are unsuccessful, simply because they did not know or properly identify their potential customer.

YOUR ART AND SERVICES

How are your services and products different from your competition's? You may be competing not only with other glass artists, but also with other decorative or fine arts media, home furnishing and improvement options, architectural elements, even other glass shops. How would you convince a potential customer to buy your stained glass window instead of investing the money in a different home improvement? If your supplies are competitively priced, ask yourself why a customer would come to you instead of your competition. Are you more convenient in driving distance, in hours of operation or in location? Do you offer more services? What are those services? Are your products better made? Can you prove it?

How do your products satisfy your customers? Do they add aesthetic and perceived value to the home, office, or public building? Do they increase your customer's interest in glass, enough to create future purchases? Is the customer a potential glass hobbyist who will purchase supplies from you or attend your workshops?

212

What are the qualities, design, and appearance of what you offer? Is your glass art of a unique design, carefully crafted and/or made of highest quality glass in conjunction with consumer-safe paints and leads?

What is the scope and quality of your service? Do you offer workshops, seminars, private consultations, an 800 number, convenient hours, a wide selection of supplies? Do you accept custom orders?

These questions qualify your business in the light of others. Answer them yourself and ask those you associate with to respond. Don't be surprised or offended by honest, objective viewpoints; they can identify problems you might overlook. It is also a good idea for a new business to distribute questionnaires to customers, something quick and easy for them to fill out and return to you. Their first impression of your new business is crucial.

Whatever aspect of the glass business you service, the customer determines your success or failure. Ultimately, it is the customer who decides who stays in business and who does not.

CUSTOMER FEEDBACK

Your customers can be the best source for marketing ideas. Encourage their input. You might follow up random sales with a telephone call or letter asking the customer whether they were satisfied with your service and their purchase and in what ways you can serve them better. Many auto dealers do this kind of follow-up as a matter of fact. When you have a new product, design or service, ask your customer what they think of it. Let them know you're eliciting their comments to better serve them in the future, not pressuring them to buy.

IMPROVEMENTS OVER CURRENT MARKETING STRATEGIES

If you are already in business, this is a good topic to include in your marketing plan to determine how you can adapt or change your strategies to increase your business and income. List the ways you currently market your business, areas in which you want to improve or expand, and how you can implement those ideas. Do you need to offer more services or increase your market area? If you've been selling your work in galleries, do you want to market them to corporations? If your products are selling in local gift shops, are you ready to market them to department stores?

As times, products, and customers' wants and needs change, so too must your marketing strategy. A periodic review of how you reach and communicate with your customers is more than just a good idea. In today's rapidly changing and volatile marketplace, it is mandatory. Keeping abreast of business and buying trends is as important as keeping up with new and improved products and materials. Knowledge is power, and that power can be translated into sales.

SALES PROMOTION

Sales promotion is an integral part of marketing. Each of the following will reinforce your image and help identify your business to the public.

- A logo, trademark, and succinct sales message, or slogan.
- Personal, staff, and studio or shop appearance, word of mouth, product and service quality, sales staff, direct contact with customers.
- Publicity.
- Advertising.
- Sales Literature.

SALES GOALS AND ACTION PLANS

How much volume and dollar amounts are needed to meet your expenses and show a profit?

What outlets will you use to sell your products and services? Will your marketing outlets be your own studio or shop, retailers, galleries, craft shows, exhibitions, museums, magazines, trade shows, home decorating shows, or television?

Determine which months would be better for selling your product. Plan an aggressive sales promotion for those periods. Do you produce Christmas items or glass products in seasonal colors? Do you stock glass items produced by persons who create such items? Can you offer special discounts or incentives at certain times of the year? Do not make the mistake of believing that art and craft related businesses do not have to compete on this level. They do.

To help generate the answers you need, and to get an idea of how others handle similar situations, read the trade publications, local newspapers, and consumer and business magazines relevant to your goals. Contact trade associations, such as the Stained Glass Association of America, Art Glass Suppliers Association, Glass Art Society, and the Small Business Administration, and your local and state chambers of commerce for information and assistance. Visit libraries; they provide sources of information, including numerous magazines and books on marketing, advertising, and general business practice.

SAMPLE MARKETING PLANS

1. Decorative Boxes

Let's say you're a new artist who creates limited edition decorative boxes. The boxes are utilitarian as well as decorative. You want to earn $15,000 profit the first year.

Using the outline of the above marketing plan, your sense of purpose would be to have your art sold at fine craft shows, stores, or glass boutiques around the country. Your customers are middle-income consumers who purchase hand-crafted products as decorative artifacts for their homes. They are discriminating buyers who like unique things. Your boxes differ from those of other glass artists because the colors and designs you use are those currently in vogue throughout the home fashion industry. You use art glass rather than cathedral glass to create a more artistic look and the solder joints are neater than your competitors'. Your glass boxes are more colorful than wood boxes and can decorate any shelf in any room. The designs vary to appeal to the different decorating styles indigenous to various regions around the country. You also create designs indicative of the seasons and holidays. This allows your customers to change their decorating scheme for holidays and seasons inexpensively and easily. You welcome custom orders and make boxes in a range of sizes.

Because you specialize in boxes, your logo and trademark could appropriately be one of your original designs. They would appear on your letterhead, envelopes, business cards, order forms, and invoices so recipients would be able to easily identify the boxes with you. You would reach the crafts stores and boutiques through direct mail and by participating in wholesale craft shows. Letters and brochures sent to craft stores would focus on the reasons your boxes are unique. The craft stores would be located in the geographic areas where your potential customers would most likely live. You would find a listing of craft stores in the booklet *Shopping for Crafts in the USA*, published by American Craft Enterprises. You would include pricing, credit terms, and delivery, and minimum orders in your correspondence to each

store or give them to interested retailers at craft shows. If you are selling directly to customers at retail craft shows, the retail price would be the same as your suggested retail price at craft stores. You would provide the retail customer with promotional material that describes the uniqueness of the boxes and also lists your special services such as custom-designed boxes.

2. Tiffany Reproduction Lamps

As a maker of Tiffany reproduction lamps, your goal is to sell them to collectors of Tiffany lamps, and of antiques in general. Antique dealers are your marketing outlet. Your goal is to net $15,000 the first year.

Your lamps outshine those of other lamp artists because of the skill with which the glass has been cut and soldered. Your lamps are fine reproductions due, in part, to the intensive study you've done regarding Louis Tiffany as an artist and a person, and your knowledge of the techniques used to make the lamps that carried his name. You attempt to incorporate as much of Tiffany, the artist, as you can into each lamp you produce. You use various art glass to reproduce as closely as possible, the colors and shade gradations of original Tiffany lamps.

You would reach antique dealers by advertising in magazines directed to the antique collector's market, such as *Art and Antiques*, *Antiques Magazine*, *Antique Peddler*, *Antique Trader* and *Treasure Chest*, and any local publications that advertise antiques. Your advertisement could be in black and white and include a photo of one of the Tiffany reproduction lamps. Because you're attempting to reach antique dealers that are familiar with Tiffany's lamps, the photo would represent a style that is easily identifiable as a Tiffany. You would identify yourself as a lampmaker and include a brief

description of your specialty and services, as well as your name, address, and telephone number. You would also have available additional descriptive and promotional material about your background and ability as a lampmaker to give to dealers who contact you. You would also frequent those antique shows and displays where buyers and sellers of Tiffany related glass find each other. Maybe you could place your business card with a dealer who might at first be interested in someone who can properly repair stained glass lamps? Such a service would be a perfect introduction to the quality of your finished pieces. Quality photos are a must. The point is, if the right people see your work, and hear of your work, they will consider your work.

3. One-of-a-Kind Sculptures and Lamps

You create one-of-a-kind sculptures from glass and want to be represented by galleries. You are not limiting your customer base to glass art collectors. Your potential buyers are individuals who purchase one-of-a-kind works of art in various media both for the aesthetic beauty and potential investment or increased value. Before you contact galleries, you would begin your marketing strategy by entering as many exhibitions as possible to generate credibility for your work and yourself as an artist. This would include local, regional, national, and international exhibitions sponsored by museums, galleries, and corporations. Exhibitions that give awards or whose sponsors are well known in the art community could be especially helpful to you. Each enhances your acceptance as a credible artist. They also increase the likelihood of sales through the exposure you would receive as a participant. Because you would build your reputation through exhibitions the first few years of your career, your sales goals would begin in the third year once your work is

in galleries. Success in selling one-of-a-kind work can come more slowly than selling production work. Its success depends, in part, on your reputation. As a result, you forecast a net profit of $10,000 beginning in the third year.

Your art is unique because of its style, construction or balance, and your use of colored glass. Most importantly, your work generates an emotional response. After two years of exhibiting your work and winning awards, you put together a professional-looking portfolio to send to galleries. The portfolio includes slides (or photos, depending upon what the gallery wishes to see), a one-page statement defining your work, a resumé listing your exhibitions, awards, magazines that featured your work, favorable reviews, and relevant educational information, in addition to a one-page cover letter briefly describing your background as a glass artist.

Once you're represented by the galleries on your marketing plan, you would continue increasing your marketability by participating in exhibitions, accepting commissioned work, writing articles for trade and collector magazines, and conducting workshops.

4. Stained Glass Panels

By choosing to design and make stained glass panels, you can market your work to homeowners, interior designers and decorators, architects, and public and private institutions such as hospitals, schools, churches, and local, state, and federal government agencies. You've established a profit goal of $12,000 the first year.

If you choose to make panels for home use, your end customers would be upper middle and upper income homeowners and home buyers. Incorporating stained glass, beveled, or frosted panels into a home are attractive additions

because they enhance the appearance and have the potential to increase the value of a house. You would work closely with the builder or decorator to ensure your panels are designed to fit into the architectural scheme and style of the house. Your panels are superior to your competition because you understand house construction and carpentry, are able to install the panels yourself, and use a wide selection of art glass to create individualized designs. You also work well with others.

You could promote yourself by sending a well-designed promotional package to decorators and builders of upscale homes, joining their professional organizations, and advertising in their trade publications.

To direct your promotion to the targeted group, you would purchase a mailing list of builders and decorators you most want to reach. You would find the names of companies that provide mailing lists in the classified section of the telephone directory. Kim Wickham of Wickamore Studios in Merchantville, New York, developed a successful marketing plan aimed at residential and commercial architects. On the front side of a product sheet was a color photo of an A-frame church whose front glass facade she designed. On the back of the product sheet was Kim's biographical information. The package included two slides, one of a contemporary installation and one of a Victorian-style panel. A cover letter explained who she was. In the letter she offered a slide portfolio for a $10 fee. Charging a fee weeded out those who were not serious. It also offset the cost of producing the slides. Kim followed up the mailing with a telephone call. "It put me above everyone else because it provided a personal touch." To major firms, she sent a three-ring binder with pictures.

Ads aimed at the consumer could appear in upscale regional magazines and home building and decorating trade

publications. Stained glass is a great attention getter. You would also try to generate articles in magazines and local newspapers about you and your work.

If your plan is to market panels on a large scale to public buildings, ask your state council on the arts to put you on their mailing list. Most states provide public art opportunities through Percent-for-Art programs whereby a percentage of a project's cost is set aside for the purchase of art. Awards are not always limited to state residents. Information about the programs nationwide can be obtained from the National Assembly of State Arts Agencies, in Washington, DC, or by contacting each state's council at the state capital. Specification requirements and proposal requests are publicly announced. Application forms specify the information required by each submitting artist.

5. Corporate Art

Whatever type of glass art you make, you have the opportunity of having your work purchased by corporations. If your plan is to market to corporations, galleries, art agents, and art consultants who work for corporations are your best inroads to the corporate art market. If your work is in a gallery, discuss with the gallery your interest in having your work made available to corporate collectors and collections. Give the gallery slides or photographs of work you think is suitable for corporate installations. This is important, especially if the work is different in size or style from your pieces seen in the gallery. If you contact art consultants directly, send them slides, slide descriptions, a resumé, exhibition list, and cover letter. Include in your exhibition list: public or private collections, media coverage and awards. The *International Directory of Corporate Art Collections* provides a comprehensive listing of corporations throughout the world that

collect art, the kind of art they collect, the business they're in, their address, telephone number and the contact person.

6. Church/Restoration

Plan a direct mail program to the governing body of churches, colleges and public buildings, as well as to architects if your goal is to make and/or repair church or institutional windows. In the direct mail package, include photos or slides of work you have done, testimonials from persons for whom you've done the work, and a resumé, listing your studies in history, restoration, and religions. Because of the inherent problems of restoring stained glass windows, a resumé is important. It will help prove that you know the historical and religious bases associated with the windows and that you understand the architectural considerations associated with restoration.

Constructing and restoring church, institutional, or architectural windows is a niche market within a niche market. It is a market well served by old line and established stained glass concerns with the facilities to handle the large scale of most church related projects. Opportunities in this area require more than skill, knowledge, and marketing savvy. Your studio must have the capacity, manpower, and insurance capabilities to encompass both the unusual dimensions of such work and the enormous financial responsibilities associated with it. Clients are as concerned with these requirements as they are with your studio's reputation for skillful work and fair pricing. Be aware of these requirements before you approach this market.

7. Retail Store

If you choose to sell supplies as well as glass art, your objective would be to get customers to buy the products you

222

sell, whether they come into your store or order through the mail. Your customers are hobbyists who work in stained glass as well as those who work in other media, such as wood, who may want to incorporate glass into their projects. Your customers would be young people, homemakers, and retired persons who would practice the craft and buy stained glass supplies to support their interest. Middle income consumers looking to purchase decorative objects for their homes and for gifts are another market segment. Your business plan calls for a net income of $35,000 at the end of the first year.

Your store is different and better than your competition because you offer more services, such as assisting hobbyists and artists with their projects at no charge and guaranteeing the tools and equipment you sell. You conduct workshops and are open convenient hours for your customers to shop. You are knowledgeable about every aspect of stained glass. Your mail order service with 800 and fax numbers enables customers beyond a convenient driving distance to purchase your products easily. Your selection of supplies is greater than any other glass retailer in your targeted area.

Your supplies are attractively displayed and accessible to your customers. Your showroom of finished products is separate from the supply area. Your mailers are attractively designed, offer new and well-known products, your pricing is competitive, and ordering by mail is easy.

To reach more potential customers, you conduct how-to and informational workshops, not only in your store, but at enrichment classes in your community. You give demonstrations at community functions to generate interest in what you sell and the services you provide.

To help generate the strategies for your marketing plan in whatever area of glass art you work, you would read the trade publications, art and craft magazines, local newspapers

and relevant consumer, decorating, and business magazines. You would contact trade associations, such as the Stained Glass Association of America, American Craft Council and local craft organizations.

Your objective would be to establish your business in the minds of your customers. Put your business in their sights; help and suggest to them the possibilities of stained glass as both a decorative item and a rewarding hobby. By reading what your customers read, talking the same language as they do regarding style, colors, interior fashions, and in the case of hobbyists, the rewards of creative stained glass work, you would establish a common ground. They would then be more likely to venture a trip to your studio or shop.

SALES PROMOTION MATERIALS

Having completed your marketing plan, you know where you want to go and have determined how you will get there. Well designed and professional-looking promotional materials will help you reach your goal. They include letterhead, business cards, brochures, newsletters, postcards, catalogs, press releases, and print, radio and television advertising. Brochures, newsletters, postcards, catalogs, fliers and letters can also be used as direct mail pieces; that is, information you send to a prospective customer's home or business.

To ensure that your sales promotion materials have the look you want and convey the message you want, unless you have writing and designing skills, rely on the skill and advice of experts. Work with advertising agencies, graphic designers, photographers, and writers experienced in creating promotional material. They're listed in the telephone directory under their specific categories. You can also call the chamber of commerce and ask for a referral from their membership roster.

224

Well designed and well written promotional material make a positive statement about your business. If you have them from the beginning, you have a better chance of generating sales. You will also save money by not having to redesign and reprint promotional materials that have not worked. Gear all of your promotional material to getting your business known and your products or services sold.

Good, professional marketing and advertising services need not be expensive. You will not be contracting with a Madison Avenue agency. Most local agencies are geared to local businesses and their smaller budgets. Talk to as many local ad agencies as you can. Get a feel for the kinds of work they do best. Some excel in print ads, others in direct mail strategies. Some specialize in packaging radio ads (the most overlooked of all affordable marketing tools) and local cable television air time. Talk to them and ask questions. Their attitudes, experience, and suggestions will help you determine which agency you will be most comfortable with.

Logo

Your printed marketing package begins with a logo. The logo is the foundation for all your marketing promotions. It is your company's signature and would appear on all your printed material. From your business plan, you've determined the kind of glass art or service you want to sell and who your target audience is. With that in mind, you are ready to develop a logo that defines the image you want to project. If you choose not to have a logo, but feel more comfortable using only your name, that's fine. Many glass artists use their own name, followed by the word studio to identify their business. The appearance of your name in a particular type style and size, will act like a logo and define your image to the public.

A logo is a very individualized statement. It can be a graphic design incorporated with a particular style of type, or simply the type style you choose to illustrate your name and address. Consider your logo carefully. Work with a graphic designer to create an appropriate logo, whether it's a visual or verbal symbol. A good graphic designer will ask you questions about your personality and your art before working on your logo. He, or she, will want to express your identity and the image you want to project in the logo. That is the designer's job. You are not paying simply for someone who knows how to draw and who knows about type.

Ask to see his, or her, portfolio to determine whether you like their style of work. Although the logo will be designed to suit you, the designer's particular style will naturally appear in the design. You need to decide whether the designer is successful in capturing the image of his clients' businesses in their logos. You may want to call some of the designer's clients as references. They may be the best judges of the designer's work and working style. Remember, it's your money and your business. Your business' logo has to serve your purposes first and foremost. Anything less will be a waste of time, effort, and your money.

Working with a graphic designer is a more cost-effective, creative, and professional approach to developing a logo than selecting stock art from your local printer. A graphic designer can arrange to have your business cards and letterhead printed, or you can take the design to your local printer. Check the cost of each and proceed as you see fit. In some cases, having your designer contract the printing will cost more. This extra cost will often be offset by the headaches and frustrations you will avoid if working with printers for the first time. Professional printing, especially high quality printing, is a very specialized craft, with a language and

226

procedure all its own. By having your designer include the printing in his, or her, proposal, the job becomes theirs. Good graphic designers are always working with a number of printers and understand the ins and outs of the printing trade. Their experience is a valuable asset to you, the client. The graphic designer can also create brochures and other sales promotion material to further develop, in print, your image and promotional package.

The initial cost of several hundred dollars to have a suitable logo designed and developed will be money well spent. Once the logo is designed, it can be put on all your business and promotional material easily and inexpensively. Developing an appropriate logo in the beginning of your career can save you money in the long run. Until you decide on the image you are most comfortable with, you could spend hundreds of dollars having a different style of letter-head and business cards printed every few months, not to mention brochures, newsletter and all of your other sales promotional material that may incorporate your logo. Establishing an identifiable logo in the beginning of your career creates a professional, identifiable image.

Business Cards

The most basic sales promotional piece is your business card. It provides the public with your name, address, and telephone number. It creates and furthers your image and serves as a reminder of the kind of glass art you create or services you provide.

Innovative, appealing business cards let your message be heard. Create an interesting card with your logo, graphics, photos, and highlights about yourself and it's likely people will remember you.

Most business cards are made of paper, and you have a

227

wide variety of types of paper from which to choose. However, consider other material such as colored see-through plastic if you work with stained glass, or a frosted look if your specialty is sandblasting. Have a photo of one of your best works reproduced as the front of a business card. Use the reverse side for logo, your name, address, and telephone number. Whatever material you choose, the cards can have a flat or glossy finish; they can be textured or smooth.

Identify your work by graphics or photos on the cards. The graphics can be your logo. Many quick printers can incorporate your own camera-ready artwork, such as your logo design, onto the card very easily. They can also reproduce photos.

Use color. Color is dynamic. Coordinate the color of your business card with the color of your stationery and other printed material to create a unified look.

Color adhesive labels are a great way to keep a photo of your work in front of people. They easily adhere to business cards and lets the recipient recall at a glance the kind of glass art you create. The labels can be made from transparencies of 35mm slides and come in a variety of sizes. For instance, Photo Labels in Carol Stream, Illinois, offers labels in sizes ranging from seven-eighths inch by eleven-sixteenth inch to three and three-sixteenths inches by four and three-quarter inches. They can include logo, lettering, and graphics on the label. Put the labels on as many business cards as you deem necessary for a period of time. Use a different label when you create a new design or product you want to promote. Incorporate different size labels on your letterhead, envelopes, brochures, and newsletters. It creates a unified look inexpensively.

Pop-up cards are another way to get attention. Put a simple message on the front cover such as "What pops up in

your mind when you thing of...." enhance the pop-up with a graphic or photo of your work.

Another choice is die-cut cards. Illustrate your work by having the front of the fold-over card shaped to the design of one of your products.

Cards made to fit Rolodex files serve a dual purpose, even though many Rolodexes are being replaced by computer databases. They fit into the file easily without the recipient having to write the information on a file card. Their design helps create a handy reference for the client of what you do and where to find you.

Use the back of the business card. If you have a retail shop or studio, put a map with directions to your shop or studio on the reverse side. Highlight significant achievements, awards, exhibitions, or collections. List special services you provide. Make as much use of the space as possible, always keeping in mind the image you want to project.

Portfolio

A portfolio is a collection of pertinent information about you, your art, and your business. You can use a portfolio to promote yourself to galleries, antique dealers, architects, interior decorators, magazine editors, potential buyers, and workshop organizers. It's a good marketing tool to have on site at your store or studio and at craft shows. The portfolio can include a resumé or curriculum vitae. Include slides, photos, a sheet that identifies them, pertinent news clippings of feature articles and favorable critical reviews, photos of work that's been in exhibition, and certificates of awards you've won. Show how your work has progressed with a series of photos.

A portfolio can be a three-ring binder or pocket folder, depending upon its use. If you provide a portfolio at a craft

show or in your studio or store for potential buyers to glance through, a three ring binder works well. Place all the information in plastic sheet protectors. Put the portfolio in a convenient location, such as on a corner of a shelf or table where people can easily see it and look through it.

If you are sending information to a gallery, antique dealer, architect, decorator, magazine, or television stations, a pocket folder makes an attractive inexpensive presentation. On the cover place a picture of your work. A three by five inch color adhesive label of your best piece makes a positive statement. In the pockets, include a one-page cover letter identifying yourself and a brief description of your work. A slide or photo sheet, showing six to eight different pieces that represent your style in a range of sizes should be accompanied with a sheet describing each slide or photo. The descriptive sheet should be typed or neatly printed. Include the dimensions, indicating height x width x diameter in that order in inches, the technique, the wholesale price (optional), and the year the work was completed. On your resume list all of your exhibitions, your education pertinent to glass, the names of newspapers and magazines that featured your work, awards your work has won, and public collections. List private collections only if you have the collector's permission.

Some galleries will want to see that your work has been in exhibitions, that it is credible to those in the glass art field. Other galleries will accept work whether or not it's been in exhibitions if they think it is appropriate for their buyers. If you want to place your work in retail outlets, craft stores, or glass boutiques, it's not necessary to have shown your work in exhibitions. Persons who shop for glass in a department store, craft shop, or glass boutiques usually look for an attractive piece of decorative and perhaps functional glass

230

art. They are generally not collectors looking for award winning one-of-a-kind work or pieces that have been in exhibitions, although such endorsements may succeed in distinguishing your work form others.

Direct Mail

Direct mail includes letters, brochures, couponing, postcard decks, inserts, statement stuffers, fliers, postcards, and catalogs sent directly to a prospective client. It can be a series of contacts, beginning with a letter and a brochure , a follow up postcard, another letter and a follow up phone call. Think of direct mail as a sales campaign, not a single mailing piece. Direct mail offers the ultimate in selectivity. You can choose the people to whom you'll market your products or services. Because you can determine the exact cost to you for each sale you make, direct mail can be very cost effective. It is a convenient method for the customer to order merchandise. It is easily accountable. By putting a cut-off date on orders or special promotions, you can determine whether your effort was successful. If your shop or studio is in a poor location, a direct mail program can be helpful. When using sales promotion material as direct mail pieces, keep the following in mind:

- Be sure the direct mail piece is centered on a clear and powerful idea—an offer to the prospect. Relate everything in the mailing to that idea. Tell it at least three times—in the beginning, the middle, and the end. Repetition sells.
- Use short words, short sentences, short paragraphs, and many subheads. It makes the piece look interesting and easy to read. The more you tell, the more you sell.

Direct mail is one of the aspects of doing business that has generated numerous studies, books, magazines, newsletters, and informational sources. If direct mail is a possibility for your type of glass business, you would do well to read up on as much information as you can before, while, and after you put your mailing program together.

Brochures

A brochure's purpose is to convince people to go to your store or purchase your art, or glass product. A brochure should impart information which benefits your customer, stresses the value of your products or services and highlight new features.

Brochures can be invaluable in promoting your business. They clearly and quickly project your company's image. They can be terrific sales stimulators if they are dynamic, interesting, and informative. They can be used as point of purchase attention-getters on your store's counter or as a direct mailing piece.

Brochures do not have to be expensive to convey your message and enhance your image. The price of producing a brochure can vary from a few hundred dollars to several thousand dollars depending on the kind of paper you use, the time spent in designing it, writing copy, and shooting pictures and the cost of printing.

Whether you are working on a limited budget, or money's no object for your brochure, you should allow 16 weeks from the start of production to completion of your presentation package. A good graphic designer or ad agency will outline the length of time each step in the process will take, and explain the different stages of production. When facing any printing project, the more you know and understand about printing conventions and operations, the better off

you'll be. A good relationship with an ad agency, or graphic artist is a very valuable asset to any visually oriented promotional endeavor.

Brochures can vary from a simple four panel two-color format on heavy stock paper to elaborate four-color pieces with gatefold pages that unfold into spreads. Brochures can range in size from four or six panels that fit into a #10 business envelope to larger custom sizes to meet your particular needs. Make the size appropriate for its use. If your product line varies, consider using a pocket brochure in which you add single sheet inserts. The information in the body of the brochure could remain the same, but as your products change, you can insert single sheets that explain the new products. Again, your graphics professional can guide you in choosing the proper print vehicle for your product or service.

Type style. The brochure should incorporate the same type style that appears in your letterhead, on your business cards, and throughout all of your promotional material. It creates a unified look. If it's used in conjunction with an advertising campaign, follow the same strategy as the ad campaign and expand on the campaign's theme. Use familiar graphics and logo. Your customers should be able to look at your brochure and identify it with you and/or your business.

Do not mix type styles. Use the same style of type with different weights (bolder or thinner type) for different purposes within your brochure.

Avoid type smaller than eight points.

Avoid printing long copy in reverse type, white on black. It's hard on the eyes.

The Cover. The cover is the most potent part of the brochure. You want it to grab the reader's attention. Use the cover to make the reader take action. You can do this several ways.

- Tell the reader what you want him to do—join, discover, look, etc. Involve the reader. The better the copy fits the interest of the reader, the harder it will work for you. For instance, "Ten Questions You Should Ask Before Buying a Stained Glass Panel," provides helpful information to the reader without sounding like a direct ad. It tells the customer you want him to be well-informed before he makes a purchase.
- Use an illustration or photo on the cover that tells a story. It will grab the reader's attention and make him ask "What's going on here?" Use only one illustration or photo on the cover. It's more dramatic than several small ones.

Layout. Keep it simple. By carefully combining copy and white space (empty space), a brochure communicates a sense of order and conciseness. White space is sometimes as important as copy. It is not simply what's left over when all your text is in place. White space allows the eyes to rest and the reader to absorb what he, or she, just read before continuing onto more information. White space is a positive attribute of the page. White space works best when it has a clearly defined geometric space; the reader perceives that it's supposed to be that way.

Use photos, illustrations, sketches, charts, graphs and diagrams, whatever it takes to promote your business and create a desire in the reader to buy.

Use testimonials from customers. They add credibility. Use a quote from an expert in your field. Use headlines and subheads.

Spotlight important information with graphics, boxes, bullets, and boldface type.

Text. Use as many words as is appropriate and necessary

to relate everything you want to say while keeping the copy from becoming a pale gray rectangle from either repetitive claims or too many unnecessary wordy passages. The visual grayness produced by a great deal of copy can be dull and tiresome to read. To avoid this, you can do a number of things:

- Break up the material on each page into bite-size chunks. The reader notices the material more quickly and absorbs easily. The shorter the paragraphs, the more appealing the material is to read.

- Indent paragraphs in normal fashion, or more deeply. Don't be afraid of widows (the last few words of a paragraph that appear by themselves on the last line). Like the indentations, if used properly they can let in white space. However, do not begin a new column with a widow left over from the previous paragraph. It looks unbalanced. Finish the idea of the paragraph on one page or one column.

- Begin the first paragraph of each copy with bold letters.

- Use headlines in a bold and larger type to highlight different elements within the brochure.

- Spotlight the important facts with bullets, bold type, or graphics. Tell the consumer about prices, the hours you are opened, any specials, what's included in the purchase. If you're selling glass panels, does the price include consultation, design changes, delivery, and installation?

Photos. Each photo you use should be a selling point. It should explain pictorially what is unique or important about the product it represents.

- Use photos instead of drawings. Photos suggest reality. Scenes of people are even more realistic.

- If you use photos, let one picture dominate the page. If all the photos on one page are the same size, their appearance can blend into one another with none of them being clearly defined.
- Always put a caption under a picture. Next to the cover, captions are the most frequently read part of a brochure. Captions that give relevant information are most effective.
- Blow up details for added impact.
- Chose a photograph of a glass panel, window, or lamp in a classic, rather than trendy, style. Classic styles date less quickly. They can prolong the life and usefulness of your brochure.

If you hire a photographer to shoot the pictures for your brochure, agree on a photo fee in advance. Some photographers fees are based on the creation time and usage. This means if a photo was taken for use on a brochure cover, you'd have to pay the photographer an additional fee to use the photo again, for some other purpose. Ask for a buyout of the photos so you'll own the negatives and have unlimited use of them. Negatives are usually the property of the photographer. If you do not get a buyout, whenever you need a black and white or color photo made, you would have to order it from the photographer. Talk to your photographer about using stock photos. These are photos that are readily available and could enhance your work or accentuate your message. For instance, if you're focusing on a southwestern theme, a desert scene could be the background for your art. Or for a more classic focus, a stock photo of a marble background could be used. Also to show how glass is made, or how glass objects are mass produced, stock photos of such processes could be appropriate and less expensive than an

Recap of Basic Rules for Better Brochures

1.Put the selling message on the cover.

2. Be helpful, not clever. Avoid humorous copy and gimmicky layouts.

3. Give practical, useful information.

4. Keep the layout simple

5. Give the brochure a look that resembles your other promotional materials

6. Use single illustrations on the cover

7. Select a picture that tells a story

8. Include captions with all pictures

9. Don't be afraid of long copy

10. Highlight the important facts

11. Use photos instead of drawings

12. Make the brochure worth keeping

13. Tell the truth

14. Be human—talk to one person

15. Ask for the order

16. It doesn't have to be expensive to be good.

on-site shooting.

Different films, filters, lighting, and techniques can create special effects, and stylish photos. For instance, lighting glass with a spotlight through the top radiates the light all over.

Prepare in writing a list of all the subjects you want to have photographed. Photography is an art and photographers will exercise creative judgment if allowed to. Be clear about what you intend to pay for. You could be charged for the photographer's time and materials for some photos, such as different angles, close-ups, etc. that you didn't want

Get the agreement in writing.

The more you can show the photographer what you want, the better he can serve you. Bring in pictures from magazines and catalogs that illustrate the kind of look you want. They give the photographer a place to begin.

Whether you design the brochure yourself or hire a professional, knowing the basic concepts of a well-designed

brochure is helpful.

Fliers

For store owners or craftspeople who sell at craft shows, fliers can be an inexpensive alternative to a brochure. Printed on standard size letterhead or legal size paper, fliers can contain information about your products or workshops. Standard size paper can be folded in half or thirds and easily used as a mailer. Scott Haebich of The Stained Glass Place

Drawing upon his background in graphic design and commercial art, Scott adds photos and drawings, uses a variety of type sizes, and styles to highlight the information. The fliers are interesting, informative, and visually appealing.

Scott uses fliers extensively in his direct mail promotions. Ten to twelve times a year, he sends them to a growing customer base with information about workshops, free seminars and demonstrations, new products, and special sales. "Fliers are the most important sales promotion tool I have," says Scott.

Many of the guidelines for developing your brochures can be applied to putting together fliers.

Catalogs

Catalogs can be an important adjunct to your store or studio. Include in them the products you offer, but send them to people who do not, or cannot, come into your place of business. As a direct mail vehicle, a good catalog, well designed and thought out to promote sales can extend the range of your business' sphere of influence, usually limited to a fifty mile radius around your location, to wherever your catalog can be mailed. Some astute stained glass retailers have found mail order catalogs to be an important part of their sales and marketing efforts. A new catalog, with the latest tools, glass

and special offers, mailed a number of times throughout the year, can not only increase sales, but increase the customer base as well. Glass enthusiasts and hobbyists who do not have local sources will naturally turn to mail order as a convenient way to buy their supplies.

Many of the guidelines that apply to producing brochures and fliers also apply to catalogs. Whether you employ a professional graphics person, or do your catalog in-house, remember the following:

- Use the cover to your best advantage. Catch the reader's eye with a dramatic picture of an art glass product related to your work and your company's image. Catalogs are generally lengthier than brochures.
- In addition to photos and information about your products, include as much information as you can about your company, its beginning, its growth, its principals, its employees.
- Write about the people. Let the readers know they're dealing with real people and not a telephone ordering system.
- Throughout the catalog include testimonials from satisfied customers. Nothing can be more convincing to a new buyer than to know other customers have been satisfied.

Look through the catalogs of the most successful retailers. Adapt their styles. Make it easy for the customer to order from you.

- Ensure customers their satisfaction is guaranteed. People place a premium of being satisfied with a product and if not, being able to return it with no hassle. Stress that in your catalog. For example, guarantee return or replacement privileges.

Newsletters

Newsletters are powerful sales aids that keep you in touch with current customers and enhance your chances to attract new ones. They can be high-impact, low-cost advertising vehicles for studio artists and retailers. They keep current customers informed about the growth of your business and potential clients of your success. They can tell readers what you've accomplished, awards you've won, seminars you've conducted, exhibitions you've been in, media coverage you've received, and trade conferences you've attended. They pre-announce sales, giving preferred customers first choice. They make readers aware of new products and services. They build interest in your products by discussing how they have helped other clients solve problems. They illustrate how to get the most benefit from your products. They show prospects that you have satisfied customers by providing testimonials. They keep readers informed of decorating trends, new products, and additional services. They prove your expertise. All of this is done without making a straight sales pitch.

Information in newsletters is presented in short articles that feature as many of the above topics as appropriate for your business. Newsletters should concentrate on news and information that will assist and educate your clients and prospective customers.

The information in newsletters is more important than its design. Keep it simple and easy to read. Start with a typewritten newsletter on your letterhead and upgrade it later to several pages with photos, boxes, and other graphic designs. Make it enjoyable to read so people will look forward to receiving it. Make it as personable as appropriate for your clients as you can, while always maintaining an element of professionalism. Keep it neat.

Send your newsletter out monthly, quarterly, or semi-annually depending upon the amount of information you have. Artists will generally find that sending out a newsletter in the early Spring and Fall works well. This alerts readers to upcoming exhibitions (most are which are held in the those two seasons) and recaps the exhibitions you were in since your previous newsletter. Include the names of any newspapers and magazines that mentioned your work, awards you have won, and new designs or techniques that you've developed. An easy way to dress up a newsletter is with small color adhesive labels. Feature one or two or more of your works with color labels in each newsletter. (If you're short on information, color labels can fill up the space) This lets people who aren't familiar with your work see what you do.

Newsletters can also generate sales. Describe the piece featured on the color label including its size, materials used, its application, and if it's been shown in an exhibition. If the work has been used as part of an advertising campaign, tell where it's appeared. If it has won an award, name the organization that presented it, where and when it took place. If it's the first in a new style or application, or employs a new technique, or new kinds of glass, mention that.

Newsletters are an especially helpful marketing tool for artists because they let your customers know that you are serious about your work, that you continue to build the monetary value of your work through exhibitions and new applications, and that you are interested in keeping them informed of your activities. Also, never forget that repetition in advertising leads to sales. The more your clients and prospective clients encounter you, your studio, or your shop's name, the more established you will become in their minds. When they are ready to buy, you will be the first they

241

7 Essential Elements of a Good Ad

1. It creates an identity. Incorporate into print ads the same distinctive elements, such as type, logo, and artwork that appear in all of your other work. The more easily people identify your company, the more easily they'll remember it. This recognition can translate into future sales.

2. Use a simple layout. Let the reader's eye move in a simple, logical sequence from headline to sub-headline to illustration to copy to price to your name, and logo. A dazzling ad might get initial attention, but it could lead from attraction to distraction.

3. Have a focus. Direct the reader's eye to a well chosen photograph or interesting artwork that will then lead to your message.

4. Feature customer benefits in headlines and copy. Let the customer learn why it is advantageous for him to buy what you're advertising.

5. Avoid congestion. Leave enough white (blank) space so the reader's eye can occasionally rest, so your copy can breathe. As in brochures, white space is an eye catcher that allows the copy to stand out.

6. Tell the whole story. Tell all of the most appealing points there are to know about your product or service. Be enthusiastic. Write as much as you need to convey your message. It might be the only time you'll have the reader's attention.

7.List the price. It prevents readers from over- or underestimating omitted prices. If the price is comparably high, justify it with the product's outstanding features, such as the timeless and enhancing beauty of stained glass and decorative glass items. If it's unusually low, let the customer know why, a clearance or special sale, etc. This dispels the reader's idea that a low price means low quality.

will consider. Your newsletter can be one of the most effective and convenient advertising tools you use.

As a retailer, insert coupons or free drawing forms into your newsletter from time to time and note the response. Feature information about your employees, new products, important commissions, or restorations. Let your customers know that you are their link to the world of stained glass. If you sell supplies to other artists, your newsletter can help establish you as their professional "ear to the ground," so to speak. Your importance to these customers will translate into loyalty and sales.

If the newsletter is on one sheet of paper, mail the news-letter in an envelope. It makes a more professional presentation than being folded in thirds and stapled. If several pages long, it's appropriate to fold it in half, staple the halves together and use a portion of the newsletter for the mailing label. Such a format is called a "self-mailer."

However you design and mail your newsletter, think how you would feel reading it. Put yourself in you readers' place. The recipients of the newsletter will probably feel the same way.

Print Ads

Print ads can be costly in terms of dollars and the production methods used to make an impression upon the readers. When putting a print ad concept or program together, you must first identify the audience you want to reach and the message you want to convey. These two all-important factors will determine what direction your ad will need to take to be successful. Before you place a print ad, look at ads in magazines and newspapers. Determine what you like or dislike about each. What catches your eye, makes you think or turns you off? In what way can the positive elements be used in your ads?

Your print ad should generate inquiries by instructing people to call or write for more information in the form of something free, such as a brochure, or catalog. If you're advertising out of your local area, include an 800 number.

Be sure these important instructions are clear and ac-curate. It may sound simple, but many ads have basic infor-mation like address, phone, and store hours misprinted, rendering the ad ineffective. Check, double-check and triple-check your copy for such errors.

Co-op ads provide a way to reduce your advertising

11 Ad-writing Tips

1. Write short sentences.
2. Use easy, familiar words

Do not waste words. Say what you want to say.

3. Use personal pronouns
4. Avoid cliches
5. Do not over-punctuate
6. Use contractions whenever possible
7. Translate product features into consumer benefits
8. Write from the reader's point of view. Avoid we, us, our
9. Be singleminded
10. Use testimonials
11. Let your ads build consumer confidence in you and your business.

costs. A co-op ad is simply one large ad featuring the products and/or services of a number of merchants, all of whom share the expense of producing and running the ad. You can plan a co-op ad campaign with shops in your community. Some ad agencies do not limit co-opping to print ads. They can also offer attractive rates on block radio advertising and local cable TV, one of the most exciting opportunities for today's small businesses. If your shop or studio is in an historic or otherwise unique locale, your co-op ad can attract browsers and tourists. Do not dismiss the fact that customers seeking out other businesses in the co-op effort may find your ad attractive enough to chance a visit to you. Co-op advertising can enhance your product, service, or business effectively and inexpensively.

Telephone Directory

The Classified telephone directory is the most important place to advertise. It is the most likely place consumers look to find glass studios and retailers, even if you don't use a display ad. Be sure your business is listed in the Yellow Pages under "Glass, Stained and Leaded." Try to list everything

you do including repairs as well as decorative work and classes. Describe your selection of books, tools, supplies, collectible, etc., if your business is such. If you sandblast or etch, say so in your ad. If your work is appropriate for homes, restaurants, churches, antique collectors, let the reader know. Say as much as you can about what you do.

As in any print format, a good ad gets the reader's attention. It uses trigger words such as new, now, at last, finally, amazing, free, how to, suddenly. It generates interest, it creates a desire, and impels the reader to take action. It must look like it's worthwhile to pay attention to. Remember that people look to the Yellow Pages once they have decided to buy something, not just to browse. Be sure these customers encounter your business' ad when they begin looking.

PUBLICITY

"If you want to position yourself best for publicity, give the person as much information as you can and try to figure out what to do to make their job easier,"
—*Paul Stankard*

Publicity is part of marketing. It is the information you provide about your business to the media. Publicity, or business news as it's also called, generates from the business, not the news media. Unlike advertising, you don't pay the publication to print the information about your business.

Publicity plants a seed. It's a method of putting positive information about yourself and your company out to the public. Businesses thrive on publicity. The more favorable news people read about you, the more likely you will increase your business. Whatever your market niche, you can benefit from publicity.

Through free publicity you can generate new markets, target your audience, and project yourself as an expert in glass. Whether you've just turned your hobby into a business, have been a retailer for years, or have a reputation as a artist, you can generate newsworthy information that will get your name in print.

Going from a hobbyist to a businessperson is news; hiring or promoting someone is news; expanding or renovating your business is news; developing a new product, design, or technique is news. So is attending a workshop, offering a special service, going after new markets, making public appearances, sponsoring special events, receiving an award, exhibiting your work and submitting designs. The list is endless.

Getting free press is not difficult. Newspapers and magazines rely on businesses for information to help them fill their pages, and fill their pages they must. Much of what we read about businesses is publicity, probably generated from press releases from the companies themselves. Publications such as Glass Art, Professional Stained Glass Stained Glass News, American Craft and The Crafts Report welcome news from artists and craftspeople. In addition, there are a number of decorating, architectural and hobby magazines as well as regional magazines and local newspapers. Read any of these types of publications and you'll see information about glass and glass artists.

The easiest and most common method of providing the news media with information is a press release. Newspapers and magazines not only use information submitted on a release, but use the release to generate additional articles about the business or individual. A press release not only gets news about yourself and your company in print but could establish you as a valuable source of information about

the glass field. Your involvement with glass makes you alert to economic, education, environmental, decorating, and industrial trends that could affect others in the glass field as well as consumers.

The information in a press release must be newsworthy. It can not sound like an ad. It must provide information that the editor believes will benefit his readers. What is considered newsworthy varies among publications. Information about being open extended hours could be of interest to readers of your local paper, but not to a technical magazine. A new technique that you have developed or a new application you've discovered would be interesting to readers of Professional Stained Glass, Glass Art or Stained Glass News, but not to readers of a regional lifestyle magazine. Read the publications and understand the type of information they publish. No matter how interesting your information is, if it's not appropriate for a publication, it will not get published.

Learn what their lead times are. Lead time is the number of weeks or months before publication that you must submit your press release. Daily newspapers usually like to receive press release about two weeks before the release date; quarterly and monthly magazines work on a six to eight week lead time. If the information is seasonal, for instance, if you have a Christmas design pattern appropriate for a general decorating magazine, send it in six months before the publication date. If the publication has a special issue, they might require a longer lead time. Gale's Directory and Bacon's Publicity Checker lists the names of magazines and newspapers throughout the country. Both of these publications can be found in a library's reference section.

Press releases give you control over what is printed about yourself and your business. "Along with the basic information, the best press releases include interesting quotes by an

artist about how his or her work has changed, why he, or she, has changed and what his or her goals are," says Betty Freudenheim, craft critic for Glass magazine and the New York Times. "People like to know how the artist's work differs from others in his field. An explanation of his or her technique in simple terms, makes an interesting press release." Send out press releases regularly. Make them the basis of your publicity campaign.

Press releases are simple to prepare. Editors don't expect you to have the writing talents of a Pulitzer Prize winning author, but they do expect the release to be written in a concise, coherent, and grammatically correct manner with all words spelled correctly.

Press releases follow a standard format. They should be typed and double-spaced on 8 ½ x 11 inch paper with two-inch margins. Use a simple type style and letter quality printout.

The first page should be on your letterhead. Subsequent pages can be on plain white paper. At the left margin, a few spaces down from your letterhead, type the word CONTACT in capital letters, followed by the name and telephone number of the person the editor can contact in case he has a question about the information in the press release. The CONTACT name is important even if your name appears in the letterhead. Editors look for the CONTACT name. In either the upper right or left hand side, place the current date as you would for a business letter. A few spaces down, at the left margin, type FOR IMMEDIATE RELEASE or FOR RELEASE ON (and the earliest date you wish the information to appear). This helps the editor determine at a glance the timeliness of the information and when he should plan to print it.

Start the release one-third of the way down the page.

Center a headline above the body of the release. This headline might not appear in the paper, but it gives the editor an idea of the kind of information the release contains. It is a working headline. Beginning the release one-third of the way down the page gives the editor room to write a different headline.

Two spaces below the headline, begin the body of the release. Indent five spaces and type the name of the city from which the press release originates. This is called the dateline. Separate the dateline from the body with two dashes.

The press release can read like a news story. Put the most important information in the first paragraph, less vital information in the second paragraph, and the least relevant information in subsequent paragraphs. This enables the editor to cut the story to fit his space restrictions without eliminating necessary facts or having to rewrite the release, or tossing it because it's unclear.

In the opening paragraph answer the questions who, what, where, and when. Tell the readers who you are, what you've done or will be doing, and where and when it has taken or will take place. In the second paragraph, answer the questions how and why, if relevant. Tell how you accomplished what you did and why you did it. In subsequent paragraphs, include additional information relevant to the topic. Keep the release to one page if possible. An editor can more easily find space in his magazine or newspaper for all the information on a one page release than he can on a release that has two or more pages of information. Also, the information you provide on one page can be enough to generate his interest to do a feature article about you or the topic you've discussed.

Whenever possible, deliver press releases in person. This further identifies you to the editor. Send all releases to the appropriate editor. Releases would go to the business editor,

arts editor, or features editor of a newspaper depending upon the topic. Always address a press release to a person.

Whether you have sent the release or delivered it in person, do not call to ask if it will be published. Such interruptions are an imposition upon editors. If they believe your release is newsworthy, they will publish it.

Photos

When a photo is appropriate for use with your press release and it's going to a newspaper, include a 5 x 7 inch glossy black and white photo with an appropriate caption. The photos must be in focus and on a plain background. Betty Freudenheim urges you to get good photographs if you want them to be used. "Often the background is inappropriate or slightly out of focus," says Betty. The further away from the original print the photo gets, in terms of graphic reproduction, the less clear it becomes; it loses in subsequent translations from format to format. This is especially noticeable in the publishing process of newspapers. Make the photo look as clear, sharp, and in focus as possible, with few shadows, highlights, or other distractions.

When you send a photo to a newspaper in connection with an exhibition, the photo should be of one of the pieces at the exhibition. If that's not possible, the photo should represent the style of work that's being shown. Betty says she frequently receives photos from artists who are participating in exhibitions and the photos not only aren't of works that are in the exhibition, but don't even represent the style of work that's being shown.

When a photo appears in a newspaper, it serves as an ad. People are drawn to an exhibition, for example, because of the photo. If the illustrated work isn't at the exhibition, it paints the artists as unprofessional as a businessperson, espe-

cially if people attend the exhibition with the intention of buying the piece that appeared in the newspaper.

Caption

A caption is important because sometimes editors will use only a captioned photo instead of the release. The caption should be one or two sentences long. It should clearly identify the object or person in the photo and be understood by the reader, especially if the photo is used without an accompanying release. If you have won an award for your work, the photo could be of the winning piece and the caption could say, "Jane Doe, a stained glass artist from Glassboro, New Jersey, received the 1992 Horizon award from Fine Glasswork magazine for Awakening a stained glass panel 30" high by 18" wide. This was the first time in the magazine's 35-year history that the Horizon award was given to a stained glass artist." At the end of the caption, type the words "Photo by" (and the name of the photographer.)

The sheet of paper on which the caption is written should be as wide as the photograph. The top half of the sheet should be taped to the back of the photo. The information should appear just below the photo. This enables the editor to look at the photo and read the caption at the same time. Never write on the back of a photo. The ink could come through during the printing process. Adhere a small label with your name and address on the bottom of a back corner of the photo. This identifies the photo if it becomes separated from the caption. If you want the photo returned, neatly print the words "Please return to" on the label above your name. To protect the photo from cracking and bending, send it in an envelope with a sheet of cardboard the same size as the envelope.

The photo probably will not be returned. They usually

aren't. Be pleasantly surprised if it is, but don't expect it to be. For this reason, you should never send out your only print of any photo. Have enough copies made of important photos to take advantage of opportunities as they come up.

Slides

The nature of glass invites it to be seen in color. Ask the magazines if they want a color slide or a transparency of your work. Glass magazines, like Professional Stained Glass welcome slides and transparencies from artists. "We like to know what artists are doing," says the publisher. "The slides don't have to be accompanied by a press release, but we like to receive a resume, a description about the project, and anything else that helps us perceive the project in terms of importance for clients, or its technical applications. It doesn't have to be a formal presentation."

If the piece in the slide is to be used for publication, and has been installed in a home, office, or other building, show the work in place. It gives the reader, homeowner, designer, contractor, architect, or builder a sense of scale. *PSG* invites artists to send slides at any time, but at least 120 days ahead of publication if you would like it to appear in a specific issue.

Publicity Campaign

A carefully thought out publicity campaign is as important as a business and marketing plan. It gives you a road map for promoting yourself inexpensively. It keeps your name in front of the public. A publicity campaign is what you want the public to know about your art and your business. It can include press kits, featuring two or three articles abut your company with photos or slides, or be as simple as a one-page press release.

Begin your publicity campaign by listing everything you

do in your business that could enhance its perception to potential customers; anything that is of interest to art, craft, glass, decorating, consumer or architectural magazines, or to local newspapers. Include exhibitions, awards, workshops, increased services, new techniques, expansion, promotions, special events, design patterns. Maintain up-to-date bios on yourself and everyone involved in your operation. Accumulate a history of your business along with photos.

Decide which audience you want to reach and consider the appropriate media from local newspapers, regional, national, trade, consumer, general and specific magazine, professional and technical journals, and international publications. Choose the appropriate information from your files and write with the publication's specific audience in mind.

When you're showing your work through an exhibition or at a craft show, send press releases and photos to the organization sponsoring the exhibition or show. Reputable, well established shows will conduct their own publicity campaign and will send press releases and photos of representative work to the news media. This is an excellent way for you to get news coverage and promotion without having to do much of the work.

Here are two sample publicity plans: one for studio artists, the other for retail stores. The press releases would be sent to local newspapers and magazines as well as glass and art magazines. News of national interest could be sent to the wire services, such as the Associated Press.

PUBLICITY PLAN—STUDIO ARTIST
January:
Prepare a press release about a corporate exhibition of your work. Include one photo with each release. Send the release to your local papers. If the corporation is not planning a

publicity campaign, send the release to the papers that serve the community in which the corporation is located.

February:
Submit a press release and slides to glass magazines about a new technique you've developed. The slides would be of work representing the technique. This could lead to your writing an article for a glass magazine about that technique.

March:
Send a press release to local papers, glass, and craft publications about your participation in an artist-in-residence program you've been accepted to. This identifies you to the local community, and increases your credibility as an artist to trade publications and organizations.

April:
You've received a public commission. Send a press release and background information to local papers, glass and craft publications, general interest magazines and newspapers in the community the commission will be installed.

May:
Send a press release to local papers, regional, glass, craft and art magazines about a grant you have just received.

June:
Send a press release to local papers and trade magazines about coverage your work has received in a major newspaper. Include in the release why your work was written about in the *New York Times*, for instance. Was your work in an exhibition? What did the reviewer say about it?

July:
Send a press release to trade publications and your local papers about your new instructional video. When sending it to your local paper, be sure it doesn't sound like an ad. Stress the benefits to the paper's readers of your having prepared the video, how it was produced and the benefits of the

information and techniques it describes.

August:

Send a press release to local and trade publications about being named a finalist in the XXX magazine award. If you win any of the awards, send another press release at that time, with a photo of the winning piece.

September:

Send a release about inviting the public to your studio for a special sale and to help them learn more about the glass making process. To make the information acceptable to your local paper, the studio tour should be free of charge. The release can include information about the types of equipment visitors will see as well as their being able to take a step-by-step tour of crafting glass and seeing the finished products. This should sound like a public service, educational project.

October:

Send a follow-up release after the public has visited your studio. You can thank them for their interest and discuss some of their questions. Include photos you've taken of persons participating in the tour. Also, announce that you plan to host another open house in the Spring.

November:

Send a press release to local, regional, glass, craft, and art publications about your acceptance to a glass program, such as those offered by the Creative Glass Center or Pilchuck. This increases your credibility as an artist in the eyes of collectors, gallery owners, and museum curators.

December:

Send a press release to local, regional, glass, craft, and art publications about a museum asking you to make a Christmas tree ornament for their annual trimming ceremony.

PUBLICITY PLAN FOR RETAIL STORE

January:

Send a press release to local publications about giving free workshops to a special group of people, e.g., school children, senior citizens, etc.

February:

Send a press release to local papers and trade publications about your expanded product line. In the release to local papers, you can highlight the fact that you are carrying additional products as a result of the favorable attendance and interest from the special groups who attended your free workshop in January. In the release to the trade publications, you can stress how the increased product line makes you a major supplier and how it came about as a result of your January workshop.

March:

Send a press release to local papers about hiring additional employees. Emphasize the growing interest in glass as well as what you see as a reflection of a growing economy and higher employment in your community.

April:

Send a press release to local papers about receiving an award from your national glass association. Ask the organization if they'll send out a release to trade publications. If not, do so yourself. In the release to your local papers, explain what the organization is, how interest in decorative glass is growing, and how your receiving the award benefits the community.

May:

Send a press release to local papers about your establishing a local craft fair. Springtime is a great time for craft fairs. Mention how your fair is unique, what it will include, and how it will benefit the community.

June:

Send a press release to trade publications and the wire services announcing your new 800 number to service customers outside your local area. You can tie this in with the success of your craft fair, which indicated a widespread interest in glass. As a result, you're now reaching out and extending your services to people throughout the country.

July:

You have written an article about using stained glass in decorating homes and offices for a national home decorating magazine and another for a business magazine . After the article is published, send a press release to local papers, regional magazines, and trade publications announcing the article's publication and how it has helped make the public aware of the beauty of stained and decorative glass.

August:

Send a press release about your teaching stained glass as part of your local school's continuing education curriculum. Highlight the growing interest in stained glass you've noticed over the past year. Include the benefits to the program's participants and how your class will promote a greater understanding of stained glass as a craft and an art form.

September:

Send a press release to your local paper about your attendance and/or participation at a trade show. This increases the public's perception of you as a professional, as someone who is interested in his trade, and bringing the latest information to his customers.

October:

Write an article for your local paper's special section on decorating with stained glass for the holidays. This can tie in with your fall classes and with the article you wrote in July.

November:

Send a press release about workshops your staff attended. This can reap the same benefits as your September release.

December:

Send a press release to local papers and trade publications about expansion plans you have scheduled for January. Focus on the increased interest and demand in stained glass. The release to glass publications can focus on how you are altering the layout of your store to improve traffic flow and product sales.

Plan your press releases and information around holidays, discussing special gifts for Valentine's Day, graduation, weddings, Easter, Christmas, Hanukkah, and any community related anniversaries.

Many newspapers have special sections throughout the year featuring topics such as: wedding preparation, home improvement, gardening, and local seasonal festivities. Think how your products and services can be appropriate for these different sections and approach the proper sources to suggest an article, photo, or feature.

Once you've written a magazine or newspaper article, consider writing for that publication again. They liked what you wrote the first time or they wouldn't have printed it; they'll likely welcome your ideas for other articles.

COMMUNITY INVOLVEMENT

Press releases are only one method of getting your studio or store known in the community. Volunteer to speak about glass art at local groups, in schools, at libraries. Sponsor local sports teams or donate a gift to a charitable event.

Museums and non-profit organizations sometimes conduct silent auctions. Make your product or service available for such programs. As a contributor, you place the value on

your product or service and decide the amount of the minimum bid. In such auctions, you do not give your product or service away for free, but you do give a percentage of the final selling price to the organization.

Join any organization that works to benefit the community and offer to have a meeting in your studio or store. One glass artist hosted a Christmas party in the retail section of his studio and sold several hundred dollars in gift items as a result.

Offer to distribute another non-competing business' brochures in your store if they'll distribute yours. Find a business whose products may enhance yours, and vice versa, like a home improvement business or decorating firm. Such connections can mean long term relationships with value for all concerned.

Rather than donating money to sponsor an event, offer to give a gift. Your company's name can get lost on a roster of donors. A free gift, especially if it is substantial in value, could generate free publicity, and turn into sales.

Look around your community, understand your audience, focus your energies, and you can come up with various ways to get free publicity that can generate business.❖

13

Accounting

"Many small business enterprises which seem to have all the
ingredients for potential success—a good product, a hardworking
owner—nonetheless operate far below their potential or even fail
because of inadequate financial records or the ability to
interpret records properly."
—*Michael Scott*, late editor and publisher of The Crafts Report

A set of books is like a road atlas. The ingredients to travel
are there, but the lines must be read and interpreted
before you can arrive at your destination. Your financial
books contain information that make up a financial atlas of
your business. Accounting interprets that information.

Accounting and bookkeeping/record keeping are re-
lated, but different. A bookkeeper records the income and
expenses of your business; an accountant uses those records
to determine whether your business is showing a profit or
reflecting a loss.

The larger and more complex your business, the more
likely you'll need an accountant on a regular basis. Even if
you're operating a one-person studio, it could benefit you to
have an accountant set up an accounting method or proce-
dure when you begin your business. This will help you
determine the records you must keep and enable you to see

on a regular basis the profit or loss your business is experiencing, where it's experiencing it, and how to increase the profit or correct the loss.

Even if you do not use an accountant during the year to interpret the financial information of your business, using an accountant's services at least once a year to prepare your taxes could help ensure that you receive all the allowable deductions on your return.

ROAD MAPS IN THE ACCOUNTING ATLAS

Your accounting picture will include information from the following:

- Accounts payable—used to record what your company owes to creditors and suppliers
- Accounts receivable—records the balances which customers owe you.
- Cash receipts—records the cash your business receives
- Cash disbursements—records your business' expenditures
- Equipment—records your company's capital assets, e.g., equipment and furniture.
- Inventory—records your company's investment in stock which is needed to arrive at a true profit on your financial statement and for income tax purposes.
- Sales—records and summarizes monthly income.
- Purchases—records the purchases of merchandise bought for the business.
- Payroll—records the wages of employees and their deductions, e.g., taxes.

Peggy Karr

Peggy Karr fell "passionately in love" with stained glass almost from the instant she began working with it in 1974. Now a wholesaler of fused plates, Peggy first made glass terrariums and then custom designed lamp shades, but found the process of cutting little pieces of glass, foiling, and soldering them into shades to be labor-intensive and time consuming. It wasn't much fun for her.

"I liked the intensive colors of stained glass and thought if I could color the glass, not just paint it, I'd find satisfaction in making shades." says Peggy. After reading a book by Harriet Anderson about fusing glass, the former ceramist and potter dusted off her pottery kiln and experimented with fusing layers of glass together. She found that fusing wasn't good for lamp shades, but that the process made wonderful plates. She spent the next two years testing different methods, techniques, and styles. "Of all the techniques I've used in working with stained glass, I found fusing to be the easiest, most fun, and most rewarding." After three years, Peggy believed her plates were well crafted and well designed enough to present them to the public for sale.

"Craft shows were the most logical places for me to market my plates, but I didn't want to go to retail craft shows every weekend.

Because I love my craft but hate to have to sell my work, I chose to market the plates at wholesale shows where I would display them and take orders for a specified number from various retailers, such as gift shops, department stores, and gourmet shops. The retailers in turn would sell the plates to the public. At the time, around 1987, the Rosen Agency was just beginning to organize wholesale shows and because I was the only person who made fused plates to apply to the show, I was accepted."

The plates were an instant success. After participating in the Rosen Agency's Buyers' Market, Peggy applied to the 1988 New York Gift Show the day it opened its craft section. She wrote $10,000 worth of orders at the New York show.

In the beginning, Peggy made all the plates herself and had enough business sense to take orders for only as many plates as she could make. Working out of a small studio apartment, Peggy's overhead was low and she reinvested all the profits into the business. The operation snowballed. In a few years fusing layers of stained glass went from an idea to nearly a million dollar company.

Today, Peggy Karr Glass employs several persons who design, cut, transfer, fuse, finish, package, and ship the plates to more than 3,600 customers throughout the world. The plates are sold in gift shops, hospitals, gourmet shops, department stores, museums, and Disneyland. Among the museum shops that carry her work are the Metropolitan Museum of Art and the Museum of Natural History in New York. Special designs have been commissioned by corporations who present the plates as gifts to their customers and vendors. Custom designs as well as stock designs in motifs depicting fruit, vegetables, flowers, fish, and animals are made into saucers, bowls, plates, platters, tabletops, and clocks. Peggy refers to the plates as decorative, yet functional, artware. They are non-toxic and dishwasher-safe.

She also still attends wholesale shows throughout the country ."The craft market in general is strong," says Peggy. "People like to buy handcrafted work."

The markets for her plates continue to grow. The ideas continue to come.

ACCOUNTING METHODS

The two accounting methods used by businesses are the accrual method and the cash method.

Accrual Method

Income is reported in the year earned and expenses are deducted or capitalized in the year they were incurred, regardless of whether the money was received or spent during that year. For instance, suppose you order a large quantity of glass in December, but aren't billed until January. With the accrual method of accounting, you would list the expense of the glass in the year it was ordered, not the year in which it was paid. Regarding income, an invoice you sent to a customer for a panel would be credited as income on the date it was sent, not the date payment was received. The accrual method of accounting can be beneficial and provide a tax advantage if you carry a large inventory of unsold work, because you can deduct the cost of the materials the year they were purchased, while waiting until the products are sold to record the income from the inventory. If you have a large inventory, the accrual method can give you a clearer picture of your financial condition.

Cash Method

In this method, income and expenses are recorded in the same tax year in which the money is received or expended. This is commonly used by small businesses. It cannot be used by corporations or partnerships having a corporation. With the cash method, the glass you ordered in December and paid for in January would be recorded as an expense in the year in which you paid the invoice, not the year in which you ordered the glass. Income would be recorded when payment is received, not when the statement was sent out, as in the accrual method.

264

Once you determine which method you should use, you can begin your accounting system. This includes keeping records of assets and preparing financial statements. From the records you've kept in your ledgers and journals, your accountant can prepare statements that will help you analyze the financial position of your company, such as whether adjustments in income or expenses are needed to increase your profit the following year.

Two of the most commonly used financial statements are the balance sheet and the income (profit and loss) statement. They are designed to show you how your business is doing relative to the goals you've established.

BALANCE SHEET

The balance sheet shows your company's assets (what you own) and liabilities (what you owe) and your net worth (assets less the liabilities) for a particular date. Subtracting the liabilities from the assets gives you the equity (net worth) of your business. The figures are taken from your ledgers and journals. Most balance sheets are prepared by an accountant, usually once a year. If the assets and liabilities of your business are simple and straightforward, you can probably prepare the balance sheet yourself with information taken from your income tax return.

Assets

For accounting purposes, assets in your business are all the things you own that can be measured in terms of money. That includes real estate, machinery, equipment, cash in the bank, inventory, and raw materials. Assets are broken down into:

- Fixed Assets—real estate, tools, equipment
- Liquid Assets—bank accounts, inventory, and ac-

counts receivable (assets that can easily be turned into cash)
- Tangible Assets—assets that have physical properties such as equipment and inventory
- Intangible Assets—assets that don't have a physical property, such as studio or store's good will or a list of customers, or a unique glass process

Liabilities

Liabilities are what you owe in money, goods, or services. Bills you haven't paid are liabilities. Glass art paid for by customers but not yet shipped by you are liabilities. There are current and long term liabilities. Current liabilities are those whose payment is due within the current year. Long-term liabilities are obligations that extend over several years, for example, mortgages or bank loans.

PROFIT AND LOSS STATEMENT, ALSO KNOWN AS INCOME STATEMENT

The profit and loss statement should really be called the income and expense statement. It is a summary of all your income and expenses over a period of time, usually one year. This is a statement you can prepare yourself by taking the figures used in each category in preparing your income tax. Because the P&L clearly shows the profit or loss of a business, its impact is immediate. If your profit is lower than you expected or wanted, an accountant can use the P&L to analyze various aspects of your business transactions.

The balance sheet and profit and loss statement show the financial picture of your business at a specific time. They're important documents. However, the most important financial aspect of your business is your cash flow.

266

Cash Flow

This is the amount of money a studio or shop needs to carry on business from day to day. All businesses function on cash. Successful businesses maintain a sufficient cash flow. Understanding and controlling your cash flow enables you to have enough cash on hand to pay your bills, to plan for future expenditures such as craft shows or promotions, and to put money away for months when sales are slow but regular expenses need to be paid. The term "cash" refers to cash, checks, money orders, and checking accounts. Because having enough cash is important to your business' economic health, use a cash flow chart to keep abreast of cash flow and your current cash position.

This is designed to estimate future cash receipts, outlays, and balances. A cash flow chart for your business is like a budget for your personal expenses. List your expenses due each month on the date they're due. This will show you how much money you will need at various times of the month. Comparing the actual results with the estimate at the end of each month can help you adjust your strategy to increase sales, lower expenses, or plan for seasonal fluctuations in cash flow.

CURRENT CASH FLOW

If you discover cash shortages are anticipated, there are several things you can do to remedy them.

- If any of your customers, more than likely your professional accounts, are given thirty days to pay their bills, consider offering the customer a 4 or 5 percent discount for paying sooner, rather than the normal 1 or 2 percent discount. Or mail your invoices so they reach your customers far enough in advance so you can expect payment by the time you

267

need the money.

- Line of credit. If you established a line of credit when the business was showing a strong profit, utilize it in times of need. Credit can be a lifesaver during lean months, although it makes good business sense to use it judiciously and sparingly. Always establish credit when you have assets and cash.

- Reduce your inventory from a 60 day to a 30-day supply. If you spend $5,000 on inventory every two months, by ordering half the amount of supplies, provided, of course, that your business can operate properly under such conditions, you'd free up $2,500 in cash to pay bills.

- Ask your creditors if they'll wait an extra week or two for payment. No creditor likes to wait. But they would certainly appreciate your communicating with them concerning your bills than having to chase you around for payment. Needless to say, this should be done only when absolutely necessary.

Your accountant can help you determine the amount of cash you need to operate your business during a period of time, for example, three, six, or 12 months. Cash flow is one of the two measuring sticks of success in operating a business, the other being profitability.❖

14

Bookkeeping and Record keeping

*"A good record keeping system increases the chances of
survival and reduces the likelihood of early failure."*

Maintaining accurate records is vital to every well run business. It helps a business owner determine his deductions, expenses, income, and tax liability. It makes applying for credit easier. It enables a business owner to get the maximum benefit by taking all the deductions, he or she, is permitted. Inventory records can show you what products are selling, which ones are not, and whether certain products sell better at different times of the year. This can help you plan your production and relieve you of the financial burden of buying inventory when you don't need it. Keeping track of your advertising results and expenses can help you determine the best method to advertise to get the most response for your advertising costs. Accurate record keeping helps the new business owner increase his chances of staying in business and the experienced business owner, his profits.

The more simplified your record keeping system, the easier it is to know the status of your business, to track the

successful endeavors, and unsuccessful ventures, to prepare financial statements and income tax returns, and to maintain the information about your employees' income and withholding taxes that the government requires.

An adequate record keeping system can show you:

- How much money you're spending over a given period,; how much you've earned, and how much is outstanding in accounts receivable.
- How much cash you have on hand and in the bank.
- How much money is tied up in inventory.
- How much you paid out to suppliers and creditors.

Don't let the government's requirements or your own need for accurate record keeping overwhelm you. A record keeping system can be simple. In fact, a good system is simple to use. It is also easy to understand, reliable, accurate, consistent, and designed to provide you with the information you require, whenever you require it.

THE RECORD KEEPING SYSTEM

The accounting/record keeping system can be either a single- or a double-entry system.

Single Entry

The single-entry system records the flow of income and expenses by keeping a daily total of cash receipts and monthly summaries of cash receipts and disbursements. You simply note in the journal the date of the expense, the company you paid, and under the appropriate heading, the amount of the expense. It includes only business income and expenses. If you operate a one-person studio, you might find it easier and less time consuming to record all your income and expenses once a month. As your business becomes more

complex, you might find it more appropriate to keep records on a daily or weekly basis. A single-entry system is a simple and practical system appropriate for small businesses.

Double entry

In the double-entry system, daily transactions are entered in a journal and then their summary totals, usually at the end of each month, are recorded in the general ledger accounts. The double-entry system has built-in checks and balances to assure accuracy and control. Each journal entry is made up of debits and credits. When the amounts are entered into the ledger accounts, the total of the debits equals the total of the credits and the accounts are in balance. The double-entry system is more burdensome than a single-entry system and is usually not necessary for a small glass business. If you are undecided about which system is best for you, consult your accountant.

Record keeping systems are available on computer software programs. Many are designed for maintaining employee and business records whether you operate a one-person studio or employ several persons. Record keeping software programs are designed to work for any kind of small business, and because the tax information you will be required to maintain is similar to other businesses, you needn't find one designed specifically for the glass business. Many software programs are designed to be used by persons with little or no experience or training in bookkeeping or accounting. If you don't want to keep these books yourself, a bookkeeper or accountant can maintain the journals and ledger for you. You may also wish to consider hiring a firm that prepares payroll to maintain the payroll journal.

Preston Studios

Visit Florida's most prestigious homes and you'll likely see entranceways designed by Preston Studios. Known for its stylistic beveled and art glass entrances and nature study panels, Preston Studios has been commissioned by homeowners throughout the country and major developers throughout the Sunshine State since 1983. Its work has been featured on the covers of such magazines as the *Journal of the American Veterinary Association*, *Florida Real Estate Magazine*, *US Glass*, and *Professional Stained Glass*, as well as two different articles in the *Design Journal of Korea* (which goes to over 60 countries).

Preston Studios emerged from a drugstore promotion in 1972 of making candle holders from glass bottles. "It was very primitive but fun," says partner John Emery. Like other stained glass artists, he and Jerry Preston found the medium entrancing. Entirely self-taught, Jerry and John started the business of Preston Studios in 1976, selling Tiffany style lampshades of new and original designs through antique dealers. To

supplement the income from the lampshades, they began designing limited edition stained glass panels of birds and nature scenes. The first panels featuring birds indigenous to the Southeastern coast were accepted into the Atlanta Merchandise Mart in 1979. Soon the panels were seen in the marts of New York, Dallas, and Miami, as well. The panels sold well and became part of many private collections, including those of numerous well-known personalities in the entertainment industry.

In 1983 a friend introduced their work to a European developer in Florida who commissioned Preston Studios to create a series of nature portraits of indigenous flora and fauna found on the property of the 200-acre development in Melbourne Beach. The designs appeared in the developer's literature and national advertising campaign, and original pieces were placed in residences, club houses and on signs throughout the project. Four years later, the studio created panels for a 2,000 acre development in Tampa. "These two commissions established us," says John. With a reputation of having worked with two of Florida's major developers, and having joined the local home builders and contractors association, John and Jerry were soon hired by other developers and builders. In 1985 they withdrew from the Merchandising Marts to concentrate on custom commissions in the home building trade. Preston Studios has become a distinctive part of Florida's home building industry.

Over 90 percent of the studios' work is flatwork. John and Jerry focus their energies on their individual talents. John conceptualizes the overall look of each piece. He designs, helps select the colors and glasses, and assists with the foiling and soldering. Jerry's the technician. He does all the cutting. In addition, Jerry selects the details of colorations in the birds and flowers.

Distinctive styling and fine workmanship contribute to half the success of Preston Studios. Just as important is John's marketing efforts, such as joining an organization appropriate for the focus of their work, and putting together a marketing program that includes portfolios and newsletters, and getting their name and work in the press.

Business Bank Account

Begin your record keeping by depositing all business receipts in a bank account separate from your personal checking or savings account. Make all disbursements from that account. In this way, business income and expenses will be clearly defined and well documented. This is important not only to give you a clear and accurate picture of your business expenses and income, but for verifying to the IRS the income, deductions, and other items listed on your income tax return. A business account is absolutely necessary in establishing the necessary wholesale and supply sources you'll rely upon for your working glass, art, and craft materials.

Avoid writing checks for cash from your business account. It can be difficult to verify that a cash withdrawal was for a business expense. If you must write a check for cash to pay a business expense (for instance, if you're taking money out of your business account to pay for postage or miscellaneous supplies), include the receipts for the postage and supplies in your records. If you cannot get a receipt, put a note in your records to explain the payment. All business expenses paid by cash should be supported by receipts or statements showing their business purpose.

Business Use of Your Car

If you use a car for business purposes, and the car is not an asset of the company, you can deduct the standard mileage rate for the current tax year determined by the IRS, or you can deduct the actual expenses. Whichever method you choose, you must be able to prove each expense, the mileage incurred for each business use of the vehicle, the date of the expense or trip, and the business reason for the use of the vehicle. Record the information in a daily or weekly log. It is easier to record where, when, and for what reason you used

the vehicle nearer the time it took place, than months later. Keeping a log book in your vehicle and recording the information at the end of each trip makes record keeping easy. File together all receipts that document expenses connected with each trip.

RECORD KEEPING BOOKS—JOURNALS AND LEDGERS

Record keeping information can be recorded in journals and ledgers that are readily available in office supply stores. A journal is a columnar book. It is the simplest way to record business transactions. Each column can represent a different type of expense or income, such as glass, disposable supplies, photography, postage, freight, utilities, subscriptions/books, auto expenses, entertainment, etc.

A general ledger records transactions and balances of individual accounts. Expenses and liabilities are listed under a debit column in a ledger; income or assets are listed under a credit column. At the end of an accounting period or the fiscal year, the accounts are closed and balanced. Their figures are used in the income statement and balance sheet.

Some studios use a separate journal for expenses, one for sales, another for accounts receivable, and a fourth for salaries.

- Sales/Income Journal includes all receipts you receive showing income. Identify the source of income, noting the name of the gallery, store, art dealer, individual, corporation, or public agency (if it's a commissioned piece), magazine, if you were paid for an article or a design you submitted, school if you taught classes, or individuals, if they attended workshops in your studio or store. Indicate whether the income is taxable or non-taxable and whether it's subject to sales tax. If your work was sold by an

agent such as a gallery or store, the seller would be responsible for collecting and paying the sales tax. Along with recording the amount you received, note the total selling price of the item if it was sold by someone other than you and they received a commission from you. When you prepare your income tax return, list the total amount of the piece sold as part of the total sales and the commissioned amount paid as a business expense.

- Expense Journal shows all the expenses incurred in the day-to-day operation of your studio or store. These expenses would likely be allowable tax deductions. They could include items such as postage stamps, office, or studio supplies that were paid for at the time of purchase as well as those for which you were sent an invoice. Include payments for utilities, equipment repairs, leases, subscriptions to professional magazines and journals, professional fees, advertising, auto costs, seminars, entertainment, insurance premiums, commissions paid to galleries, agents or other parties acting on your behalf, freight costs to ship your work, and other items you purchase in performing the duties of your business. You won't likely have the same expenses every month. For example, you might pay insurance premiums quarterly, semi-quarterly, or once a year. You should nonetheless place that outlay under an expense category.

Any item that you intend to declare as a deductible business expense, including those mentioned in Chapter 15, must be supported by some kind of documentation, such as a receipt.

Withholding Requirements

For income tax withholding, you must keep the following records:

1. Each employee's name, address, and Social Security number.

2. Total amount and date of each wage payment, the period of time the payment covers, and for each wage payment, the amount subject to withholding.

3. The amount of withholding tax collected on each payment and the date it was collected.

4. If the taxable amount is less than the total payment, the reason why it is less.

5. An employee's earning ledger, which you can buy at office supply stores, has space for the information required above.

- Accounts Receivable Journal. Maintaining a separate journal for accounts receivable enables you to see at a glance the status of any outstanding account. List each account, the items sent, the date they were sent, the date the bill was sent, and the amount due. Note when payment was received. At the end of each month, list the accounts and amounts that are more than 30 and 60 days past due. Make a notation of any correspondence or conversation you've had with the account. To help ensure that the accounts are current, be sure the statements are mailed to the correct address. Sometimes the delivery location is different from the mailing address.

- Assets Journal includes equipment and inventory. For each asset, record the date you acquired it, its cost, description, supplier, and depreciation or depletion. Depreciation allows you to recover the cost of a business property by deducting part of its cost each year on your tax return. You can charge a monthly depreciation amount to your expenses or record a year's total depreciation to your expense

account at the end of the year. Maintain a permanent record of all the business assets you can depreciate. This could include buildings, equipment, tools, vehicles, furniture, and fixtures. If the assets are sold or capital improvements made to them, a permanent record will show how much of their cost you've recovered.

Keeping records of your assets is important for insurance purposes. The most difficult insurance claim to settle is a loss from theft, simply because you have to prove the articles existed. Insurance companies want to see some records of what you've paid for the item. If you have machinery, they usually like to see some proof of purchase. Often, they'll accept brochures or an operating, or parts-list manual if you cannot provide a copy of the sales receipt. Slides or photos of machines, or a written inventory are acceptable as documentation. Maintaining current photographs of your entire studio and all its contents can help substantiate fire damage claims, in the event of such a disaster. Also keep records that show the basis of your property if you own the space in which your store or studio is located. *The Tax Guide For Small Businesses*, publication 334 of the IRS, describes basis as the amount you have to spend to acquire an asset. When you make a capital expense, your cost becomes part of "basis." Keep records of the purchase price, any purchase expenses, improvement costs, depreciation, and deductible casualty losses.

Have as many categories and journals as you need to show a clear picture of your business, but avoid too many accounts. Breaking your sales and expenses down to minute distinctions can confuse rather than clarify.

 • Payroll Journal lists employees' compensation, and

applicable Social Security and Medicare withhold-ings, pension plan contributions, workers' compen-sation and such if they apply, and any other state and local taxes relevant to your locality. Because the amount of taxes you withhold every pay period could vary, keeping a separate file for these expen-ses simplifies your record keeping and enables you to see the expenditure and withheld amounts more easily.

State and federal governments require employers to make quarterly and annual reports of payroll payments. Two forms can help you maintain the necessary data. A summary payroll , made each payday, can show the names, employee number, rate of pay, hours worked, overtime hours, total pay, and the amounts of deductions for FICA, withholding taxes, and deductions for insurance and pension plans. A separate sheet could contain the same information for each employee. At the end of each quarter, total the information of both sheets for the quarterly and annual reports.

In addition, the federal government requires you keep the following information on file concerning your employ-ees. It's not as onerous as it might look at first glance. The situations that would cause you to record the information might never occur. Nonetheless, whatever data you have to record can be easily kept in the employee's file.

For the IRS:
- Copies of any statements furnished by employees relating to nonresident alien status, residence in Puerto Rico or the Virgin Islands, or residence or physical presence in a foreign country.
- The fair market value and date of each payment of

non-cash compensation made to a retail commission salesperson, if no income tax was withheld.

- For accident or health plans, information about the amount of each payment.
- The withholding allowance certificates (Form W-4) filed by each employee.
- Any agreement between you and the employee for the voluntary withholding of additional amounts of tax.
- Requests by employees to have their withheld tax figured on the basis of their individual cumulative wages.

For Social Security and Medicare:

- The amount of each wage payment subject to Social Security and Medicare taxes.
- The amount of Social Security and Medicare tax collected for each payment and the date collected.
- If the total wage payment and the taxable amount differ, the reason they differ.

For Federal Unemployment Tax Act (FUTA):

- The total amount paid to your employees during the calendar year.
- The amount of compensation subject to the unemployment tax.
- The amount you paid into the state unemployment fund.

SELF-EMPLOYMENT TAX

Maintain records that show how much of your earnings are subject to self-employment tax. This is important because the Social Security you receive when you retire or become dis-

abled, or which your family will receive upon your death is determined by the amount of self-employment tax you paid based on your net earnings.

STORING YOUR RECORDS

Store the receipts and records of each category in separate folders. Keep them in a fireproof cabinet. Keep records that are not used on a regular basis in a safe deposit box or elsewhere away from your studio or store. Your records must be available for inspection by the Internal Revenue Service at any time.

INSURANCE POLICIES

Besides keeping records of your assets for insurance purposes, also keep records of your insurance policies. Show the type of coverage, the name of insurer, renewal and expiration dates, and annual premiums. Check with your accountant whether your insurance premiums can be considered a business expense, or not.

HOW LONG DO I KEEP RECORDS?

You must keep all your records on employment taxes (income taxes, withholding, Social Security, Medicare, and Federal Unemployment Tax (FUTA)) for at least four years after the due date of the return or after the date the tax is paid, whichever is later, according to the IRS.

Keep records supporting items reported on a tax return until the period of limitations for that return runs out. According to the IRS, that date is usually the later of:

- Three years after the date your return is due or filed or;
- Two years after the date the tax was paid.

Keep records used in determining depreciation values, original and replacement costs, and capital improvements related to your business for as long as you need them to support those values, costs, and improvements.

Keep copies of your tax returns for seven years. By showing your previous year's deduction, they will help you prepare future tax returns.

The above information about government requirements is taken from IRS Publication 334, *Tax Guide for Small Business*. This guide includes information about business entities, taxes, and accounting and is written in an easy-to-understand manner. Contact the IRS for a copy.❖

15

Taxes

"The difference between taxes and sharks is that you can escape sharks"
—Anonymous

As a businessperson, you are entitled to tax deductions not available to non-business owners. You're also responsible for paying certain types of taxes not required of private individuals. The types of business deductions you are allowed to take on your income tax return and the taxes you'll be required to collect and pay as a businessperson can be numerous. To help sort them out, this chapter is divided into two sections: the first describes deductions; the second section describes the taxes you will likely be required to pay.

ALLOWABLE DEDUCTIONS

All legitimate costs incurred in establishing and operating of your studio or store are deductible on your income tax, even if those expenses are greater than the income generated by your store or studio provided you operate your business to make a profit. To be deductible, a business expense must be ordinary and necessary, according to the IRS. An ordinary expense is one that is common and accepted in the glass field. A necessary expense is one that is helpful and appropriate

for your work in glass. Business expenses must be kept separate from personal expenses. If you have an expense that is partly for business and partly personal, you must separate the personal part from the business part.

CAPITAL EXPENSES

Business expenses generally take the form of capital expenses and personal and business expenses. Capital expenses are considered part of your investment. Their costs are deducted through depreciation, amortization, or depletion on your income tax return. The three types of costs that must be capitalized are:

- Going into business
- Business assets
- Improvements

You can deduct the amount you spend on a capital expense through the methods of depreciation, amortization or depletion. These methods allow you to deduct a part of the expense each year over a number of years. In this way you're able to "recover" your capital expenses.

GOING INTO BUSINESS

The costs of going into business before you actually begin business operations are all capital expenses. Those costs may include expenses for advertising, professional services such as accounting and legal fees, rent, utilities, tools, equipment, costs of surveying potential markets, wages for employees who are being trained, travel costs to establish distributors, suppliers or customers, and salaries for company principals. These are the same kinds of costs you can deduct after you've opened your business. As a capital expense, the start-up costs are amortized, or deducted in equal amounts, over 60

months or more.

Start-up costs for corporations can also include, in addition to the above, the cost of temporary directors and organizational meetings, state incorporation fees, and accounting and legal costs in setting up the corporation.

Capital expenses for a partnership must be for the creation of the partnership and not for starting or operating the partnership business. Organizational expenses, such as legal and accounting fees for negotiation and preparation of a partnership agreement and the filing, are capital expenses.

Start-up and organizational costs are amortized in equal amounts over a period of not less than 60 months. To figure your deduction, divide your total start-up or organizational costs by the number of months in the amortization period. The result is the amount you can deduct each month.

BUSINESS ASSETS

The amount you spend for an asset that you will use in your studio or store for more than one year, is a capital expense. Assets could include land, buildings, equipment, furniture, vehicles, trademarks, and trade names. You capitalize the full cost of the asset.

IMPROVEMENTS

If the improvements you make to a business asset add to the value of the asset, lengthen the time you can use it, or adapt the asset to a different use, the cost of making that improvement is a capital expense.

Improvements could include new electric wiring, new roof, new floor, new plumbing, new lighting, or installing larger windows for more light. Capitalize your costs of reconditioning, improving, or altering your property as part of a general restoration plan to make it suitable for your busi-

ness. The costs of replacements that stop deterioration and adds to the life of your property are capitalized, and depreciated. You can deduct as a business expense the cost of replacing parts of a machine that keep it in normal working order, but if your machinery undergoes a major overhaul, the cost is a capital expense and can be depreciated.

BUSINESS EXPENSES—HOW MUCH CAN BE DEDUCTED?

In most cases, you can deduct the full amount the business expense actually cost you. Provided the amount is reasonable, there is no limit as to how much you can deduct. If your expenses are more than the income the business brought in, you have a net loss. As long as you operate the business to make a profit, a net loss may be allowed. It is not unusual for a studio artist to operate at a net loss for as long as three years. It's sound business practice for a retailer's business to be in the black after one year. If you operate your studio or store for several years at a loss, the IRS might question whether you're operating a hobby rather than a business.

The expenses listed below are typical business expenses you as a glass artist or retailer could deduct. They are explained in greater detail in IRS Publication 535 entitled *Business Expenses*:

- Advertising expenses
- Auto expenses
- Bad debts
- Cost of acquiring a lease
- Dues and subscriptions
- Educational expenses
- Employees' pay, including salaries, bonuses, awards, and commissions, as well as non-cash payments in the form of awards, the cost of meals and lodging, inventory items, capital assets, shares of

Chris and Vicki Payne

Recognize and seize opportunities. That's what stained glass artists Chris and Vicki Payne have been doing since they went from hobbyists to professional artists in the 1970s.

Vicki learned how to work with stained glass at a local class. The craft also lured Chris, who, after working for a glass shop owner for a brief time, opened his own studio and store. Vicki began her career by accepting a few commissions a year and assisting Chris while maintaining her full-time job as seminar director for the American Institute of Banking, a division of the American Banking Association. When her commissioned work provided as much income as her position with the ABA, Vicki joined Chris full-time. Vicki ran the studio, while Chris focused on developing a major retail store.

Vicki started teaching workshops at the store using the techniques and strategies she learned at the ABA. As the retail business continued to grow, Vicki lectured and conducted workshops around the country. When a workshop participant suggested to Vicki that she make a video, Vicki acted on the idea. Her first video was about professional soldering techniques. Vicki marketed her videos to television and was picked up by The Learning Channel.

"Through a video I could teach hundreds of people; through television, I could reach millions," she says. Vicki writes each script and designs each finished piece while Chris directs the production. Using the videos as an advertising medium, they promote their mail order business at the end of each segment. Vicki's weekly show is telecast on more than 180 PBS stations throughout the country.

Professionally produced, well scripted and favorably received by the television media, the videos set the standard for instructional videos throughout the stained glass industry. Success hasn't been without its setbacks. Says Vicki, "We made every mistake you could make, but we tried to make them only once."

stock in your business, medical and life insurance, tuition reimbursement, moving expenses, supplemental unemployment benefits, compensation for injuries, cafeteria benefit plans, almost any cost you incur in the course of doing business.

To be deductible, employees' pay must be ordinary and necessary to carry on your business, reasonable in amount for the work performed, for services actually performed and paid (if you use the cash method of accounting) or incurred, (if you use the accrual method).

ADDITIONAL BUSINESS EXPENSES

- Employee fringe benefits such as an automobile, free or discounted commercial airline fight, vacation, discount on property or services, membership in a county or social club, ticket to an entertainment, or sporting event.
- Employment taxes.
- Entertainment of business clients.
- Health plan costs.
- Insurance premiums for the business.
- Interests on loans, mortgages and moneys borrowed against life insurance policies.
- Legal and professional fees.
- Licenses and regulatory fees paid to state or local governments.
- Lobbying expenses incurred to appear before or send statements to Congress or its committees regarding legislation of direct interest to you (keep this in mind if Congress decides to restrict the use of lead in glassmaking). You can also deduct the cost of dues to a lobbying organization.
- Medical expenses (if you're disabled, you can de-

duct expenses necessary for you to be able to work as a business expense, rather than a medical expense. For example, you use a wheelchair and when you go out of town on business, you need someone to carry your luggage, assist you through architectural barriers, etc. You do not need those services when you're in your studio. The expenses of paying someone to accompany you on out-of-town trips can be a business deduction.)

- Permanent improvements you make to a leased property as a lessee.
- Personal property tax imposed by state or local government on personal property used in the business.
- Real estate taxes.
- Rent on your place of business whether it's outside your personal residence or on your personal residence, if you use part of your home as your place of business.
- Repairs, including the cost of labor and supplies to your studio or store.
- Retirement plans.
- Sales taxes paid on non depreciable items.
- Sales taxes collected and paid to the state.
- Self-employment tax.
- State and local income tax.
- Studio space in the home.
- Supplies and materials, including glass, solder, foil, lead, fluxes, patinas, molds, disposable supplies, office supplies, photography, shipping supplies.
- Travel costs, including transportation, lodging, meals, telephone calls while traveling away from your home or place of business.

- Use tax.
- Utilities—telephone, electric, gas, water, heat, trash collection.

Cost of Goods Sold

Some of the expenses you incur will be directly related to the making of your glass art. Use those expenses to figure the cost of the goods you sold during the year. Subtracting the cost of goods sold from the total amount of sales determines your business's gross profit for the year.

The gross profit is the total amount of money your business took in less the amount of money it cost you to make or purchase products for resale. Among the expenses that determine the cost of goods sold are:

- The cost of products or raw materials in your inventory, including the cost of having them shipped to you.
- The cost of storing the products you sell.
- Direct labor costs.
- Depreciation on machinery used to produce the products.
- Studio or store overhead expense.

Once you determine your gross profit, calculate your business deductions. If you use an expense to figure the cost of goods sold, you cannot deduct it again as a business expense.

Taxes

Whether you are your company's only employee or you employ other persons to work in your business, you are responsible for paying and withholding taxes different from those of a non-business owner. On a federal level, those taxes include self-employment tax, Social Security, and Medicare.

> ### Self-Employment Tax
> To determine the amount of self-employment tax you owe:
> **1.** Determine your net earnings from self-employment.
> **2.** Determine the amount that is subject to the tax.
> **3.** Multiply that amount by the self-employment tax rate.
>
> The self-employment tax rate is a higher rate than the Social Security and Medicare tax you withhold from your employees' salaries, but you can deduct half of your self-employment tax as a business expense in figuring adjusted gross income. The self-employment tax begins once you earn a specified minimum amount of income and ceases after you've reached a maximum amount. Even if you are not required to pay the self-employment tax, for example, if your income reflects a loss or is less than the minimum amount, you can choose to pay the self-employment tax in order to continue your Social Security benefit coverage.

The state and local taxes you're required to pay or withhold from employees vary among municipalities. Because of the various tax laws throughout the country, this chapter will focus on the federal taxes the IRS requires you to pay or withhold. Contact your local, county, or state department of revenue or your accountant to learn what taxes your local tax authorities require you to pay or withhold.

SELF-EMPLOYMENT TAXES

If you are the sole proprietor of your business, your income from your business is subject to self-employment tax.

If you are a partner in a business, your share of its income is subject to self-employment tax. If you and your spouse work together in the business and share in the profits and losses, a partnership has been created and you and your spouse must report the business income on a partnership income tax return, Form 1065. If your spouse is an employee and not a partner, you must pay Social Security taxes for him, or her.

If you receive fees for performing services as a director

of a corporation, those fees are considered self-employment income. But, if you own most, or all, of the stocks of a corporation, your income as an employee or officer of the corporation is not self-employment income.

Self-employment tax is a Social Security and Medicare tax for individuals who work for themselves. It is similar to the Social Security and Medicare taxes withheld from the pay of wage earners. You may be liable for paying self-employment tax even if you're fully insured under Social Security or are receiving benefits. The amount of self-employment tax due is based on your net business earnings, that is the income less all allowable business deductions.

If you are the sole proprietor of a retail store and a studio and each is a separate business, you must combine the net earnings from each business to determine your net self-employment income. A loss you incur in one business will reduce your gain in the other business. If your retail store made a net profit of $25,000 last year and your studio had a net loss of $500, your net self-employment income would have been $24,500.

EMPLOYMENT TAXES

If you have employees, you'll probably be required to withhold federal income tax from their wages. You may also have to withhold and pay Social Security and Medicare taxes. If you do not withhold these taxes, or withhold the taxes but don't deposit them, you could be subjected to a penalty.

For IRS purposes, there are four types of employees:

1. Independent contractors.
2. Common-law employees.
3. Statutory employees.
4. Statutory nonemployees.

Independent Contractor

An independent contractor is a person who follows an independent trade, business, or profession in which they offer their services to the general public. In the glass art business, independent contractors would include carpenters who frame an area in which you'll install a panel, or who will install it themselves, an artist who gives a workshop at your store, as well as an accountant, a publicist, an agent, photographer or any other professional from whom you contract services. The general rule, according to the IRS, is that an individual is an independent contractor if you, the employer, have the right to control or direct only the result of the work and not the means and methods of accomplishing that result. You do not have to withhold or pay taxes on payments you make to independent contractors.

The IRS looks unfavorably upon employers who classify an employee as an independent contractor without a reasonable basis. Employers who do so are liable for penalties of 100% of income, and Social Security and Medicare taxes that were not withheld. If you are unsure whether a person whose services you use is an employee or an independent contractor and want the IRS to make that determination, you can file, with the district director, *Form SS-8* Determination of Employee Work Status for Purposes of Federal Employment Taxes and Income Tax Withholding.

Common-Law Employees

Under the IRS' common-law rules, every individual who performs services subject to the will and control of an employer as to what must be done and how it must be done is an employee. Even if you allow the employee discretion and freedom of action, as long as you have the legal right to control both the method and the result of the service, that

person is an employee. Two characteristics that define a common-law employee are that you have the right to discharge the employee and you supply the employee with tools and a place to work.

It doesn't matter whether you define the person as an employee, associate, partner, agent, or independent contractor. If the relationship meets the criteria described above, the person is an employee. It doesn't matter how the payments are measured, how they're made, or what they're called. Nor does it matter to the IRS whether the individual is employed full- time or part-time. You may have to withhold and pay taxes on wages you pay to common-law employees.

Statutory Employees

While you do not have to withhold federal income tax from a person who is not an employee under the common-law rules, you could be liable for Social Security and Medicare taxes if an individual who works for you, for pay, is described in any of the following four categories:

1. A driver who distributes your products, if he, or she, is your agent or is paid on commission.

2. An individual who works at home on materials which you supply and which must be returned to you or to a person you name, if you also furnish specifications for the work to be done.

3. A full-time traveling salesperson who works on your behalf and turns in orders to you from wholesalers, retailers, and contractors. The products sold must be merchandise for resale or supplies for use in the buyer's business operations. The distinction between whether a salesperson is an employee or independent contractor will be discussed later in this chapter.

You would be liable for Social Security and Medicare taxes for the above persons if:

- The service contract states or implies that almost all of the services are to be performed personally by them.
- The individual has little or no investment in the equipment and property used to perform the services.
- The services are performed on a continuing basis.

Unless a statutory employee works at home, you must also pay federal unemployment tax on his wages.

Statutory Nonemployee

A statutory non employee is a person who is engaged in selling or soliciting the sale of consumer products in the home or at a place of business other than in a permanent retail establishment. A statutory nonemployee could be a person who sells your line of products through home shows. You do not withhold or pay taxes on payments to statutory nonemployees.

WITHHOLDING INCOME TAX

You generally must withhold income tax from wages you pay employees if their wages for any payroll period exceed the amount of their withholding allowance for that period. The amount withheld is based on their gross wages before deductions for Social Security and Medicare taxes, pension, insurance, etc., are made. The amount to be withheld is figured separately for each payroll period.

A payroll period is the period of time for which you usually make a payment of wages to a employee. Regular payroll periods can be daily, weekly, biweekly, semimonthly, monthly, quarterly, semiannually, or annually. A miscel-

laneous payroll period is any other period. The amount to be withheld is determined by the number of exemptions the employee has claimed on his W-4 Form.

In addition to wages, the following payments or benefits may be subject to withholding:

- Unemployment benefits
- Sick pay paid by a third party
- Annuity or pension payments
- Bonuses or awards
- Nonmonetary wages such as goods, lodging, food, clothing, or services

An employee's contributions to a simplified employee pension (SEP) plan, or IRA, are excluded from the employee's gross income. The contribution amounts are not subject to Social Security, Medicare, federal unemployment taxes, or income tax withholding. However, an employer's SEP contributions paid under a salary reduction agreement are included in wages for purposes of Social Security, Medicare, and federal unemployment taxes.

SOCIAL SECURITY AND MEDICARE TAXES

Social Security and Medicare taxes, also known as Federal Insurance Contributions Act (FICA), are levied on both you and your employees. You must collect and pay the employee's part of the taxes and you must pay a matching amount. These taxes have different tax rates and wage bases. The following could also be subject to Social Security and Medicare taxes:

- Meals and lodging.
- Sick pay.
- Employer contributions to a profit-sharing or stock bonus plan.

- Supplemental unemployment payments.
- Wages paid to your spouse or child over 18 years of age for services in your studio or store.
- Social security and Medicare taxes and withheld income tax are reported and paid together. Employers are required by law to deduct and withhold income, Social Security and Medicare taxes from employees' wages. As an employer, you would be liable for the payment of these taxes to the federal government whether or not you collect them from your employees. If you deduct less than the correct amount from your employees' wages, you are still liable to the federal government for the full amount. Generally, the taxes are reported on *Form 941 Employer's Quarterly Federal Tax Return* and filed. If you pay the taxes after the due date, you may be subject to a penalty.

FEDERAL UNEMPLOYMENT TAX (FUTA)

The Federal Unemployment Tax provides unemployment payments to employees who have lost their jobs. FUTA is in addition to any state unemployment tax. This is a tax employers must pay. According to the IRS, you, as an employer, are subject to FUTA tax on the wages you pay to employees if:

- In any calendar quarter, the wages you paid to employees totaled $1,500 or more or
- In each of 20 different calendar weeks, there was at least a part of a day in which you had an employee. The 20 weeks do not have to be consecutive; nor does it have to be the same employee each week. Individuals on sick leave or vacation are counted as employees.

Income received by employees in the form of tips or wages not paid in money are included in their earnings when you determine the amount to be withheld in FUTA taxes. The FUTA tax rate, and the amount of an employee's earnings the tax is figured on are subject to change from year to year.

FUTA is reported on Form 940 Employer's Annual Federal Unemployment Tax Return. The form covers one calendar year. Payment is generally due one month after the year ends.

STATE AND LOCAL TAXES

Taxes imposed on business by states, counties, and local municipalities vary across the country. Contact your state and local governments or your accountant for tax information and procedures relative to your locality regarding the products you sell and the services you provide.

Tax regulations can be onerous and confusing. The IRS offers dozens of publications on various taxes, credits, deductions, and exceptions to assist businesses in filing their tax returns. However, because tax regulations can change between printings, the IRS does not guarantee that the information in their publications are accurate. Double check with your accountant or the IRS if you're uncertain about the regulations.

To simplify your payroll preparation, consider hiring a firm that specializes in preparing payrolls, or obtaining a computer software program designed specifically for payrolls.❖

16

Insurance

"What do you mean it's not covered?"
—Anonymous

A recognized expert on law and the arts, Leonard D. Duboff, relates the story of how a stained glass sun catcher caused a half million dollars worth of damage. The sun catcher, purchased at a craft show, was hung in a window where it focused the sun's rays on living room draperies. The draperies caught fire and the house suffered extensive damage. The ornament, according to Duboff, was beveled on only one side, which caused the sun's rays to be concentrated on a fixed point. The craftsperson was guilty of product liability because the ornament should have been beveled on both sides to avoid a concentration of light and heat rays. The story, which appeared in the February 1992 issue of *The Crafts Report* clearly illustrates the need for glass artists to understand the risks of running a business. Risk is an inherent part of business.

Only in the last few years have affordable insurance plans been designed for the specific needs of glass artists. As a studio artist or retailer, you can reduce the risks and protect different components of your business with various types of insurance. Property, liability, business interruption, a

299

buy/sell agreement, and worker's compensation are business-related insurances suitable for studio artists and retailers. Property, liability, business interruption insurance, and a buy/sell agreement can be designed to fit your specific needs. Workers' compensation coverage is mandatory in many states. Each kind of insurance addresses a different need and protects against a different risk.

PROPERTY INSURANCE

Property insurance comes under the umbrella of property and liability (or casualty) insurance. It covers your business property and is similar in concept to your homeowner's insurance in that it covers damages done to the building and its contents. Property insurance protects against damage and theft to your building, machinery, equipment, tools, raw materials, supplies, finished art work, works in progress as well as at exhibitions and shows, and in transit. Peak season coverage is available to protect you if your inventory is greater at certain times of the year. Other available types of property coverage are accounts receivable and valuable papers. Almost anything related to your business' operation can be insured.

Besides having coverage on your studio's or store's premises, you can insure inventory taken out for shows or exhibitions and as well as your display booth against property and liability damages.

If your inventory is greater at certain times of the year, you can include a provision in the policy to increase your coverage at that time of year. For example, if you sell decorative objects at craft shows in the fall you can include a provision to increase your coverage in August and September. Property coverage also includes the cost of reproducing valuable papers, such as design plans. Also covered are costs

you incur in reproducing accounts receivable records damaged in a fire or as a result of vandalism or theft and for payment you are unable to collect as a direct result of losing records.

Money stolen through theft, burglary, robbery, or employee dishonesty can also be covered.

If an item has been made and paid for, but not delivered because it was damaged or stolen, the insurance company will give you the selling price of the piece. If the piece was made and stolen while in your possession, and you did not get paid from the buyer, the insurance company would give you its replacement cost. (See Keeping Records for more information)

ACTUAL VS. REPLACEMENT COSTS

The amount of coverage is determined by the actual or the replacement value of the business' inventory from the least expensive item of inventory up to major equipment and the building. Actual cash value is based on the replacement cost of the item, less depreciation. For example, if you converted a 200 year-old barn at a cost of several thousand dollars and it burned, the actual value for insurance purposes would be based on its replacement value less depreciation. No doubt, the actual value as determined by the insurance company would be much less than what it would cost you to replace the barn. Reimbursement for damages under actual cost would be based on the current value of an item less depreciation.

Replacement value is coverage for the cost of what a piece of machinery or any equipment, tool, or item, and the premises used in your business would cost you today regardless of when it was purchased. It makes more sense to purchase a policy based on replacement value. Replacement

value is also predicated on the amount of coverage you purchased. For example, if you have $7,000 worth of coverage because you determined that's what your tools and equipment cost when you bought them years ago, but replacement costs are $15,000 at the time of loss and everything needs to be replaced as a result of a fire, you will receive only $7,000 from the insurer.

Determine the amount of property coverage you want that includes replacement value by making an inventory of every business-related item. This list can also serve to prove what items were lost in case of damage. Review your policy annually to ensure the amount of coverage represents the true replacement value of the business' property.

Property coverage comes in two forms—basic and deluxe. Basic coverage lists the things the policy covers. Deluxe coverage specifies what it excludes. Anything not excluded is covered under deluxe. While premiums for deluxe coverage are greater than those for basic, after reviewing each policy carefully and considering the kinds of risks your business could incur, the deluxe policy might make more sense. Coverage against flood or earthquake damage is not included in a property policy and must be purchased separately.

Insurance companies vary on how they determine the premiums. Some base their premiums on the business' estimated receipts, others on contents value, and still others on a combination of receipts and contents. For property premiums, insurance companies might also consider the construction of the building, the deductible, and the state in which the business is located. Some companies use the gross receipts to determine a premium for liability and the contents' replacement value to determine the property premium. If yours is a new business, an estimate of receipts would

be used as part of estimating the premium. At the end of the year, the insurance company will adjust the premiums based on your actual receipts. Most insurance companies charge a minimum premium, usually a few hundred dollars, regardless of the beginning receipts.

It's important to know that a homeowner's policy excludes any kind of business exposure either for property or liability. Whether your studio is in a room or the basement of your house, or attached to the house, or is a separate building on the property, if you operate a business, it is not covered under a homeowner's policy. For example, if your studio is in your garage and it incurred fire damage, it is unlikely that the homeowner insurance company would cover the damages in the work area, although damages to the house would be covered. "It's not that insurance companies want to cause additional hardship," says Charles Moran, an independent agent at Bollinger Insurance in Montclair, New Jersey. "It's a matter of contract. Your homeowner's coverage is for your house, not your business. Even if the insurance company agrees to cover damages done to the outside of the building, they definitely will not cover damage to equipment because that is a clear business exposure." When an insurance inspector or claims' reviewer suspects there is a business in your house, he, or she, will likely ask for income tax returns to prove you've operated a business. If you dispute with the insurance company to pay you for damages that are excluded from the homeowner contract because you contend what you do is a hobby, they probably will not renew the policy.

If you file a claim for property damage, go over the values for damages with the claims adjuster until you reach some agreement on the facts. If you disagree with the insurance adjuster's determination of the claim, consider hiring a pri-

vate adjuster who can document the damage and negotiate a settlement with the insurance company. Private adjusters usually receive a portion of the settlement.

KEEPING RECORDS

The most difficult claim to settle is a theft loss because you have to prove the articles existed. Insurance companies want to see some record of what you've paid for the item. If you have machinery, they usually like to see some proof of purchase. Often, they'll accept brochures, operating or parts-list manual if you cannot provide a copy of the sales receipt. Slides or photos of machinery, or a written inventory are acceptable as documentation. Store the records in a safe deposit box or elsewhere away from the property for safekeeping. Insurance companies would request the same kind of documentation if you had a loss covered under your homeowner's policy.

LIABILITY COVERAGE

Once you sell something or operate a business, you have created a liability exposure. Liability insurance (also known as casualty insurance) protects you against legal damages. If someone injuries himself on your property and sues you, or is injured from a product you make or sell, your liability insurance will apply. Medical expenses incurred by someone who injuries himself in your store or studio would be paid for under the liability portion of your liability coverage.

Product liability laws enable consumers to sue a product's retailer, distributor, and manufacturer. In every product liability case, according to Leonard Duboff in his article about the sun catcher, the plaintiff must prove that (1) the product was defective, (2) an injury was caused by that defect, and (3) the defect existed in the product when the

defendant (seller or maker) had control over it.

There are two kinds of defects: mechanical and design. A mechanical defect could be a faulty component part, such as the electrical wire in a lamp. Although you, as a lampmaker, could not detect the electrical defect, under rules followed by most states, you could be held liable.

Design defects include those that make the piece shatter or unstable. The sun catcher mentioned above had a design defect, so could a panel that shatters, or a plate that contains toxic paints or finishes. Testing the product before you sell it and recording those test results could help you prove that the product wasn't defective when it was in your possession. Failure to adequately test has been cited as a reason to impose punitive damages in addition to actual damages, according to DuBoff.

Million dollar awards in product liability cases are not uncommon. Your best protection is product liability insurance.

Besides state laws regarding liability, there are at least two federal laws that could affect glass artists. One is the Hazardous Substance Labeling Act. It empowers the Federal Trade Commission (FTC) to label a substance as hazardous and prohibit its use in a product to which a child could have access. Tiny beads that were once used in dolls' eyes are one such substance listed as hazardous. Small pieces of glass used in jewelry or a finish you use on a product might be construed as hazardous by the FTC. Contact the FTC in Washington, DC, for a listing of hazardous substances.

The second law comes under the Consumer Product Safety Act. This allows the FTC to regulate a consumer product's content and design and impose safety standards. For example, the FTC has banned paints containing lead and has imposed regulations regarding the use of architectural glass in doors, windows, and walls. If you have any doubt

about the safety or toxicity of the materials you use, contact the FTC or OSHA.

The recommended amount of liability insurance varies throughout the country depending upon the amount of money awarded in liability cases in the geographic area your store or studio is located. In Maryland, independent insurance agent Doug Edwards of the firm Oxley and Goldburn in Rockville, recommends a minimum of $1,000,000. That figure is based on the dollar amount awarded in lawsuits in the Baltimore/Washington area.

If as a subcontractor you design and install entrance panels, the companies for whom you do work will likely ask you to prove you have liability insurance and workmen's compensation coverage.

If you participate in a show, the landowner or building owner might require that you prove you have insurance coverage. "If someone trips over your stand in a building owned by another person, the building owner wants to know you have a policy that's going to pay for the alleged damage." says Moran. There is usually no charge from your insurer if you request a Certificate of Insurance. In some cases, usually in malls or in schools on municipal property, the owners could require you to add them to your policy as an additional named insured. Insurance companies make a premium charge for that coverage and will issue a certificate that would show the coverage.

BUSINESS INTERRUPTION INSURANCE

This insurance provides you with an income if your studio or store is damaged and you cannot resume business for a period of time. You would receive the amount of money the business would have generated during that time.

Let's assume you gross $50,000 a year with 80 percent or

$40,000 of your income generated in December. There's a fire in your studio in November and all the inventory you were planning to sell in December is destroyed. It's April before the claim is settled and you haven't been able to make anything since the fire. Business interruption, also called business income coverage, would pay you the amount of net profits you would have earned while your studio was unusable. Business interruption insurance can provide an income up to 12 months from the date of loss. Payments don't include the salaries of employees if they were laid off because of an interruption in the business, but it will include their salaries as long as they are needed to get you back in business. You may add employee payroll as an option.

WORKERS' COMPENSATION

Workers' Compensation provides medical coverage and salary continuation for persons injured on the job. "Workers' comp is very controversial and expensive," says Doug Edwards. It is also required in most states.

Know whether the person you cover is an employee or an independent contractor. An individual considered an independent contractor under the tax laws might be considered an employee and eligible for worker's compensation under your state's insurance laws.

For example, a person helps you in your glass business or studio a few days a week. You consider him an independent contractor, pay him in cash and give him a W-4 at the end of the year for the amount of money you paid him. That arrangement is legitimate for tax purposes.

Let's assume that person is injured in your studio. They go to the hospital's emergency room for treatment. He, or she, presents the $500 medical bill to his, or her, health insurance company. It refuses to pay because they were

injured while working in your studio. You did not have workers' compensation coverage but your state's workers' compensation law stipulates that if you hire a person, you must have the coverage. Because their insurance would not pay the medical costs, you get the bill. Who is going to pay the $500 emergency room bill? Because you did not have workers' compensation coverage, you could be fined in addition to having to pay the hospital bill to cover the injury.

Workers' compensation laws vary from state to state. Check with your insurance agent or your state department of labor for information. Rates are based on payroll and occupation. You might be able to purchase a minimum premium policy to cover work related injuries for the person who works only occasionally.

In some states you, as the sole proprietor or partner, cannot be covered, or can opt not to be covered, under workers' compensation. If your state does not allow you that coverage or if you forgo that coverage, Doug Edwards recommends that you buy "24-hour" coverage from your health carrier and a disability coverage program. The premiums would be based on how much money you've made, how long you want to be covered and how long you want to wait before collecting. A good program provides 24-hour coverage and could pay you for the rest of your life.

BUY/SELL AGREEMENT

Buy/sell agreements can be between the owner and any other person, even family members or your competition. It is typically used in small businesses, according to Edwards.

This type of agreement can be especially helpful if you are disabled and cannot continue to work or choose to sell the business. It can provide a smooth transition of ownership from you to another person. This is how a buy/sell agreement works:

You own a glass business or studio and have a valued employee; you become disabled and can't continue to run the business; your employee would like to buy the company from you, but does not have the money to do so. You're faced with having to sell the business to another person or watch it deteriorate because of your inability to continue working. Through a buy/sell agreement, the employee may purchase the business from you or is given the first right of refusal. Under such an agreement, the insurance company gives the person mentioned in the agreement the money he needs to purchase the business. The agreement directs the person to pay you the money he received in exchange for the business. You and the other party negotiate the selling price at the time the agreement is initially reached. The price can be increased as time goes on.

CHOOSING AN AGENT

When planning your business insurance needs, seek the advice of a reputable insurance agent.

"Don't let costs alone be your guide," says Edwards. A broker who understands: commercial insurance, is familiar with glass art, or craft related businesses, knows the specific needs of glass studios and stores, and knows local ordinances, can be beneficial to your business and help keep your costs down more than an unfamiliar insurer who simply writes a low-cost policy. A local broker is usually familiar with your state's workers' compensation laws. An independent agent, who represents several companies, is more likely to help you select insurance appropriate to your particular needs than a representative from one insurance company. An independent broker can help you choose from a number of insurance companies that provide competitively priced policies, as opposed to a sales agent from one com-

pany, whose job is to sell just that company's products.

Develop a relationship with your broker. Tell him all about your business, what you do, where you do it, how you do it. Show him your studio, store, and art. Companies that inspect the premises usually give the best rates, according to Edwards. The more the broker knows about your business, the better prepared he, or she, will be to recommend changes in your coverage and alert you to laws that affect your operation and coverage. Your insurance needs will likely change as your business grows.

An option to working with a local broker is to consider the insurance plans offered by several craft organizations, such as the American Craft Association, Art Glass Suppliers Association, and the Glass Art Society. You might also buy coverage through state and regional craft organizations.

Review your policy annually with your broker to ensure your coverage is adequate and you're not paying for risks you no longer have. Every few years get bids from other brokers to ensure that you are getting the best coverage at the best price.

KEEPING COSTS DOWN

Along with working with a broker who understands your specific needs and can help you reduce your risks, you can keep costs down by:

- Taking a higher deductible.
- Choosing basic rather than deluxe coverage.
- Trying to be claims free. If your claims are low, the insurance company might reduce or credit your premiums. Ask them if that's their practice. Keep the studio or store as clean and neat as possible to prevent accidents. If you open your studio or store to tours, place plywood or cardboard against the

shelves of glass to prevent anyone from getting cut. Unplug all electrical equipment and machinery. Place lead and hazardous materials in a safe, out-of-the-way place.

- If you rent space, make sure the landlord is in compliance with state and local regulations. For instance, if local ordinances require smoke detectors or sprinklers and your landlord does not have them, your insurance costs could be higher. Conversely, an alarm system or other safety or deterrent devices could reduce your premiums. Discuss this with your broker. A local broker would likely know what your state and local regulations are.

HEALTH INSURANCE

America's health care coverage has been one of the country's most important issues for individuals and businesses, especially small businesses. Each year soaring medical costs devour a larger percentage of the United States' gross national product and more money out of the pockets of business owners. As costs have soared, insurance companies have transferred more of the burden to consumers. As federal and state governments attempt to manage their health care costs, they've shifted the responsibility to employers, who in turn shift their costs to employees in many forms, such as mandating participation in managed health care programs such as health maintenance (HMOS) and preferred provider organizations (PPOs).

If you've had medical coverage supplied through your former employer, buying health insurance for yourself, your family, and your employees could be a shocking experience. Health insurance coverage has evolved into a complex procedure with a myriad of types of coverage, preventative

311

plans, deductibles, and exclusions, not to mention costs.

Until health care coverage is simplified, seek the advice of an insurance broker who specializes in health insurance when choosing health insurance coverage for yourself and your employees. A broker who sells only property and liability coverage for businesses might not be as astute in health care coverage as a health insurance specialist.

Study how benefits are designed and shop around for what best suits your family's and employees' needs. Examine your individual situation regarding the age and needs of your family members and your employees. Determine what those needs are. Do you need coverage for spouses and children, spousal coverage only, maternity coverage? Does it appear your children will need braces? If so, compare the cost of dental insurance to the cost of braces. If you or someone you'll be covering has an existing health problem, learn whether that condition will be covered by an insurance plan. Find out what the pre-existing conditions, limitations, and exclusions are in each policy you examine. Once you have determined your needs, ask the insurer to provide you with a financial breakdown of the plan's component parts.

Investigate the wellness programs of different plans. Do they promote and encourage fitness? Do they offer weight loss programs, blood pressure screenings, well baby check-ups, or smoking cessation classes?

Managed care programs have been less costly than traditional coverage. If you choose a managed care organization, find out how it selects the doctors for its provider network. Ask to see a copy of the application physicians complete to join the network. Ask to read a copy of the contract between the physician and the organization. Be satisfied that the physicians in the network are conveniently located. Ensure that your employees can receive care if they're out of town.

Ask the managed care company what provisions it has for providing care and covering costs for treatment sought away from your area.

Review your coverage annually with a broker to ensure that you are getting the benefits you're paying for, and that what you're paying for is the kind of coverage you want.

Health insurance premiums charged to individuals, whether the entity is a one-person studio or a small business employing several persons, have been notoriously high, costing thousands and tens of thousands of dollars a year. To help you control that portion of insurance coverage, look into the group plans offered by local chambers of commerce or craft organizations throughout the country. As a member of a group, insurance premiums are lower, as the insurance company's risk is spread out over a larger number of people.

In addition to choosing the right broker and having appropriate and adequate coverage, learn about the company offering the insurance. Your health and property insurance coverage is only as good as the company who offers it. Smaller, off-brand name insurance companies might offer the best rates. They also might be out of business next year. Insurance regulations vary from state to state. Contact your state insurance commissioner to learn the status of any company seeking to do business in your state; whether the company is allowed to do business in your state and the state's recourse for action if problems arise. ❖

17

Contracts, Copyrights and the Law

"The dynamic quality of American art is mirrored in the development of art law."
—*Tad Crawford* Legal Guide for the Visual Artist

When the *Legal Guide for the Visual Artist* was first published in 1977, art law was in its infancy. As the artist population increased and more and more artists commissioned, sold, and exhibited their work, the legal and art communities saw a need for laws protecting the property and moral rights of artists, and for lawyers who understood the special needs of artists. The Volunteer Lawyers for the Arts grew out of that need. It is an outstanding resource.

VLAs are groups of attorneys who assist artists with art-related legal concerns such as copyrights, trademarks, contracts, business entities, taxes, product liability, and leases and zoning ordinances, especially as they relate to the glass artist's use of materials that involve fire, fumes, and other safety factors that could affect the building they're renting or other individuals in their employ. VLAs publish information regarding new development in art law and refer callers to other resources and services. VLAs are located

314

throughout the country. Each VLA is an independent organization. If the VLA is not listed in your telephone directory, contact your state art council or a state or regional art/craft association for the name and location of the VLA in your city or state.

As an artist, you face unique legal considerations. As a business person, you share similar legal needs as any other businessperson. This chapter will address both aspects.

COPYRIGHTS

From the moment you create an original work in a viable form, your work is protected by the US. Copyright Law. It does not have to be registered with the Copyright Office to be protected. The copyright gives the artist the exclusive right to do and to authorize others to do the following:
- Reproduce the copyrighted work.
- Prepare derivative works based upon the copyrighted work.
- Distribute copies of the copyrighted work publicly.
- Display the copyrighted work publicly.

It is illegal for anyone to violate any of the rights provided to the owner of the copyright.

The copyright becomes the property of the artist who created the work as soon as the work is created. The work is protected by copyright for 50 years after the artist's death.

Artists who created work jointly are co-owners of the copyright unless there is an agreement to the contrary.

In the case of works for hire, in which a work is created by an employee within the scope of his, or her, employment (for example a lamp, or plate, is designed by an employee of a studio), the employer owns the copyright. The basis for this ruling is that the employee is being paid a regular salary for

the work he does in the studio and the employer instructs, supervises, or has some control over the work done by the employee. If the employee creates something outside the studio, separate from his scope of employment, the copyright for that work would belong to him.

If a work is commissioned, the copyright belongs to the artist. Generally, with commissioned work, the artist is not an employee. He, or she, is not paid a regular salary and his work is not controlled by an employer. He, or she, is an independent contractor who agrees to create a work of art.

The copyright belongs to the artist even when the work is sold. The law provides that transfer of ownership of any material object that embodies a protected work does not of itself convey any rights in the copyright.

The work does not have to be available for sale, nor does it have to be unique to be protected by the copyright law, but it must be original, display a degree of originality, and be in a tangible form to be protected under the law. Ideas cannot be copyrighted. Only the aesthetic features of functional items can be copyrighted and only if those features can be separated from the functional aspect. For example, designs on fused glass plates could be copyrighted; the plate itself could not because a plate is considered functional. A glass design on a table could be copyrighted if the design is irrelevant to the table's function. The design of a leaded glass lampshade could be copyrighted because the lampshade does not make the lamp function. It adds to the lamp's aesthetic appearance, but not to its function according to copyright law.

NOTICE OF COPYRIGHT

Any work protected by the copyright law should be affixed with a copyright notice—the letter C in a circle © or the word

"Copyright" or the abbreviation "Copr.", the year the work was created and the name of the owner of the copyright. For example, © 1992 Jane Doe. This notice identifies the work as copyrighted and liables anyone who uses the copyrighted work. If a copyright is infringed, the owner may be awarded actual and/or statutory damages by the federal court. Actual damages are monetary losses the copyright owner endured as a result of his copyrighted work being used to make money for the infringer. For example, let's say a copyrighted design was used on panels that were subsequently sold. The copyrighted design was used without the owner's permission and the copyright owner did not receive any moneys resulting from the sale of the panels. The amount of statutory damages awarded can vary depending upon whether the infringement was innocent or willful. The statute of limitations on infringement cases is three years from the date the infringement took place.

COPYRIGHT REGISTRATION

You need not register your copyright. However, the registration provides certain advantages. Among them are the following:

- Registration establishes a public record of the copyright claim.
- Registration is ordinarily necessary before any infringement suit may be filed in court.

If someone copies your design, having the copyright registered could make it easier for you to have a law suit decided in your favor. Registration may be made at any time during the life of the copyright.

A copy of the Copyright Act of 1976 Public Law 94-553 detailing all of its provisions is available free from the Infor-

mation and Publications Section, LM-455, Copyright Office, Library of Congress, Washington, DC 20559. The office publishes several circulars on various aspects of the law. Ask for a copy of *Circular R2 Publications on Copyright*, which lists all the registration forms and circulars available. If you do original work, you should have a copy on file.

VISUAL ARTISTS RIGHTS ACT

In June 1991, the Visual Artists Rights Act was added to the federal copyright law. This act protects the rights of attribution and integrity. Attribution means the artist has the right to have his artwork attributed to him and to prevent his name from being attributed to works he did not create. Integrity rights give the artist the right to prevent his name from being associated with any of his work that has been modified, distorted, or mutilated without his permission. The act protects paintings, drawings, prints, or sculptures which are in a single copy or in a limited edition of no more than 200 copies. If in a limited edition, the copies must be consecutively numbered by the artist and bear his, or her, signature or identifying mark.

Attribution and integrity rights always belong to the artist. They cannot be transferred even if the copyright is conveyed to another person. The artist may waive the rights by identifying in writing the work and the uses of the work that may be waived. If the work was created by two or more artists, the rights of all the artists can be waived by one of the artists.

These moral rights can be especially helpful to the artist whose sculptural works are placed into buildings and whose removal would harm the integrity of the work.

The Act allows the artist to seek an injunction to stop the offensive act, seek monetary damages for the harm his rep-

utation has suffered, and claim statutory damages by show-ing the infringement was willful. The Act also permits the court to require the infringer to pay the artist's legal fees.

Moral rights laws exist in some states which could be affected by the federal statute. To learn more information about the federal statute and your state laws, contact the Volunteer Lawyers for the Arts.

DESIGN PATENTS

A design patent differs from a copyright in that the design must be unique, not just original. To determine the unique-ness of a design, you would have to conduct a design search. This can be a lengthy and expensive process, and is best accomplished under the supervision and guidance of a patent lawyer. Patent protection can be an option if you have a design that is not entitled to copyright protection. To apply for a design patent, contact the Commissioner of Patent and Trademark, Patent and Trademark Office, Washington, DC 20231.

TRADEMARKS

A trademark is a brand name that identifies your studio, store or product. It may be words, logos, colors, or symbols. Exxon and Pepsi are familiar trademarked words. Stipple Glass is a trademark of Youghiogheny; ImagePro is a trade-mark of PhotoBrasive Systems. Each identifies and protects the identification of certain products each company sells.

In a competitive market, a distinctive trademark gives your business an edge. Consumers identify companies through their trademarks. Once the mark is used in the marketplace and as soon as consumers associate its name with a product, that name is entitled to legal protection as a trademark.

Choosing a Trademark

Select a distinctive, strong word, or phrase that identifies your studio or store. There are no magic formulas for choosing a strong trademark other than brainstorming. List the trademarks that have made an impact on you and give a clear picture of a studio or store. What, if anything, do they have in common?

New words or symbols generally make a strong impact. Suggestive marks that conjure up a favorable impression about a product or service can be strong trademark elements.

Among marks considered weak are those that use surnames, geographic locations, generic descriptive terms, and misspelled words whose identity is only apparent when the word is seen, not heard.

Deceptively misleading names, as well as obscene or scandalous trademarks, can be denied trademark protection.

Consider the potential strength of a name in the marketplace. Carefully choose your trademarks. They easily become known once advertised and circulated in the professional community.

A trademark is not a copyright or a patent. It cannot prevent one studio or store from copying the goods or services of another. However, it does protect a trademark owner against another person or business using a trademark that can be confused with the owner's.

Trademark Search

A trademark search helps you determine if someone else is using a trademark you'd like to use. It also identifies registered trademarks. Searches are done by patent and trademark attorneys and can cost several hundred dollars. However, the money is well spent when compared to the cost of remarketing your product under a new name. Check your

telephone directory for the names of patent and trademark attorneys or contact the Volunteers Lawyers for the Arts who may be able to refer you to an attorney who specializes in patents and trademarks.

Trademark Registration

Trademarks can be registered on the state and federal level. A trademark registered with the federal government is afforded more rights and protections than a non registered mark. Registration enables you to place the registered symbol with the trademark. This tells everyone that you have the exclusive right to use that trademark. It could deter others from using the mark. It also prevents goods bearing a mark identical to yours from being imported. Also, once a registered trademark has been in use for five consecutive years, its validity is incontestable. Registrations remain in effect for 20 years and can be renewed in 25 year increments. State registrations provide similar benefits to the federal registration but those benefits do not extend beyond the state's borders.

To receive a federal registration, your trademark must be distinctive and actively used in interstate commerce. You'll be required to complete an application and submit drawings of the trademark. After you submit the paperwork, the mark is published in the Trademark Gazette—a publication sent to and reviewed by trademark attorneys—for 30 days. If no one disputes the mark, you will receive a certificate of registration. Contact the Patent and Trademark Office for an application.

Once you've registered your trademark, use it consistently. If you don't, a registered trademark can be ruled abandoned.

Registration and searches can be time-consuming. How-

ever, they can also be beneficial to glass artists or retailers who have developed a reputation for quality work and services. Consider speaking with an attorney to help you determine whether the benefits to your particular business justify the costs of registering your trademark.

CONTRACTS

Putting agreements in writing has become a mainstay of American business. Buyers and sellers of any commodity tend to feel more comfortable when all the provisions of a sale are detailed in a contract. As a craftsperson, artist, or store owner, if you sell, commission, or consign work, or purchase supplies, you will likely enter into contracts of some sort throughout your career. A contract is a legally binding promise.

A contract's basic components are the offer, the acceptance, and the consideration (method of payment). For example, if you offer a plate for sale at a craft fair, the purchaser likes the plate and agrees on the price, you have a contract. If you offer your talents to produce an original panel and the customer accepts your offer and you and the customer agree on the price based on the design, color, and shape of the panel, you have a contract.

Contracts can be written or oral, expressed, or implied.

An expressed contract spells out all the details. Let's say you sell your work to a craft store. Your contract says you'll deliver 12 plates in a specific pattern you and the dealer have agreed upon, 10" in diameter, for delivery by June 1, at a price to you of $24.00 each to be paid within 30 days of delivery. If any of the elements of the contract is not met, a breach of contract has occurred, and the aggrieved party is not required to meet his, or her, obligations. If no settlement is reached, the aggrieved party can file suit. If either party has

322

a problem meeting the contractual obligations, it's good business policy to tell the other party rather than just allowing the agreement to breach without notification. It helps maintain a good working relationship and your reputation as well. One gallery owner tells the story of a customer who wanted to purchase several glass goblets as a wedding gift. The artist agreed to send additional goblets within a certain date to meet the customer's requirement for a specific number of goblets. The goblets never arrived; the artist never notified the gallery; the gallery no longer does business with the artist. Not only do you risk losing the gallery as a selling outlet, it's likely you'll become known to other galleries or shops as being unreliable.

An implied contract is generally less specific than an expressed contract. It is a contract you'll frequently enter into when purchasing supplies. For example, you place an order over the phone for 20 sheets of glass. By placing the order, you're implying that you'll pay for it, even though you don't expressly state that you will.

The length of any of your contracts will vary with the project and the customer. Government agencies, educational institutions, hospitals, churches, and corporations will likely have detailed contracts to present to you in the event of their contracting your artwork or services. Contracts between a homeowner and yourself will be shorter, outlining the proposal, materials used, installation, if any, completion date, and amount to be paid.

Standard contracts used by architects and building or general contractors were designed by the American Institute of Architects. If you contract architectural work, you'll likely come across these standard contracts, known as A201 and A107. It's a good idea to familiarize yourself with these contracts before they are formally presented to you by a

commissioning client. You can purchase a sample copy from local AIA chapters.

A201 is lengthy and very detailed. In addition to defining the parties and the work, it details minute aspects of the project including: who processes the paperwork, who approves payment, and the arbitration process in case there are disputes about changes in the project. This form is frequently used when projects are put out to bid.

A107 is known as "The Abbreviated Form of Agreement Between Owner and Contractor." It is shorter, less detailed and provides blank space to specify the elements of the projects, such as the work, contract sum, time schedule, and payment. This form is appropriate when contracts are negotiated.

Not every job you'll do will require these types of contracts. Sometimes a more simple letter of agreement outlining what you will do will suffice, especially if the job is small, say for a homeowner. Specify what you are including in your price and be clear about what is not included. For example, if you are installing a window panel and the frame needs to be painted, specify whether you will paint it or whether it's the responsibility of the owner. Specify whether the cost to the homeowner includes your hiring a carpenter to assist in the installation. Note whether the homeowner is to supply ladders, scaffolding, etc. If you and the homeowner agree that you will bring all the equipment, specify who will be responsible for paying the cost of renting any of the equipment, such as scaffolding.

If your project is out of town, include the cost of travel and other expenses, such as long distance calls and overnight mail delivery that you would not incur if the project were local.

Kim Wickham of Wickamore Studios does only commis-

sioned work. She prepares three copies of each contract on which she has spaces for the project description, details, costs including handling charges (delivery, mailing), installation, sales tax, and deposit. Be sure the party authorized to pay you is the person who signs the contract.

Whether you work with a standardized contract form like one prepared by the AIA or design one yourself, whether it's for a homeowner or a major corporation, be sure to include information that covers the following details and specifies the responsibilities of each party:

- Location and date for final delivery of the work, with provisions for delays of a few days.
- Dimensions.
- Expenses.
- Installation costs and responsibilities.
- Insurance coverage for the work in progress (if it's on site) and for the workers involved in the installation.
- Payment schedule.
- Shipping costs and insurance.
- Termination of agreement.

DESIGN AGREEMENTS

Because commissioned work lends itself to being one-of-a-kind, you will likely be asked to draw up a design before you create the work. This costs you time and money. A design agreement tells the client what you'll charge for creating a design and gives you the right to retain the design. Some artists collect a separate design fee only if a work never reaches the fabrication stage. Under such circumstances the artist is compensated for his, or her, design and the parties are no longer associated. The artist retains ownership of the design. Some artists charge for design work, then incorporate

or waive such costs if the work is finally commissioned. You must choose which method best suits your business style and operating costs.

The design agreement should include the following information:

- Dimensions of the finished project.
- Materials and equipment for finished project.
- Approximate cost of finished project.
- Design fee and how and when it is to be collected.
- Completion date for design.
- Conditions and costs for design changes (how often and up to what point in the design process will you agree to let the client make design changes without increasing the design fee).
- Ownership of the design.

EXCLUSIVITY CONTRACTS

Galleries expect some degree of exclusivity, whether it's regional or national. This means only the gallery can sell your work within a predetermined geographic area. If a gallery wants the exclusive right to market your work, ask how they will promote your work and when you could expect an exhibition. If you are a new artist, the gallery will likely want to wait until your work is selling well before arranging for an exhibition.

There is nothing wrong with exclusivity contracts. A good gallery works to build an audience for the artists they represent. In the best of worlds, an exclusivity agreement with a reputable, conscientious gallery will benefit both parties. Many have clients throughout the country and even the world. If you show your work through several galleries in one area of the country, the galleries' interests in promoting your work would not be as strong as if they were the sole

representative. Understand what exclusivity means to you and how it can impact your life, your relationship with galleries and reps, and your ability to market your work. "Exclusivity acts as a catalyst and motivation for the gallery that insures the gallery's efforts will be rewarded," says Doug Heller, of The Heller Gallery in New York City, "Those benefits are diffused when an artist is represented by several galleries, especially galleries that didn't bring the artist to the fore."

A reputable gallery will develop a close bond with the artist as well as form a business relationship.

Consignments

Consignments are a normal business practice in the art and craft world. They provide many artists with selling outlets and they enable dealers to carry work without having to purchase the work. When an artist leaves his work on consignment with an art dealer, whether it be a gallery, craft store, or agent, he often assumes the dealer will be responsible for any loss to the work as a result of fire, theft, or damage. It's also normal to assume that the dealer will remit to the artist an agreed-upon amount of money after the work has been sold. Once you agree to consign the sale of your work to a dealer, state everything you've agreed to in a letter. Include in the letter a description of the consigned piece, the wholesale price the gallery will pay you, whether the work is insured by the dealer against loss or damage, the amount of the protection, whether you're responsible for the deductible amount of the dealer's insurance, who pays for shipping to and from the gallery, when and how often the gallery will hold an exhibition, the length of time of the exhibition, what the gallery provides for the exhibition of your work (printing and mailing costs of invitations, advertising, refreshments),

all provisions concerning exclusivity, and whether the gallery expects their percentage of the selling price if you sell the work yourself.

If you leave your work on consignment, you could lose that work to the consignee's creditor if the consignee goes bankrupt. Until 1990, in Pennsylvania, all objects on consignment could be taken and liquidated to satisfy creditors in the event of bankruptcy. In response to pressure from artists and art groups, several states have enacted consignment laws to protect the artist from losing his work when a dealer files bankruptcy. State laws on consignment vary. Before leaving your work with a gallery, store, or dealer, learn what the consignment laws are in the particular state.

LEASES

A lease is a binding contract between a property owner and a person who is using that property. It stipulates the terms and duration of the rental, or lease, which should be detailed in clear, unambiguous language. A lease should always be in writing. The following aspects of a lease are important whether you're leasing studio space or a retail store space:

- Rental Space—the difference between rentable and usable space. Rentable space is all the space you are paying rent on; usable space is the amount of rentable space you can actually use. Rentable space includes communal hallways, walkways, stairways, basements, restrooms, and parking spaces. Rents for commercial space are quoted in per square foot per year terms. For example, your lease stipulates that you'll pay $10 per square foot of rentable space for each year. If you have 3,000 sq. feet of space, your yearly rent will be $30,000. If you're paying $10 a sq. foot for 3,000 square feet of space,

but can only use 2,000 sq. feet for your studio or store, the actual cost of usable space is $15 per square foot (2000 x 15).

Knowing the difference between usable and rentable space can help you determine whether renting the particular space is beneficial and cost effective to your glass operation. Sometimes landlords are willing to negotiate the rent based on the amount of usable vs. rentable space. Ask about it.

- What the rent covers—Ask whether the rent includes the cost of your share of utilities, janitorial services, trash removal, snow plowing of the parking lot, repairs (minor and major—and stipulate what's considered in terms of dollars a minor and major repair), and insurance. What formula is used to determine your share of those costs? Will you be charged for increases in these costs? This is known as an escalator clause. It means that for every monetary increase in janitorial services, your rent will be increased to cover those expenses. Escalator costs can dramatically increase your rent. Read their provisions carefully and understand their impact on your business. Will you have to raise your prices to cover these costs?

- Who is responsible for any damage done to your store, studio, or its contents as a result of a structural damage, such as a leaky roof? Who's responsible for damages incurred during the repair? The landlord is generally responsible for the soundness of the structure, however, even if he has insurance, the lease might read that you are responsible for amounts up to the deductible figure. Find out whether you'll be required to carry liability insurance for injuries that occur outside your store or

studio in communal areas such as hallways.
- Who pays for security? Will you be allowed to install locks and alarms if the security of the premises is your responsibility and not the landlord's? Will you be able to remove those locks and alarms when you vacate the premises?
- Which improvements will be paid by, and become the property of each party. For instance, if you pay for new lighting and shelving, will you be able to remove the lighting and shelving at any time you wish while you're leasing the space or when you vacate the premises? If major remodeling is necessary, who pays for that? Will you be required to restore the premises to its pre-remodeled configuration and condition when you vacate the space?
- How are the rent increases structured? Will you be charged a flat rate per square foot per year, or is the rent determined by the amount of your gross sales? The latter is a common practice in shopping centers and malls.
- Are there any restrictions? If your store or studio is in a shopping center, can you remain open later than other stores in the center? Are you allowed to conduct classes? Are there any restrictions on the equipment that students may use, on the equipment you use? Do safety regulations restrict the materials you can use in your demos or classes? Does your lease give you the flexibility to receive deliveries at a time convenient to you, or must deliveries be made between certain hours and at a specific location in the building or the shopping center?
- Are you permitted to operate a retail store and a studio at the same location? Is a zoning variance

required from the municipality to locate your business on the premises? If so, who requests the variance, pays the fee, and appears before the appropriate governing body to explain the reasons for the request?

• Can the space be partitioned and subleased? With an eye to expanding in the same location, you might decide it's cost effective to sublease a section of the space you're renting. This would enable you to have a portion of your rental costs paid by another person while keeping the space available for expansion

Speak with other tenants about the landlord's responsiveness to their requests, maintenance and interest in the appearance of the building and its common areas, and his respect for tenants' privacy.

Leases are usually secured for periods of one to ten years. If your lease is for a year or two, it's a good idea to have the option to renew. This means you'll be given the opportunity to renew your lease at the end of its term before the landlord can make the space available to someone else. This can be beneficial for several reasons. Your location helps identify your business. Customers come to expect it to be at the same site for a period of time. Relocation every few years can give your customers the impression that your business is not stable. It can also make it difficult for occasional and repeat customers to locate you. Along with the cost of physically moving your supplies and furnishings, you incur additional expenses in advertising and promoting your new location.

Landlords often use a prepared document called a "form" or "standard" lease. The clauses and stipulations are always weighted in the landlord's favor. Remember, however, leases are negotiable. If you're presented with a form

lease, study each provision closely and suggest modifications that are fair to you. Every lease is negotiable. Non-negotiable leases should be avoided. Have an attorney review the lease before you sign it. In addition to the lease, keep records of all oral and written communications you have with your landlord. They could help protect your rights as a tenant and settle any disagreements or misunderstandings that occur. Address any problems quickly and attempt to resolve them fairly.

Most contracts favor the originator. Before signing any agreement, read it over very carefully, clarify any discrepancies, and review any ambiguities with your attorney. Your contracts and agreements directly affect the operation and profitability of your glass business. Do everything you can to ensure that your contractual agreements are ones you can live with.❖

18

Customer Service

"Never take success for granted. No matter how sophisticated the
business, there remains the human element to communicate a potent
message that human beings are attending to human needs."
—*Paul Renwick*, author of The Small Business Bible

Service sells. Today's consumers want not only value for
their money, they also want service for their time.
Whether they're dealing with a one-person studio or multi-
faceted retailer, consumers want respect, friendliness, hones-
ty, and attentiveness. They like businesses to listen and
respond to their concerns. In today's market of global com-
petition, the company that caters to the needs and desires of
its customers stands a better chance to succeed. As a glass
artist, your customers could be galleries, museums, and an-
tique dealers as well as the end user. Each requires a service
of one kind or another.

Thanks to mega leaps in communications, 800 numbers,
and fax machines, consumers have more buying choices than
ever before. The degree and quality of service you provide
will determine whether or not they remain your customers.

DEVELOPING GOOD CUSTOMER RELATIONS

Good service can begin by determining what value about

333

your business you want to project and creating an atmosphere that conveys that value. For instance, does a finished window evoke in the customer a feeling of artistic integrity in your work? Do several windows show the range of your artistic ability? Does the layout of your shop convey an artistic impression? Does it evoke a sense of friendliness and helpfulness? Build on the impression you want to convey and develop the kind of service you'll provide from that foundation.

Peter McGrain, who does commissioned work, establishes a personal relationship with his clients immediately. He shows them slides of what he's done, takes notes on the style they like, whether they're looking for the abstract or the traditional, what they like and don't like about pieces he's done and generally gets as much information as he can from the meeting. Showing slides helps him determine what the customer wants much more easily than drawing a design. Because of the feedback he receives from the slide presentation, he can begin the project with a better sense of his client's needs and desire. They leave his studio feeling comfortable that he knows what they want.

People tend to buy from people they trust. Letting your prospects get to know you helps build trust in a business environment. Tell them as much about you as is necessary for them to feel comfortable. People seem to be very interested in what makes someone an artist. They are eager to understanding the creative personality. Doug Heller, of Heller Gallery, notices that when collectors purchase a piece, they want to be a part of the artist's creative process. At craft shows, people often are in awe over the ability of a glass artist to create a sculpture. They want to know what makes him tick, what enables him to make the kind of glass art he does. People are interested in an artist's background, his studio

and his technique. Share some of that with your customers. It will build their trust in you.

On a practical level, you have to be outgoing, pleasant, and helpful, according to several successful retailers. Dale Bauers, of Rainbow Stained Glass, services equipment at no charge. "I feel responsible for the equipment if I talk someone into buying it." One of his customers came in with a soldering iron that did not stay hot. The distributor said it was checked by the manufacturer who found nothing wrong with the point. The problem was a loose connection in the handle. Dale took the handle apart, found the problem, soldered the wires and corrected the problem.

Your customers make dozens of subconscious decisions about your business every time they make contact with you or someone in your company. These decisions determine whether they will do business with you or not. Evaluate the impressions the customer is receiving with every verbal and nonverbal transaction. Those impressions directly relate to the customer's perception of the kind of service you'll give to them. See your organization as a total package designed to serve customers. If customer service is integrated throughout your organization, consider whether:

- Your store or studio is in disarray. Creative minds may rarely be tidy, but that doesn't mean the store or studio has to be a mess.
- The employees' style of dress relates to the image you want to convey. If your reputation is built on repairing tools or finished products, wearing work-type clothes or a shop coat could be appropriate.
- Your advertising is consistent and coordinated, or is it slipshod and poorly focused?
- The design of your stationery reflects the image you want to convey.

- Your products are attractively exhibited. Are they easy to see? Does their accessibility make is easy for you to talk about them?
- Your business forms are easy to handle and read
- Your staff answers the phone pleasantly. The importance of excellent telephone manners cannot be overemphasized. It is often the first impression of your company the customer receives. Many decisions about doing business with you are made during that first contact.

Your customer relations are only as strong as your weakest employee. Everyone in your company must be responsible for helping the customer. Getting good service makes people feel good. People like to do business with those companies that make them feel good.

Good service means giving your customers more than they expect, handling their problems efficiently, and answering the phone quickly and courteously. While it takes time, money, and effort, keeping a customer costs a lot less than generating a new one or trying to regain a lost customer. Since most of a company's business is the result of repeat sales or referrals, gaining and keeping customers is simply good business practice.

If you promise delivery of a product within a month, have it at the customer's door within three weeks. If you know you can have a product at your store in 10 days, tell the customer it will be there in two weeks and then call when it arrives in 10 days. The customer will not only be surprised, but know that you care enough to have the product ready as soon as possible.

If there is a delay in getting the product, tell the customer immediately. Keep them posted on its whereabouts every

few days or each week. Let them know why there is a delay. Make your customers feel that their needs are an important part of your business (as they should be).

If a customer thinks he, or she, has been mistreated, they have. Throw out all the rules, all the excuses, all the reasons why your company handled the situation the way it did. If you don't, you'll likely lose not only that customer, but potential buyers he, or she, will share their tale of woe with.

If a customer has a complaint, be sure the first person, or no more than the second person, he speaks with can handle the problem. The last thing you need is a disgruntled customer becoming more agitated by having to repeat their problem over and over again. Let the customer relate the entire problem. Interrupting him may make him feel you aren't interested in his problem or that you don't totally understand it. Apologize for the problem, and if appropriate, thank him for bringing it to your attention so you can take steps to prevent it from happening again. Offer the customer a choice of solutions; it will give him, or her, some control over the situation.

Answer the phone quickly and pleasantly and avoid subjecting callers to an array of recorded messages and instructions to press buttons. In a US. survey by communications briefings, 82 percent of the 524 subscribers questioned said the way the phone is answered influences their opinion of a company.

When asked what bothers them the most, 42 percent of the respondents said automated phone menus were the phone practice that irritated them the most; 25 percent said they are annoyed when a phone isn't answered by the third or fourth ring and 21 percent reported that busy toll free numbers are a bother.

When asked to identify the most annoying phone habit,

34 percent said being put on hold without being asked permission.

Respondents were also bothered by employees uninformed about a product or service, those using poor grammar, and those unwilling to identify themselves.

ENCOURAGE CUSTOMER FEEDBACK

Having good customer relations can be better than all the market research in the world. A customer will tell you how he, or she, feels. What he, or she, likes and dislikes. Encourage feedback from your customers about your business. It will tell you how your company is being perceived; whether the message you think you're broadcasting is the one that's being received. It will help evaluate your customer service, the quality of your products, and even your pricing. Soliciting feedback shows you want to satisfy the customer's needs and that you respect his opinion.

Asking a person for his input is perhaps the most potent way of saying thank you. Few things have as strong an effect on a person as being appreciated for his ideas. The easiest way to get feedback is to ask for it, either verbally at the end of a sale or through a questionnaire inserted with the receipt or mailed to the customer shortly after a sale. Generate questions that reflect every aspect of your business and which will provide information you can really use.

KEEP IN TOUCH WITH YOUR CUSTOMER

Keeping in touch with your customers can mean increased sales.

One effective method of keeping in touch is with a newsletter about your company, its products, and services. A newsletter is not an ad; it is a compilation of what's new and interesting to your customers about your artwork, your busi-

ness, employees, and your industry. In today's business environment, more small businesses and individual artists are publishing newsletters than ever before.

Newsletters are appropriate for artists as well as retailers. They can be as simple as a typed message on a 8 ½ x 11 letterhead or an elaborate multi-page form. As an artist, you can mention your achievements, awards, media coverage, recent, past, and upcoming exhibitions and craft shows, and public collections, as well as new styles you've incorporated into your work and new applications for your work.

If you are a retailer, mention achievements and recognition of your employees by the business and trade communities. Cite media coverage your shop or studio has received. Inform your customers about industry trends, and how they will help you provide better work or service to them. Your newsletter will place you in front of your competition. It will let the customer know you're informed. Even though your customer may not visit your shop or studio frequently, your newsletter will keep your name current in their minds.

Fill the newsletter with information important to your customers. Note price changes which can give your customers a reason to buy now and save money. If you supply glass hobbyists with tools and materials, describe the new products you're introducing that can make their work easier, or better. Whenever possible, highlight a section of the newsletter most appropriate to the individual client and write a short note pointing it out to him.

Newsletters are just one way to stay in touch with your customers. Let your customers know they're smart to do business with you. If a favorable item about your company appears in a newspaper or magazine, don't wait to mention it in the newsletter, send a copy of it immediately to your

customers. It tells them they've made a wise choice in doing business with you but also tells them that you know who they are, and that you value their business.

A more personal approach is to keep records of certain customers activities within their experience with glass. If you learn a customer received an award or recognition, send him a congratulatory note. It reinforces to the customer that you're interested in them as a person and artisan and that you recognize them as more than just an accounts receivable.

Feature your customers in your newsletters. It will strengthen their ties to your business and serve as testimonials to the quality of your service and products.

Always say thank you. Immediately after the sale, write the customer a thank-you note. A few days later call to see if they are satisfied with the purchase. Are there any questions about the item's use, material, or care?

Give a gift. If you give a gift in conjunction with another retailer, the cost can be divided and you both benefit. Your customer remembers your goodwill and the retailers generate new business. Remember your most valued customers with tickets to sporting or cultural events. For instance, if you are participating in a locally or nationally sponsored craft or art show, in many cases, free admission tickets are made available to participating artists and craftspeople. Make sure these complimentary tickets go to your most valuable customers first.

Find out what your customers like. If you receive a referral, thank the person who brought you the new customer with a gift made by you.

Cross-reference your current mailing list to remind customers when they last ordered. They'll see you as dependable and come to rely on you. Cross-referencing also helps you identify specific products with each customer. If a cus-

tomer always purchases a specific brand of glass, or if he, or she, likes a certain style of your work, you can let them know when a new line arrives or when you have new pieces in a style they might like.

As a studio artist, let your customers know when you've made something that will interest them, perhaps a special design, or the use of a unique style of glass they've expressed an interest in.

Send a dollars off coupon or special offer to customers who haven't made a recent purchase.

At every opportunity make your customers feel important. Remember also, those who place small orders. They are essential to your company's growth. With your help, they might place large orders.

Promos, ads, and publicity might get buyers in the door, but it's the attention and care of customers long after the sale that will bring them back. Keeping your customers is simply good business practice.❖

19

Management

"Hire a Who, Not a What"
—*Linda Silverman Goldzimer*, author of I'm First:
Your Customer's Message to You

Employing the appropriate staff is essential to the successful operation of your business. However, the smaller the operation, the more important it becomes. The success of your business is dependent upon the service you give your customers. When hiring employees, seek out those who can build strong customer relationships, whether it's with direct customer contact or through the quality of work they produce. Working in the creative arts such as glass, whether in a studio helping to create the object or in a store helping craftspeople, requires an attitude and aptitude not found in other types of business.

"I look for someone who's skilled, who's a problem solver, who's self-motivated, who takes prides in what he, or she, is doing and knows that what he, or she, does is special," says Noel Hilliard, owner of Lamps by Hilliard.

JOB DESCRIPTION

Begin your hiring process by analyzing the job. Ask yourself what you expect the person in that position to accomplish

and what impact he, or she, would have on your customers. Include these facts in a job description. Identifying goals or results, rather than activities, in a job description will help accomplish the long-term goals you've established for your business. Follow the goals with a summary of the employee's responsibilities: a listing of academic, business or technical knowledge you think is necessary, such as fusing, glassblowing, painting or installation techniques, or the ability to develop a marketing and publicity program, or understanding shipping rates and methods.

List everything about the job on the job description. Be up front about what you expect. Learn what the employee expects in terms of salary and the potential for advancement. Set specific review times and a range of possible salary increases. For new hires, a review after three months is reasonable. Other reviews can take place at six or twelve-month intervals with appropriate salary increases. A clear job description helps you and the employee understand what's expected.

Different situations require different abilities. If your new hire will work directly with customers, consider the importance of his, or her, appearance, poise, personality, interest, courtesy, and knowledge of glass in general and your operation in particular. "I look for personality more than glass working skills," says Scott Haebich, owner of The Stained Glass Place. "I can teach them skills, but not personality." If the person will be installing windows, does he, or she, have carpentry skills and understand basic house construction? Are they mechanically inclined? Does he, or she, understand details, such as stress points, wood finishing, cosmetic touch-up, on-site repairs, etc.? If those you hire will be working in the studio, find out whether they can work with their hands. Some people have wonderful concepts and

can articulate their ideas, but cannot work well with their hands.

In some cases, the employee may be required to do only one job, such as designing, glass cutting, fusing, or painting. Ask yourself if the person will be satisfied doing the same job every day. "Some people love doing one thing," says Peggy Karr, owner of Peggy Karr Glass. "Be sure the employee knows what his job will be," says Peggy.

Avoid putting someone in a job for which he, or she, is either under or overqualified. If a person can't do the job for which he was hired, you will find yourself in an awkward position. It's never easy to fire someone. If you hire someone who's overqualified, he, or she, may become bored and you'll be faced with an unhappy and unmotivated employee.

Build the strength of your company by hiring to your own weakness and the potential employee's strength. If you are strong in technical skills, but weak in marketing, look for a strong marketing person, someone who knows how to project and publicize your business. If you're good at layout and design, but not in detail work, look for someone who can enhance your work with a fine sense of detail. Scott Haebich plays to his employee's strengths by having one person take on special projects, such as coordinating community education programs in the area's schools. Another salesperson arranges the displays and merchandise; a third is a good pattern designer. The Stained Glass Place publishes and sells her patterns.

If you decide to hire someone, determine if your studio or store can afford the added costs and whether you must increase prices to cover those costs. An employee will probably work at a slower pace than you as an artist and owner of the business. As a result, your costs will increase and the efficiency will decrease. If you make a lamp in 100 hours at

$10 an hour, it could take an employee 200 hours at a cost of $20-$25 an hour. You incur those additional costs. The money has to come from somewhere. In addition, the cost per hour to operate a business once you have employees skyrockets because of mandated expenses like workers' compensation coverage, unemployment, and Social Security contributions as well as the cost of maintaining efficiency and the need for more space.

ADVERTISING

Classified ads are only one source for finding potential employees. Consider looking at vocational, art, academic, and business schools, colleges and universities as sources for prospective employees. Students are likely to welcome the opportunity to work for you in a hands-on environment. Working in an established glass studio is often the first step for those seriously considering a career as a glass artist. Employment agencies that provide temporary clerical and accounting help could be another good source.

Referrals can be an effective way to get good employees. Tell everyone you know, including your customers and present employees, what kind of person you're looking for. Potential employees that have heard about your business (both its good and bad points) from your customers and employees are likely to have a better understanding about your studio or store than anyone else.

Target your ads specifically to the kind of person you want to hire.

In your ads, talk about the job in human terms. Using the word "art" in your ads could generate an interest from creative people. Even if the job opening is for a clerk in her shipping department, Peggy Karr uses the word "art" in the beginning of her ad. "It's brought in people who enjoy work-

ing in an artistic environment," she says. Targeting for certain types of people and personalities is effective. Also, be honest and specific in describing the real-life work environment at your place of business.

INTERVIEWING

Historically, businesses have hired people based on their resumé, their education and professional experience. It hasn't always worked. Look for the intangibles—the co-operative nature, the ability to relate to customers, to generate ideas, to work at one process, or several every day, independent judgment, poise, energy, and patience. Generate questions that will uncover those qualities. Learn to recognize characteristics that will tell you how well the person being interviewed will fit into your environment. Steve Lundberg, of Lundberg Studios, considers a person's attitude toward health and work and whether they'll fit in with his staff. A positive outlook, interest in exercise, and a love of glass are imperative to Steve.

Ask questions that generate a thoughtful response, not simply a yes or no answer. Brian Maytum of Maytum Glass Studios Inc., listens to what a person says about the choices he, or she, has made and how he, or she, made them. "If a person's unclear about what he does, I don't want him," says Brian. "I want someone who has a clear idea of who he, or she, is and how they relate to other people." Brian looks for character. The "quality of the soul within" is how he describes character.

The interview process should be fun and relaxing. Put the person at ease. A genuine smile and a warm introduction can do wonders, as can a little small talk about local, non-threatening issues. Note the person's nonverbal message—his or her mannerisms, gestures, and dress. Remember that

they will probably never come to work more neatly dressed than for the interview.

The potential employee will be interviewing you as much as you are interviewing them. Expect to answer questions. Encourage them.

Take the finalists for the job on a tour of your operation. Show them the work environment, introduce them and encourage your employees to talk with them. The interviewee's reaction can indicate whether they'll be comfortable or not.

Once a person has agreed to work for you, follow up your verbal offer with a letter of welcome. Include in the letter (or present it at the time the person accepts the job) an employee manual detailing all the information about the company that will be relevant to their position, such as hours, insurance coverage, vacation time, sick leave, and holidays. A large part of job dissatisfaction is due to misunderstanding these items. Take every step to avoid such misunderstandings.

HIRING FAMILY MEMBERS AND FRIENDS

It is difficult to resist hiring a family member who does not have the talent or requirements for your business. The emotional aspects of family relationships can be hard to fight, especially if your brother-in-law is out of work and you have a successful, growing business. It's best to separate family from business and approach any request to hire a family member from a strictly business standpoint.

Your brother-in-law might be out of a job, but what if he costs you more than he's worth while under your employ? What would be the ramifications if you had to fire him? Recognize any talent or lack of talent before hiring a family member. If you can't avoid bringing a family member on board, consider where, despite any weaknesses, you can place him, or her, so they can make a contribution without

disturbing customers and other employees. The effect a family member can have on employees should be uppermost in your consideration. If he or she takes advantage of the family relationship, don't be surprised if your other employees become demoralized and resentful.

KEEPING YOUR STAFF

Next to your own dedication and vision, productive employees are your company's most important asset. Surround yourself with capable people who share your goals. Successful studios look for people who want to be there long-term. They provide their employees with the support and tools they need to function effectively. They know that motivated results-oriented employees help establish high staff morale and a productive work environment. They welcome and elicit input from their employees. A wise employer will encourage his employees to tell him what he needs to hear, not what he wants to hear.

Even if you've hired the best person for the job, remember that there is always room for improvement. Good employees welcome training, not only to do their present job well, but to move on to more challenging work. A well trained and motivated staff means better employee morale, lower turnover rate, less waste, improved productivity and increased sales. A training program can be as simple as taking time on the job to train the employee for a new task, or involving them in classes and professional seminars or workshops.

Part of training is delegating work to your employees. By delegating, you help to develop their potential while freeing yourself to use the special talents you bring to your company. Delegating enables you to plan your company's expansion. Without it, you will likely get bogged down with daily

minicrises and workload details that would be better left to someone else.

Pay your employees at least the going rate to start, with the promise of salary increases based on performance. If possible, set up the kind of employee benefits found in other types of employment, such as retirement plans, etc. Give yearly bonuses or job related awards relative to the goals that have been achieved as well as for exceptional performance and creativity.

Recognizing and praising your employees for personal and professional achievements can go a long way in maintaining high morale and productivity. Acknowledge your employees' contributions in ways that are meaningful to them, such as time off, monetary awards, gifts, etc. Know what's important to each of your staff. A parent of young children might appreciate time off from work more than a gift. You could show your appreciation to an employee who enjoys sporting or cultural events with tickets or invitations to such events. Give a gift that relates to an employee's hobby.

Many successful studio owners and retailers attribute the success of their operation in large part to their employees and themselves having a sense of family and responsibility toward one another.

Treat your employees as nicely as you treat your customers.

Day To Day Management

Establish priorities. It is one of a business owner's chief responsibilities. Begin by simplifying, focusing, and concentrating on your priorities. Find the time to do the important things that truly matter to your business. Know what's important and consider ways to be more productive.

Eliminate unnecessary information. We drown ourselves in newspapers, magazines, reports, newsletters and bits of information we think might be important. Even though we've transferred much of our business paperwork, record keeping, bookkeeping, personnel files, advertising schedules, inventory lists, etc., to computers, information overload is still with us. It's unproductive and the lack of productivity caused by it, can ruin a business.

Determine what your information needs are. If you sell your work only through antique dealers, you do not need a listing of craft shows. If you place your work in galleries, maintain current information only on galleries appropriate for your work. You don't need to know the names of galleries that sell only paintings and prints.

Once you have a clear focus of what business you're in and where you want to go with it, you're on the road to clearing the path of useless information.

Eliminate unnecessary chores but know the financial status of your business at all times. On a daily basis, know the amount of cash on hand and the business' bank balance. Maintain a daily summary of sales and cash receipts. Correct all errors in recording collections on accounts and maintain a record of all moneys paid out by cash or check.

Each week review accounts receivable, contacting slow payers; and accounts payable, take advantage of discounts; disburse payroll checks and submit taxes and reports due to the federal and state governments.

At least once a month, classify all journal entries according to appropriate income and expense categories and post them in your general ledger. Prepare a balance sheet and profit and loss statement for the previous month. The balance sheet lists assets, liabilities, and your investment. A P&L statement shows income and expenses. It can help you deter-

mine ways to increase your income or reduce your expenses, such as taking advantage of discounts and avoiding penalties for taxes and reports that were submitted late. Reconcile your bank statement. Balance the petty cash account, make all federal and state tax deposits, and age the accounts receivable to 30, 60, 90 days, etc. past due. Check and update your inventory.

These procedures monitor the health of your business.

Hands-on Management

Yogi Berra is attributed with saying "You can observe a lot just by watching." Despite having capable, reliable, devoted employees, the success of your business rests primarily on your knowing what's going on in every facet of your store or studio.

Visit every area of your operation, even if it means covering several thousand square feet of space each day, or visiting everyone's desk or workbench. Let your employees see that you are there to help them.

Communicate with your customers, either in person in the store or studio, over the telephone, or by direct mail. Let them know you appreciate their buying from you.

Test the products you sell by using them yourself in the ways your customer would. If you create sculptural works, place them on pedestals in your home to see how they catch the light, whether a round or a geometrically shaped pedestal enhances the design. If you make lamps, adorn your house with them, noting the amount of light they cast, the direction in which they cast it, the shadows that appear, how the glass reacts to the light, whether the design is effective or not. Use your products to determine ways to improve their design, appearance, and use.

WORKING WITH YOUR FAMILY

Making your business a family affair can be frustrating, awkward and disruptive. It can also be challenging, exciting, and rewarding if all parties recognize the strengths and weaknesses of each family member and put their individual strengths to work. In some glass studios and stores, both spouses are artists, and in others, one spouse may be the artist and the other the business manager.

Balancing the creativity required to design and sell glass and the rationality needed to handle the business can be difficult. Each area is time consuming, yet the marketing and accounting of a business is as crucial to its success as a well designed and crafted glass object.

"Decide who is going to do what and make that decision based on what each is good at, not what each wants to do." says Vicki Payne of Cutters Video Productions. Vicki and her husband, Chris, have operated a retail store and a mail order supply business and produce instructional stained glass videos. "Once you decide who's in charge of what, live with that decision and don't second guess the person in charge," she says.

Chris Payne oversees all the shipping and mail order of the videos and stained glass supplies the company sells. He supervises the video crew and production company. Vicki decides what will be on each video and writes each script.

"We knew we liked working together and had to decide who was strong and weak in which areas," says Vicki. "The ultimate goal was more important than our egos."

"Keep an open mind," say artist, lampmaker, instructor, author and publisher Joe Porcelli and his wife Vici. Joe designs and markets the Tiffany reproduction lamps he makes. Vici is the back office. Using her accounting background and experience with an investment banking firm,

Vici set up the record keeping and handles the shipping, sales, and invoicing from all of their enterprises—Arts & Media, Inc., The Glass Press, The Glass Library, sales of Joe's instructional videos, his book The Lampmaking Handbook, and his lamps. They collaborate when they're developing a new product, designing promotional material, or dealing with client problems. But they don't do everything together. "There's wisdom in letting your partner do what he or she does best," says Joe.

Noel and Janene Hilliard are lampmakers who despite their different styles and approaches to making lamps love working together. "We realized years ago that we couldn't collaborate effectively. We were both strongly opinionated about how we believed a lamp should look." says Janene. Over the years they've used each other's strong points (Janene's artistic approach and Noel's technical expertise) to increase their market. A full-time manager oversees the daily operations, enabling Noel and Janene more time to design lamps. They both manage the manager.

If your studio or store is a family endeavor, keep three important factors in mind:

1. Emphasize each other's strengths.
2. Give each other space when necessary, and;
3. Have a good time.

Understanding your partner's need to be alone or to work uninterrupted can be the most difficult, yet important part of living and working together.

SELF-DISCIPLINE IN THE HOME STUDIO

Self-discipline is absolutely necessary when you work in a home studio if you expect to take your career seriously. You're dealing with designing, creating, producing, adver-

tising, marketing, selling, bookkeeping, and bill paying, to say nothing of managing home and family responsibilities at the same time. Unless you are self-disciplined, time will slip away while the tasks remain undone.

Begin each week by deciding what you want to achieve as an artist and as a businessperson during that week. Determine your financial goals and calculate how much time you have to devote to your business to earn that amount of money.

Allocate blocks of time when you're at your most proficient to do the work that requires the most energy, and leave the times when you are least efficient to cleanup, file, make phone calls, place orders, pay bills, or other billpaying and routine tasks.

It may sound elementary, but writing down your goals can be extremely useful in helping you achieve them. Set goals within goals. List what you want to achieve by the end of a week and then specify the action you'll take each day. Breaking down weekly goals by days makes them more attainable. After each goal is achieved, set another goal. This step by step method makes any project seem smaller. Keep the list reasonable in length so you can accomplish most of the tasks you've listed. Planning to do too many things in one day can be overwhelming, unrealistic, and stressful.

Take a break when you need one.

Avoid the temptation to get sidetracked. When you take a coffee break and look around at the household chores that need to get done, it's easy to take a few minutes to do them. Don't. Keep yourself focused on your studio work.

Work at your art every day. You have to create, so practice your craft each day. Do one difficult thing every day. The will is like a muscle; it has to be exercised regularly to become strong. The stronger your will, the more you'll accomplish.

Working alone at a home studio can get lonely. There are times when no one else will be around to share your enthusiasm of the moment. Reward yourself after completing a difficult or lengthy project, or achieving certain goals. Do whatever makes you feel good. It will reinforce your sense of accomplishment.

Space Invaders

If you've ever worked outside the home, you know the stress of balancing work time with family needs. You come home from work and everybody wants your attention. They're hungry. They need help with homework. Your spouse and children want to talk with you. It can be confusing, upsetting, and it can stretch your patience and endurance to the limit.

Working at home has numerous benefits, not the least of which is flexibility. The hours are yours to do with them what you wish. Or are they? Working as an artist is serious business. How do you balance work time and family time when they share the same site? How do you separate your time as an artist from that of a spouse and parent?

With proper planning you can have the best of both worlds, the creative time imperative to your work as a glass artist and the pleasure that comes from being with those you love. It begins with being committed to your work.

Communicate to your family and friends your need to work undisturbed in your studio for a period of time. Let your answering machine take care of incoming calls during your work hours, if need be. Establish your studio in an area separate from family activities. Emphasize that you and the area are not to be disturbed; that the work area is for your use only, not anyone else's.

At the same time, understand your family's need and desire to be with you. Scheduling your time can be extremely helpful.

Creativity has many positive effects, not the least of which is its effect on the artist's lifestyle. Because human nature is often at its best when it's creating, the creative act is a positive experience. It pushes negativity aside. That positive feeling can be felt in every aspect of the artist's life. Having satisfied their artistic needs and desires, creative people then approach their other responsibilities with a positive attitude. Many artists find that allotting a certain number of hours to their work each day enables them to concentrate on their art and afterward transfer that positive experience to other areas of their life, like their family.

To balance your time between work and family, hire a baby-sitter if your children are small. It's just about impossible to focus your energies on your artwork when you have toddlers underfoot. It can be distracting, unnerving, and frustrating. It's also a health and safety risk to have children in a glass studio and work environment. As children get older, they tend to better understand your need to work and respect that need if it's balanced with their own. Let them know you will work for a period of time and then you'll spend time with them. It works. If you and your spouse both work at home, respect each others' work schedule. Taking breaks at the same time can be a pleasant diversion and gives you a chance to share your ideas in a quiet atmosphere.

Interruptions are bound to occur from time to time, but by communicating your needs and understanding your family's, they can be kept to a minimum.

FINANCIAL SUPPORT

If your family's involvement is money they have loaned you, treat the loan as you would if it were from a bank or other lending institution. The conditions of the investment or loan, including the repayment schedule, the interest to be paid, the

degree of involvement of the borrower in the business, and his, or her, share of the profits should be detailed in writing. Family investors might view your managerial decisions only in terms of dollar signs, while you consider the impact of your decisions on the production, sales, and personnel. You might consider an expenditure an investment; they might view it as a frivolous expense. If you engage in a family-owned business, realize how these kinds of conflicts can occur and prepare yourself for them. Avoid them if possible.❖

20

Planning for Growth

"The most serious risk to unplanned growth is financial instability."

A rt glass is a wide open field. In the world of retail businesses, it is a relative newcomer. Whether you choose to market to the craft buyer, collector, the home owner, architect, corporations through craft shows, galleries, or museums, whether you work in cold or hot glass, the options and opportunities are there for the taking. As your abilities increase and interests change, you can change your audience, adapt your knowledge, and alter your focus. You can teach, sell, supply, and exhibit.

Preparing for expansion and implementing long-term goals requires the same diligence of thought that goes into starting a business. Plan for growth immediately. Successfully managing a business from the get-go involves planning for expansion, even if in the beginning your only plans are being aware of the factors involved with growth. Anticipate how much and how quickly the growth will and can occur. Consider its impact upon your costs, employees, customer service, product quality, management, work space, and cash requirements. When you start your business, the idea of where you'd like to be professionally in five years need not

be put on paper, but it should be contemplated. Eventually, the idea will need to be in a tangible form.

The greatest danger of unexpected growth is financial instability. Unmanaged and unexpected growth could result in lower profit which could put the future of your company at risk. For example, let's say there is an increased demand for the leaded glass lamps you make. To meet that demand, you hire more employees. By having more employees, you increase your costs of salaries, taxes, insurance, and workers' compensation coverage. In addition to the increased costs related to hiring more staff, a demand for your work would likely result in your purchasing more materials, which would increased your outlay. If the cost of the materials represents 50 percent of the selling price and your business increases sales $50,000 in one year, then your material costs are increased by $25,000. In addition, consider what impact the increase business would have on utility and shipping costs.

Consider what brought about the increased demand. Did you promote more extensively through paid advertisements? Did you expand your promotional program by mailing more brochures, attending more craft shows? Did you extend credit? These increased costs could be incurred weeks or months before your lamps are sold. As a result your cash flow would be diminished and your profits reduced. The increased costs could devour your company's profit if they have not been anticipated. Having a well thought out expansion plan will allow for additional costs to be safely incurred with increased demand.

Growth is good. Without it many glass artists might still be unknown, unsuccessful, and unfulfilled. Understand that there are risks with growth and prepare for them. When Noel Hilliard of Lamps By Hilliard realized he would have to hire

a manager to oversee the studio if he wanted to devote more time to designing lamps and less to the day to day operation, he prepared for it for two years by increasing the efficiency of his studio so it could afford the additional expense of a manager.

EXPANSION PLAN

Recognize and prepare for risks associated with growth by having an expansion plan. This is similar to the business plan. It helps you identify your long-term goals and institute mechanisms needed for expansion. If your strategy is to expand without financial assistance, preparing an expansion plan and having the details on paper can give you a clearer picture of the feasibility of your idea. The plan need not be extensive, but it should contain information that projects a clear picture about your company's history, regarding its products, market, and sales.

- Begin with a brief summary of your company and the reasons you want to expand.
- Identify your present market. Attempt to forecast the growth of that market for the next five years through information from trade associations, craft show organizers, gallery owners, other artists, and retailers and business and trade magazines. If you intend to expand into other markets, identify and analyze each of them as you did your original market in your business plan, asking yourself if your product or service is needed, if it's a growth or static market, what your product or service does for your customer and what is unique about it. Project the percentage of the market you'll aim for in each year of your expansion plan. Define your marketing strategy. Will it differ from the way you market your

present products or services?

- Identify the competition in the expanded market. Attempt to determine their strengths and weaknesses. List your advantages over the competition.

- List additional equipment, materials, and space (and their cost) you'll need to make the products for the new market.

- Incorporate into your expansion plan a well thought out financial schedule. Include the amount of money you'll need and your anticipated return on that money. Calculate all the costs involved in making and marketing your products. Be realistic in your figures.

- If you are preparing the plan for a lender, describe how and why you went into business. Define your past, present, and future market segments. Determine your company's strengths. Tell the lender what has made your business successful. Describe the sales patterns of your products. Are they generally sold in a particular season, through specific kinds of outlets, in a certain geographic area? Explain how you'll expand into other markets. Whatever information you can provide about the market share of your products and that of your competition, would be helpful. Trade associations or a marketing expert might be able to help you with this. Mention new technologies and concepts you're using. This tells the lender that you are forward-minded.

- Describe how your products are developed, from design to delivery, and how you anticipate the changes that will occur as a result of the expansion. Provide the names of your suppliers.

- Include balance sheets, profit and loss and cash flow

statements for the next three to five years. Expanding a business involves the same cash flow situation as beginning a business. There will be a period of time before the amount of outgo is replenished by income.

Focus your expansion on your strengths. Companies that do enjoy a better chance of succeeding.❖

21

Retirement Plans

"Love what you do and you'll never work a day in your life."

When you do something you love, it can be hard to imagine a time when you won't be doing it. After all, if you love your work, why would you retire from it? However, ill health, or a change of priorities can have an effect on whether you'll continue to work with glass. Your needs may change as you get older. You might decide to market your glass on a part-time basis without consideration to the income it derives. You might want to sell your store and pursue other interests. The needs of your spouse or partner may alter your lifestyle. Anything might happen. Given today's variety of retirement plans, it's never too soon to plan for your retirement.

CHARTING YOUR RETIREMENT

The first step in planning for retirement is to consider how much money you need to maintain a certain lifestyle, keeping in mind the effect of inflation on the value of current dollars. Take into account Social Security, personal savings and investments, and pension plans you or your spouse might have from other employment. If you intend to sell your house,

consider the amount of equity that would be available.

Whether you choose to establish a retirement plan like those described below, or wish to put money aside without the tax benefits of a retirement plan, many investment vehicles are available. They include certificates of deposit, mutual funds, government securities, stocks, and annuities.

Plan your income to last as long as your life expectancy and that of your spouse. According to the IRS, a person aged 55 has a life expectancy of 28.6 additional years; a person of 70, 16 more years. The IRS table is used to determine how much money you must withdraw from an IRA once you've reached 70 years of age. With people living longer today, unless you have a life-threatening disease or a family history of early death, it's not farfetched to expect to live into your 80s and 90s.

THE BUSINESS OWNER'S CHOICES

The variety of tax deferred retirement plans are more plentiful than ever before. They can also be more confusing. As a business owner, you can choose a plan for yourself and your employees from the same menu as Fortune 500 companies. These can include Simplified Employee Pension (SEP) plans and profit-sharing plans as well as Money Purchase Plans, Profit Sharing/Money Purchase Plan combinations, and Defined Benefit Plan.

SIMPLIFIED EMPLOYEE PENSION

The simplest type of retirement plan for businesses with fewer than 50 employees is the Simplified Employee Pension plan

A SEP is appealing for several reasons. It requires no government reporting and may be established and funded up to the due date for filing your business' federal income

tax return, including extensions. Contributions of up to fifteen percent of each employee's salary can be made annually. Contributions, which are tax deductible as a business expense, may be invested in a variety of vehicles. The accumulated funds are tax deferred until withdrawn. Contributions are immediately vested. Although the employer makes the contributions for the employees, each employee may choose where his portion of the money will be invested. Assets can be taken out at any time, although a 10 percent penalty is assessed if withdrawals are made before age 59 ½. Part-time workers who meet salary and longevity guidelines established by the government must be included in a SEP.

How a SEP Works

You have two full-time employees with earnings of $20,000 each. Your current salary is $50,000. By contributing 15 percent of your, and each employee's, compensation you reduce your taxable business income by $13,500 ($7500 for yourself and $3,000 for each employee.) If you continue to contribute $7500 for yourself for five years in vehicles that earn 8 percent interest, your account would be worth about $40,000. After 10 years, you would have more than $110,000 and after 25 years more than $500,000.

Profit Sharing Plans

Like SEPs, contributions to profit-sharing plans are tax deductible, may be placed in a variety of investment vehicles and can total 15 percent of compensation for each employee. There the similarities between the two retirement programs end.

Profit-sharing plans can be custom designed for each company. They can be as sophisticated and loaded with options or as simple as you wish. The contributions may vary

from year to year, but the law requires the company to make "recurring and substantial" contributions based on profitability. All full-time employees over the age of 21 must be included in the program. The law defines full-time as working at least 1,000 hours a year. Part-time employees or seasonal employees can be excluded from a company's profit-sharing plan. Either the employer or employee may select investments for profit-sharing plans, depending upon the design of the plan. A key feature of profit-sharing plans is its vesting schedule. An employer can design the plan whereby contributions and earnings are vested over a specific number of years. An employee who leaves before the end of that vesting period would not be entitled to the plan's full benefit. With SEPs, the assets can be taken at any time. With both types of plans, a 10 percent penalty is assessed if the withdrawals are taken before age 59 ½.

Profit-sharing plans are more flexible in their design than SEPs, but they are more difficult and more costly to administer. Not only must they be reported annually to the IRS, but the IRS or Labor Department could require additional documentation for such investment vehicles.

Of the two plans, SEPs are easier to implement, more efficient to operate, and more economical to administer. However, if you don't wish to include part-time or seasonal employees in your retirement program or if you have specific objectives in mind, a profit-sharing plan could be more appropriate.

OTHER PLANS

In addition to the above, more complex retirement programs are available, such as Money Purchase Plans, Profit-Sharing/Money Purchase Plan combinations and Defined Benefit Plan.

A Money Purchase Plan is designed for the business owner who wants to contributes more than 15 percent of compensation each year. It requires that company contribute the same percentage of compensation every year regardless of profits. As a result, a Money Purchase Plan provides a more secure retirement benefit for employees than a profit-sharing plan. It also provides a significant tax deduction for the employer. Money Purchase Plans are generally used by companies with stable profits and/or those willing to commit to a fixed annual contribution. A Money Purchase Plan can be used as a basic retirement plan or combined with a profit-sharing plan.

The combination Profit-Sharing/Money Purchase Plan would enable business owners to make additional contributions (based on profits) in more profitable years, without being locked into the higher amount each year.

All the plans outlined above are known as defined contribution plans because the benefit is determined by the defined amount of contribution.

The Defined Benefit Plan works the opposite way. It requires you, as the employer, to contribute the necessary amount of money that would pay a specified annual benefit at retirement. The annual contribution would be determined by salary increases, mortality rates, vesting schedules, employee turnover, and investment returns. A Defined Benefit Plan can be a complicated plan but is an excellent tax shelter. The closer you are to retirement, the more you can contribute to the plan. It is best suited for a company with predictable profits since quarterly funding requirements must be met.

Any investment should be undertaken with extreme care and only after all the benefits and risks are clearly understood. Business needs and national and international economic changes can bring out new types of plans. For

instance, the plans mentioned above redefine the Keogh Plan, a term which is no longer used. For a complete explanation of retirement plans available to you as a business owner, consult with your banker, brokerage firm, or financial advisor. Review each program with your accountant to determine how its advantages and disadvantages affect your company.❖

22

The Future of Glass

"We have the workings for a glass explosion."
—*Maureen James*

Never before has art glass been more accessible to the public. From small decorative objects to architectural panels in public places, glass impacts people's perception of it as an art form and decorative element. No longer is glass relegated for ecclesiastical or utilitarian purposes only. The future will be an exciting time for glass if the momentum continues. It is happening now. We're seeing glass at craft shows, in retail stores, galleries and museums, books, on videos, and on television. Instructional books and videos, creative individuals and entrepreneurs, innovative techniques, and greater accessibility to equipment, are making glass more appealing to new craftspeople and a larger audience than ever before.

The future of glass is dependent upon everyone involved with glass working together. Artists, manufacturers, suppliers, retailers, educators, patrons, promoters, and administrators must collaborate. "We must recognize the common bond among all of the professionals involved in glass. The strength of this interwoven fabric will determine the longevity and well being of the art glass industry," says Larry

Kolybaba of Baye Glass.

Each professional must educate the other about his product and persons outside the profession, about glass. Education will increase the demand and enable artists to get justly compensated for their work. Sharing information is the most important element in moving stained glass forward into the realm of fine art, according to glass artist, Peter McGrain.

Camaraderie among the professionals is vital. "If we have fun, we will be able to implement longevity and well-being," says Larry Kolybaba. Kay Bain Weiner sees the camaraderie everywhere. "The craftspeople I see at workshops are excited about glass," she says. "There's a fervor, an excitement in them. At workshops I see hobbyists, professionals, and instructors coming together." Enthusiasm and camaraderie are there among the artists. They are resources from which the future of art glass will be molded.

THE GREATEST NEED SEEMS TO BE IN EDUCATING THE PUBLIC

Enthusiasm and excitement are vital elements which must be coupled with educating the public if an artist or retailer expects to make his livelihood from glass. Retailers who sell glass supplies see a product and activity that people can quickly and inexpensively enjoy. Stained glass is relaxing, pleasurable, and a great hobby, but many people do not know about it. "Why isn't the industry promoting itself?" ask several retailers. "No one is promoting the industry to the betterment of everybody. Each of the glass organizations that exist focus on a limited segment of the industry."

There are no ads in major circulation magazines or on television. Retailers suggest the industry run ads focusing on the industry in general, similar to the way citrus growers and the dairy industry promote their products. The ads could benefit manufacturers, suppliers, and artists. By increasing

awareness of glass as a decorative element, more supplies and equipment would be needed to meet the public's desire for glass. Retailers say they receive no promotional material, such as point of purchase displays, posters, or booklets from manufacturers or associations that could be helpful to attract and educate customers.

Suppliers believe the industry could benefit by having more retailers. Business, some suppliers say, is increased when retailers are located close to each other since interest in glass is determined by the public's awareness.

Maureen James, editor of Glass Patterns Quarterly, says more pattern books of all kinds are needed. "Some people are not interested in doing their own designing; they're more comfortable following a pattern. The more types of techniques and patterns available, the more creative and interested others will become."

HOMEOWNERS

There are probably hundreds of thousands of homeowners who don't have an inkling about incorporating glass into their homes. To get glass into homes, there needs to be more communication between suppliers and artists regarding colors and textures, according to John Emery, of Preston Studios in Florida. "It's important to get glass into houses and one of the ways is to key glass colors and textures with the colors promoted by the interior design field in carpeting and fabrics," says John. "If the artist is clever enough, and designs a panel well enough, he combines colors to create a panel that can be timeless."

On a broader scale, there is no end to the possibilities of placing art glass. There is no architectural structure in the world that could not accommodate glass stylistically, whether in the form of a window or autonomous work. One major

supplier sees glass opportunities opening up in the design market as architects and designers look to it as a building material.

Lamps, of course, are items that have infinite possibilities and applications. The lighting industry, one in which glass lamps have always been an important part, is rich in opportunities for those glass artists and craftspeople whose works and designs are appropriate.

The antiques community offers a wealth of possibilities to the conscientious glass professional. Restoration, repair, and replacement work for glass objects can be a constant source of revenue for individuals, studios, and shops versed in the styles and requirements of antique glass objects.

OPTIMISM

There's a lot to be proud of in the art glass industry and lots of reasons to tell the world about the excellence that's developed over the years.

One need only go to a museum anywhere in the world to recognize that art is important to humankind. It is virtually the only thing that has been regarded so highly that it has been maintained, revered, and passed on, so lovingly. Our culture will certainly pass along data and technology, but we must also pass on a perspective and human identity of our culture to give it all meaning. Art has provided, and will continue to provide, this gift.

The thrust of promoting glass has, for the most part, come from individual artists who market instructional videos, books, and workshops, and who use professional marketing techniques to promote themselves and their creations to galleries, museums, consultants, antique dealers, and other retailers. As museum professional Daniel Stetson stated, "Unless I see an artist's work, the work doesn't exist for me."

The more glass is seen, the more the interest in it grows. "If we could get the public high on art glass, we could never produce enough." An appropriate closing statement from Larry Kolybaba.❖

23

Resources

Affiliated State Arts Agencies of the Upper Midwest
528 Nennepin Ave. #302
Minneapolis, MN 55403
(IA, MN, ND, SD, WI, IA)

American Craft Association
21 South Ettings Corner Road
Highland, NY 12528
800-724-0859

American Craft Council
72 Spring Street
New York, NY 10012
212 274-0630
Fax 212 274-0650

American Craft Museum
40 West 53rd St.
New York, NY 10019
212 956-3535
Fax 212 459-0926

Appalachian Center for Crafts
Route 3, Box 347-A1
Smithville, TN 371665
615 597-6801

Art, Crafts and Theater Safety (A.C.T.S.)
181 Thompson Street, #23
New York, NY 10012
212 777-0662

Art Glass Association of Southern California
12548 Melrose Place
El Cajon, CA 92021

Art Glass Suppliers Association
1100-H Brandywine Boulevard
P.O. Box 2188
Zanesville, OH 43702-2188
614 452-4541
Fax 614 452-2552

Center for Safety In The Arts
5 Beekman STreet
Suite 1030
New York, NY 10038
212 227-6220

CERF Craft Emergency Relief Fund
Suite 9
1000 Connecticut Ave., NW
Washington, DC 20036

Chicago Artists' Coalition
5 West Grand
Chicago, IL 60610
(312) 670-2060

Corning Museum of Glass Rakow Library
One Museum Way
Corning, NY 14830-2253
607 937-5371

Creative Glass Center of America
Glasstown Road
P.O. Box 646
Millville, NJ 08332-0646
609 825-2410

The Foundation Center
79 Fifth Ave
New York, NY 10003
212 620-4230

Glass Art Society
1305 Fourth Ave.
Seattle, WA 98101
206 382-1305
Fax 206 383-2630

International Sculpture Center
1050 Potomac Street, NW
Washington, DC 10007
202 965-6066
Fax 202 965-7318

Michigan Glass Guild
44290 Willis Road
Belleville, MI 48111

Mid-America Arts Alliance
20 West 9th Street, Suite 550
Kansas, Mo 64105
(AR, KS, MO, NE, OK)

MidAtlantic Arts Foundation
11 East Chase St., Suite 2A
Baltimore, MD 21202
(DC, DE, MD, NJ, NY, PA, VA, WV)

National Endowment for the Arts
1100 Pennsylvania Avenue NW
Washington, DC 20506
202 682-5400

New England Foundation for the Arts, Inc.
25 Mount Auburn Street
Cambridge, MA 02138
(CT, ME, MA, NH, RH, VT)

Ontario Arts Council
Chalmers Building
35 McCaul St.
Toronto, Ont. M5T, 1V7
Canada
416 977-3551

Society of Craft Designers
6175 Barfield Road,Suite 220
Atlanta, GA 30328
404-252-2454

Southern Arts Foundation
1401 Peachtree St., NE
Atlanta, GA 30309
(AL, FL, GA, KY, LA, MS, NC, TN, SC, VA)

Stained Glass Association of America
6 SW Second Street, Suite #7
Lee's Summit, MO 64063
1-800-888-7422

Western States Arts Foundation
141 East Palace Ave.
Sante Fe, NM 87501
AZ, CO, ID, MT, NM, NV, OR, UT, WA, WY

Worldwide Glasscrafing
696 Palisades Ave.
Teaneck, NJ 07666
201 836-8940
Fax 201 836-4107
(hold annual stained glass festival w/workshops)

SCHOOLS

Alfred University
SUNY College of Ceramics
School of Art and Design
P.O.Box 1155P
Alfred, NY 14802
607 871-2141

California College of Arts and Crafts
5212 Broadway
Oakland, CA 94618
415 653-8118

Georgia Southwestern College
Americus, GA 31709
912 928-1357

Glass Workshop Inc.
80 Fitzpatrick Road
Grafton, MA 01519

Haystack Mountain School of Crafts
Deer Isle, ME 04627
207 348-2306
Horizons

Kent State University
Glass Program
School of Art
107 Administration Building
Kent, OH 44242
216-672-2600

The New England Craft Program
374 Old Montague Road
Amherst, MA 01002
413-549-4841

New Orleans School of Glass-Works
272 Magazine Street
New Orleans, LA 70130
504-529-7277

The New York Experimental Glass Workshop URBAN GLASS
647 Fulton Street
Brooklyn, NY 11217
718-625-3685
Fax 718 625-3889

376

**Ohio State University
Department of Art**
146 Hopkins Mall
128 North Oval Mall
Columbus, OH 43210
614-422-5072

Penland School of Crafts
Penland Road
Penland, NC 28765
704-765-2359

Pilchuck Glass School
107 South Main Street
Seattle, WA 98104
206-621-8422
Rhode Island School of Design
Two College Street
Providence, RI 02903
401-311-3511

**Rochester Institute of Technology
School for American Craftsmen
College of Fine and Applied Arts**
One Lomb Memorial Drive
Rochester, NY 14623
716-465-2643

Studio Access to Glass
261 North Baker Street
Corning, NY 14830
607 926-3044

**University of Illinois
Department of Art and Design
Fine and Applied Arts Building**
Champaign, IL 61820
217-333-0642

PUBLICATIONS

American Artist
1515 Broadway
New York, NY 10036
212 764-7300

American Craft
72 Spring Street
New York, NY 10012
212 274-0630
Fax 212 274-0650

Antique Review
P.O. Box 538
Worthington, OH 43085
614 885-9757

Antique & Arts Weekly
5 Church Hill Road
Newtown, CT 06470
203 426-3141

Antiques & Auction News
P.O. Box 500
Mount Joy, PA 17552
717 653-9797

Architectural Digest
5900 Wilshire Blvd.
Los Angeles, Ca 90036

Art and Antiques
89 Fifth Avenue
New York, NY 10003
212 260-7050

Art in America
980 Madison Avenue
New York, NY 10021
212 734-9797

Crafts **magazine**
P.O.Box 1790
Peoria, Il 61656
309 682-6626

The Crafts Report
Box 1992
Wilmington, De 19899
800-777-7098

Craftworks for the Home
MSC Publishing, Inc.
243 Newton-Sparta Road
Newton, NJ 07860

Faith & Forum
1777 Church Street, NY
Washington, DC 20036
202 387-8333

Glass **magazine**
NY Experimental Workshop
647 Fulton Street
Brooklyn, NY 11217
718 625-3685
Fax 718 625-3889

Glass Art
P.O. Box 1507
Broomfield, CO 80038-1507
303 465-4965
Fax 303 465-2821

Glass Patterns Quarterly, **Inc.**
8300 Hidden Valley Road
P.O. Box 131
Westport, KY 40077
502 222-5631

Niche **magazine**
Suite 300
Mill Centre
3000 Chestnut Ave.
Baltimore, MD 21211
301 889-2935

Pocket Guide to Chemical Hazards
National Institute for Occupation
Safety
DHHS NIOSH Publication 90-117
Superintendent of Documents
Government Printing Office
Washington, DC 20402-9325
202 783-3238

Professional Stained Glass
PO Box 678
Richboro, PA 18954
215-579-2720

Shopping for Crafts In The USA
American Craft Enterprises, Inc.
P.O. Box 10
New Paltz, NY 12561

Stained Glass News
2345 28th Street SE
Grand Rapids, MI 49508
800 365-2999
Fax 616-940-2999

Stained Glass Quarterly
4050 Broadway
Suite 219
Kansas City, MO 64111

Victorian Homes
550 Seventh Street
Brooklyn, NY 11215
(718) 499-5789

378

***Workbench* magazine**
4251 Pennsylvania Ave.
Kansas City, MO 6411

Woman's Day
1633 Broadway
42nd Floor
New York, NY 10019
212 767-6434

Index